Perspectives on
American Folk Art

Perspectives on American Folk Art

EDITED BY

Ian M. G. Quimby
and Scott T. Swank

PUBLISHED FOR
The Henry Francis du Pont Winterthur Museum
WINTERTHUR, DELAWARE

W · W · Norton & Company
NEW YORK LONDON

Library of Congress Cataloging in Publication Data

Main entry under title:

Perspectives on American folk art.

Includes index.
1. Folk art—United States—Addresses, essays,
lectures. I. Quimby, Ian M. G. II. Swank, Scott T.
III. Henry Francis du Pont Winterthur Museum.
NK805.P47 1980 745'.0973 79–24889
ISBN 0–393–01273–5
ISBN 0–393–95088–3 pbk.

1 2 3 4 5 6 7 8 9 0

Contents

Ian M. G. Quimby
Editor, Publications Office
Winterthur Museum and
Editor, *Winterthur Portfolio: A Journal of American Material Culture*

Scott T. Swank
Deputy Director for Interpretation
Winterthur Museum and
Adjunct Associate Professor of History
University of Delaware

Beatrix T. Rumford
Director
Abby Aldrich Rockefeller Folk Art Center

Marsha MacDowell and C. Kurt Dewhurst
Curators, Folk Arts Division
The Museum
Michigan State University

Marion J. Nelson
Chairman, Department of Art History
University of Minnesota and
Director, Norwegian-American Museum

List of Illustrations

Preface

What do we mean when we call something "folk art"? Where is the "art" and who are the "folk"? The eleven contributors to *Perspectives on American Folk Art* provide almost as many different answers to these and related questions. For some the judgment is primarily an aesthetic one. For others it is a matter of ethnic identity. For still others the region, with its peculiarities of geography and climate, provides the basis for a special identity. These are relatively easy categories to deal with, yet upon close examination they tell us little and indeed they fail to cover all the expressions that have been declared "folk." As several contributors to *Perspectives* point out, the very terms we use in discussing this phenomenon reflect hierarchical assumptions and unspoken but profound prejudices. It is folk because it is primitive or childlike; it is low art because it is not high art. The folk person is someone different from ourselves. It is no accident that folklorists have chosen to study survivals, dying subcultures, while the collector-dealer-museum world of folk art enshrined modest craftsmanship as symbols of a less complicated age.

It is a curious fact that those who deal with American folk art usually do so in isolation from those concerned with American folklore and folk life. For all practical purposes there is no communication between the two groups. Each group has its favorite journals and conferences, and neither group feels the slightest degree of discomfort from living without knowledge of what the other group is up to. This book is an attempt to change that situation. Its purpose is to encourage examination of the basic assumptions about folk art and to spark critical thinking about its definitions, methodology, and associated values. The authors of the essays represent the viewpoints of museum curators and directors, art historians, anthropologists, and folklorists.

The first essay explores the origins and development of col-

lecting folk art in America. It is followed by five essays examining regional or ethnic manifestations. The last five essays explore the theoretical implications of the phenomenon while dealing with the sensitive problem of definitions. *Perspectives on American Folk Art* is, in part, a revisionist treatment of the subject. It takes to task the heretofore unexamined value judgments of collectors, dealers, and curators who have done much to popularize folk artifacts but too little in the way of analyzing their cultural context. The book suggests the great richness and variety of folk art in America. But it also asks so many searching questions and offers so many startling insights that it transcends the study of folk art. *Perspectives* has significant implications for everyone interested in studying the artifact in American culture.

IAN M. G. QUIMBY

Acknowledgments

Special thanks are due to Charles van Ravenswaay who first offered institutional support for the folk art project at Winterthur; to Kenneth L. Ames, Elaine Eff, and Joseph W. Hammond for their work on the conference program; to consultants Louis and Agnes Jones, Beatrix Rumford, and Henry Glassie; to Catherine Wheeler, Patricia R. Bullen, and Katherine J. Kcenze for their untiring efforts on conference arrangements; to all those participants who contributed so much to the atmosphere of the conference; and to James Morton Smith, director of Winterthur Museum; and to the Division of Research Grants, the National Endowment for the Humanities, for providing supporting funds.

SCOTT T. SWANK

Perspectives on
American Folk Art

Introduction
Scott T. Swank

Meanings have been studied less well than forms.
Western scholars are most comfortable when they
study things with limits, things they can control, and
the matter of meanings appears to be infinite and
uncontrollable.

Henry Glassie,
All Silver and No Brass [1]

Perspectives on American Folk Art is the direct outgrowth of a
three-day conference on American folk art held at the Henry Fran-
cis du Pont Winterthur Museum in November 1977. The confer-
ence was part of a major effort by the museum to explore the sub-
ject of folk art. That effort began with an exhibition of 225 ob-
jects from the Winterthur collections at the Brandywine River
Museum in Chadds Ford, Pennsylvania, in the fall of 1977. En-
titled "Beyond Necessity: Art in the Folk Tradition," the exhibi-
tion attracted twenty-two thousand visitors over a two-month pe-
riod. The objects displayed were collected over many years by
Henry Francis du Pont, one of the major early collectors of Amer-
icana. Mr. du Pont's focus on artifacts of the eastern seaboard re-
inforced trends which were current in his day and which are still
very evident among museums and collectors. Consequently, the

[1] Henry Glassie, *All Silver and No Brass* (Bloomington: University of
Indiana Press, 1975), p. 95.

1

objects displayed at the Brandywine River Museum were "familiar faces," and the exhibition offered few conceptual challenges or surprises.

The catalogue of the exhibition, also entitled *Beyond Necessity: Art in the Folk Tradition*, included an interpretive essay by Kenneth L. Ames, teaching associate at the Winterthur Museum and adjunct associate professor of art history at the University of Delaware. Ames's essay shocked the world of folk art. Often brash and irreverent in tone, always penetrating in its analysis, the essay is a trenchant examination of values relating to museum and collecting practices. While the publication contained a checklist of objects in the exhibition, there was no attempt to interpret all of them. Ames did not ignore the objects in the exhibition, but he used them in an unconventional manner for a museum catalogue. They became foils for analyzing concepts, including the contexts in which the objects were produced, used, and ultimately collected and studied. No one within the museum field had so openly challenged so many assumptions about collecting and exhibiting folk art. For many observers, the exhibition and catalogue seemed to represent distinct points of view.

Beyond Necessity was published in September 1977 when the exhibit opened. By the time the Winterthur conference on folk art convened in November, most specialists in American folk art had read or heard about Ames's essay. It established the tone for the conference which became a sociological phenomenon in its own right.

Some conferees came "armed for bear." One distinguished representative of the New York folk art scene labeled the conference the "shoot out" at Winterthur. For some the "bear" was Kenneth Ames in particular. Others saw Ames as a spokesman for Winterthur and came—and perhaps left—convinced that Winterthur does not believe in folk art. Some who came ready to tackle Ames and/or Winterthur found the anthropologists and folklorists an even greater threat. Many with art historical training, and perhaps sympathetic to Ames's point of view, were appalled by the folklorists' analysis of folk "art" and found many of the folklorists "deliberately contentious."

The conference atmosphere was electrically charged. Participants readily took sides and clustered with their ideological peers, almost as if at a political rally. Was it a political rally as well as a symposium on folk art? If so, what fundamental ideological values were being challenged and threatened? Ames addresses this question, partially, in "Folk Art: The Challenge and the Promise." Or was the liveliness of the conference simply the healthy result of intellectual interchange? Expansion of the mind generates conflict, as intellectual historians are fond of telling us. An extension of this individual stretching of the intellect can be seen in the process which characterizes the development of an academic field of study.

Alexander Fenton, a British ethnologist, observed in connection with a symposium intended to define regional ethnology in the British Isles that "expansion as often as not involves conflict, which in this instance takes the form of an opposition between one set of approaches and concepts marked by historical bias, and another set, taken over from general anthropology, which rejects history." Colin Young, in another set of conference proceedings, echoes Fenton's remark. Young, the Scottish-born director of the National Film School of Great Britain and former professor of Theater Arts at UCLA, contends that "Conferences about method are arguments about power; representatives of one approach are racist about all others. This is obviously a waste of time. If different languages are being used we just have to learn their rules to avoid confusion." [2]

The Winterthur conference witnessed more than two opposing viewpoints in a thinly veiled struggle for preeminence. The papers challenged fundamental presuppositions and raised major issues of philosophy. One major division in the approach to folk art appeared in the form of criticism voiced by some conferees that too many of the papers were idea-oriented rather than object-oriented. The object/idea dichotomy is unfortunate and potentially destructive for meaningful study of material culture. The

[2] Alexander Fenton, "The Scope of Regional Ethnology," *Folk Life* 11 (1973):11; Colin Young, as quoted in Paul Hockings, ed., *Principles of Visual Anthropology* (The Hague and Paris: Mouton Publishers, 1975), p. 79.

implicit bias against theory is alarming because that bias threatens to isolate the intellectual from the object and doom the object to intellectual oblivion as its devotees contemplate the material counterpart of their particular navels. Many of these same critics referred to the "primacy of the artifact," as if ideas and objects are mutually exclusive or incompatible.

No matter where a sociological analysis of the conference takes us, another question remains unresolved: Why did Winterthur sponsor a conference and an exhibition on folk art in the first place? Why spend several years on a project seemingly far removed from the high-style eighteenth-century artifacts for which the museum is noted?

For many years, Winterthur's approach to its collections, like that of most art museums, has been dominated by a "top-down" diffusionist theory. Simply put, the search for antecedents and prototypes usually proceeds to the highest socioeconomic levels of society, often to urban centers, and frequently to Europe, which is usually seen as the free-flowing well of ideas and good design. Consequently, urban society and courtly circles, and the artifacts and artisans catering to those segments of society, are the chief sources of design. The closer the bourgeois artisans of Europe and America come to imitating the high-style object, the greater their reputation. Those craftsmen who "fail" to understand the designs they presumably are copying or "fail" in the execution of their imitation are deemed "naïve" or "primitive," and sometimes labeled "folk," or their products are considered debased examples of earlier genius. Consequently, folk "things" are not by definition worthy of serious attention by art historians, whereas high-style objects and their bourgeois copies are.

The top-down diffusionist theory, usually associated with an art historical approach to artifacts, provides a poor basis from which to assess many utilitarian objects found in American museums or outside of them if the objects were not deemed worthy of acquisition by a museum. In coping with this dilemma, the folkloristic approach to material culture studies became especially important in the early 1970s with the behavioral analyses of Michael Owen Jones, the ethnographic work of John Vlach, the structural analy-

ses of Henry Glassie, and the humanistic approach of Roger Welsch.

Decorative arts scholarship normally follows the "top-down" approach, but Robert Trent, in his analysis of Connecticut chairs in *Hearts and Crowns,* tries to resolve this dilemma of decorative arts scholarship. Leaning heavily on the thinking of Henri Focillon, George Kubler, and Henry Glassie, Trent postulates the following: (1) that an object's significance derives more from its position on a continuum of preceding and subsequent work than from its own uniqueness; (2) that folk art craftsmen work according to their own systems of compositional logic which may or may not have a direct relationship to "high-style" influences; (3) that the "masterpiece" theory of decorative arts scholarship has prevented serious aesthetic consideration of folk artifacts because that theory assumes a model of "correctness" based on neo-Palladian ideals and a fine arts aesthetic; and (4) that to be fully understood aesthetically each object must be compared to all the art forms of its culture and yet be simultaneously recognized as an independent composition on that continuum, one which responds to stylistic and market impulses and the compositional logic which the craftsman has brought to it. This continuum approach helps to avoid placing value judgments on the concepts expressed by the words "high," "fine," and "folk," and by recognizing that folk and elite art are parallel systems of aesthetic experience or "alternative systems of compositional logic." Trent's contribution lies in his retention of a basis for art historical qualitative judgments without denying the relevance of anthropological structuralist theory in regard to pattern and system.[3]

One intellectual aim, then, in tackling the problem of folk art, apart from the practical purpose of exhibiting a relatively neglected portion of Winterthur's collection to a wider audience, was to incorporate folk things into the museum's thinking about American culture. The aim was to put ordinary things into a dif-

[3] Robert F. Trent, *Hearts and Crowns: Folk Chairs of the Connecticut Coast 1710–1840 as Viewed in the Light of Henri Focillon's Introduction to "Art Populaire"* (New Haven: New Haven Colony Historical Society, 1977), pp. 23–24.

ferent perspective and to expose staff and students to the best theoretical analyses of folklore, not to eschew an art historical approach in favor of a folkloristic approach. Not to try to convince anyone that earthenware pots are more important than porcelain bowls, but to be more comprehensive and balanced in examining objects and to redress a neglect based on previously dominant elitist values.[4] The result is the realization that whether folk "art" exists or not, the "folk" patterns and rules governing the production and use of ordinary and typical things provide insight into modes of human perception and behavior that do not owe their existence to top-down diffusionist theory, but have a vital life of their own.

In planning the conference, we made no attempt to impose a definition of folk art on the contributors. With the exception of the article on African popular art by anthropologists Johannes Fabian and Ilona Szombati-Fabian and one on fine and plain arts of Latin America by George Kubler, all contributors focused on North American topics. Some chose to interpret folk art broadly and included craft products in their presentations. Many selected material not usually classified or collected as folk art by museums and collectors. Not all regions of the country nor all types of artifacts were covered, but our purpose was to suggest new directions, not to be encyclopedic.

Beatrix Rumford's "Uncommon Art of the Common People: A Review of Trends in the Collecting and Exhibiting of American Folk Art" records for the first time the growth of the folk art phenomenon in the United States. Her story begins with "primitive" American paintings collected by sophisticated New York "modernist" artists, many of whom were European immigrants. This elaboration of the role of the "modernists" is one of the most significant aspects of her article, not only in demonstrating the connection between various art movements, but because the em-

[4] In 1958 the Winterthur Museum hired Dr. Frank H. Sommer III as keeper of folk art, with responsibility to add and to research already extensive Pennsylvania German collections. Sommer continued as keeper until 1963 when he assumed his present position as head of the Winterthur Museum Library. The keeper-of-folk-art mantle was never transferred.

phasis on folk paintings as art set the tone for collecting patterns and exhibition themes for a full generation. Rumford later sketches in the expansion of the folk art phenomenon as it broadened the scope of its material, found acceptability in the art museum world, and was institutionalized in the New York State Historical Association in Cooperstown, New York, and the Abby Aldrich Rockefeller Folk Art Center in Williamsburg, Virginia.

The pivotal 1974 Whitney exhibition, "The Flowering of American Folk Art," culminated decades of interest in the folk art of the northeast. The bicentennial provided a natural impetus for states outside the northeast to survey, collect, and exhibit their own folk art. Implicit, of course, was each state's prerogative of creating its own working definition of folk art. The methodology and findings from one such project are reported by Marsha Mac-Dowell and C. Kurt Dewhurst in "Expanding Frontiers: The Michigan Folk Art Project." MacDowell and Dewhurst recognize the limitations and arbitrary nature of defining a cultural entity according to state boundaries, but they conducted an impressive survey in Michigan based on their own working definition of folk art. The article describes the trials and triumphs of their aesthetic approach.

Debate over the validity of treating folk art aesthetically reverberates throughout *Perspectives on American Folk Art*. Historically, as Rumford illustrates, aesthetic considerations have predominated over cultural analysis, although in the 1970s these two approaches do occasionally live comfortably with one another. Marion J. Nelson's "The Material Culture and Folk Arts of the Norwegians in America" is an example of this compatibility. Nelson, an art historian, provides succinct, deft comparisons of forms, techniques, and types of decoration known in Norway and extant (or lacking) among Norwegian Americans. Always with an eye for design antecedents and the movement of ideas through time and space, Nelson does more than provide iconographic analysis. He sets product, maker, and user in the context of the old and new worlds, bringing his analysis to the present with a description of the role of folk art in the live "new ethnicity" of present-day Norwegian Americans.

Nelson brings the perspective of the art historian to ethnological inquiry. In the process he, like other contributors in this volume, questions the conventional definition of folk art. But he does not question the concept that folk art or craft frequently have an ethnic base. Several authors in this volume explore the concept of folk art from an ethnic foundation. Frederick S. Weiser, a Lutheran pastor of Pennsylvania German descent, examines his own ethnic group in "Baptismal Certificate and Gravemarker: Pennsylvania German Folk Art at the Beginning and the End of Life." Weiser's approach is explicitly ethnographic rather than aesthetic.

Lonn W. Taylor, in "*Fachwerk* and *Brettstuhl*: The Rejection of Traditional Folk Culture," barely mentions folk art at all, for he sees in the *embourgeoisement* of nineteenth-century Texas Germans a clear rejection of Old World vernacular in favor of Anglo-American values more suitable to their New World aspirations. Taylor's article is important because it introduces the concept of social class into the consideration of folk art. The concept is more fully developed in subsequent articles by George Kubler and Johannes Fabian and Ilona Szombati-Fabian.

The last of the ethnographic essays is John Vlach's "Arrival and Survival: The Maintenance of an Afro-American Tradition in Folk Art and Craft." Vlach revises the work of earlier anthropologists of Afro-American culture and presents an exciting array of material culture for us to consider. He examines such crafts as basketwork, boatbuilding, ironwork, and pottery in which he demonstrates a recognizable African component. He adds a vital element to the corpus of American material culture, and he succeeds in raising to a new level of consciousness the persistence of Afro-American culture in the face of brutal pressures for extinction.

Ethnicity may or may not coincide with a second basis for ethnographic study—regionalism. The Pennsylvania Germans are a case in point. While the Pennsylvania German diffusion was widespread—to Canada to the north, Virginia and the Carolinas to the south, and Ohio, Indiana, Iowa, and other midwestern states to the west—the cultural hearth lay firmly in eastern Pennsylvania. A full understanding of this ethnic group lies in a consideration of their

regional identity as well as the ethnic and religious factors stressed by Frederick Weiser.

Roger Welsch's "Beating a Live Horse: Yet Another Note on Definitions and Defining" provides a transition piece between those essays which are primarily ethnographic in nature and those which contain important ethnographic material but are essentially theoretical. While he touches on the implications of Great Plains space for the production of folk art, his emphasis in this essay is not regionalism but the nature of the process of defining. Vivid regional imagery buttresses his attack on the overcompartmentalization of knowledge. Welsch makes a strong humanistic statement about folklore and folklife inquiry.

George Kubler's "The Arts: Fine and Plain" concentrates on Hispanic American materials from Mexico, but it is really an elaboration of Voltaire's dictum that "all the arts are brothers." Kubler argues that the arts cannot be studied in isolation from one another or in light of value judgments which obscure one in favor of another. He sees fine art and popular art as a "binomial expression" and endeavors to explicate both in light of the dimensions of social class, the history of taste, and iconographic meaning. Kubler decries the separate roles of the art historian and the anthropologist and chastises both for their tunnel vision in approaching the arts. The result is a model for the study of the "plain" arts which Kubler suggests may be applicable to other countries with racial and social histories as complex as those of Mexico.

Johannes Fabian and Ilona Szombati-Fabian reveal in their article "Folk Art from an Anthropological Perspective" that anthropologists are increasingly sensitive to aesthetic concerns, just as Kubler and a few other art historians are incorporating anthropological insights, especially structuralism, into their work. Like Kubler, Fabian and Szombati-Fabian are dealing with ethnographic material from outside the United States—in this case popular art from Shaba Province, Zaire—but the theoretical concerns of their article have wider applicability. They want to push the study of art beyond schools, styles, and periods, and they caution against the imposition of antithetical values, whether those of the scholar or the marketplace, upon the material culture being con-

sidered. With Kubler, they argue that objects cannot be parceled out to different disciplines for meaningful interpretation.[5] The Fabian and Szombati-Fabian study of African popular art is also an exercise in semiosis, defined by the authors as "the transformation of experience into coherent systems of signification." [6] Such application of linguistic theory to material culture has important implications, for it allows objects to be seen as ideas in motion, as nonverbal communication, as patterned behavior. The chief exponent of this approach for American material culture is Henry Glassie.[7]

The interpretation of objects as signs or symbols operating within cultural frameworks according to conceptual sets of rules suggests the role that art—even art evaluation—can play in the social control and manipulation of people. Fabian and Szombati-Fabian depict the role of art within a producing culture. Kubler describes the interpretation of art by culture and suggests that art interpretation is frequently a value-laden cultural drama. Both articles set the stage for Kenneth Ames's essay, "Folk Art: The Challenge and the Promise." Ames provides the least amount of eth-

[5] This emphasis on the convergence of disciplines is one of the most exciting aspects of material culture study in the 1970s. See Leland Ferguson, ed., *Historical Archaeology and the Importance of Material Things* (n.p.: Society for Historical Archaeology, 1977), which is a report of the 1975 conference held by the Society for Historical Archaeology in Charleston, South Carolina.

[6] See p. ooo elsewhere in this volume. The Fabian and Szombati-Fabian essay should be read in conjunction with their earlier essay on Shaba paintings which provides more information on the iconography and cultural significance of this genre of popular art. See Ilona Szombati-Fabian and Johannes Fabian, "Art, History, and Society," *Studies in the Anthropology of Visual Communications* 3, no. 1 (Spring 1976):1–21.

[7] The development of Henry Glassie's thinking on material culture over the past decade can be seen in the following (listed chronologically): *Pattern in the Material Folk Culture of the Eastern United States* (Philadelphia: University of Pennsylvania Press, 1969); "Structure and Function, Folklore and the Artifact," *Semiotica* 7, no. 4 (1973):313–51; *Folk Housing in Middle Virginia: A Structural Analysis of Historic Artifacts* (Knoxville: University of Tennessee Press, 1976); "Meaningful and Appropriate Myths: The Artifact's Place in American Studies," in *Prospects: An Annual of American Cultural Studies*, vol. 3, ed. Jack Salzman (New York: Burt Franklin & Co., 1977), pp. 1–49. His most direct essay on folk art is "Folk Art," in *Folklore and Folklife: An Introduction*, ed. Richard M. Dorson (Chicago: University of Chicago Press, 1972), pp. 253–80.

nographic data of any of the contributors. His article is an exercise in the sociology of knowledge and a study of the significance of value formation in human behavior. Like several other authors represented in this volume, Ames is interested in breaking down barriers to inquiry by challenging presuppositions that we tend to accept uncritically or unwittingly. He calls attention to the fact that these unexamined presuppositions control the questions we ask in evaluating objects and consequently help to determine our results. He advocates a centrifugal pattern of inquiry which in its approach to material culture subordinates objects to people.

The last essay in the volume builds upon the behavioral foundation erected by Ames. In "L.A. Add-ons and Re-dos: Renovation in Folk Art and Architectural Design," Michael Owen Jones focuses on contemporary alterations to domestic structures and the rearrangement of personal space in Los Angeles, California, in an effort to suggest new directions for folk art study. Jones's approach is unabashedly behavioral and revisionist, and for those reasons it will be highly controversial. He endeavors to turn folkloristics as a field on end to provide a model which allows folklorists to consider twentieth-century phenomena of urban, mass culture (both people and their "outputs") instead of being confined to survivals of rural culture. Rather than concentrate on folk "art," folk "culture," or a group designated as "folk," Jones proposes to elevate human behavior to the status of a "centrally-informing concept." He would emphasize people, their skills, and the use of their skills as well as their "outputs" (the things they make or do). It is a long way from the early aesthetic appreciation of the "primitive" by the "modernists" to the radical position of Michael Owen Jones who advocates that as scholars we should abandon the concept of "art" when dealing with artifacts and the concept of "folkness" in dealing with people.

Perspectives on American Folk Art does not arrive at a new consensus on the definition or understanding of folk art, although it does extend the parameters of folk art scholarship. Several major approaches to folk art are delineated here. They do not for the most part present explicitly conflicting arguments about premises and definitions, but they will enable the serious student to use the lines of inquiry laid down here to pursue many exciting and

original avenues. Hypotheses are presented that need to be tested, criticisms made that need to be answered, and challenges offered that need a new generation of concentration. *Perspectives* is just the beginning of a new level of discovery and debate.

> The meaning of an artwork, its presence as a sign, is not to be found only in the thing itself, nor only in infinite personal associations. Meaning vibrates between these realities, between properties in the thing and ideas in the minds of its performers and audiences.
>
> Henry Glassie.
> *All Silver and No Brass* [8]

[8] Glassie, *All Silver and No Brass,* p. 95.

Uncommon Art of the
Common People:
A Review of Trends in the
Collecting and Exhibiting of
American Folk Art
Beatrix T. Rumford

The recognition of the art of the common people as a special category came about in Europe during the 1860s and was at first limited to peasant arts and crafts. The interest was fostered by a romanticized view of the simple life of the folk and an intellectual climate rife with democratic or nationalistic ideas.

In this country, collecting of the many kinds of objects now commonly called folk art began about thirty years later. A few decorative arts enthusiasts, like Edwin Atlee Barber, specialized in Pennsylvania German pottery. An occasional anthropologist, chief

I am indebted to Tom Armstrong for generously providing me with transcripts of interviews and other materials pertaining to early collectors of American folk art which he compiled in 1968 and 1969, while curator of the Abby Aldrich Rockefeller Folk Art Collection. His research greatly facilitated my study. I am also grateful to Bland Blackford and Ann Barton Brown for their invaluable assistance in ferreting vital bits of information from archives at Colonial Williamsburg and elsewhere.

among them Henry Mercer, gathered tools and craft products to document old ways about to be supplanted by an increasingly urban industrial society. History-minded local antiquarians such as Cummings Davis in Concord, Massachusetts, preserved genealogical artifacts. But folk art collecting as a national phenomenon received much of its impetus from a small group of artists in New York City, many of whom were of immigrant ancestry.

Not until 1923, when a special showing of the portrait *Mrs. Freake and Baby Mary* (ca. 1674) at the Worcester Art Museum engendered several review articles, is there clear evidence of a developing interest in the aesthetics of "American primitives"—a term initially applied to paintings by Raymond Henniker-Heaton, an English art historian who was curator at Worcester. In discussing the picture, Henniker-Heaton commented:

The portrait has much naïveté, but it is not sufficient to dismiss it as amusing, historical, or a mere primitive effort, for in an art sense it is supremely interesting. . . . Our artist's lack of training was an art gain, and resulted in the balance of his work leaning toward the esthetic rather than the technical. . . . The reason this picture is important from an art standpoint is not because the artist was a painter by instinct, without academic technical skills, but because he was creative by instinct, was little acquainted with studio methods, and was unconscious of any handicap in this respect.[1]

Ten years earlier, in the summer of 1913, Hamilton Easter Field, a painter and writer who subsequently established *Arts Magazine* (1920), launched the Ogunquit School of Painting and Sculpture at Ogunquit, Maine. Robert Laurent, a sculptor and a native of Brittany, was involved with the colony from its inception. By 1920, Wood Gaylor, Marsden Hartley, Stephan Hirsch, Bernard Karfiol, Yasuo Kuniyoshi, Niles Spencer, and William Zorach were among the artists who had been invited to spend summers at the Ogunquit Colony. They worked in fishing shacks that lined Perkin's Cove. Purchased by Field to serve as studios, the cottages were rented for seventy-five dollars for the summer. Their simple furnishings included such decorative accents as decoys,

[1] Raymond Henniker-Heaton, "Portraits of John Freake and Madam Elizabeth Freake with Baby Mary," *Bulletin of the Worcester Art Museum* 14, no. 3 (October 1923): 62.

weathervanes, homemade rugs, and unsophisticated paintings which Field, who enjoyed hunting antiques, had purchased cheaply at local auctions or junk shops.

The modernists who summered at Ogunquit were determined to break away from the representational and impressionist tendencies of late nineteenth-century academic art. Each artist was struggling to develop a visual language expressive of emotion. Several of Ogunquit's pioneers of modernism depicted the setting, their colleagues, and activities of the art colony in distinctly personal compositions. Niles Spencer painted a view of the shacks in *Perkin's Cove* in 1922 (Newark Museum), while *Picnic at Shaker Lake* by Wood Gaylor (collection of John Laurent) dates from the following summer. Four of the artists depicted in Gaylor's scene— Kuniyoshi, Alice Newton, Frank Osborne, and Dorothy Varian —were lenders to the first exhibit on American folk art held at the Whitney Studio Club in February 1924.

Both Karfiol and Laurent were so intrigued by the design quality in the best of Field's finds that as early as 1916 they had begun collecting for themselves. The enthusiasm of the Ogunquit group was contagious; Charles Sheeler, Elie Nadelman, and other New York artists caught up in the modern movement also began acquiring American primitives. They recognized in the neglected carvings and portraits many of the same abstract qualities that were the essence of their own art and came to appreciate what America's unschooled eighteenth- and nineteenth-century craftsmen and amateurs, unshackled by aesthetic theories, had achieved.

Some of these modernists were attracted to American primitives because of their European counterparts' much publicized interest in primitive art forms. American artists who had spent time in Paris witnessed the Fauve enthusiasm for exotic objects found in African, Oceanic, and other non-European cultures, while those who had studied in Munich or Dresden were aware of the interest of such groups as Der Blaue Reiter and Die Brücke in the art of peasants and children.[2]

Elie Nadelman, a talented Polish Jew, had become interested

[2] Holger Cahill, *American Folk Art: The Art of the Common Man in America, 1750–1900* (New York: Museum of Modern Art, 1932), pp. 26–27 (hereafter *Art of the Common Man*).

in German folk art while living in Munich before he emigrated to the United States in 1914. In 1919, he married Mrs. Joseph A. Flannery, a wealthy widow who collected European embroidery. Between 1923 and 1938, the Nadelmans spent a half million dollars acquiring "the more beautiful examples of folk art that came to their notice." They amassed a huge, wide-ranging assortment of decorative arts that was international in scope and eventually included nearly fifteen thousand items. Their collections were installed in a museum built on their estate at Riverdale-on-Hudson, New York, "for the purpose of showing the beginning and development of American taste with its European backgrounds." [3] The Nadelmans' museum opened to the public in 1924.

When Mrs. Nadelman's fortune was lost during the Great Depression, most of the museum's contents were sold to the New-York Historical Society and, subsequently, dispersed to Abby Aldrich Rockefeller, Henry Francis du Pont, the Cloisters of the Metropolitan Museum of Art, and the Brummer Galleries. Nadelman continued to be infatuated with the concept of "art for people" and, using money from the sale of the first collection, began purchasing American weathervanes, quilts, carvings, and paintings. Mrs. Nadelman sold this second collection after her husband's death in 1946. The New York State Historical Association at Cooperstown enriched its holdings by the addition of thirteen Nadelman pieces, chosen for purchase by Stephen C. Clark and Louis C. Jones.[4]

In February 1924, the painter Henry Schnackenberg selected and arranged the first public showing of folk art, which he titled "Early American Art," at the invitation of Juliana Force, director of the Whitney Studio Club—Gertrude Vanderbilt Whitney's gathering place for artists, and the precursor of the Whitney Museum founded in 1930. Juliana Force was herself an avid early collector of folk art (Fig. 1) and formed a collection of sixty-four

[3] "Report of the Board of Trustees," as quoted in *Annual Report of the New-York Historical Society* (New York: New-York Historical Society, 1938), pp. 16, 17.
[4] Louis C. Jones, "The Folk Art Collection," *Art in America* 38, no. 2 (April 1950):109–28.

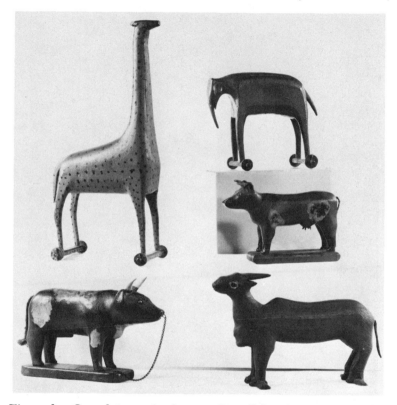

Figure 1. Carved toy animals, ca. 1850. Painted wood; giraffe, H. 16½". Found by Juliana Force and subsequently owned by Mary Allis. (Collection of Stewart E. Gregory: Photo, Abby Aldrich Rockefeller Folk Art Center Archives.)

paintings for the Whitney, most of which were deaccessioned and sold through M. Knoedler and Company in 1950.

The eight-page pamphlet prepared in conjunction with the show lists forty-five objects, many belonging to Schnackenberg's artist associates. The three illustrations, all photographed by Charles Sheeler, show a striking portrait owned by Mrs. Force; a James Bard steamboat, *The Francis Skiddy*, which belonged to

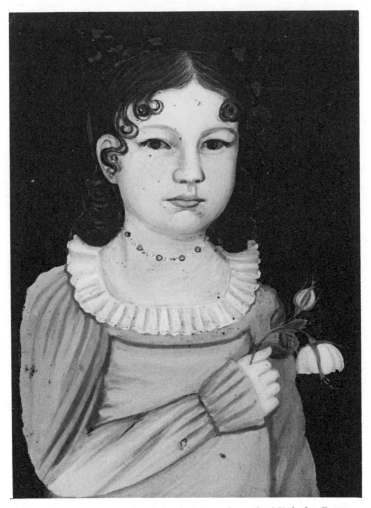

Figure 2. Benjamin Greenleaf, *Mary Ann C. Nichols.* Boston, July 29, 1817. Reverse painting on glass; H. 16″, W. 11″. (Location unknown: Photo, Abby Aldrich Rockefeller Folk Art Center Archives.) Handwritten paper label on original wood backing inscribed: "This portrait of Mary Ann C. Nichols aged 5 years and half. Painted by Benj. Greenleaf at Boston, July the 29, 1817."

Harve T. King; and a precise watercolor rendering of a locomotive, loaned by Yasuo Kuniyoshi. The exhibit also included four carvings of wood or bone, Benjamin Greenleaf's portrait of Mary Ann Nichols (Fig. 2), theorems, a brass bootjack, a plaster cat, and two pieces of pewter.[5] Reviewing the show in *The Arts,* Virgil Barker commented:

The exhibition of Early American Art which Mr. Schnackenberg assembled at the Whitney Studio Club was thoroughly enjoyable. The discovery of our artistic past which is now progressing with increasing rapidity satisfies more than the collecting instinct, for such paintings and miscellaneous objects as were brought together in this exhibition have the tang of reality. They are actually and adequately expressive of their time; they form a genuine contribution to cultural history.[6]

Schnackenberg's exhibit quickly stimulated dealer interest and involvement. Less than a year later, in December 1924, the New York dealer Valentine Dudensing presented an exhibit entitled "Early American Portraits and Landscapes." The show consisted chiefly of pictures Dudensing had borrowed from his client, Robert Laurent, and included two children's portraits, *Child with Kitten,* recently attributed to Zedekiah Belknap, and *Dover Baby* (Fig. 3).

Writing about the show for *International Studio,* Guy Eglington suggested, "the new American Wing at the Metropolitan might be enlivened by the addition of a little naïveté." Eglington was completely smitten with the *Dover Baby* (so titled because Laurent had found the portrait near Dover, New Hampshire) and initially misdated the portrait as seventeenth century. He felt, "it should certainly be given a place of honor on the third floor. But there, I take it back. The Dover Baby is I think much too alive to be condemned, so young, to a museum. Even in Mr. deForest's new wing he wouldn't, I fear, be entirely happy." [7]

The first dealer to market American primitives was Isabel

[5] The painting of Mary Ann Nichols is listed as no. 27 in the catalogue by Henry Schnackenberg for the exhibition "Early American Art" at the Whitney Studio Club in 1924.

[6] Virgil Barker: "Notes on the Exhibition," *The Arts* (March 1924), p. 161.

[7] Guy Eglington, "Art and Other Things," *International Studio* 80, no. 333 (February 1925):419.

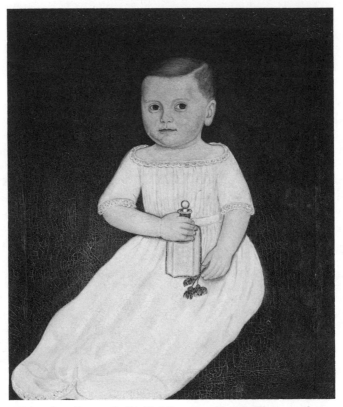

Figure 3. *Dover Baby Holding Bottle and Flower*, 1825–
50. Oil on canvas; H. 25″, W. 21″. (Collection of Mr. and
Mrs. John Laurent: Photo, Geoffrey Clements.)

Carleton Wilde, who operated an antiques shop featuring pine
and maple furniture and New England glass in a nineteenth-cen-
tury house she had restored in Cambridge, Massachusetts. Oral
tradition claims that sometime in 1924 she purchased a stunning
composition of grapevines stenciled on velvet (Fig. 4). Having re-
cently heard a lecture on Far Eastern art, she assumed it to be of
Indian origin. When Mrs. Wilde realized the picture was Ameri-
can, she hastened to acquire related examples. Her interest quickly

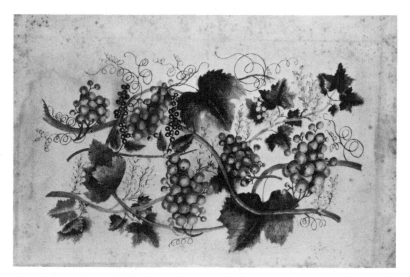

Figure 4. *The Grapevine*, 1800–25. Painting on velvet; H. 15¼", W. 23⅛". (Abby Aldrich Rockefeller Folk Art Center.)

extended beyond velvets, and she advertised in the November 1926 issue of *Antiques*: "Beginning November 1st Isabel Carleton Wilde announces an important exhibition of American Primitives including paintings on velvet and glass, portraits in oil, water colors, pastels, and tinsels. Many of these are in their original old frames." [8]

Three months later, Juliana Force borrowed some of Mrs. Wilde's "early American paintings" for a loan exhibit at the Whitney Studio Club. The collection received further exposure in 1930 with showings at the Harvard Society for Contemporary Art and the Newark Museum. In 1932, Mrs. Wilde dispersed much of her folk art through the New York gallery of John Becker. Mrs. Rockefeller bought *The Grapevine*, perhaps the freshest and most original of the many velvet paintings that she acquired.

Because of her role in the rediscovery of folk art in New England, Isabel Wilde was appointed to the National Committee of the

[8] Advertisement, *Antiques* 10, no. 5 (November 1926):394.

American Chapter of the International Commission on Folk Arts. Created in 1928 under the auspices of the League of Nations, with headquarters in Brooklyn, the purpose of the commission was to document and to preserve traditional folk arts and crafts and, through exhibitions, demonstrations, and articles, to use folk art to foster better understanding among people of all nations. Mrs. Wilde thus became the first of a series of dealers whose commitment to folk art and whose influence on the field extended beyond sales activity.

In 1927, presumably in response to viewing an exhibition of some of Mrs. Wilde's paintings, Homer Eaton Keyes, editor of *Antiques*, wrote: "The attribute of primitivism in a work of art is, indeed, seldom so much a matter of its actual date as of the degree of aesthetic and technical cultivation displayed by the artist who has produced it." [9] With the perspective of someone conditioned by looking at modern art, he pointed out:

On first examination, their inadequacies of drawing will be the only element that is apparent to the average person. If, however, the fact is borne in mind that, in many of these pictures, the various elements of the design are to be viewed only as decorative symbols, and not as naturalistic renderings of particular objects, appreciation will shortly begin to develop.

Then he concluded with a warning:

Nevertheless, while a good many apparently crude pictures are worth collecting and keeping, it should by no means be assumed that crudity *per se* is a mark of merit, and that all pictures in which that attribute is observable are to be viewed with favor. Nothing could be further from the truth.[10]

Of the initial group of artist-collectors of folk art, Robert Laurent had the greatest influence. He accumulated a solid collection of nineteenth-century carvings and paintings when few peo-

[9] Homer Eaton Keyes, "Some American Primitives," *Antiques* 12, no. 2 (August 1927):119.
[10] Keyes, "Some American Primitives," p. 122. See also illustrations accompanying Louise Karr, "Paintings on Velvet," *Antiques* 20, no. 3 (September 1931):162–65.

ple cared about them, and he was always willing to show his collection to interested viewers. Laurent inherited Field's entire estate after Field's death in 1922, including the Ogunquit properties, which he continued to rent to artists. In the summer of 1925, one of Laurent's tenants was Sam Halpert, a painter. He was accompanied by his wife, Edith Gregor Halpert, a former efficiency expert for the investment firm of S. W. Straus and Company. Mrs. Halpert was preparing to open her Downtown Gallery in Greenwich Village where she proposed to represent the work of living American artists, including members of the Ogunquit summer colony. The Halperts returned to Maine the following year with a guest, Holger Cahill, then on the staff of the Newark Museum for which he was building a contemporary collection. Cahill had previously spent a summer in Norway, Sweden, and Germany visiting provincial museums and had become interested in European peasant art.

When Edith Halpert and Cahill were introduced to American primitives at Laurent's home, they were fascinated by the contemporary look of the nineteenth-century carvings and paintings he had collected. They also realized that Laurent and other post-Armory Show modernists had inadvertently found in these creations a means to dignify their own use of simplified forms, arbitrary perspective, and unmixed color by suggesting that such methods were rooted in an earlier American tradition.[11] Karfiol's painting, *Making Music* (Fig. 5), depicts the living room of Laurent's home as it appeared when Cahill and Mrs. Halpert visited. The folk portraits on the wall include *Child with Kitten* and *Dover Baby*.

Although contemporary artists had rediscovered the material, Edith Halpert and Holger Cahill must be credited with initiating the widespread appreciation and collecting of American folk art as a proper artistic expression. They invariably valued the aesthetic importance of an object, in and of itself, over any potential documentary significance. Cahill's awareness of handcraftsmanship as a dying American tradition had been instilled by studies with Thor-

[11] Holger Cahill, "American Folk Art," *American Mercury* 24 (September 1931), p. 46.

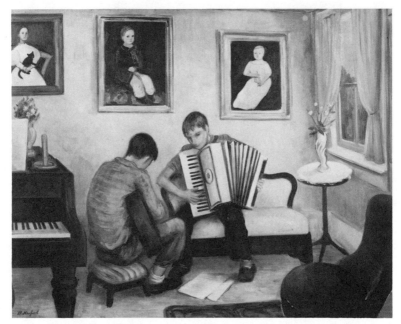

Figure 5. Bernard Karfiol, *Making Music*. Ogunquit, Maine, 1938. Oil on canvas; H. 32″, W. 40″. (Collection of Bunty and Tom Armstrong: Photo, Geoffrey Clements.)

stein Veblen and was nurtured during his association with John Cotton Dana, director of the Newark Museum. Cahill wrote well and knew how to organize meaningful exhibits. He functioned as the spokesman.

Blessed with considerable business acumen as well as a discerning eye, Mrs. Halpert immediately realized the sales potential of first-rate folk art and capitalized on her opportunity. She was the promoter. Having become aware of folk art in Ogunquit, she too began acquiring it. During August, when the Downtown Gallery was closed, she toured the New England countryside in a station wagon, stopping at homes that she thought might have interesting old things. Approaching a likely looking house, she would

tell the inhabitants, "There are troughs for horses but no drinking fountains for human beings." [12] People often offered the thirsty lady tea, one thing led to another, and she invariably ended up exploring in the attic.

Edith Halpert began selling folk art at the Downtown Gallery in 1929. Abby Aldrich Rockefeller was an early customer. Mrs. Halpert soon needed more space, and in September 1931, she formally opened her American Folk Art Gallery, the first to deal exclusively in this field. In a promotional piece for *The Art Digest*, she wrote of her expanded activities in the area of American folk art. She bluntly stated that the folk art she offered had been chosen "not because of . . . antiquity, historical association, utilitarian value, or the fame of their makers, but because of their definite relationship to vital elements in contemporary American art." [13]

The first straightforward definition of folk art was published in October 1930 in a pamphlet prepared by Lincoln Kirstein and two other undergraduates, Edward M. M. Warburg and John Walker, to accompany an exhibition of American folk painting that they had organized for the Harvard Society for Contemporary Art in connection with the Massachusetts Tercentenary Celebration. "By folk art we mean art, which springing from the common people is in essence unacademic, unrelated to established schools, and, generally speaking, anonymous." [14] The show was designed to stress the continuity of American art by calling attention to the modern look of earlier pictorial material. Some 108 examples of portraits, landscapes and seascapes, still life compositions, and amateur copywork were borrowed from individuals in the Northeast and from the Society for the Preservation of New England Antiquities. Sizable loans were made by Isabel Carleton Wilde and Mrs. Henry T. Curtiss, Kirstein's sister, whose husband was inter-

[12] Interview with Tom Armstrong, New York City, January 22, 1969. Archives, Abby Aldrich Rockefeller Folk Art Center, Williamsburg, Va. (hereafter AARFAC).

[13] Edith Gregor Halpert, "Folk Art in America Now Has a Gallery of Its Own," *Art Digest* 6, no. 1 (October 1, 1931):3.

[14] "Exhibition of American Folk Painting in Connection with the Massachusetts Tercentenary Celebration" (Cambridge, Mass.: Harvard Society for Contemporary Art, 1930), unpaginated.

ested in handcrafts and collected American objects from about 1920.[15]

No *Fraktur* certificates or other examples of inherited Old World forms appear in the list of objects assembled for this exhibit. Most of the pictures were a reflection of popular culture. In fact, the introductory essay reveals that the Harvard group's conception of folk art was more nearly analogous to what we now define as kitsch. Kirstein and his associates glibly state that given sufficient space and adequate examples, they would have included "circus posters, side show banners, broadsides for quack medicine doctors, screens made of cut postage stamps, shells, feather and woolen flowers, frosted windows of dining [lunch] cars." [16] Watercolor renderings of tattoo designs were also featured, and, although peripheral to the stated title of the exhibit, the artistry of New England gravestone carving was recognized in a series of photographs.

Just four days after the Harvard exhibit closed, the Newark Museum staged the most comprehensive showing of American primitives yet assembled. The exhibit was Holger Cahill's idea. While the enthusiasm for primitives had been spreading from artists to dealers and collectors since the mid-1920s, little had been written about the material. Cahill suggested to Beatrice Winser, who had been named director of the Newark Museum after Dana's death in 1929, that it was time for a museum-sponsored, selective exhibition of folk paintings accompanied by an informative catalogue. Miss Winser agreed, chiefly because her much admired predecessor had talked of building a similar exhibit around a pair of important local portraits of James and Catherine Van Dyke that had been bequeathed to the museum in 1921.[17]

Because Cahill was determined to feature fresh material, it took over a year to assemble the show. It opened on November 4, 1930. Organizational responsibilities were shared with two mem-

[15] Lincoln Kirstein to Tom Armstrong, July 7, 1969, Correspondence File, AARFAC.

[16] "Exhibition of American Folk Painting," unpaginated.

[17] These likenesses are now known to have been painted about 1787 by Mrs. Van Dyke's nephew, John Vanderpool, who is believed to have been a New York City sign painter. Curiously, these portraits, which had been restored in 1929, were not included in the 1930 show.

bers of the museum staff, Katherine Coffey, who handled business details and supervised the installation, and Elinor Robinson, who researched and compiled the catalogue entries. The trio made several expeditions in search of interesting paintings. Their most important discoveries were two scenes by Joseph Pickett, *Coryell's Ferry*, 1776 and *The Council Tree*. Pickett, who owned and operated a grocery in New Hope, Pennsylvania, until he died in 1919 at age seventy-one, had taught himself to paint. In his spare time he labored over four remarkable compositions that he presumably painted for his own satisfaction. The inclusion of Pickett's pictures in the Newark show reflected the organizers' interest in contemporary folk art as well as that of the past.

In his catalogue essay, Cahill maintained that "the word primitive is used as a term of convenience and not to designate any particular school of American art, or any particular period. It is used to describe the work of simple people with no academic training and little book learning in art." [18] Several paragraphs later, he succinctly summarized the attraction the pictures held for him.

The peculiar charm of their work results sometimes from what would be technical inadequacies from the academic point of view, distortion, curiously personal perspective, and what not. But they were not simply artists who lacked adequate training. The work of the best of them has a directness, a unity, and a power which one does not always find in the work of standard masters.[19]

The eighty-three paintings in the exhibition were divided into three categories according to the subject: portraits, landscapes and other scenes, and decorative pictures. Each section was preceded by chatty descriptive notes prepared by Elinor Robinson, who never alluded to biographical or historical facts but rather emphasized compositional and design elements, often suggesting purely subjective analogies with other forms of artistic expression. Clearly, the intent of the show's organizers was to emphasize aesthetics. To be fair to Miss Robinson, most of the pictures were unsigned and their painters thus unidentified. Furthermore, while

[18] Holger Cahill, introduction to *American Primitives: An Exhibit of the Paintings of Nineteenth-Century Folk Artists* (Newark, N.J.: Newark Museum, 1931), p. 7.
[19] Cahill, introduction to *American Primitives*, pp. 8–9.

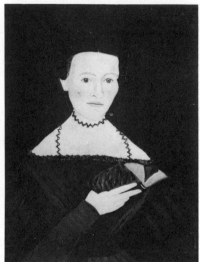

Figure 6. *Portrait of a Child,* ca. 1840. Oil on canvas; H. 36″, W. 29″. (Newark Museum, Felix Fuld Bequest.)

Figure 7. *Portrait of a Woman,* attributed to R. W. and S. H. Shute, 1825–50. Pastel and watercolor on paper; H. 28¼″, W. 21¼″. (New-York Historical Society.)

groups of related portraits had already come to light in Kent, Connecticut, and Fall River, Massachusetts, their attribution to Ammi Phillips and the Prior-Hamblen School could not be made until more examples were found and a conclusive signature discovered.[20]

Not surprisingly, several of the Ogunquit collectors were among the lenders to the Newark show. Robert Laurent was the

[20] For an example of Miss Robinson's comments, see, for instance, thoughts on the Nadelman watercolor in *American Primitives: An Exhibit of the Paintings of Nineteenth-Century Folk Artists* (Newark, N.J.: Newark Museum, 1931), p. 19, no. 27. For a discussion of the Kent limner, see Mrs. H. C. Nelson, "Early American Primitives," *International Studio* 80, no. 334 (March 1925):450–59. For an early discussion of the Fall River School, see H. E. Keyes, "Some American Primitives," *Antiques* 12, no. 2 (August 1927): 121–22.

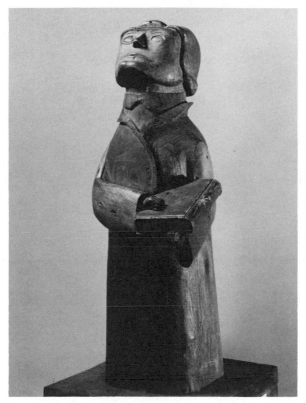

Figure 8. *The Preacher*, ca. 1870. Butternut and eastern white pine; H. 21″, W. 7½″. (Abby Aldrich Rockefeller Folk Art Center.)

major contributor; among the fifteen pictures he loaned were views of *Boston Prison* and *Mount Vernon* and the appealing *Dover Baby* and *Child with Kitten*. Other artist lenders included William Zorach and Elie Nadelman. Zorach found *Portrait of a Child* (Fig. 6) in Maine and sold the painting to the museum following the exhibition. Nadelman lent *Portrait of a Woman* (Fig. 7) to the museum in 1931 and subsequently sold it to the New-York Historical Society in 1937.

Items belonging to Mrs. Wilde and the New Jersey Historical Society were also included in the exhibit, which was so well received that after the exhibition closed on February 1, 1931, some of the pictures were selected for a special loan show that traveled to the Memorial Art Gallery in Rochester, the Renaissance Society of Chicago, and the Toledo Museum of Art.

While they were seeking paintings for Newark's American primitives exhibit, Cahill and his colleagues had also discovered some first-rate sculpture. Three especially exciting carvings were slipped into the painting show, and their presence was noted on an unnumbered page at the end of the catalogue. One of the three, *The Preacher* (Fig. 8), was until recently thought to represent Henry Ward Beecher. It is now believed to have been inspired by a metal replica of Ernst Rietschel's enormous bronze monument to Martin Luther erected in Worms in 1868.

Cahill was freelancing during this period, and, between assignments, he collected folk art for himself, Edith Halpert, and others. When Miss Winser commissioned Cahill to mount a sculpture show in 1931, he insisted on folk sculpture. Again assisted by Katherine Coffey and Elinor Robinson, Cahill borrowed nearly two hundred objects from artists, collectors, and dealers and displayed them by media—wood carving, metalwork, and pottery and plaster ornaments.

In his foreword, Arthur F. Egner, president of the museum board, stated: "Here is another persuasive example of the truth of John Cotton Dana's constant assertion that articles of common and humble character may well be as significant expressions of art as products of cost and circumstance." [21]

Miss Robinson's descriptive notes incorporated more specifics on identified artists than the previous catalogue, but otherwise they followed the same subjective, art-oriented format of the painting catalogue. A typical example is this portion of the entry for *Devil Bootjack* (Fig. 9): "Sprightly figure, suggestive of African in vigorous simplicity and conventionalization of forms. Perhaps the surprising presence of such a personage in New England, where he

[21] Holger Cahill, *American Folk Sculpture: The Work of Eighteenth- and Nineteenth-Century Craftsmen* (Newark, N.J.: Newark Museum, 1931), p. 9.

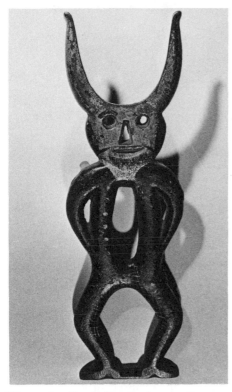

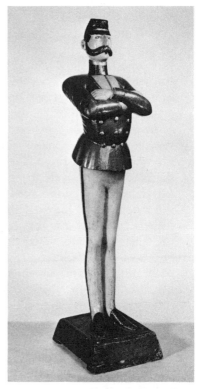

Figure 9. *Devil Bootjack,* ca. 1850–75. Polychromed cast iron; H. 10½″, W. 3¼″. (Abby Aldrich Rockefeller Folk Art Center.)

Figure 10. Thomas J. White, *Captain Jinks of the Horse Marines.* Newark, N.J., 1879. Painted wood; H. 75″. (Newark Museum, gift of Herbert Ehlers.)

was shunned with such zeal, may be accounted for by the fact that he would have to be stepped on every time he was used." [22]

Among the most striking carvings featured in "American Folk Sculpture" was the suave, attenuated figure of *Captain Jinks of the Horse Marines* (Fig. 10), which had doubtless been inspired by a popular Civil War song. For fifty years, it functioned as a shop

[22] Cahill, *American Folk Sculpture,* p. 82, no. 159.

sign outside Feary's Cigar Store in Newark until it was given to
the museum in 1924.

Approximately 10 percent of the entries in the Newark exhi-
bition of folk sculpture were listed in the catalogue as "from a pri-
vate collection." The anonymous lender was none other than Mrs.
Rockefeller, who had become very interested in American folk art
by 1931. Her interest was aesthetic, rather than antiquarian, and
grew out of her appreciation of contemporary art. A founder and
active supporter of the Museum of Modern Art, Mrs. Rockefeller
was acquainted personally with many of the progressive young art-
ists who exhibited there. She was sensitive to their problems, and
she tried unobtrusively to help them. In a 1936 review, an art re-
porter for *Time* commented: "The prizes she offers, the pictures
she acquires, and the gifts she makes are all done with such skill-
ful reticence that few recognize her for what she undoubtedly is:
the outstanding individual patron of living artists in the U.S." [23]

Mrs. Rockefeller took special pleasure in ferreting out and
purchasing the work of unrecognized talent, a quest that brought
her to Edith Halpert's Downtown Gallery in 1928, two years after
it opened. Besides offering the work of Kuniyoshi, Sheeler, Zorach,
and other contemporary newcomers, Mrs. Halpert was also selling
nineteenth-century pictures and weathervanes gathered on her for-
ays around New England. The timing was propitious. The Rocke-
fellers were becoming increasingly absorbed in the restoration of
Williamsburg. On being introduced to nineteenth-century primi-
tives, Mrs. Rockefeller was soon persuaded that here was another
aspect of American cultural history worth preserving, one that
would provide a logical background for her sizable collection of
modern American art.

Guided and assisted by Mrs. Halpert, Holger Cahill, and
others, Mrs. Rockefeller spent nearly ten years acquiring significant
objects fashioned by gifted amateurs, artisans, and craftspeople
who had little, if any, training in the principles of academic art.
Ultimately, her collection encompassed a great variety of forms
ranging from paintings, weathervanes, and shop signs to pottery,
quilts, and other decorative household accessories. Mrs. Rocke-

[23] "53rd Street Patron," *Time* (January 27, 1936):28.

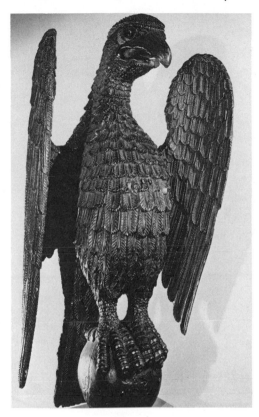

Figure 11. Carved eagle, European, ca. 1500. Pine; H. 55½″, W. 31¾″. (Abby Aldrich Rockefeller Folk Art Center.)

feller was particularly attracted to children's portraits and student art such as calligraphy, memorials, and theorems, and she acquired numerous examples of varying quality in each of these categories.

One of Mrs. Rockefeller's favorite pieces, a massive eagle (Fig. 11), was acquired for her by Mrs. Halpert. It was believed to have been used as a sign outside the ·Eagle Tavern in Pawtucket,

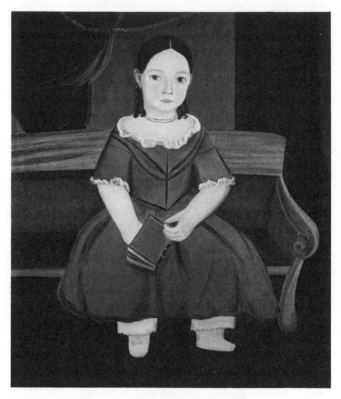

Figure 12. *Girl Seated on Bench*, attributed to William W. Kennedy, ca. 1840. Oil on canvas; H. 26″, W. 22″. (Abby Aldrich Rockefeller Folk Art Center.)

Rhode Island. The handsome bird was exhibited widely beginning with the 1930 Newark show. Recent research found no evidence of an Eagle Tavern in the Pawtucket area, and, on the basis of wood analysis and stylistic similarity to surviving European examples, it appears that the enormous bird is actually a French or German lectern support made about 1500, probably for use in a church. It is now shown infrequently as a prototype for the nineteenth-century carvings of Wilhelm Schimmel and others.

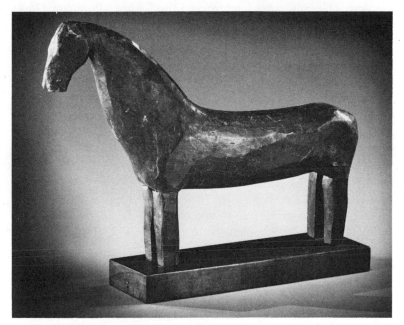

Figure 13. Carved horse, ca. 1860. Poplar; H. 16½", W. 21½". (Abby Aldrich Rockefeller Folk Art Center.)

Mrs. Rockefeller personally approached Robert Laurent about purchasing *Girl Seated on Bench* (Fig. 12) after seeing it in his home in Brooklyn. Laurent bought the portrait at an auction in Maine in 1924; he liked it and for a long time would not sell it. Refusing to take no for an answer, Mrs. Rockefeller eventually got Edith Halpert to persuade him to part with the painting.[24]

In 1932 Cahill, who was serving as acting director of the Museum of Modern Art, organized a show for the museum entitled "American Folk Art, the Art of the Common Man." Aided by Mrs. Halpert, Cahill arranged to borrow 174 items from Mrs. Rockefeller's newly formed collection for the exhibition. Mrs. Rockefeller, who hated publicity, requested that her ownership not be

[24] This portrait was singled out for comment by Eglington, "Art and Other Things," p. 418.

revealed. The only other lender was Cahill whose *Primitive Horse* (Fig. 13) Mrs. Rockefeller had never liked well enough to buy.[25]

The 1932 show was the culmination of Holger Cahill's previous efforts in Newark and the first exhibit to cover both painting and three-dimensional pieces. Unquestionably, it established American folk art as an aspect of our art history that deserved to be recognized. Some of the show's impact must be credited to the 225-page exhibition catalogue, containing 173 full-page illustrations prepared by Holger Cahill with the assistance of Dorothy Miller and Elinor Robinson. The entries are generally brief and specific. They are supplemented by an occasional well-researched and informative biography.

In a remarkably perceptive introductory essay, Cahill refined the definitions of *primitive, provincial,* and *folk* offered in his earlier catalogues and concluded:

'Folk art' is the most nearly exact term so far used to describe this material. It fits very well the work of such men as Joseph Pickett, Edward Hicks, John Bellamy, and other strong personalities thrown up from the fertile plain of every-day competence in the crafts. The work of these men is folk art because it is the expression of the common people, made by them and intended for their use and enjoyment. It is not the expression of professional artists made for a small cultured class, and it has little to do with the fashionable art of its period. It does not come out of an academic tradition passed on by schools, but out of craft tradition plus the personal quality of the rare craftsman who is an artist.[26]

Cahill's introduction is still being quoted, and curators and collectors continue to regard the 1932 catalogue as an indispensable reference.

The show was received enthusiastically by the public and was widely reviewed in the press. Writing for the *New York Sun,* Henry McBride was ecstatic:

These extraordinary objects of art are as different as can be, the one from the other, but all are alike in springing, untaught and carefree,

[25] Cahill, *The Art of the Common Man*, p. 43, fig. 139. The horse was purchased from Mr. and Mrs. Holger Cahill for the Williamsburg collection in 1957.
[26] Cahill, *Art of the Common Man*, p. 6.

from a culture that was in the making. . . . It is impossible to regard them, even casually as one is apt to do in museums, without a nostalgic yearning for the beautiful simple life that is no more. . . . Artists who find themselves growing mannered or stale will always be able to renew their appetite for expression by returning to the example of these early pioneers, and for that reason it becomes necessary for our museums to take our own primitives as seriously as they already take those of Europe.[27]

On the other hand, Malcolm Vaughan of the *American* was caustic in his criticism of the 1932 show. He viewed American folk art as a fad dreamed up by "patriotic niche-diggers" bewitched by the notion that art springs from a "naïve and unsophisticated" point of view. According to Vaughan, "the most salient quality in folk art is the least important quality known to art, namely caution—caution of hand, mind, and spirit. In their every technical device, one recognizes the cautious hand of the amateur." [28]

After the exhibition closed in New York, it circulated to museums in six other American cities during 1933 and 1934 in an effort to introduce folk art to a broader audience.

Meanwhile, Mrs. Rockefeller continued to collect and acquired, among other things, some of the finest pieces sold by Mrs. Wilde and Elie Nadelman. Conscious that most of her finds were from the Northeast, Mrs. Rockefeller sent Holger Cahill south for several months in 1934 to search that area, thereby initiating the first regional folk art survey. She was rewarded with a unique watercolor, *The Old Plantation* (Fig. 14), found in Orangeburg, South Carolina, that documents blacks performing a ritual dance. The significance of the watercolor is still debated by students of Afro-American culture, and it is generally considered one of Mrs. Rockefeller's most important acquisitions. In Atlanta, Cahill purchased *The Portrait of a Merchant* (Fig. 15). It is inscribed "August 16th, 1836 / R. B. Crafft Dr for cas[h] pain[t]." [29] Cahill felt it was a

27 Henry McBride, as quoted in *Art Digest* 7, no. 6 (December 15, 1932):14.
28 Malcolm Vaughan, as quoted in *Art Digest* 7, no. 6 (December 15, 1932):14.
29 Crafft was painting portraits until at least 1865 and, while he is

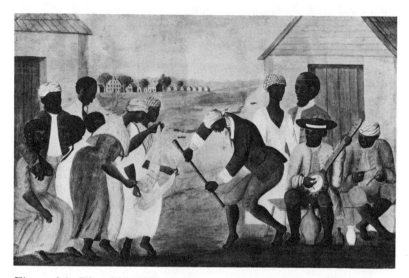

Figure 14. *The Old Plantation,* ca. 1800. Watercolor on paper; H. 11¾″, W. 17⅞″. (Abby Aldrich Rockefeller Folk Art Center.)

fine example of the professional portrait painter's technique and demonstrated why modern artists who deliberately experimented with multiple perspectives were attracted to certain folk paintings.

When Mrs. Rockefeller's 1932 loans ended their circuit and were returned to her Fifty-fourth Street address, she found she had accumulated more folk art than she could house. The problem became such a concern that her husband, John D. Rockefeller, Jr., asked Kenneth Chorley, then president of Colonial Williamsburg, if his wife's folk art would be of interest to visitors to the restored town where the everyday pursuits and interests of the common people of colonial Virginia were being interpreted in taverns, kitchens, and shops. In a subsequent memo, Mr. Rockefeller made it clear that he was anxious to settle the matter. "If the collection is to go to Williamsburg, I think the sooner Mrs. Rockefeller gets it out of the house, the sooner will she be relieved

known to have worked in Indiana and Kentucky, this artist's career warrants more research.

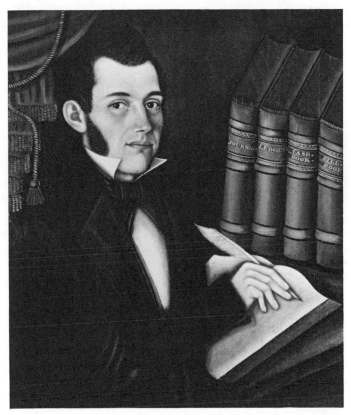

Figure 15. R. B. Crafft, *The Merchant*, August 16, 1836. Oil on canvas; H. 25⅛″, W. 30″. (Abby Aldrich Rockefeller Folk Art Center.)

of the constant thought and planning in regard to it which its presence involves." [30]

Thus in 1935, Mrs. Rockefeller loaned a portion of her folk art collection for public exhibition in Williamsburg. Most of it was installed, under Mrs. Halpert's direction, in the Ludwell-Paradise House, an original building located on Duke of Gloucester

[30] John D. Rockefeller, Jr., to Kenneth Chorley, November 16, 1934, Colonial Williamsburg Archives (hereafter CW Archives).

Street in the center of the historic area. A few items, mostly pic-
tures, were hung in other exhibition buildings or operating taverns.

The Ludwell-Paradise House was converted to an art gallery
and costumed guides were provided with a fifty-page interpretive
manual prepared by Holger Cahill. It included his 1932 essay and
was supplemented with inventories and advertisements of Wil-
liamsburg artists and craftsmen. Cahill emphasized that "as it is
defined by the objects in this exhibition, Folk Art is the work of
people with little book learning in art techniques, and no aca-
demic training." While noting that this kind of work was oc-
casionally produced by Williamsburg artisans, gifted amateurs, and
students enrolled in local boarding schools, Cahill stressed aesthet-
ics. As he put it, an object had to have "art quality" to be classi-
fied as "folk art."

The term 'art quality' is not easy to define, though it is not hard to
understand. It is the 'something' beyond simple craftsmanship, a skill
in drawing which transforms the merely competent outline of the
craftsman into the contour drawing of the artist, a native feeling for
arrangement and color combinations, a sense of unity which makes
for good composition and clarity of statement, the craftsman's feeling
for 'good joinery' carried over into the making of paintings and
sculptures, and a dozen other qualities through which the pedestrian
'work' becomes the 'work of art.' . . . In any event, the number of
objects which have art quality in the welter of artisan-craftsman-
amateur work is low.[31]

About the time that Mrs. Rockefeller's folk art was placed in
Williamsburg, Cahill was appointed national director of the Fed-
eral Art project, which included *The Index of American Design.*
Since he no longer had time to advise Mrs. Rockefeller, his role

[31] Holger Cahill to Helen Bullock, January 7, 1935, CW Archives. In
spite of Cahill's efforts, some hostesses volunteered their own interpretation.
According to one visitor's account, he heard a hostess remark that, in the
days when there were no movies, radio, or other modern forms of entertain-
ment, people amused themselves by doing folk paintings on Sunday afternoons.
Another time, a hostess told some visitors that when Mrs. Rockefeller was a
little girl she brought these funny pictures home. Her mother objected to
them and made her take them to the attic. When her mother died, the pic-
tures were brought down and later presented to Colonial Williamsburg;
Bela W. Norton, memorandum to files, March 29, 1944, CW Archives.

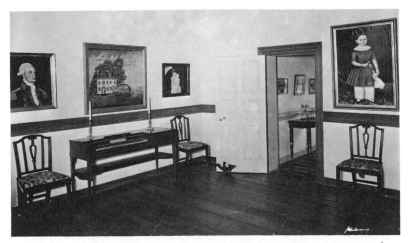

Figure 16. Interior view of the Ludwell-Paradise House in 1940 featuring some of the folk art Mrs. Rockefeller gave to Colonial Williamsburg in 1939. (Abby Aldrich Rockefeller Folk Art Center.)

passed to Edith Halpert. Mrs. Halpert was always closely involved with the collection and continued to give Mrs. Rockefeller first refusal on unique pieces "because of her superior tastes and because of my sentiment for the collection." [32]

At a time when few dealers kept records, Mrs. Halpert meticulously photographed and filed detailed fact sheets on every thing she handled in a series of black notebooks entitled "Primitives." The sheets were continually revised and updated and were often the basis for the informative annual theme shows held at the American Folk Art Gallery between 1932 and 1967.

Despite a heavy business schedule, Edith Halpert made several trips to Williamsburg in the late 1930s to rehang the collection in the Ludwell-Paradise House (Fig. 16). She never hesitated to needle Colonial Williamsburg executives when she felt that they had not made enough use of the research and publicity materials she provided. While such concern may have been motivated in part by self-interest, Mrs. Halpert genuinely believed in the impor-

[32] Edith Gregor Halpert to James Cogar, April 30, 1940, CW Archives.

tance of Mrs. Rockefeller's efforts. After reading over a draft of the introduction to a new edition of the Abby Aldrich Rockefeller Folk Art Collection catalogue, she wrote:

I should like to suggest that you strengthen your introductory paragraph. With all the 'hot news' from the World's Fairs, east and west, the art editors require a mighty powerful prod to arouse their interest. And the Rockefeller collection certainly has the 'goods.' Without exaggerating the importance of Paradise House, it is safe to say that the objects exhibited there comprise the *only public collection devoted entirely* to folk painting and sculpture of early America. It is the most comprehensive representation, covering every phase and including all media in the transition. It furnishes a unique opportunity for both students and the public to see a complete cross-section of American Folk Art, painting and sculpture. Both aesthetically and historically, the Rockefeller collection in Williamsburg plays an important part in the cultural life in America and I think might be played up accordingly.[33]

The principal part of the collection was presented to Colonial Williamsburg in 1939. This did not please Mrs. Halpert, who would have preferred to have it located in the Northeast because so many items were from New England and Pennsylvania. Mrs. Rockefeller had previously given a few pieces to Dartmouth College, Fiske College, and the Newark Museum. The balance of the collection went to the Museum of Modern Art, which later shared the gift with the Metropolitan Museum of Art.

By 1942, Mrs. Rockefeller had stopped collecting folk art, and no significant additions were made to the exhibits at Ludwell-Paradise House before her death in 1948. Seven years later, through the cooperation of the Museum of Modern Art and the Metropolitan Museum of Art, most of Mrs. Rockefeller's original folk art collection was reassembled in Williamsburg. John D. Rockefeller, Jr., provided funds for a building designed specifically to house the collection plus an endowment for a professional staff and an accessions fund. A catalogue of the collection, written by Nina

[33] Edith Gregor Halpert to Bela W. Norton, March 20, 1939, CW Archives.

Fletcher Little, was prepared for the opening of the new museum in March 1957.

The Rockefeller collection languished as a static display for nearly twenty years in the face of phenomenal growth in the appreciation and understanding of American folk art, which found expression in books and articles, lectures and seminars, and special exhibitions organized by dealers, museums, and historical societies. Semantics became an issue, and collectors, art critics, historians, and museum people engaged in unresolved debates about the appropriateness of the term *folk*.[34] The collecting patterns of the 1940s and 1950s, however, reflect a broad working definition that acknowledged both the aesthetic and the documentary significance of the material. Folk art, made by and for the average American, was interpreted as the creative work of middle-class artists—whether for pay, personal pleasure, or to fulfill a school assignment.

When new collectors ventured into folk art in the 1940s, they found specialist dealers prepared to instruct and advise them. Those in business before 1960 who have been particularly influential include Mary Allis, Hattie Brunner, Sidney Janis, Joe Kindig, Jr., Knoedler's, Harry Shaw Newman, and Harry Stone. Meanwhile, several previously formed private collections were transferred to (or became) public institutions, which have helped to familiarize the uninitiated with the material and have provided museum curators, collectors, interior decorators, and students easy access to representative examples of folk art.

The institutional collections that appear to have made the greatest impact are those impressive holdings of Americana gathered by individuals of great wealth. The earliest such collection is Henry Ford's history museum complex at Dearborn, Michigan, which opened in 1929. Ford was attracted to anything that re-

[34] Other terms that specialists have tried to introduce include *naïve, nonacademic, pioneer, popular, primitive, provincial, self-taught, uninhibited,* and *vernacular*. Louis C. Jones, the sole folk culturist involved in these discussions, accepted folk art as "an esthetically satisfying creation produced in either the craft or domestic tradition, rather than the tradition of the professional artists." See "What is American Folk Art," *Antiques* 57, no. 5 (May 1950):360.

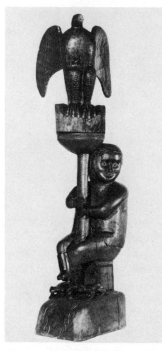

Figure 17. Edgar Alexander
McKillop, *Figural Group.*
Balfour, N.C., 1929. Wal-
nut; H. 51½″. (Henry Ford
Museum and Greenfield Vil-
lage.)

flected this nation's social, cultural, or economic growth. In his
words, "I am collecting the history of our people as written into
things their hands made and used." [35] As a result, every conceiv-
able folk art form is represented—usually without interpretation—
somewhere in the encyclopedic collections shown in Greenfield
Village and the adjacent museum. The highly original carving of a
man, an eagle, and two frogs (Fig. 17) is the creation of Edgar

[35] Donald A. Shelley, "Henry Ford's Museum and Greenfield Village,"
in *The Antiques Treasury*, ed. Alice Winchester (New York: E. P. Dutton,
1959), p. 155.

A. McKillop, a blacksmith and self-taught artist from Balfour, North Carolina. McKillop presented the piece to Ford in 1929 to commemorate the opening of the museum.

Electra Havemeyer Webb was another Americana enthusiast who accumulated a large holding of folk art as well as other specialized collections. Born with the collecting instinct, Mrs. Webb's taste for country furniture, hat boxes, decoys, and other neglected arts and crafts may perhaps be attributed to her early overexposure to the Impressionist pictures, Cypriot glass, and Chinese porcelains that appealed to her acquisitive parents, the Henry O. Havemeyers. In 1907, at the age of eighteen, Electra Webb distressed her mother by paying fifteen dollars for a cigar-store Indian she spotted on a drive through Stamford, Connecticut.[36] Forty years later, her early enthusiasm found full expression in the installation of a sizable collection of folk sculpture in the Stage Coach Inn on the grounds of what is now the Shelburne Museum. Some of the eagles, Indians, and weathervanes had previously served as lawn decorations at the Webbs' Long Island home.

Although the Indian should have given her a head start, Mrs. Webb's folk art collecting was sporadic and diffuse until she became a client of Edith Halpert's late in the 1930s. From then on, her interest was more focused. After establishing the Shelburne Museum in 1947, she was assisted by Mrs. Halpert, Mary Allis, Kenneth Byard, and others in developing a collection of folk painting. The decoy collection was greatly expanded in 1952 with the purchase of some one thousand birds from Joel Barber's estate. Mrs. Webb's was an object-oriented conception of folk art: "My interpretation is a simple one. Since the word 'folk' in America means *all* of us, folk art is that self-expression which has welled up from the hearts and hands of the people." [37]

Henry Francis du Pont was a good friend of Electra Webb and was probably influenced by her taste for folk art. While his extraordinary collection of American decorative arts did not be-

[36] Electra H. Webb, "The Shelburne Museum and How it Grew," talk (CW Antiques Forum, January 30, 1958), transcript of tape recording, Shelburne Archives.

[37] Electra H. Webb, "Folk Art in the Shelburne Museum," *Art in America* 43, no. 2 (May 1955):5.

come accessible to the public until 1951, the fine quality of du
Pont's carefully selected Pennsylvania-German material was com-
mon knowledge among other collectors and dealers as early as
1932.[38]

Beginning in 1935, Maxim Karolik assembled a magnificent
three-part collection of decorative arts for the Boston Museum of
Fine Arts to illustrate developments in the whole spectrum of
American arts and crafts from 1720 to 1875. Karolik clearly had an
eye for quality folk art and may also have been encouraged to col-
lect in this area through his association with Mrs. Webb.

Another Bostonian, Clara Endicott Sears, used some of her in-
heritance to finance pioneer research on the role of the itinerant
portraitist. Her collection of New England portraits, many in the
folk tradition, has been exhibited in the picture gallery at Fruit-
lands Museum at Harvard, Massachusetts, since 1940. Before
parting with her paintings, Miss Sears had researched each signa-
ture carefully; she published her findings in *Some American Prim-
itives*, the first book of its kind.[39]

Any list of important collectors of folk art must include Ed-
ward Duff Balken, a man of modest means with an art history
background, who served as curator of prints at the Carnegie Insti-
tute between 1915 and 1935. Balken vacationed in the Berkshires
and began collecting folk art there during the 1920s. In 1958, he
presented sixty-five paintings, including several powerful portraits
by Ammi Phillips (Fig. 18), to Princeton University where he had
been a member of the class of 1897.[40]

Balken in turn inspired J. Stuart Halladay and Herrel G.
Thomas to begin collecting folk art about 1932. As co-owners of
an antique shop in Sheffield, Massachusetts, they were in an ad-
vantageous position to purchase pictures from the families of orig-
inal owners in New England and upstate New York. Halladay and
Thomas acquired local portraits and a series of nineteenth-century
landscape and genre scenes documenting aspects of everyday life.

[38] Abbott Ingalls to Arthur Woods, March 30, 1932, CW Archives.

[39] Clara Endicott Sears, *Some American Primitives: A Study of New
England Faces and Folk Portraits* (Boston: Houghton Mifflin Co., 1941).

[40] For an early analysis of the Balken Collection, see Walter Read
Hovey, "American Provincial Paintings," *Carnegie Magazine* 20, no. 8 (March
1947):240–44.

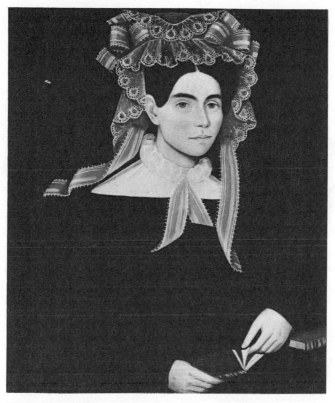

Figure 18. *Wife of the Journalist,* attributed to Ammi Phillips, ca. 1832. Oil on canvas; H. 26½", W. 32". (The Art Museum, Princeton University, gift of Edward Duff Balken.)

Their collection included five New York townscapes by Joseph Hidley, a native of Poestenkill. During World War II, their collection received considerable exposure when it was exhibited for the benefit of the American Field Service. When the Halladay-Thomas collection came on the market in 1958, it was acquired by Colonial Williamsburg to complement and enrich the Rockefeller collection.

While it is likely that the eccentric Mrs. William J. Gunn of

West Newton, Massachusetts, was a customer of Halladay and Thomas, this compulsive collector kept no record of some 600 pictures she and her husband acquired over a twenty-five year period. Mrs. Gunn always paid cash and usually sent a servant to collect her purchases, which she hoarded in an unheated, bat-infested barn. When Mrs. Gunn died in 1958, Mary Allis, who had long been puzzled by the Gunns' peculiar collecting habits, bid on the paintings. On discovering the scope and quality of much of what she had bought, she contacted Stephen Clark, who purchased 175 of the pictures for the New York State Historical Association.[41]

Within two years, Louis and Agnes H. Jones published a catalogue of folk art based on their own research which illustrated many of the Gunn paintings. As the necessary conservation work was completed, the pictures were integrated with material from the Nadelman and Lipman collections at Fenimore House, where interpretive installations were devised to complement the folk life exhibits and activities at the adjacent Farmers Museum and Village Crossroads.

Of the three private collections now merged at Cooperstown, the most significant in terms of quality, condition, and variety is that assembled by Jean and Howard Lipman. Many of the paintings, weathervanes, and woodcarvings are illustrated and their artistry discussed in Mrs. Lipman's still useful books *American Primitive Painting* (1942) and *American Folk Art in Wood, Metal, and Stone* (1948). For thirty years editor of *Art in America* and author or instigator of numerous articles documenting the careers of formerly obscure folk artists, Mrs. Lipman is primarily interested in the art in folk art, which she analyzes with the same criteria she uses to evaluate contemporary art.

The great collection of folk painting is, of course, the one assembled by Edgar William and Bernice Chrysler Garbisch, who began acquiring American "primitive" paintings in 1944, soon after they purchased a house on Maryland's Eastern Shore. By the time they had located enough pictures for their home, the Garbisches were convinced that the inherent artistry of good American "prim-

[41] Agnes Halsey Jones and Louis C. Jones, *New-Found Folk Art of the Young Republic* (Cooperstown: New York State Historical Association, 1960).

Figure 19. *The Plantation,* ca. 1825. Oil on wood; H. 19⅛″, W. 29½″. (Metropolitan Museum of Art.) One of the most admired of the many paintings collected by Edgar William and Bernice Chrysler Garbisch, which they presented to the Metropolitan Museum of Art in 1963.

itives" warranted wider recognition and appreciation. To achieve this end, they put together a collection that at one point numbered over twenty-six hundred pictures and represented all categories, media, and levels of skill.

Traveling exhibitions of Garbisch paintings have circulated throughout this country and abroad, each accompanied by a modestly priced, handsomely illustrated catalogue. To date, Col. and Mrs. Garbisch have placed segments of their collection in the National Gallery of Art, the Metropolitan Museum of Art (Fig. 19), and twenty-one other museums, often in communities where paintings of this type would not otherwise be represented. Initially they adopted the term *primitive* to describe their collection, but in 1968 they decided that *naïve* was the adjective that best defined their appreciation of these paintings. As a result, the collection has been culled of *Fraktur* and related material with tra-

ditional, Old World roots that is not considered by these patriotic collectors to be expressive of the American experience.[42]

The formulation of these public collections firmly established folk art as an accepted and recognized genre and inspired countless private collectors and dealers. As a result, most art museums now have some examples of folk art on view, variously displayed in period rooms, contemporary settings, or shown with American academic art of the same time frame.

Since 1957, when it was relocated in a modern building, Colonial Williamsburg's Folk Art Center has continued to develop along the lines established by Mrs. Rockefeller. Many objects of great rarity and quality have been added and weaker areas of the collection have been enhanced. There has been a continuing effort to fill gaps and to achieve a better geographical and historical balance. By 1978, there were nearly eighteen hundred objects ranging in date from a group of patroon pictures painted near Albany about 1730 to a fruit-stand sign made some sixty miles from Williamsburg in 1960 by Miles Carpenter of Waverly, Virginia.

The museum's scope has been broadened to include decorated furniture, pottery, iron, bedcovers, and other highly original products of traditional craftsmanship which are distinguished by the superior artistry of their form and decoration. Research on the collection and associated materials is a continuing priority. Whenever an object takes on new meaning, its gallery label and publication copy are revised accordingly. Quite naturally, the museum has a special interest in documenting and recording folk art forms of the South.

In exhibiting folk art at Colonial Williamsburg, most material is presented as art and accompanied by descriptive labels. The intent is to interpret what is presented to help visitors understand who the artist was, who he worked for and why, how he regarded himself and his work, and the attitude of his contemporaries

[42] Clifford W. Schaefer, *Preface to 48 Masterpieces from the Collection of Edgar William and Bernice Chrysler Garbisch* (Norfolk, Va.: Chrysler Museum, 1975), p. 16. It should also be noted that because of their strong feelings about terminology, Col. and Mrs. Garbisch were unwilling to lend to the Whitney exhibit entitled "The Flowering of American Folk Art" any of the "naïve" paintings they personally owned. However, a number of paintings they had given to museums were in the show.

toward his work. Admittedly, in dealing with eighteenth- and nineteenth-century material, the answers to these questions can be difficult to document.

Two other collectors, with distinctly different tastes and whose approach to folk art has profoundly influenced directions in which the folk art field is moving, are Nina Fletcher Little and Herbert W. Hemphill, Jr. For many years, Mr. and Mrs. Bertram K. Little have delighted in discovering, acquiring, and documenting all sorts of unusual household furnishings and decorative accessories that belonged to previous generations of New Englanders. Their rich and varied holdings encompass a truly great regional collection of American folk art, covering three centuries of creativity in all media. Nina Little has also acquired a reputation for her scholarship and her willingness to share her knowledge and time with the numerous students, collectors, and museum professionals who have relied on her counsel for forty years. She led the way in research on folk art. Thanks to her sleuthing and the solid articles and exhibitions based on her findings, the careers of many once anonymous painters are now documented.

For Bert Hemphill, folk art has no cut-off date. He helped found the Museum of American Folk Art in New York City in 1961, where he was curator for several years. While building a personal collection of eighteenth- and nineteenth-century folk art, Hemphill became convinced that some products of contemporary craftspeople and amateur artists also have aesthetic validity and are an unselfconscious continuation of earlier American traditions in the arts. Thus Hemphill is largely responsible for popularizing the concept of twentieth-century folk art. His viewpoint found expression in the provocative exhibition "American Folk Sculpture" that he organized for the Brooklyn Museum in 1976.

The Brooklyn Museum's bicentennial effort was but one of perhaps fifty significant shows dealing with some aspect of the subject that have been mounted during the past five years. Several historical agencies in the Northeast produced informative, well-mounted displays in 1976, and one of the most promising developments is the regional folk art survey recently sponsored by states in the South and Midwest which has culminated in exhibitions and catalogues.

The real dazzler of recent years was "The Flowering of American Folk Art," the 1974 exhibition at the Whitney Museum organized by Jean Lipman and Alice Winchester. Using 239 objects borrowed from museums and private collections across the country, it traced the development of American folk art to 1876. The organizers provided a traditional, carefully selected presentation of extraordinary objects and stressed aesthetics. In New York, the material was strikingly displayed in a contemporary installation designed by Marcel Breuer. Much of the exhibit was also seen in Richmond and San Francisco.

While less trend-setting, the "Flowering" show can be considered an update of Cahill's 1932 exhibition at the Museum of Modern Art, and, like its predecessor, it attracted extraordinary attention from the public and the press. This exhibit also prompted collectors who had previously spurned folk art to begin acquiring examples. In 1976, the aesthetics of folk art and its role in the continuity of American art were again celebrated in the folk segment of the huge historical show of American sculpture mounted by the Whitney Museum under Tom Armstrong's direction.

Since 1930 the troublesome term *folk art* has been used to describe an astonishing variety of practical and decorative items created by Americans from divergent social and professional backgrounds who were bent on artistic expression and who were often not aware of the techniques and theories required of studio-trained artists. Folk art has been rediscovered, accepted, and popularized. As more and more significant items are absorbed into major public and private collections, the popular concept of what folk art is continues to expand. This can be attributed to both a renewed interest in the life and culture of "ordinary" people and increased activity on the antiques market, particularly by private collectors. Naturally, the upward trend in prices has prompted some to purchase folk art with a view to speculation.

Admittedly, folk art is still scorned by some decorative arts enthusiasts who are attracted instead to products of aristocratic taste, such as Chippendale furniture and Chelsea porcelain. But the snobbish resistance to folk art is far greater among class-conscious Britons who have traditionally ignored the artistic heritage of the common Englishman. As a result, a steady stream of naïve

English art finds its way to the New York market where the unwary assume it to be American.[43]

Today's folk art collector continues to focus on nineteenth-century painting and carving, but there is a mounting enthusiasm for contemporary work. And, since those first exhibitions, the concept of what might be included in a folk art show has broadened to include rugs, coverlets, pottery, painted tin, and decorated furniture. Special exhibits and accompanying books and catalogues have created a market for the work of any so-called folk artist. In recent years, we have seen fads for such bizarre items as tramp-work, neon signs, decorated vans, and embroidered denim. Currently, there seems to be less interest in reverse painted glass, still-life compositions, and the type of copy work generally described as student art.

But the serious folk art collector, whether a specialist or generalist, has always sought to secure uncommon examples which manifest a real degree of accomplishment—objects that represent the best of a particular tradition, whether produced by a well-known artist or by an unrecognized hand.

[43] Beatrix T. Rumford, "Nonacademic English Painting," *Antiques* 105, no. 2 (February 1974):366–75.

Expanding Frontiers:
The Michigan Folk Art Project
Marsha MacDowell and
C. Kurt Dewhurst

The Michigan Folk Art Project was established to identify and document folk art produced by Michigan people through the years. While the search has been profitable, yielding important new discoveries that will provide insights into the cultural, social, and historical life of a people, it was necessary initially to cast off any a priori conceptions as to what would be found when the search commenced. As we began, we recalled the task assigned to the folklorist by Richard Dorson, "The first problem of the American folklorist concerned with this subject is to locate and rescue examples of folk art for preservation and exhibition in the folklore museum. While the collector of songs and tales enters the living room seeking to record members of the family, the collector of pottery and quilts searches the basement and the barn. In the future a single folklorist may engage in both these quests simultaneously." [1] The task clearly set forth was to locate and rescue (through photographs) extant examples of Michigan folk art.

The value of regional research has often been debated (Mi-

[1] Richard Dorson, *American Folklore and the Historian* (Chicago: University of Chicago Press, 1971), p. 47.

54

chael Owen Jones has justifiably warned of the "enthusiastic diffusionist who posits a genetic relationship on objects from vague geographic areas that might best be explained by independent invention and convergence" [2]), and yet, unfortunately, little serious scholarship has been undertaken in this area until quite recently. Alice Winchester, in the introduction of the catalogue of the exhibition entitled "The Flowering of American Folk Art" wrote: "It seems extremely likely that, as interest continues to grow, more and more folk art related to that of the northeast, but with its own regional accent, will be discovered in the South, Midwest, the Southwest and the Far West." [3]

The Michigan Folk Art Project affords us an opportunity to assess the potential for the continued exploration of art produced "in the folk tradition" and confirms the need for further evaluative and comparative scholarship, in-depth research on individual artists and the varied factors that have shaped the patterns of their artistic expressions. But such analysis can only reach truly meaningful conclusions when an adequate body of folk art has been located and rescued. The prospect of drawing together examples of the forms of folk art created in a state such as Michigan is indeed awesome. Although one might assume that such an undertaking would intrigue folklorists and art historians, the mission was primarily assumed by museum personnel. Michael Owen Jones has observed that "American folklorists, primarily concerned with the study of narrative and song, have been reticent to pursue the subject of art or even to include the material manifestations of culture within the realm of folklore scholarship. Owing to the absence of folklore leadership, museum personnel, usually as a secondary interest, have undertaken the crucial task of investigating folk artifacts in America." [4]

[2] Michael Owen Jones, "The Study of Folk Art Study: Reflections on Images," *Folklore Preprint Service* 1, no. 9 (March 1974):3.

[3] Alice Winchester, introduction to Alice Winchester and Jean Lipman, *The Flowering of American Folk Art, 1776–1876* (New York: Viking Press in cooperation with the Whitney Museum of American Art, 1974), p. 9.

[4] Michael Owen Jones, "Two Directions for Folkloristics in the Study of American Art," *Southern Folklore Quarterly* 32, no. 3 (September 1968): 249.

THEORETICAL STRUCTURE FOR FOLK ART RESEARCH

Perceptions of culturally accepted art forms have undergone such dramatic transitional changes in this century that it is no longer clear what constitutes good design. In general, our country's educational process relies heavily on the formulation of knowledge in literary and mathematical concepts. From early childhood on, a person is schooled in language and science, very rarely in the visual arts. Therefore, while an individual may be fairly well versed in comprehending others and expressing himself in literary and scientific language, he may be less adequately prepared in the apprehension and appreciation of the arts—even less so for involvement in the arts. While some aspects of visual art are transmitted through society via traditional, academic, or popular means of acculturation, unless there is also an understanding of the basic components of the visual idiom, quite often the form is accepted only within its avenue of dissemination. Equipped with an understanding of the formal elements of the visual language, an individual can learn to appreciate a work of art regardless of its pattern of dispersion.

In his book, *Art in Context*, Jack A. Hobbs further defines this acculturated variance in the interpretation of art when he states:

What we see (or notice) depends in large part on how we see. Seeing an ordinary object such as a hamburger depends not only on the visual data of its shape and color but also on one's own knowledge of hamburgers, including their taste, smell, feel and ability to satisfy hunger. A hamburger would look very different to a person who came from a society that did not make hamburgers and who had never seen one before—regardless of his appetite. . . . What we see in a work of art also depends on a combination of visual data and past experience. The ability to perceive image in the lines and shapes that an artist puts on a piece of paper or canvas is not automatic. It requires practice and experience—usually when one is very young—just to develop the ability to interpret the kind of pictures that are widely familiar in one's own society. . . . The whole process of viewing art is a continual interaction between vision and meaning, each enriching the other.[5]

[5] Jack A. Hobbs, *Art in Context* (New York: Harcourt Brace Jovanovich, 1975), pp. 3, 41.

Folklorists have proposed a basic framework for the analysis of folk art. Traditional, ethnic, and folk artistic production easily fall into their initially proposed and now widely accepted patterns of material folk culture. Primarily established along a horizontal basis, this framework permits the researcher to ask such questions as: Where did the object come from? How was its form transmitted? What influenced its change? and other such inquiries into typology, motif, and transference of style. What cannot be resolved using this framework is questions of aesthetic quality of an object and nontraditional art that lies outside a discernible context.

Possibly a vertical structure for object classification would respond to these questions of aesthetic value and allow the linkage of art history with folklore. When a body of material folk objects has been located, then the tools of the art historian could be used to sort the objects into three categories: object-types, craft-types, and art-types. Object-types would be those handmade items that have no evidence of a discernible craft tradition or sense of aesthetic values. Craft-types would encompass those objects which exemplify the continuation of a traditional creative expression with no effort at infusing the object with innovation or personal vision. Art-types would include those objects, functional or nonfunctional, that adhere to the accepted cultural definition of good aesthetics. Presently, any traditional craft-type item may be viewed as art if (1) there was a conscious effort on the part of the maker to construct a pleasing arrangement of form, color, and texture and (2) if the larger societal definition of beauty coincides with the arranged result. Often a reigning societal definition will capriciously neglect a medium of production, although the summation of its components falls within the dictated canons of taste.

For those art objects that are nontraditional and non-academic in nature, the folklorist might contend that they are not within his provenance. Yet, when these artists are discovered, invariably it is through the research methods of the folklorist. The art historian is not generally oriented to extensive field work. Indeed, the art historian looks to libraries, galleries, and art museums for the substance of his research. Rarely does he have a face-to-face encounter with the artist and even more infrequently

does he have the opportunity to record the thoughts, words, and manners of the artists. His inquiry into scholarship is visually based and, at that, it is limited to culturally ascribed contexts of vision. It is from this perspective that the art historian has written about, evaluated, and promoted those artists (and their work) who rely upon accepted forms of recognition via art schools, museums, and galleries.

In their fieldwork, however, folklorists often come across handmade objects which defy traditional pattern classification, and which, because of the folklorists' culturally conditioned aesthetic view, may or may not be recognized as art. By ignoring these objects, because they are nontraditional, the folklorist thereby ignores a valuable link in our knowledge and appreciation of art material.

Ap-artists (or artists apart from societal art trends) are those artists who, without benefit of contact with strong traditional artistic movements, endorsed either by a subculture or the total culture, nevertheless have produced vital, innovative expressions of creativity. Their production challenges two prevailing cultural aesthetic notions: the folklorists' view that folk art must be the product of a traditional cultural pattern and the art historians' idea that art must be related to high art movements and involve art schools, current gallery scenes, and endorsed art museum exhibitions.

By reexamining the work of these ap-artists, it is possible to include their work in the continuum of traditional patterns. On first inspection of a seemingly atypical example of folk art, the immediacy of its strong visual impact may evoke a subjective experience that colors further objective investigation. On the other hand, a closer examination of the object and its maker may provide important clues for linking these folk art products with preexisting patterns of cultural material dissemination.

DEFINING THE VERTICAL CLASSIFICATION OF ART

Having established horizontal and vertical models, a consideration of both the folklorists' and the art historians' viewpoints was possible. Hence, the Michigan Folk Art Project could follow the

structure previously set out by folklorists, yet still honor the art historians' criteria for what constitutes art. With this foundation, the next step was to fortify the model with a workable definition of art for the objects located. In this way, the vertical continuum of object-craft-art would be defined and a basis for differentiation would be established.

The development of an aesthetic theory as a foundation for survey and research projects, such as the one in Michigan, is critical to their success. We have not totally reconciled the diverse points of view held by those of us in the folk art field. Nevertheless, the following overriding conceptual approach was adopted: "To evoke in oneself a feeling one has once experienced and having evoked it in oneself then by means of movements, line, colors, sounds, or forms expressed in words, so to transmit that feeling that others experience the same feeling—this is the activity of art." [6]

The struggle to explain the response to folk art produced through the decades may be eased by applying Leo Tolstoy's conception of the "infectiousness of art" as the one "indubitable sign distinguishing real art from its counterfeit." [7] As we labor to understand the art itself, we have recently turned to the source of that art—the artist himself. Where possible, our research in Michigan included developmental interviews with the artists. Psychological theories abound that purport to cut to the quick of the matter and thereby define and explain the art that has been recognized as folk. Among the many theories culled from the artists' statements that accompanied special exhibitions of "new folk artists," one stands out over all others: the artist must have "sincerity" in the rendering of his art. According to Tolstoy, sincerity is a necessary condition to achieve infectiousness in art. In his words, "the degree of infectiousness of art [is] increased by the degree of sincerity of the artist." [8]

Tolstoy contends that "the degree of infectiousness of art" depends on three conditions: (1) The more individual the feeling

[6] Leo Tolstoy, *What is Art? and Essays on Art*, trans. Aylmer Maude (London: Oxford University Press, 1955), p. 123.

[7] Ibid., p. 227.

[8] Ibid., p. 229.

transmitted the more strongly does it act on the recipient; the more individual the state of soul into which he is transferred the more pleasure does the recipient obtain and therefore the more readily and strongly does he join in it. (2) Clearness of expression assists infection because the recipient who mingles in consciousness with the author is better satisfied the more clearly that feeling is transmitted which, as it seems to him, he has long known and felt and for which he has only now found expression. (3) Tolstoy believes that the three conditions of contagion in art

may all be summed up into one, the last sincerity; that is, that the artist should be impelled by an inner need to express his feeling. That condition includes the first; for if the artist is sincere he will express the feeling as he experienced it. And as each man is different from every one else, his feeling will be individual for every one else; and the more individual it is—the more the artist has drawn it from the depths of his nature—the more sympathetic and sincere will it be. And this same sincerity will impel the artist to find clear expression for the feeling which he wishes to transmit.[9]

Following Tolstoy's insight, as researchers, we allowed for the unique expression of the individual artist's work which was not clearly linked with a readily identifiable tradition. The aesthetic employed was necessarily one that acknowledged the potential for the discovery of forms not within the realm of those known to us through earlier scholarship (primarily folk art from the northeastern United States). Acknowledging the variant definitions of folk art as traditional material culture, decorative material, and grassroots art production, we opted to study folk art using some of the research tools of the folklorist and the evaluative theories of the art historian. In addition, the preliminary objective was to collect material based heavily on the aesthetic posed here and then to sort and hypothesize when the collection phase was realized.

OPERATIONAL METHODOLOGY

Formulating a logical strategy for locating folk art forms was the first objective. In an area as large as Michigan, a survey would

[9] Ibid., pp. 229–30.

have taken years and resulted in wasted effort if preliminary planning had not been thorough. The project proceeded by the following steps: (1) Based on the ethnological mapping of the state, areas were pinpointed that might be fertile grounds for continued observance of traditional art production. Likewise, regions were delineated that might be depositories of folk art in a particular medium. For instance, sailors' ports, logging boom towns, and favorite duck hunting areas might yield a plentiful supply of carvings. (2) Two major organizations in the state offered to work with the project. The Michigan History Division and the Michigan State University Cooperative Extension alerted their field workers to establish a list of possible informants and artists. The Cooperative Extension, and the 4-H Division in particular, with its extensive network of agents, worked with communities and offered ample opportunity to establish grass-roots contacts. The close identification of county extension agents with families, especially in rural communities, opened up avenues of information that might otherwise have been barred to the researchers. (3) A major publicity campaign was instigated with a two-fold purpose in mind. First, it encouraged people to mail information so that it could be evaluated in the central office to determine its merits for further investigation. The responses helped to build more meaningful and productive fieldwork itineraries. Second, the publicity campaign acquainted informants and possible artists beforehand that the project was legitimate. Among the means used to encourage response to our queries for information were the following: (a) a poster/brochure sent to over one thousand libraries, community centers, college art, humanities, and English departments, arts organizations, and historical societies; (b) a press release issued by the Office of Information Services at Michigan State University and sent to every newspaper in the state; (c) articles written for Great Lakes area magazines and various trade journals (from farming magazines and the Department of Natural Resources magazine to the antiques magazines); (d) local radio and television community service spots; and (e) many personal contacts. (4) Armed with information received from responses to the project's quest for information, a skeleton itinerary was established to present slide lectures on folk art at periodic intervals

and various locations in the state. After each lecture, the audience was solicited for more information on local arts or crafts and their makers. Invariably, so much information was gathered that the skeleton itinerary was fully scheduled, and leftover leads formulated the basis for the next fieldwork excursion. (5) With a continual cycle of information received by mail, audience and public leads, tips from colleagues and other professionals, as well as our constant vigil for written and oral stories on local art and artists, a pattern emerged for gathering and investigating leads.

A CURRENT ANALYSIS OF THE MICHIGAN FOLK ART PROJECT

The folk art of Michigan, like that of the rest of America, has roots in diverse cultural, historical, and, perhaps most importantly, perceptual traditions. In Michigan these traditions are accentuated by geographical factors. One historian has described the state of Michigan in the following manner:

Of all the states in the union, Michigan is perhaps least typical. It is unique geographically because it consists of two large peninsulas, because it lies in the midst of the upper Great Lakes, and because of the striking difference between the soils, climate and vegetation in those parts of the state lying north of the 43rd parallel and in those lying south of this line. Its highly industrialized southeastern region is in sharp contrast to the sparsely settled Upper Peninsula and northern half of the Lower Peninsula.[10]

The description illustrates both the problems and the potential rewards for the researcher. Certainly the surrounding lakes enable one to diminish some of the boundary controversies involving particular folk art pieces, yet due to the sporadic influx of various ethnic groups and the expansive territory, settlements retained ethnic identity for a surprising length of time in many areas of Michigan.

Although Detroit was founded in 1701, it retained its identity as a major far-west trading post up until approximately the

[10] Willis Frederick Dunbar, *Michigan: A History of the Wolverine State* (Grand Rapids: William B. Eerdmans Publishing Co., 1965), p. 7.

Figure 1. *Mackinac Island*, Mackinac Island, Michigan, ca. 1830–40. Watercolor on cloth; H. 19″, W. 12½″. (Mackinac Island State Park Commission: Photo, Folk Arts Division, The Museum, Michigan State University.)

war of 1812. James Crawford has written, "In the Great Lakes area, life in the eighteenth and nineteenth centuries was heightened by the experience of nature." [11] A preoccupation with the natural environment is prevalent in much of the folk art encountered during the survey in Michigan. A painting of Mackinac Island, executed in the 1830s, records the early importance of the island's history in the Straits of Mackinac between the upper and lower peninsulas of Michigan (Fig. 1). Artists' attempts to render the location of buildings, spatial relationships, and the placement of fortifications have provided valuable documentation for historians and archaeologists alike. These paintings frequently convey perceptions of the places and objects that provide personal identity for the people themselves. This watercolor depicts the character of early settlements of much of the northwest territory. One can see the result of French and English colonial expansion into the

[11] James Crawford in introduction to Arthur Hopkin Gibson, *Artists of Early Michigan* (Detroit: Wayne State University Press, 1975), p. 12.

Figure 2. *Nativity Scene,* Cross Village, Michigan, ca. 1850. Carved and painted wood; H. 13″ (tallest figure). (Collection of Mr. and Mrs. James O. Keene: Photo, Folk Arts Division, The Museum, Michigan State University.)

territory of the woodlands Indians of the upper Great Lakes and how the Indians lived side by side with the developing white culture.

Additional evidence of the steady displacement of native American cultural patterns is illustrated in a nativity scene found not far from Mackinac Island, near the Straits of Mackinac, in Cross Village (Fig. 2). This carved and painted wooden group was found in the earliest known church in this historic Indian settlement. The group of carvings stands as evidence of the early French missionary influence in Michigan and in the upper Great Lakes area, since the lakes and their tributaries were a ready network for transporting people as well as their beliefs and customs. Many of the folk art forms explored in Michigan can be traced to the aboriginal heritage, which in turn was based on man's interaction

with nature, including the use of earth and animal and plant life. The most widely exploited medium in this region seems to have been wood, as a great deal of carving and other three-dimensional expressions survive. While it may come as a surprise to find Indian arts included in the survey, many Indian artists worked with the same sensibilities as other folk artists in exploring new imagery with an individualized personal vision. Beyond its transcultural significance, the nativity scene conveys the sincerity of personal artistic vision and strength of conviction sought in our survey.

George P. Graff has written:

During the last half of the nineteenth century, Michigan was the natural resource center for our rapidly developing nation. It was the raw materials, in the form of metals, wood and farm products, coupled with the navigable waters of the Great Lakes, that helped to build the Midwest. Jobs were available for men who possessed skills in mining, forestry and agriculture. The word spread throughout Europe and the Mid-East that muscle power was needed in Michigan.[12]

This economic evolution based on the region's natural resources resulted in the exploration of folk art forms that reflected the lives of the artists themselves as well as their world around them. The tremendous lumbering boom that accounted for the rise and fall of towns throughout Michigan touched the lives of many early settlers. Long hard days spent in logging camps were offset by "whittling and storytelling" in the evenings. Miniature scenes based on events in the lumbering camps were frequently carved by the "artist in residence" who sought to record the life he knew so well and the rich nature of this unique visual subculture. The carvings vary widely in power and expressiveness. Quite naturally, the infamous Paul Bunyan figure reigned supreme over more than one camp. William Monigal created an extensive model of a lumbering camp over an eight-year period in the 1930s after working in a camp near Iron Mountain in the Upper Peninsula. He produced over 2,000 pieces made to a scale of less than one inch to a foot, including 156 men and 120 horses. Not surprisingly, his wood

[12] George P. Graff, ed., *The People of Michigan: A History and Selected Bibliography of the Races and Nationalities Who Settled Our State* (Lansing: Michigan Department of Education, Bureau of Library Service, 1970), p. 1.

Figure 3. Milton C. Williams, *Two Men with a Load of Lumber*.
Montrose, Michigan, early twentieth century. Carved and painted
wood; H. 8½″, L. 26½″. (Sloan Museum: Photo, Folk Arts Division,
The Museum, Michigan State University.)

carvings, fashioned with a jackknife from old telephone poles, have
enjoyed public acclaim. They were later exhibited in Madison
Square Garden in the 1930s and billed as "The World's Largest
Exhibit of Lumbering Carvings."

Two other related groups of carvings deserve closer examina-
tion. Milton C. Williams created a relatively sophisticated ensem-
ble of characters based on his reminiscences of lumbering camp
life. Although he worked primarily as a blacksmith and wood
worker, he deftly captured the mixture of ethnic backgrounds of
lumbermen and even portrayed the social patterns of life in the
camps. His carvings also record the practice of employing convicts
in mills (Fig. 3). William Drain brought a unique perspective to
his carvings of lumbering life. Like many of those second and third
generation Americans who came to Michigan, he came from New
York State. He worked as an orthopedic specialist and Swedish
masseur, and quite naturally he visited many lumber camps. Work-
ing with a jackknife, he carved during the evenings, drawing from
his observations of the logging industry (Fig. 4). As one might
expect from an orthopedic specialist and Swedish masseur, he paid
particular attention to the joints of his carved creations which are
carefully articulated. These small, unpainted carvings incorporate

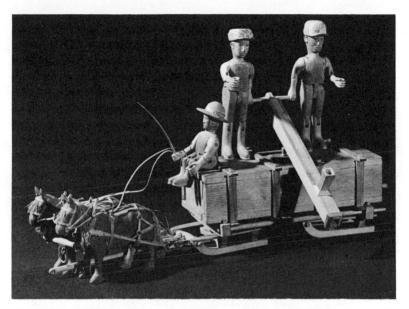

Figure 4. William Drain, *Ice Wagon*. Muskegon, Michigan, early twentieth century. Carved wood; H. 10½″, L. 20″. (Con Foster Museum: Photo, Folk Arts Division, The Museum, Michigan State University.)

all the minute detail he could possibly achieve with a jackknife. The logging industry of Michigan was documented in paint as well as wood. In 1856, Celestia Young painted Adam's Mill in Plymouth, Michigan, a small yet significant portent of the lumbering boom that was to follow.

Half-ship models and other marine paintings and carvings reflect the importance of the Great Lakes to Michigan and its inhabitants. Artists such as Charles Norton (Fig. 5), who worked as a newspaper marine reporter, painted watercolor renderings of Great Lakes vessels. The unique quality of Norton's art is partially the result of his effort to draw the ship measurements to scale, with little concession to depth and distance. Consequently, his work reveals a primitive lack of perspective. A hallmark of much of his work is the large "Bard"-like American flag that he pic-

Figure 5. Charles W. Norton, *I. U. Masters*. Detroit, Michigan, ca. 1860. Watercolor on paper; H. 15″, W. 24″. (Museum of Arts and History, Port Huron: Photo, Folk Arts Division, The Museum, Michigan State University.)

tured with great pride. Ship figureheads were not common on the Great Lakes after the advent of the Soo Locks, because they added unnecessary length to the ship. The carving that survived was primarily decorative work by master shipbuilders. There is one massive figurehead from the *Forest Queen* still in existence, and it presents a formidable image for a Great Lakes ship.

In addition to the lumbering and marine industries, the agricultural opportunities in Michigan played a major role in the growth of the state and the Midwest in general. A carving by an artist known only as Schermerhorn of Bay City, Michigan, seems to capture the quintessential midwestern farmer leaning back on his horsedrawn plow in contemplation of his progress (Fig. 6). With the farmer's Dalmatian dog under a nearby tree and a young foal beside its mother, the carving records what today we might term the spiritual virtues of a one-to-one relationship with the land and nature itself.

In another medium, the subject of life on the farm focused

Figure 6. R. W. Schermerhorn, *Farm Scene*. Bay City, Michigan, late nineteenth century. Carved and painted wood with applied sponge; H. 7½″, W. 9¾″, L. 16½″. (Collection of Mrs. Charles Bybee: Photo, Folk Arts Division, The Museum, Michigan State University.)

on the animals raised on it. About 1887 Helen Mary Rounsville made a crazy quilt with a fanciful sampler of embroidery set off with a dramatic border of horses. Preoccupied with her beloved horses, the quiltmaker carefully stitched on beads for eyes on each of the horses.

Other media explored by the artists in Michigan yield valuable insights into the diversity of the peoples of Michigan. One example is a confirmation certificate (known as a Patenspruch) created by Johann George Nuechterlein of Frankenmuth, an early German settlement in Michigan (Fig. 7). It combines watercolors, pen and ink, and pin-pricked elements in its design, and it obviously retains a strong Germanic influence.

Itinerant artists such as John Brown Walker, who left a trail of paper cutouts that served as commemorative and presentation pieces, are surprisingly rare, even in areas of rapid economic growth. Walker often combined his elaborate cutout technique with photographs and colored paper to accentuate his work. He

Figure 7. Johann George Nuechterlein, *Confirmation Certificate.* Frankenmuth, Michigan, March 21, 1869. Watercolor and pinprick on paper; H. 12″, W. 18″. (Frankenmuth Historical Museum and St. Lorenz Church: Photo, Folk Arts Division, The Museum, Michigan State University.)

traveled through Ohio and up into mid-Michigan, where he died in the Ingham County Poor House in 1908.

Louis C. Jones, in "The Genre in American Folk Art," states:

The importance of a particular folk-genre piece may be greater as a document than as a work of art and it should be recognized as a supplement to the written word, as an historical source. All social history is weak when it comes to the habits, work, dress, attitudes, play and religious life of the lower classes in *any* society and this is very true of Americans.[13]

In her painting of a lakeside scene, Anna Hart incorporates a wealth of detail that portrays what seems to be a social junket to a nearby

[13] Louis C. Jones, "The Genre in American Folk Art," in *Papers on American Art*, John C. Milley, ed. (Maple Shade, N.J.: Edinburgh Press, 1976), p. 1.

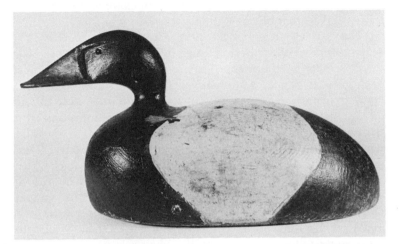

Figure 8. *Hen Canvasback Decoy*, found at Pointe Mouillee, Michigan, late nineteenth century. Carved and painted wood; L. 15″. (Collection of Lowell Jackson: Photo, Folk Arts Division, The Museum, Michigan State University.)

lake. Today, Michigan people are well known for their weekend summer escapes "to the lake," not at all dissimilar from the New York siege on the Jersey shore. Through Anna's meticulous efforts, we catch a glimpse of the social mores of the 1870s, including modes of dress and types of recreation. One even finds a black banjo player entertaining the campers in her painting. Discoveries such as this provide not only a "supplement to the written word"; they also inspire a veritable "infectious" feeling on the part of the viewer.

An artistic offshoot of the ecological system in the upper Great Lakes was based upon the abundant waterfowl and fish. A strong tradition of decoy carving grew up along what has been termed the natural "flyway" along Lake St. Clair and northward. The decoys vary widely to the degree that they successfully integrate the aesthetic components of line and form with function (Fig. 8). Function has frequently been discounted when weighing the aes-

thetic merits of art produced in the folk tradition,[14] yet, many of the decoys encountered reflect a sincerity of expression on the part of their makers that merits aesthetic consideration.

The distinctly regional passion for ice fishing reflects itself in the large number of fish decoys found in Michigan. Made originally by the Indians of the region, such as Chippewa Joseph Francis who produced slender gently curved forms, fish decoys made by whites frequently reflect more flamboyant interpretations of fins and are often characterized by technological innovation. Frequently the decoys were made from available materials by fishermen staying in cabins or cottages near the fishing sites. These creative circumstances yielded some surprising results such as the use of nail polish, rhinestones, and pieces of mirrors on the decoys. Some decoys were given a trompe l'oeil effect by spraying paint through a hair net to simulate scales. Other innovations included a hinged tail to vary the radius of the circular pattern the decoy would follow. Fish decoys, like their relatives, fowl decoys, encouraged aesthetic competition that went well beyond the ability to attract the eye of the hunted. Unfortunately, carving today is more a competition based upon power tools to achieve photorealism. The carving styles of the not too distant past were based on the personal jackknife, and these "working decoys" were the only true decoys.

Making objects such as decoys provided a creative outlet for many people, but their creations brought great pleasure to others as well. This was true of the carved and painted marionettes made by the Lano family. David Lano, the last in the line of three generations of marionettists and puppeteers, worked approximately nine months of the year on the road. Later in his life he wintered in Flint, Michigan, where he worked in an automobile assembly plant. His marionettes embody spirited characters in a style that was distinctively that of the Lano family. Although many authors have concluded that the industrial revolution signaled the end of true folk artistic expression, one can find examples that illustrate man's creative personal response to growing industrialization.

[14] Henry Glassie, *Patterns in Material Folk Culture of the Eastern United States* (Philadelphia: University of Pennsylvania Press, 1968), pp. 30–31.

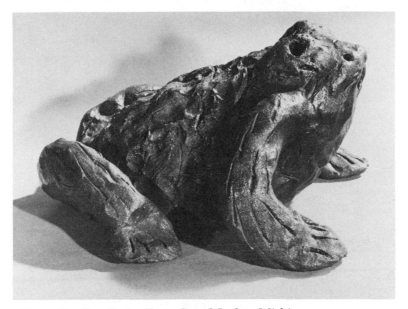

Figure 9. Roy Poole, *Frog.* Grand Ledge, Michigan, ca. 1920–30. Sewer tile clay; H. 6½″, L. 11″. (Private collection: Photo, Folk Arts Division, The Museum, Michigan State University.)

Even under such depersonalized working conditions as those of the Grand Ledge Sewer Pipe Company in Grand Ledge, Michigan, men turned their hands and minds to creating animals, containers, and utensils with roughly fashioned molds or by hand modeling (Fig. 9). These creations were then added to the kilns along with the sewer and conduit pipes. The makers took their odd creations home to family and friends and their art work provided them with a sense of identity in their own communities.

Similar efforts from an industrial setting include an underground maze of murals painted by Clarence Hewes, a troubleshooter who worked for the Lansing Board of Water and Light. To escape the boredom of his long hours on duty, he created a personal world of paintings, murals, and even sculpture in the underground tunnels of a local pumping station. One of his murals depicts a truckload of house painters waving their brushes merrily,

Figure 10. Clarence Hewes, *Rainbows in the Sky*. Lansing, Michigan, ca. 1940. Paint on cement column. (Lansing Board of Water and Light: Photo, Folk Arts Division, The Museum, Michigan State University.)

while above the truck are two large hands holding paint brushes and painting rainbows in the sky (Fig. 10). Under the painting is the following verse:

> Once a painter
> Always a painter
> Until the day they die.

Then they have a job
Up yonder, painting
Painting rainbows
In the sky.

It is from this poem that the Michigan exhibition of 1978 drew its name, "Rainbows in the Sky, The Folk Art of Michigan in the Twentieth Century." Many of the artists working in the folk tradition in this century have been painting their own personal rainbows in the sky—a sky that rarely witnesses such deeply felt unconscious personal expression.

The art of John Waslewski, a Polish immigrant who came to Michigan in the 1920s, gives further evidence of folk sensibilities in an industrial era. After working as a sweeper in a Ford auto plant in Detroit for over thirty-five years, John Waslewski retired and began carving images from his past in Poland, chiefly religious carvings and touching personal scenes. He recorded moments and memories that had deep personal meaning for him: picking flowers with his young wife, crucifixion scenes, angels, fellow union workers trying to improve the lot of the working man (one holds a button reading: "I did it for Walter [Reuther]") and a moving recreation of John F. Kennedy's funeral procession.

The contemporary folk artist retains the bold use of popular materials as well as popular cultural symbols. Russel Nye, in *The Unembarrassed Muse*, outlines five primary factors that produce and determine the character of popular culture: "increased population, mass production, urbanization, universal education, and the electronic revolution." [15] All of these forces have, needless to say, reshaped the lives of the artist, as well as the art itself, yet one cannot discount those artists who continue creating with the aesthetic sensibilities of the folk artist, in spite of changing cul tural patterns. In centuries past, print sources such as mezzotints were widely acknowledged as the basis for artistic undertaking, Today, the expanding uniformity of culture has made newspapers, magazines, and electronic media the mezzotints of today, and the folk artist draws from the ever-present mixed communication

[15] Russel Nye, *The Unembarrassed Muse: The Popular Arts in America* (New York: Dial Press, 1970), pp. 1–7.

Figure 11. John Jacob Makinen, *Happy Home*. Kaleva, Michigan, constructed 1939–41. Pop bottle and mortar wall construction. (Photo, Folk Arts Division, The Museum, Michigan State University.)

mediums. Clarence Johnson relied on World War II political cartoons for his humorous mockery of wartime leaders, including the proud and distinguished figure of Uncle Sam, standing tall above Hitler, who is depicted as a skunk, Mussolini as a snake, and Hirohito as a rat. Contemporary sources of inspiration, such as political cartoons, are as valid as the prints in nineteenth-century ladies' magazines and popular gentlemen's monthlies which inspired folk artists of that era.

A recent undertaking of the Michigan Folk Art Project was a series of videotaped interviews with folk artists active today. On a marathon fieldwork excursion in 1977, we encountered (based on a rumor heard in a bar by one of our colleagues) a bottlehouse made from over sixty thousand soda pop bottles by a soft drink distributor in a small town in western Michigan (Fig. 11). In the 1940s, aided by the obsolescence of the smaller bottles, he began to build his dream house. A ready supply of soda bottles and a

Finnish aversion to beer and liquor bottles enabled him to create his own "Happy Home." The twentieth-century folk artist's openness to unlikely materials and the exercise of an assemblage mentality is already well documented in the work of Clarence Schmidt and Grandma Tressa Prisbrey. Still, in each instance one finds a sincere expression of self in these works—frequently combined with a desire to communicate and elicit a response from their audience.

CONCLUSION

As a result of the work done in Michigan, we feel the urgent need to employ an interdisciplinary approach to the study and evaluation of folk art. We are dealing with art in its truest form as a powerful vehicle for the communication and expression of ideas. In order to arrive at a deeper understanding of both the art and the artists, we will have to rely on the interdependent roles of anthropology, sociology, psychology, history, folklore, art history, and American studies working together to achieve that end. There is a great need to recall that our primary mission is one of *locating* and *collecting* folk art in the Midwest, Plains states, Far West, South, and Southwest. One should not withdraw from the challenge intimidated by conflicting definitions of folk art depending on the academic discipline. As specimens, folk art has value for widely divergent interpretations: by the historian as a social document, by the anthropologist as cultural artifact, by the folklorist as material culture, and by the art historian for its aesthetic merits. Although we seek consensus on the very nature of the art itself, those who find such agreement a prerequisite for further scholarship may have a lengthy wait. There is validity in all of the perspectives and such critical investigation signals a lively and bright future for folk art scholarship.

The emergence of newly designated academic realms is usually followed by a typical pattern of development wherein young fields of learning proceed through an adolescent phase during which their right to exist is brought into question. The developmental phase is at once painful and exciting. Those of us from the social

sciences have experienced that phase very recently. Out of the seeming confusion of the moment will come a mature approach to the study of folk art that will permit all aspects of the material to be examined. We hope that the success of the Michigan Folk Art Project will encourage similar research in other areas, whether on a local, state, or regional basis. There is much work to be done, and only by revitalizing the study of folk art through the application of the most up-to-date techniques and conceptual tools from a broad range of disciplines will a more meaningful understanding of art in the folk tradition be developed.

The horizons of art scholarship are expanding. There is much to be gained by coming to grips with folk art in new localities, for such research may enhance not only our understanding of art itself but the essence of a people. D. H. Lawrence once said, "Every continent has its own great spirit of place. Every people is polarized in some locality, which is home, the homeland. Different places on the face of the earth have different vital influence, different vibration, different chemical exhalation, different polarity with different stars; call it what you like. But the spirit of place is a great reality." [16]

[16] D. H. Lawrence, *Studies in Classic American Literature* (New York: Viking Press, 1961), pp. 5–6.

The Material Culture and Folk Arts of the Norwegians in America

Marion J. Nelson

Folk art is not easily distinguished from the total material culture in agrarian or working-class communities where most of the materials basic to the culture are hand-produced by members of the group. No fixed criteria exist for determining what is craft and what is art. That an object appears to include nothing superfluous to its function does not exclude the possibility of its having artistic qualities or of the maker having had artistic concerns in its creation. In fact, for almost a century, the relationship of form to function has been a major aesthetic principle.

The first part of this article deals primarily with a self-sufficient "folk" society like that referred to above. No attempt will therefore be made in it to differentiate between folk art and material culture. This broad approach is in line with that generally followed by the Norwegians in dealing with the "folkekunst" of their country. The relationship is appropriate since manifestations of Norwegian folk tradition in the hand-crafted materials of Norwegian immigrants in America is the major concern of this paper.[1]

[1] In Norway, unlike America, an anthropological interest in folk materials existed by the mid-nineteenth century and gave a broad base to the concept of folk art when it arose around the turn of the century. Even the latest Norwegian work on the subject, Peter Anker and István Rácz, *Norsk*

Indeed, the study does what John A. Kouwenhoven in 1950 derogatorily referred to as tracing "the alienated remnants of great cultural traditions in charming survivals." [2]

The essentially Norwegian definition of folk art used in this paper differs in several of its connotations from the definitions commonly accepted in America. In this country naïveté is stressed, the plastic manifestation of individualism unspoiled by cultural influence. The folk art of America becomes an expression of America's democratic ideals.[3] The older European conception puts more emphasis on the group and on context. Folk art is the expression, not of individuals, but of the "folk"; it is the product of tradition. Its cultural roots, in fact, are considered *deeper* than those of high art.[4]

As long as mass immigration continued and the melting pot was taken for granted as the way to an American culture, one could hardly expect tradition to be stressed in American folk art. To do so would have pointed up foreign origins when what we wanted was a strictly American art. With the recent acceptance of, and, indeed, a fascination for, the conglomerate nature of American culture, a shift in emphasis back to "roots" in our folk art seems in order. As early as 1950 two major interpreters of American art, E. P. Richardson and James Thomas Flexner, recognized the importance of tradition as an element in folk art. "Folk art is an unselfconscious, highly developed, traditional craft," wrote Richardson. "Whereas a primitive artist is untrained, a folk artist is the product of an ancient and traditional sense of design." Flexner went even further in emphasizing the traditional in folk art. To him it is "art that is passed down practically without

folkekunst (Oslo: J. W. Cappelens Forlag A/S, 1975), includes folk architecture, furniture, and undecorated implements as well as painting and sculpture.

2 Kouwenhoven, "What is American Folk Art?: A Symposium," *Antiques* 57, no. 5 (May 1950):359.

3 Jean Lipman refers to American folk art as "a free artistic expression of the very spirit of the flowering American democracy" ("What is American Folk Art?: A Symposium," p. 359).

4 The origin of the Norwegian conception of folk art is well covered in Peter Anker, *Folkekunst i Norge* (Oslo: J. W. Capplens Forlag A/S, 1975), pp. 21–24.

change from generation to generation by simple people who live in a static society that can be expressed by traditional symbols." [5]

The peripheral location of Norway in Europe's cultural sphere, the country's rugged terrain and rather severe climate, and four hundred years of foreign domination prevented industrialization from getting under way until the last half of the nineteenth century. Even then the life and culture in many of the remote valleys of this mountainous country remained firmly rooted in the Middle Ages, and later cultural developments left their mark only to the extent that they could be incorporated into the old culture. The economy of these rural communities remained largely self-sufficient. Wood and wool were the basic raw materials from which objects for everyday use were produced.

During the forty-year period from 1836 to 1876, almost two hundred thousand Norwegians, most of them from isolated rural communities, left Norway and came to the United States where they settled primarily in the undeveloped prairie lands of Illinois, Wisconsin, Iowa, and Minnesota.[6] Many smaller household implements and tools were brought from Norway, but these will not concern us here. Vehicles, houses, and furniture had to be built. An inadequately developed transportation network in the upper Midwest made the mass-produced goods of the industrial East inaccessible or too expensive. The initial supply of cash for the purchase of goods was also limited. The materials produced during this period reveal remarkable retention of techniques and patterns from the homeland. Where innovation occurred, it was generally due to slight differences in materials available, a shift in practical needs, or influence from settlers of different ethnic backgrounds.

After having disembarked at a port on the Great Lakes or having arrived at a terminal railway station, one of the first needs of most immigrants was a vehicle for travel farther inland. A standard solution for the wheels of such vehicles was a slice of

[5] Richardson, "What is American Folk Art?: A Symposium," p. 361; Flexner, "What is American Folk Art?: A Symposium," p. 357.

[6] The latest comprehensive history of Norwegian immigration, Arlow W. Andersen, *The Norwegian-Americans* (Boston: Twayne Publishers, 1975), includes a selected bibliography of most major references on the subject, basic among which is Theodore Blegen, *Norwegian Migration to America*, 2 vols. (Northfield, Minn.: Norwegian-American Historical Association, 1931, 1940).

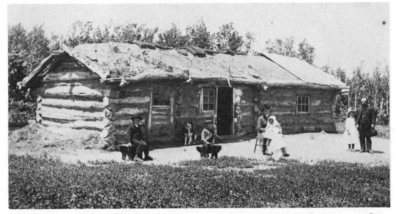

Figure 1. Norwegian immigrant parsonage, North Dakota, ca. 1870.
(Norwegian-American Museum.)

solid log surrounded by a band of iron and shaped so that the
greatest thickness was at the hub where the wear would be con-
centrated. There are many references in early immigrant litera-
ture to wagons with wheels of this type, and one example, from
about 1840, is preserved in the Norwegian-American Museum,
Decorah, Iowa. The model is a small farm wagon found in certain
areas of Norway. The type reflects the prehistoric and medieval
approach to wood construction in which the natural forms of the
material are utilized to the ultimate. This tradition served the
early immigrants well because tools were scarce and time was at a
premium.

Log construction, used almost exclusively for early houses in
wooded areas, also utilizes wood in its most natural form. The
corner joining represents the only major intrusion on the log. The
residence of an early Norwegian pastor in North Dakota, as seen
in a photograph from about 1870, illustrates the extent of reli-
ance on native tradition in the use of material (Fig. 1). The
notching is of the saddle type, and the ends of the logs project
slightly at the corners. The roof is low pitched and covered with
sod. A window is placed adjacent to the door. When it became
necessary to expand the house, it was extended from a gable end.

Figure 2. Norwegian immigrant log building, Ottertail County, Minnesota, ca. 1870. Frame portions removed. (Drawing, Dana Jackson.)

All of these characteristics are a direct carry-over from traditional Norwegian architecture.[7] The only major difference is that the logs in the immigrant house are not carefully joined along their lengths nor worked to a rectangular shape with slightly convex sides. These characteristics are seldom found in immigrant buildings, a fact which might be explained as the result of expediency in what was generally considered temporary housing. It could also have resulted from the problems of having to work with such irregular woods as poplar or oak rather than the straight Norwegian pine. Complaints about the difficulty of working available woods occur in immigrant letters.[8]

Even such medieval characteristics in Norwegian log building as the projecting second story at the gable end is not uncommon in Norwegian immigrant building. The area beneath the projec-

[7] A Norwegian house with most of the same characteristics is shown in Halvor Vrien, *Norsk trearkitektur* (Oslo: Gyldendal Norsk Forlag, 1947), p. 11.

[8] Problems with difficult woods in log building are referred to by A. Bugge, "Emigration as Viewed by a Norwegian Student of Agriculture in 1850," *Norwegian-American Studies and Records* 3 (1928):50.

Figure 3. Norwegian immigrant log building, Decorah, Iowa, 1852. (Norwegian-American Museum: Drawing, Dana Jackson.)

tion is generally framed in and covered with siding, a characteristic which is also common in later Norwegian building. An immigrant house of this type from Ottertail County in central Minnesota had a lean-to on the gable end, in addition to the area below the overhang (Fig. 2). The roof of the lean-to was supported by extension of the two lower logs from the gable end.

The most common Norwegian-American house type during the first period of mass immigration has dovetailed joining and is one-and-one-half stories high (Fig. 3). The roof is shingled and has a slightly higher pitch than the Norwegian sod roof. The door and abutting window are on the long side, and the exterior surface of the house is whitewashed or covered with siding. This house type was thought to have developed under Yankee influence because of deviations from earlier Norwegian building traditions. Recent investigations of nineteenth-century cotters' and workmen's houses in Norway indicate that the house type could

Figure 4. Norwegian immigrant log building, Ottertail County, Minnesota, 1875–1900. (Drawing, Dana Jackson.)

have been brought to this country by Norwegian immigrants.[9] Only the use of whitewash to draw moisture from the logs, rather than pitch to keep it out, does not, to my knowledge, have Norwegian precedent.

The addition of a one-story kitchen projecting at a right angle from the basic house is one of the ways by which the immigrants brought their houses into accord with American building tradition. This plan has no prototype in Norway where dwellings are generally of a simple rectangular shape. A typical example of the L-shaped Norwegian-American log house is found in Ottertail County, Minnesota (Fig. 4). An exceptional example, which reveals even further assimilation, is found in Rock County, Wisconsin. It originated about 1842 as a one-and-one-half-story log building completely Norwegian in character. The construction suggests that the roof may once have been sod. Early in its history a stone kitchen was added at a right angle to the main house and the entire complex was faced with stone. Since insulation could

9 The unpublished results of a survey of Norwegian nineteenth-century rural architecture made in 1973 by Darrell Henning, curator, Norwegian-American Museum, Decorah, Iowa.

scarcely have been a concern in the original unit with its large and tightly fit logs, it would appear that the stone facing was added purely to bring the building into accord with the fine limestone houses being constructed in the area by incoming Germans from Pennsylvania.[10] Stone buildings are rare in rural Norway where much of the rock is igneous and difficult to cut.

Furnishings for homes in rural areas of nineteenth-century Norway covered a range of types and styles, reflecting all of the major periods in European cultural history from medieval through neoclassic. This apparent eclecticism was the result of cultural accumulation in an essentially conservative society. Consistency in the way the styles were treated by the country craftsmen, however, generally gave an astonishingly unified character to the peasant interior.

Furnishings of the immigrant home show the same range of styles found in Norwegian folk furnishings. Two characteristics, however, distinguish them. One is the comparative simplicity of immigrant furnishings. While the form and construction of traditional Norwegian furnishings were retained, decoration was generally omitted. The impact of neoclassicism on nineteenth-century folk taste, as well as limited time, tools, and materials, may account for this in part. The other distinguishing characteristic is the incorporation of mass-produced American materials, the first and most common of which appears to have been the stove. An eyewitness to the first caravan of Norwegians to arrive in the area of Decorah, Iowa, wrote that one wagon looked like a battleship because of the stovepipes tied to the side.[11] Stoves were available in the ports of the Great Lakes and the Mississippi through which most of the immigrants came. They would have had priority over other furnishings because of limited space in immigrant wagons and because they were not easily produced on location after settlement. Even the construction of a hearth depended on the avail-

10 Claire Elaine Selkurt, "The Domestic Architecture and Cabinetry of Luther Valley: A Norwegian-American Settlement" (Master's thesis, University of Minnesota, St. Paul, 1973), pp. 90–98. I also inspected the building in 1975.
11 Hjalmar Rued Holand, *De norske settlementers historie* (Ephraim, Wis.: Published by the author, 1909), p. 350.

ability of proper stone and mortar. No early immigrant dwelling has come to light with the traditional corner fireplace of the Norwegian home. Already in 1820, the famous trail blazer of Norwegian immigration, Cleng Peerson, said in a letter from upstate New York, "When I was in Rochester, I bought a stove for twenty dollars, fully equipped with pans, pots for meat, a baking oven, and other things—so we shall not need to build a fireplace." [12]

The log chair used in Scandinavia since medieval times continued to play a fairly prominent role in early immigrant furnishings. It consists of a section from the trunk of a tree which has been hollowed out and carved to fit the body. A plank seat is set in loosely so that it will not cause stress when the log contracts. It is another perfect example of the Norwegian tendency to avoid joining and to use natural forms in creating functional objects from wood. The relative simplicity of production undoubtedly accounts for the log chair's prevalence among the immigrants. Most extant examples are from Wisconsin, where one finds both a traditional medieval type in which the log is given a concave shape, with a carved band around its narrowest point, and a tubular type in which the natural shape of the log is more directly retained. An example of the latter from the Eau Claire, Wisconsin, area has been given rockers (not evident in the illustration), a surprisingly modern and American addition to a chair which for at least five centuries had been firmly planted on the floor (Fig. 5). The addition to this chair of armrests with supporting posts is not as surprising. Armrests are suggested in the carved decoration of a famous Norwegian log chair from the eighteenth century (Fig. 6), an indication that they must have actually existed in other early chairs. A comparison of the Norwegian chair with the Eau Claire example illustrates the continuity of the Norwegian form and the abandonment of the Norwegian decoration.

Although not "sitting furniture," a baptismal font, made near

[12] Theodore Blegen, *Land of Their Choice* (Minneapolis: University of Minnesota Press, 1955), p. 20. A summer kitchen with a corner fireplace from Rock County, Wis., is now in Old World Wisconsin at Eagle near Milwaukee. See Marion Nelson, "Folk Art Among the Norwegians in America," in Harald S. Naess, ed., *Norwegian Influence on the Upper Midwest* (Duluth: University of Minnesota, 1976). pp. 77–78.

Figure 5. Log chair, Dallas, Wisconsin, ca. 1860. (Author's collection: Drawing, Dana Jackson.)

Figure 6. Log chair, Sande, Vestfold, Norway, ca. 1700. (Norwegian Folk Museum, Oslo: Drawing, Dana Jackson.)

Litchfield, Minnesota, in 1874 by Ellef Olson, an early Norwegian settler in the area, will be considered here because of its relationship in style and construction to the log chair (Fig. 7).[13] In spite of its refined surface treatment, it is essentially the medieval wood font (Fig. 8) as found in a number of stave churches. The log is tapered from both ends toward the center, where it is encircled by a carved projecting band. The central ring characterizes the type and has a counterpart in one of the traditional treatments of the log chair. The style does not belong to any revival

[13] Charles Ness, Jr., "Ness Lutheran Church," *Ness Lutheran Building Centennial—Aug. 11, 1974*, mimeographed.

Figure 7. Ellef Olson, baptismal font. Ness Lutheran Church, Litchfield, Minnesota, 1874. (Drawing, Dana Jackson.)

Figure 8. Baptismal font, Uvdal Stave Church, Numedal, Norway, probably thirteenth century. (Drawing, Dana Jackson.)

that could have reached Minnesota in the 1870s; it must, therefore, be considered the unromantic utilization of a medieval model because of its simple construction.

Examples of three-legged chairs based on a traditional type found in western Norway have recently come to light on immigrant farms in Wisconsin and central Minnesota (Figs. 9, 10). Three upright posts are mortised to receive the tenons of a T-shaped support for the plank seat. The structure is reinforced by a bentwood rail fitted into slots in the top of each post. The rail, which is U-shaped, also serves as both backrest and armrests. From

Figure 9. Three-legged chair, Kenyon, Minnesota, ca. 1860. (Collection of David Caffes: Drawing, Dana Jackson.)

Figure 10. Three-legged chair, Mølster farm, Voss, Norway, probably nineteenth century. (Voss Folk Museum: Drawing, Dana Jackson.)

seven pieces of wood a light, sturdy, and comfortable chair is formed. The construction is so well suited to the function that it has been used by the modern Danish designer Nils Kjaerholm for one of his classic creations in stainless steel.[14]

While spindle-back chairs became the standard sitting furniture of the common people in nineteenth-century America, a simple rectangular chair, of empire inspiration, assumed this position in nineteenth-century Norway. Although chairs appear to have been among the earlier types of mass-produced furniture to enter the immigrant interior, examples of locally produced "peasant empire" chairs are not infrequently encountered in Norwegian immigrant homes of the upper Midwest (Fig. 11).

Simple benches without backs had been the standard sitting

[14] Erik Zahle, ed., A Treasury of Scandinavian Design (New York: Golden Press, 1961), p. 20.

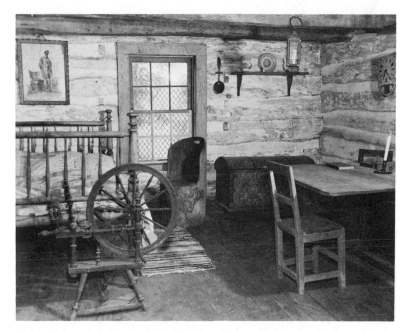

Figure 11. Interior of Hans Haugan House, Decorah, Iowa, ca. 1865. (Norwegian-American Museum.)

furniture for the "folk" in Norway through the eighteenth century. Connotations of distinction or authority went with the use of the chair [15] Such benches were probably not extensively used in the immigrant house, but they continued to be the sitting furniture of craftsmen. The immigrant box bench with sliding door— designed astonishingly like the medieval box tables of Scandinavia —was probably used in this context (Figs. 12, 13).[16]

Settees and settles, or bed-benches, were standard objects in the immigrant home. There are two major types. One has scroll ends of the type known from Jacques Louis David's famous portrait of Madame Recamier painted in 1800. It is not common in

[15] Anker and Rácz, *Norsk folkekunst*, p. 13.
[16] Two similar immigrant examples are in private collections in Rochester, Minnesota. For illustrations of the Norwegian box table, see Anker and Rácz, *Norsk folkekunst*, nos. 96–97.

Figure 12. Immigrant box bench, Rushford, Minnesota, ca. 1860. (Collection of David Caffes: Drawing, Dana Jackson.)

nineteenth-century Norwegian furniture, but Norway must have furnished the model for the many examples found in immigrant homes in northwest Iowa (Fig. 14). Its prominence there could be due to the influence of one craftsman. The material is invariably solid walnut with natural finish, an indication that it may be directly inspired by bourgeois furniture. It appears either as a simple settee or as a bed-bench with a seat that can be folded over or pulled out to form a double bed.

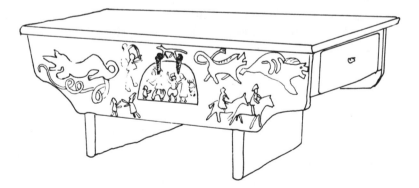

Figure 13. Norwegian box table, Høydalsmo, Telemark, Norway, ca. 1700. (Norwegian Folk Museum, Oslo: Drawing, Dana Jackson.)

Figure 14. Immigrant bench, Dorchester, Iowa, ca. 1860. (Norwegian-American Museum: Drawing, Dana Jackson.)

More widespread is the bed-bench with a covered box as its base (Fig. 15). With the lid raised, it can serve as a single bed. Many examples have a backless drawer in the base which can be pulled out to double the width. The backs and armrests are occasionally solid or paneled, but more frequently they have separated vertical slats. A memoir describing early Norwegian immigrant life in east central Wisconsin reports that "nearly all farmers" had bed-benches.[17] Most known examples have specific forerunners in Norway and are neoclassic in style.

Of the four major types of tables common in rural Norway during the nineteenth century, three have come to light in immigrant homes. The missing type is the trestle table, which even in Norway was disappearing from general use at the time. Three examples of the gateleg table, with leaves extending nearly to the floor, have been found (Fig. 16). Typical of the rural Norwegian version of this baroque table type is the large drawer in one end for the flat breads used to accompany most meals. The fold-down table, which had a standard place beside the corner hearth in Norway, is also known in three immigrant examples from Iowa,

[17] Erna Xan, *Wisconsin, My Home* (Madison: University of Wisconsin Press, 1951), p. 107.

Figure 15. Immigrant bench, southern Minnesota, ca. 1860. (Collection of Donald Gilbertson: Drawing, Dana Jackson.)

Minnesota, and Wisconsin (Fig. 17). By far the most common country table in use among the immigrants was a neoclassic type which relates closely to the peasant empire chair (Fig. 18). The legs are tapered, and the sides fit into the legs with mortise and tenon joining. Rather obvious pegs keep the joints secure. The top is frequently removable, and tapered slabs are wedged into grooves on the underside to prevent warping.

Chests of drawers and desks are the most frequently encountered types of fine furniture made by Norwegian immigrants. Both were comparatively recent arrivals into rural homes in Norway and may have had significance as prestige objects. Since the Renaissance, chests of drawers had slowly been replacing trunks as the furniture for textile storage in upper-class homes. The transition had just reached the countryside at the time of emigration. One interesting consequence was that the trunks were freed for use as luggage on the Atlantic voyage. Another possible consequence was that chests of drawers carried associations of moder-

Figure 16. Immigrant table, Decorah, Iowa, ca. 1860. (Norwegian-American Museum: Drawing, Dana Jackson.)

nity and an improved social and economic status. Desks, of course, were also symbols of literacy with the added association of business involvement.

Early chests of drawers are almost invariably of one type (Fig. 19). There are generally four drawers. The two middle drawers are recessed from the plane of the facade, and the top and bottom drawers often have a cyma curve profile. Half columns often flank the recessed middle section. The upper drawer may have compartments, some of which have sliding covers. The top is dovetailed to the sides and is surrounded by a molding which creates the impression of a heavy top plate projecting beyond the sides. There are no pulls on the drawers; they were intended to be drawn by the key. The wood in most examples known to me is butternut, probably used to simulate the birch of many Norwegian prototypes. Painted examples are generally of pine, and the treatment is

Figure 17. Immigrant table, Beldenville, Wisconsin, ca. 1860. (Norwegian-American Museum: Drawing, Dana Jackson.)

Figure 18. Immigrant table, southern Minnesota, 1875–1900. (Author's collection: Drawing, Dana Jackson.)

a golden brown or reddish graining suggestive of the veneered surfaces of upper-class Norwegian examples. Escutcheons are often of bone and of a diamond shape.

Variants of the standard immigrant chest of drawers reveal Victorian influence. Additions to one such chest include handkerchief drawers, carved pulls, and simulated paneling (Fig. 20). These new elements, with their greater curvilinearity, are tastefully incorporated into the basic empire chest of drawers. The pulls are simpler and more rhythmic in design than the usual carved Victorian pulls with their naturalistic leaves, flowers, or nuts.

The standard immigrant desk resembles the immigrant chest of drawers. Some had the recessed middle section, and some did not. The desk unit itself could be cylinder top (Fig. 21), slant top (Fig. 22), or fall front. In the cylinder type, the writing surface is often the cover of a unit which pulls out like a drawer. In the slant-top and fall-front desks, the writing board has either its own pull-out supports or it rests on the extended upper drawer. More often than not the pigeonholes and small drawers are in the same plane rather than tiered, and there is generally a central compart-

Figure 19. Immigrant chest of drawers, Ottertail County, Minnesota, ca. 1870. (Author's collection: Drawing, Dana Jackson.)

ment with a door or cover. The desks are frequently made of pine and finished with a grained or otherwise mottled surface, although varnished walnut examples also exist. The most monumental of such desks known to me is an empire fall front with Victorian details made by an immigrant craftsman in Decorah, Iowa, around 1870 (Fig. 23).

Norwegian-American cupboards show greater variety in their design than most other objects because so much attention was given to their details and decoration. The cupboard held a prestigious place in the Norwegian household as a symbol of material wealth, and this special position appears to have been retained by the cupboard in the early Norwegian-American home. Most types have specific forerunners in Norwegian tradition, but

Figure 20. Immigrant chest of drawers, Moorhead, Minnesota, 1872. (Author's collection: Photo, Darrell Henning.)

variations resulting from contact with American Victorian furniture are evident here as in the desks and chests of drawers. Several standard types of cupboards will be dealt with first. The exceptional examples will be taken up later as part of a fuller consideration of the craftsmen who produced them.

A common type of large wall cupboard in the areas of Wisconsin settled in the 1840s and 1850s is one that stands about one foot off the floor on bracket-type feet which are extensions of the plank sides (Figs. 24, 25). Because of the shape of the feet, these cupboards do not stand without being attached to the wall. They

Figure 21. Immigrant chest of drawers with cylinder desk top, Dorchester, Iowa, ca. 1860. (Norwegian-American Museum: Drawing, Dana Jackson.)

have large double doors generally opening to shelves or, occasionally, to shelves and small drawers. The location of this piece was beside the door in the traditional country home in central Norway.[18] Whether or not the traditional location continued among the immigrants is difficult to determine because most of the remaining examples have been moved from their original sites.

The small, rectangular hanging cupboard, which in Norway had its location between the table and the bed, also comes to light with some frequency in Norwegian-American communities (Fig. 26). The illustrated example, from Plum Creek, Wisconsin, is typical, if somewhat finer in craftsmanship and more complicated

18 A house from Valdres, Norway, with such a cupboard as part of its original furnishings, was moved to the Outdoor Division of the Norwegian-American Museum in 1974–75.

Figure 22. Immigrant chest of drawers with slant top desk, Rushford, Minnesota, ca. 1860. (Collection of Donald Caffes: Drawing, Dana Jackson.)

in its interior arrangement of drawers, shelves, and spoon rack than many such cupboards. The cupboard is known to have been produced before 1890 by the country craftsman Johannes Jacobsen Bergit, who made furniture and carved decorative objects.[19] The raised diamond on the door is a common motif in immigrant cupboards, another indication of neoclassic influence.

A hanging corner cupboard behind the table was a standard part of the furnishings in early Norwegian rural homes, but most immigrant corner cupboards are of the floor type which, by the nineteenth century, had also begun to find its way into the Norwegian peasant interior. A favorite among the immigrants was a two-piece bow front, or quarter cylinder type, known in England and on the Continent before entering urban Scandinavia around

[19] Information from Donald Gilbertson, Osseo, Wisconsin, who had obtained it from members of the Bergit family.

Figure 23. Fall-front desk, attributed to Johan Jackwitz, Decorah, Iowa, ca. 1860. (Norwegian-American Museum.)

1800 (Fig. 27).[20] The design offers a considerable challenge to the craftsman because the curved sides and doors are cut rather than bent. In spite of the complexities involved in their construction, the numbers in which these monumental pieces were produced throughout the Norwegian areas of Wisconsin, northern Iowa, and Minnesota indicate that they held some special significance to the immigrant group. The appeal of the type may have been its association with the urban rather than with the peasant home, an

[20] For illustrations of Norwegian prototypes, see Yngve Woxholth, ed., *Norske storgårder og kulturskatter* (Oslo: Jhemmenes Forlag, 1976), pp. 200, 408.

Figure 24. Wall cupboard, south-east Minnesota, ca. 1860. (Collection of Donald Gilbertson: Drawing, Dana Jackson.)

Figure 25. Wall cupboard, Heggenes, Valdres, Norway, ca. 1800. (Norwegian-American Museum: Drawing, Dana Jackson.)

association that could have been attractive to the successful immigrant farmer.

So far, this article has emphasized the norm in the material culture of the Norwegian-Americans during the period of settlement when they were still living in areas not substantially affected by industrialization. Medieval and neoclassic characteristics dominate in the style of these frontier objects, and simplicity of production, social connotations, or spacesaving concerns appear to have determined the types. Most pieces are based rather directly on Norwegian models.

Almost from the beginning there were exceptions to the norm, and these are what give Norwegian-American material cul-

Figure 26. Johannes Jacobsen Bergit, hanging cupboard. Plum Creek, Pierce County, Wisconsin, 1875–1900. (Collection of Donald Gilbertson: Photo, Darrell Henning.)

ture its flair and richness. The exceptional pieces generally grow out of the baroque and rococo strains in Norwegian folk art, and they can deviate extensively from the Norwegian models. Many were difficult to produce and reveal little concern for practicality. The craftsmen who created them were definitely part of the immigrant folk group, and they produced for the group; their creations, however, are distinct from what appears to have been standard for that group. They were individuals driven by forces other than those that were shaping the general material culture of their society at the time.

The first three atypical artists to be considered all lived in southern Wisconsin. The first to arrive from Norway was Aasmund Aslakson Nestestog, who crossed the Atlantic in 1843. He settled with his family on a farm in the Koshkonong area, southeast of Madison, and spent his entire life in that region. Although said to be totally self-taught in his home area of Vinje, Telemark, his mastery of gunsmithing, jewelry making, printmaking, wood carving, and painting had made him a legend in Norway before he left

Figure 27. Erik Egge, bow-front corner cupboard. Decorah, Iowa, ca. 1865. (Norwegian-American Museum.)

for America at the age of forty-six. Years after he left, articles about his exceptional ability continued to appear in Norwegian newspapers. A major admirer was the author and poet Aasmund Vinje.[21]

[21] Information on A. A. Nestestog before leaving Norway is drawn from Øystein Vesaas, *Rosemaaling i Telemark*, vol. 2 (Oslo: Mittet & Co. A/S, 1955), pp. 147–53. Since the preparation of this article, *Norwegian-American Wood Carving of the Upper Midwest* (Decorah, Iowa: Vesterheim, 1978), an exhibition catalogue with articles by Darrell Henning, Marion Nelson, and Roger Welsch has been published giving more specific information on Nestestog and other American woodcarvers of Norwegian origin.

In America, Nestestog was primarily a farmer and cultivated two hundred acres of rich land. He is also known to have continued smithing. A number of silver spoons with his hallmark, in the possession of descendants, are said to have been made by him in this country.[22] Although known in Norway as a painter with an exceptionally original style, there is no evidence that he continued this art in America. Several examples of fine wood carving are known. In 1861 he produced the altar for the first Norway Grove Lutheran Church near DeForest, Wisconsin. Mysteriously lost less than twenty years ago, the work is known from a photograph to have been a unique tiered creation with panels of acanthus carving at the sides and an elaborate sunburst at the top.[23] The seriousness of its loss is evident from the few surviving examples of the work of this artist: a box with acanthus carving on the cover; an open letter box dated May 2, 1876, with a panel of reticulated acanthus carving on the back; and an isolated panel of similar type dated March 18, 1876 (Fig. 28). The carving on these pieces has a rhythm, a freedom, and an asymmetrical balance among the best in Norwegian folk art. The intertwining tendrils and drawn out leaves suggest a tradition going back beyond baroque to the Ringerike style of the late Viking age. The pieces confirm what the poet Vinje said about Nestestog: "He put his powerful personality into the tiniest piece he created." [24]

There is no indication of appreciation for the work of Aasmund Nestestog in the immigrant community to which he belonged. No record appears to have been kept of his having carved the altar in the Norway Grove Church, although family tradition says that he did and the photograph mentioned above supports this contention. A neighbor who knew him in his last years said he ended his days taking care of the pigs on his farm.[25]

Similar to Nestestog in versatility but less accomplished as a craftsman is Martin Olson, another immigrant from Telemark

22 Most information on Nestestog in America was obtained from an interview with his grandson, Howard Norsetter, of Cottage Grove, Wisconsin, October 17, 1977.

23 *100th Anniversary, Norway Grove Lutheran Church* (DeForest, Wis.: Published by the congregation, 1947.), p. 12.

24 Vesaas, *Rosenmaaling i Telemark*, 2:147.

25 Vesaas, *Rosemaaling i Telemark*, 2:152.

Figure 28. Asmund Aslakson Nestestog, carved panel. Cottage Grove, Wisconsin, March 18, 1876. (State Historical Society of Wisconsin.)

who was active near Elkhorn, Wisconsin, in the 1860s and 1870s. The painted figures on a set of doors from a small house where he once lived were inspired by illustrations in *The Complete English Bible*, London, 1788. They reveal an affinity with the bright and decorative style in figure painting that developed under baroque and rococo influence in rural Norway during the eighteenth century. The exaggerated gestures, the predominance of primary colors, and the strong rhythmic lines give them that expressive quality characteristic of Norwegian folk painting. A baptismal font

Figure 29. Cupboard, attributed to Erik
Johnsen Engesaether, DeForest, Wiscon-
sin, 1870. (Minneapolis Institute of Art,
Julia B. Bigelow Fund.)

from the Sugar Creek Lutheran Church, the only other known
remaining work from his hand, is also baroque in style, but it is
more awkward in execution than the paintings. An organ built for
the same church by Olson is lost.[26]

The third Wisconsin artist is known only through two almost
identical painted cupboards; he is not identified by name. One is
dated 1868 and belonged to Erik Ericksen and Solvi S. D. En-

[26] The doors are privately owned and have not been available for
photography. Information about Olson was supplied by his granddaughters,
Elma and Thelma Olsen, Elkhorn, Wisconsin.

gesaether. The other, dated 1870, belonged to John Eriksen and Brithe Sjursdatter Engesaether (Fig. 29). Both cupboards are now in museums, the former in Little Norway, Mount Horeb, Wisconsin, and the latter in the Minneapolis Institute of Arts. With the assistance of genealogist Dr. Gerhard Naeseth, University of Wisconsin, I have discovered that the original owners were brothers who both belonged to the Norway Grove Lutheran Church, DeForest, Wisconsin, where A. A. Nestestog's carved altar originally stood.[27] In design, construction, and painted decoration, the two cupboards are so similar that they must be the product of one craftsman.

The cupboards are unusual in being more purely Norwegian and in revealing a greater range and refinement in techniques than is typical for immigrant furniture. Most puzzling is the complex and superbly executed painting. Nothing comparable by a Norwegian immigrant in the nineteenth century has come to light. The borders framing the decorated panels have expressive blue-on-white abstract designs painted wet-on-wet with rapid and firm strokes. Similar blue-on-white decoration covers portions of the interior, including a wide range of designs from floral motifs to abstract patterns. The same virtuosity in brush work is found in the inscription on the back of the open area dividing the upper and lower sections. The rather highly stylized floral decoration in the panels themselves is carried out in red and yellow which, together with the blue of the ground, creates the traditional Norwegian triad of primary colors. Gold and silver leaf has been applied under the paint in the centers of the flowers, a difficult technique used only by the most experienced of the Norwegian folk painters.

Several circumstances point to Erick Johnsen Engesaether, the father of John and Erik, as the artist of these exceptional works. It is not uncommon for Norwegian craftsmen to produce one major piece for each of their children. The creator of the

[27] My major source of information on the Engesaether family is a brief genealogy compiled by Dr. Gerhard Naeseth, University of Wisconsin, Madison. Slight variations occur in the names, e.g., Erik (Erick) and Engesaether (Engesaethe, Engeseth). Assistance in reaching members of the family was given by Selmer Hatlem, DeForest, Wisconsin.

cupboards must have learned his trade in Norway, since he knew so intimately the form and construction of the traditional Norwegian cupboard and mastered so completely the techniques of Norwegian folk painting. Erick Johnsen Engesaether was thirty-six years old in 1846 when he left Leikanger on the Sognefjord in western Norway and settled in Dane County, Wisconsin. The practice of painting the name of the owner in the open middle area of the cupboard was common in this region; it was not common in other parts of Norway.[28] The style of painting has counterparts both in Sogn and in Valdres, an inland valley which has Sogn as its major western port. Erik and John are also the two oldest sons of Erick Johnsen Engesaether, the children for whom he would undoubtedly have begun his heirloom project.

Two circumstances speak against the cupboards having been made by Erick Johnsen Engesaether. Twenty years passed between his arrival in America and the date of the first cupboard. The techniques could scarcely have been retained this long and still be applied with the assurance found in these pieces—unless the painter had continued to practice his craft, and no earlier examples are known. Had Erick been a painter of the caliber found in the cupboards, it is strange that the Norway Grove congregation, of which Erick appears to have been both a founder and member of the building committee, went twenty miles away to hire Nestestog as a carver for the altar and did not use Erick as a painter. An early photograph of the interior of the church shows it in pristine white, although country churches in Norway of the period were still being marbleized and otherwise decorated in schemes not unlike those found on the cupboards.[29]

Whoever was the master of the Engesaether cupboards, he apparently went unnoticed by the community. No information about the cupboards has been passed down to the members of the Engesaether family who still reside in the DeForest area. The cupboards were sold by the family in the 1930s without the remaining

[28] An example is illustrated in Janice Stewart, *The Folk Arts of Norway* (New York: Dover Publications, 1973), p. 111.

[29] *100th Anniversary, Norway Grove Lutheran Church*, p. 12.

Figure 30. Lars Christenson, cupboard.
Benson, Minnesota, ca. 1880. (Norwe-
gian-American Museum.)

members who were living at the time retaining any memory of
them.[30]

The major known Norwegian-American folk artist, Lars

[30] Records at the Little Norway museum date the acquisition of its
cupboard to June 11, 1937; and records accompanying the Minneapolis
Institute piece, when purchased in 1977, indicate that the first sale would
probably have occurred in the 1930s. Interviews on October 15, 1977, with
Bert Engeseth, DeForest, Wisconsin, a grandson of the original owner of
the Minneapolis piece, and on October 16, 1977, with Lida Bostrom, Stough-
ton, Wisconsin, who had lived in the home of a son of the owner, indicate
that all memory of the cupboards had been lost.

Christenson of Benson, Minnesota, grew up in Sogndal, only a short distance down the Sognefjord from Leikanger, where Erick Johnsen Engesaether spent his youth.[31] Christenson also made cupboards for his family. Of the two known examples, one was made for a brother and the other for a son. They are as remarkable for their sculptural characteristics and carving as the Engesaether cupboards are for their painted decoration.

The earliest of the two cupboards, apparently dating from the 1800s, is the most conservative (Fig. 30).[32] Even so, it shows many deviations from Norwegian prototypes. The middle section, which would be open in a Norwegian counterpart, is a separate cabinet of nine small drawers. They are stacked in a way that suggests they were inspired by the drawers and pigeonholes inside a desk. Their position between the upper and lower sections of the cupboard is also approximately the same as the work area of a desk. This arrangement of elements is not unique. It is found in other immigrant cupboards, the best known of which is from Westby, Wisconsin.[33] Christenson's substitution of drawers in the lower section of the cupboard for the traditional enclosed shelves makes the suggestion of a desk in the central area especially strong.

The most exceptional details in the Christenson cupboard, however, are the serpents whose tails form the spirals of the crown and whose heads terminate its moldings (Fig. 31). Noteworthy details on the serpents are small front legs which make them anatomical descendants of the dragons which clustered in combat around the doors of the twelfth-century Norwegian stave churches. It was through precisely such a door that Lars Christenson passed for his baptism, confirmation, and wedding in the now de-

[31] The sources of biographical information on Lars Christenson are documented in Marion John Nelson, "A Pioneer Artist and His Masterpiece," *Norwegian-American Studies* 22 (1965):3–17.

[32] According to the artist's granddaughter, Mrs. Allie Kittleson, of Glenwood, Minnesota, the cupboard was made for Peter Christenson, of Brooten, Minnesota. It was still on the farm he had occupied at the time of the interview in 1964, but in 1970 it was purchased by the Norwegian-American Museum.

[33] Donald Gilbertson and James F. Richards, Jr., *A Treasury of Norwegian Folk Art in America* (Osseo, Wis.: Tin Chicken Antiques, 1975), p. 56.

Figure 31. Detail of cupboard shown in figure 30.

molished Stedje stave church in Sogndal.[34] The detail is the only instance known to me of the dragon motif—so prevalent in Viking, medieval, and early Norwegian folk art—having appeared in an unselfconscious way in an immigrant work. The figure has an apple in its mouth and is said to have been conceived by the artist as the serpent of temptation.[35] Later dragons in Norwegian-American art grew out of a national romantic revival of the Viking style.

In Lars Christenson's next known cupboard, a modified corner bow front dating from about 1895, the serpents have given way to freely interpreted acanthus scrolls with grape clusters (Fig. 32).[36] The upper part of this cupboard ingeniously combines in one piece the elements of the two upper sections of the previous cupboard. All that is lost is one central drawer, but the overall effect

[34] The wood portal from Stedje Church with its dragon carving is preserved in the Historical Museum, Bergen, Norway.

[35] Interview with the artist's son Hans, Ebenezer Home, Minneapolis, Minnesota, 1963.

[36] According to the widow of the artist's grandson, Wilfred Kjørness, Minneapolis, Minnesota, the cupboard was made for the artist's son John. It was purchased by the Norwegian-American Museum in 1975.

Figure 32. Lars Christenson, corner cupboard. Benson, Minnesota, ca. 1895. (Norwegian-American Museum.)

of the two cupboards is totally different. The relief decoration is also of remarkable originality. Casual observers have commented on its early American character, and there is, to be sure, some of that in the symmetry of the baskets and the vase motifs. The chances are remote, however, of Christenson's having been exposed to folk art of the eastern states before the 1890s. The inspiration more likely was west-coast Norwegian folk painting in

Figure 33. Lars Christenson, altarpiece. Benson, Minne-
sota, 1897–1904. (Norwegian-American Museum.)

which vases with single stems of leaves or flowers frequently
appear.

Christenson's major creation is the altarpiece carved between
about 1897 and 1904 for his parish church in Benson, Minnesota
(Figs. 33, 34).[37] One is tempted to call it the culmination of folk
art activity among the Norwegians in America, but that terminol-
ogy is deceiving. There was no Norwegian-American tradition for
the kind of folk art which it represents. A possible early and fleet-

[37] The history of the altar is documented in detail in Nelson, "A
Pioneer Artist and His Masterpiece."

Figure 34. Detail of right side panels of altarpiece shown in figure 33.

ing contact with one other carver in St. Ansgar, Iowa, is the only known association Christenson may have had with another artist in the immigrant group.[38] He was an isolated creative spirit whose

[38] Lars Christenson's daughter, Lena, in an informal biography of the artist written for the Norwegian-American Museum in 1950 and quoted in its entirety in Inga Norstog, "The Old Pioneer Altar," *Lutheran Herald* 25, no. 6 (February 6, 1951):127–28, mentions that he spent some time in St. Ansgar before coming to Benson. St. Ansgar is where Michael Olson, to be mentioned later, was active. There is a similarity between the acanthus with grape clusters used by Christenson in both the corner cupboard and the altar and that found in a shelf by Olson in the Norwegian-American Museum. The shelf is illustrated in Marion John Nelson, "Folk Art Among the Norwegians in America," *Norwegian Influence on the Upper Midwest* (Duluth: University of Minnesota, 1976), p. 88.

unique creations were possible because of exceptional innate ability and because of contact in his past with a tradition which was not generally transferred to the New World. In America Lars Christenson is without context.

The most striking feature of the altarpiece is the grandeur of its conception, with a composition divided three ways both horizontally and vertically. The plan is quite unlike that generally found in the altars of other Norwegian Lutheran churches in America, where the standard is a single painting or statue surrounded by an elaborate architectural frame. Christenson's plan echoes the baroque altars of Norway, primarily a type carved by German craftsmen in the seventeenth century. An example especially close to Christenson's work is the Ørskog altar in the Bergen Museum. The relationship lies not only in the overall composition and the choice of subjects for the central panels but in such details as the winged cherub heads surrounded by acanthus vines and the faces and caryatid figures on the major posts. The distorted nature of the Norwegian elements is not surprising in light of the fact that Christenson must have worked from only memory images retained for over thirty years.

A memory problem may also account for his turning to the illustrations in a Norwegian-American Bible, published by Holman of Philadelphia in 1890, for guidance in creating the individual panels. Each panel corresponds to an illustration in the Bible. The imagination used in transposing these to relief and in adjusting their proportions to fit the compositional demands of the altar is all but phenomenal. The earlier panels, of which the Last Supper is known to be one, are awkward. With experience, Christenson learned to apply to figures the same principles of design he used in his acanthus carving. The result, as can be seen in the panels on the right in the altarpiece (Fig. 33), is a pleasing style in which decorative and realistic elements meet as in high Gothic art.

The Nativity, at the lower right, is an individual masterpiece (Fig. 34). In it the space is evenly filled and the lines flow freely over the surface. The device of combining sunk and bas relief prevents the space from becoming crowded in spite of the density of

Figure 35. *Nativity*. From *Bibelen eller Den Hellige Skrift* (Chicago: Waverly Publishing Co., with permission from A. J. Holman & Co., 1890), facing p. 894.

figures in it. All this has been managed with apparent ease while also shifting the vertical orientation of the model (Fig. 35) to the horizontal orientation of the panel.

The miracle of the altarpiece is its remarkable unity and concentration. This is achieved largely by the daring exaggeration in the size of the head of Christ, at the hub of the composition, and the consistent reduction in size of forms further removed from

it. This reduced figure size is retained in all the panels which form a circle around the Crucifixion.

The lowest section of the altar was never completed because indications of dissatisfaction with the work on the part of the congregation for which it was intended reached Christenson before his plan was totally carried out. He abandoned work on it in 1904 and it stood neglected in a warehouse until the year of his death in 1910. Although it was acquired by the Norwegian-American Museum in that year, it was not mentioned in literature on the collection until its significance was recognized by Erwin Christensen, who gained familiarity with it through his work on *The Index of American Design.*[39] Lars Christenson's work was very much of his people, but they no longer recognized it as their own.

Settled late, the north woods of Minnesota and the prairies of the Dakotas have material from the turn of the century that corresponds in its retention of European characteristics to material found in Wisconsin forty years earlier. A striking example is the primitive parsonage dealt with earlier in this article (see Fig. 1). Another example is a shelf, dated 1886, which recently came to light near Detroit Lakes, Minnesota, and on which the carved decoration is an early provincial variant of the medieval palmette motif (Fig. 36). The late date and rather fragile nature of the piece speak for American production. The maker apparently came from an inner valley in Norway where early traditions in design and craftsmanship were still alive, and he settled in an area where his traditional skills could still serve the material needs of his neighbors. The inscription on the shelf suggests that it may have been a wedding gift, a possible explanation for the extent of its carved decoration. No facts regarding the origin of the piece are known, making all observations on its historic context purely conjecture.

A comparatively late immigrant to northern Minnesota was John A. Rein, the last of the Norwegian-American folk artists to be considered in this northern group. Unlike the mysterious carver of the shelf, Rein is one of the best documented Norwegian-Ameri-

[39] Erwin O. Christensen, *The Index of American Design* (New York: Macmillan Co., 1950), p. 24.

Figure 36. Shelf, Lake Park, Minnesota, 1886. (Collection of Donald Gilbertson: Photo, Darrell Henning.)

can folk artists.[40] He was twenty-two years old in 1878 when his name first appears on records near Hendrum, Minnesota, in the Red River Valley, where he and other members of the family came to join the father who had emigrated to America nine years earlier. The father, Karl, was listed as a carpenter in Norway, although he was also a farmer and a fisherman. John apparently

[40] The research is reported in Carol Rein Murray, "John Rein" (Greeley, Colo., March 7, 1976); typescript furnished to me by the author, who is Rein's granddaughter.

Figure 37. John Rein, altar painting. Roseau, Minnesota, 1895. (Roseau County Historical Society.)

learned the carpenter's trade from him, and he went on to combine that trade with farming. In addition to producing household objects of wood for sale to neighbors, he also produced church furniture. The latter activity became of increasing importance to him through the years and led to a life of constant moving in search of work. Before his death in 1916, these wanderings had taken him as far south as Kansas City and west to the state of Washington.

The works by Rein which might have had the greatest interest as folk art were plaster of paris statues of angels and other fitting subjects produced as gravemarkers for the poor. These figures were cast in molds which he made from his own carvings.[41] Unfortunately, no examples remain. His church furniture, of which he produced a great deal, is neo-Gothic and distinguishes itself only in occasional eccentricities. The altar paintings are what establish him as an exceptional folk artist, although he may not have brought to them more than a vague memory of tradition. There is no evidence that he had experience as a painter in Norway.

Of several known altar paintings by Rein, only one has been researched. It is *The Last Supper* painted in 1895 for a small country church near Roseau in northern Minnesota (Fig. 37). The circular arrangement of the figures and the rugged expressiveness of their faces brings to mind the same subject as depicted in the folk baroque altars of central Norway. A comparison with a more readily available model, however, tends to weaken the theory of Norwegian inspiration. In the same edition of the Norwegian-American Bible used by Lars Christenson, there is an illustration of da Vinci's *Last Supper* in which the figures have been rearranged to fit the page by cutting off those on both ends and placing them together below the center section. The result bears several striking similarities to Rein's arrangement of figures. For example, the five figures in front of the table face right and look toward one figure at the end who faces left. The Bible also includes portraits of the apostles drawn from da Vinci's fresco. Most of them reappear in easily recognizable form as the heads in Rein's work (Fig. 38).

Rein's *Last Supper* appears to be very much his own creation, freely put together from elements in the limited art work available to him. When these sources were not sufficient for his needs, he turned to what he saw around him. The chair in the foreground is of the peasant empire type referred to earlier which was popular in the early Norwegian settlements (see Fig. 11). The pitcher and bowl, motifs possibly introduced as the result of con-

[41] Murray, "John Rein," p. 6.

Figure 38. *St. Thaddeus.* From *Bibelen eller Den Hellige Skrift* (Chicago: Waverly Publishing Co., with permission from A. J. Holman & Co., 1890), insert following p. 890. Compare this with the apostle at the left in figure 37.

fusion between the themes of the Washing of the Feet and the Last Supper, appear to have come directly from a nineteenth-century washstand.

While the specific sources for Rein's altar painting appear to have been American, the strong expressive color and undulating line is typical of Norwegian art. The strong impact of the work results, in part, from the organic character of the shadow from which the figures rise and from the converging lines of the floor and ceiling which center on the figure of Christ, drawing the viewer into this holy company.

While he worked largely for his own ethnic group, Rein—like Christenson—received little recognition from it. Several altar paintings have been removed from their churches, and only one of at least four family portraits known to have been painted by Rein has been preserved.[42] The last years before his death in April 1916 were full of longing for the homeland. His father had returned to Norway where he was happily resettled. John wished to do the same, but concern for his children restrained him. He wrote from Ferryville, Wisconsin, shortly before his death: "If I go back, I would look back on these twenty-six years here as a bad dream." [43]

The case of John Rein poses the problem of how the concept of ethnicity relates to that of folk art. He learned the woodworker's trade in Norway and he may also have acquired there an affinity for certain kinds of line and color; as a painter, however, he was largely self-taught. His work is distinguished as much by those characteristics which we have come to call primitive as by those which might be considered part of Norwegian tradition. He is, therefore, close to that large body of self-taught American folk artists who, out of a drive to express themselves in form, have experimented their way to a medium through which their creative needs are fulfilled. In this art with its "private vision" and "personal universe," to quote Herbert Hemphill, Jr., there can be no ethnicity.[44] The word itself implies an acquired set of patterns and beliefs which characterize a group. In order to bring ethnicity into a discussion of folk art, one is forced to recognize tradition as a major element in it. There are purely self-taught artists among the Norwegian-Americans, some of whom are of considerable interest, but I am omitting them from this paper because there is

42 *The Last Supper* was moved from the Rose Lutheran Church near Old Greenbush, Minnesota, and donated to the Roseau County Historical Society at an unknown date. A grandson tells of another altar painting by Rein having been removed from its frame and stored in a coal bin. For a reference to the portraits, see Murray, "John Rein," p. 1. Murray also owns an early snapshot taken in the Rein house in which the portraits can be seen. An investigation made by me among remaining descendants in 1977 led to the discovery of only one portrait. The others have been lost.

43 Murray, "John Rein," p. 10.

44 Herbert W. Hemphill, Jr., *Twentieth-Century American Folk Art and Artists* (New York: E. P. Dutton & Co., 1974), pp. 9–10.

Figure 39. Norwegian-American wood objects with decorative carving. *Lower left:* Ole Simongaard, box. Hillsboro, North Dakota, ca. 1950. *Lower middle:* Tarkjil Landsverk, box. Whalan, Minnesota, ca. 1890. *Lower right:* Knute Reindahl, book cover. Madison, Wisconsin, ca. 1900. *Upper center:* Hermund Melheim, clock case. Ray, Minnesota, ca. 1950. (Norwegian-American Museum.)

nothing intrinsically Norwegian-American in their work. Rein falls close to these.

A fair number of Norwegian-Americans with skills or vocational interests acquired as part of growing up in a self-sufficient folk society adjusted these skills and interests in order to find a place in their new environment. They are ethnic folk artists only in their origins. They have become artist-craftsmen serving a general public or simply hobby artists. This appears to have been true of Michael Olson, an immigrant in St. Ansgar, Iowa, who did acanthus carving, much in the tradition of folk carving in Norway, on natural finished walnut furniture essentially in the Victorian tradition. It is clearly true of the wood-carver Knute Reindahl, who came to Madison, Wisconsin, at the age of nine from the heart of a folk art community in Telemark, Norway, and carved small

decorative objects during his early years to help support his widowed mother and the family (Fig. 39, lower right). After returning to his home community for more training in wood-carving, he became established in Madison and Chicago as a master of Renaissance and rococo carving and as one of the finest violin makers of his time.[45] Even in his violins, the decorative carving continued to be an important element. He is the best known of many Norwegian folk craftsmen with similar histories. A living example is the eighty-one-year-old Leif Melgard of Minneapolis, Minnesota, whose Renaissance and baroque carving on furniture and small objects ranks with the best of its type.

Another direction in which folk skills of the Norwegian immigrants are known to have been channeled is decoy-carving. An example is Peter A. Norman (1843–1923), a cooper and cabinetmaker, who settled first in Wisconsin and who eventually worked his way to Tacoma, Washington, where he spent his last days. The decoys, most of which were apparently made in Wisconsin around the 1880s, have exceptional refinement in form and beauty in coloring.[46] The brush strokes are broad and firm, possibly reflecting a background in decorative painting.

There were fewer alternatives for immigrants skilled in folk painting than for those with a background in carving. Many folk painters are known to have immigrated to America from Norway, but few traces of them remain. The notable exception is Per Lysne, the son of a well-known decorator in Sogn, who found employment as a striper in the Mandt Wagon Factory in Stoughton, Wisconsin, around 1906.[47] It is possible that other painters found employment in Wisconsin factories decorating such farm implements as fanning mills and seed drills. The Wisconsin examples are exceptionally well decorated in a free-hand style

[45] Winifred Wise Anderson, "World-Famous for his Violins," *This is Madison* (Madison, Wis.: Madison Associates, December 1976-January 1977), p. 36.

[46] Information supplied me in a letter of October 19, 1977, by Robert Odell, Vancouver, Washington, who had obtained it from a son of the carver. See also Bob Odell, "Peter A. Norman (1843–1923)," *Decoy Collectors Guide* (April-May-June 1964), p. 11.

[47] Bertha Kitchell Whyte, *Craftsmen of Wisconsin* (Racine, Wis.: Western Publishing Co., 1971), p. 28.

much like rosemaling.[48] The origin of the artists has yet to be investigated.

Many immigrants with folk skills simply turned them into hobbies. The work of this group characteristically displays skills for their own sake or symbolizes in some special way the maker's ethnic background. Chains carved from one piece of wood or objects so loaded with carved decoration that they become nonfunctional were common. Just as prevalent are miniatures of objects which had held a prominent place in Norwegian life but were disappearing from the immigrant community. Log chairs or traditional food containers were favorites. Quaint figures with obviously ethnic characteristics are also popular subjects in Norwegian-American hobby carving.

The backgrounds of the hobby artists in the Norwegian immigrant community vary greatly. Some, such as wood-carving farmer Ole Simongaard of Hillsboro, North Dakota, were thoroughly familiar with a traditional craft when they came to this country. A miniature version, in solid box elder, of a traditional bentwood box with carved acanthus decoration by Simongaard reveals unfaltering control of the technique and understanding of traditional design (Fig. 39, lower left). The graceful transition from the wide central area of the cover to the delicate spiral terminals at the ends echoes the mastery with which the terminal spirals of the prow and stern of the ninth-century Oseberg Viking ship grow out of the great hull. The fact that this is a miniature in solid wood imitating the style of a traditional box in another technique indicates that it is primarily a reminder of a passing ethnicity. It may date as late as 1950.[49]

Tarkjil Landsverk of Whalan, Minnesota, is said to have worked little in traditional craft techniques before coming to America, but he had been considerably exposed to them in his native Telemark. In America, he carved a wide range of pieces reminiscent of objects used in the homeland (Fig. 39, lower middle). His specialty became full-sized log chairs (Fig. 40, right), and

[48] An example is a seed drill in the Norwegian-American Museum marked "Janesville Machine Company, Janesville, Wisconsin."

[49] Information accompanying the donation of the piece to the Norwegian-American Museum.

Figure 40. Chairs carved by immigrants. *Left:* Halvor Landsverk, Whalan, Minnesota, 1975. *Middle:* Erik Kr. Johnsen, St. Paul, Minnesota, ca. 1900. *Right:* Tarkjil Landsverk, Whalan, Minnesota, ca. 1925. (Norwegian-American Museum.)

these are still being produced on the home farm by his son, Halvor (Fig. 40, left). A phenomenon similar to Tarkjil Landsverk is Hermund Melheim of Ray, Minnesota, who also developed his skills in Norwegian styles of wood-carving largely after having settled in this country.[50] The liberty with which he treated the traditional types is exemplified by a platform rocker log chair excessively decorated with acanthus and palmette motifs (Fig. 41). Some of the tour de force character of this piece is also found in a mantel clock now in the collection of the Norwegian-American Museum (Fig. 39, upper center), but the well-coordinated rhythms in its complex design make it a worthy descendant of the eighteenth-century carvings from rural Norway.

By the last decades of the nineteenth century, a conscious effort to preserve the native arts of Norway had begun. Schools in traditional wood-carving were established in Oslo and in the rural

[50] Interview with Hermund Melheim, 1967.

Figure 41. Herman Melheim, platform log rocker. Ray, Minnesota, ca. 1950. (St. Louis County Historical Society, Duluth, Minnesota: Photo, Darrell Henning.)

communities where the traditions had been strongest. Among the later immigrants were pupils of these institutions who continued, generally on a hobby basis, to practice the craft in this country. One of them was the theologian Erik Kr. Johnsen, who went to an evening class in animal-style carving while at the University of Oslo. Around 1900, after settling in St. Paul, Minnesota, as a professor of theology, he carved all of his living room furniture in this style (Fig. 40, center).[51] Professor Johnsen represented an urban element in the crafts revival, but he had a remarkable rural coun-

[51] Interview with the artist's daughter, Ellen Johnsen, Minneapolis, 1969.

terpart. Bernt Mageli, who attended a carpentry and wood-carving school in his native Gudbrandsdalen around 1900, continued making traditional decorated furniture in the finest taste and with the finest craftsmanship for himself and his family long after settling as a farmer outside Pigeon Falls, Wisconsin.[52]

Beginning in the 1930s, the nostalgia of folk artists like Tarkjil Landsverk met with a mass nostalgia in the Norwegian-American people. Items which had been looked on as the curious outdated creations of eccentric individuals became marketable products. The Landsverks, in the 1930s, could partly support their hobby by charging admission to the area where their creations were displayed and by selling miniature plaster casts of such romantic objects as their log chairs.[53]

The Norwegian-American who was best prepared to capitalize on this new turn of events for the ethnic folk artist was the previously mentioned Per Lysne in Stoughton, Wisconsin. About 1930 he discovered that after over twenty years of striping wagons he could again make a living on the family art of rosemaling. The extent of his production in small painted objects and in decorated furniture over the next fifteen years is staggering (Fig. 42, center). Examples can be found over the entire Midwest, and his papers include a single order from New York for two hundred plates.[54]

World War II and its aftermath were low periods in the production of traditional folk objects among the Norwegians in America, but an upsurge occurred again in the 1960s with the general revival of interest in ethnicity and the new emphasis on identity and roots among our immigrant peoples. Strains of earlier folk art activity were still alive to meet this new development. What can be called a Norwegian-American rosemaling tradition was founded by the followers of Per Lysne in Stoughton, Wisconsin (Figs. 42, right; 43). Elements of nostalgia were still in it, but there was also a more serious interest in cultural origins and artistic

[52] Interview with the artist's daughter, Mrs. M. Ringlien, Pigeon Falls, Wisconsin, October 25, 1977. See also Gilbertson and Richards, *Norwegian Folk Art in America*, p. 89.

[53] Interview with Halvor Landsverk, Whalan, Minnesota, 1969.

[54] Whyte, *Craftsmen of Wisconsin*, p. 31.

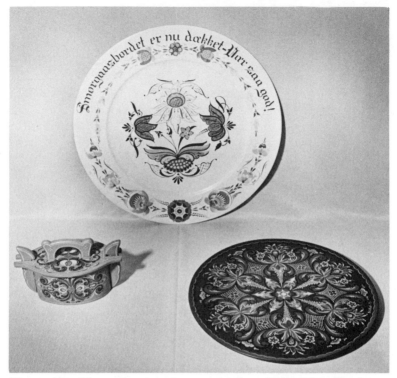

Figure 42. Norwegian-American rosemaling. *Left:* John Gundersen, box. Minneapolis, 1976. *Middle:* Per Lysne, plate. Stoughton, Wisconsin, ca. 1930. *Right:* Vi Thode, plate. Stoughton, Wisconsin, 1975. (Norwegian-American Museum.)

quality. The term *folk movement* might be used for recent developments in rosemaling both because of the rapidity with which it had spread through the general public and because of the seriousness with which the art is taken on the part of many painters. It is no routine hobby activity. Many of the painters create their compositions freely within the basic techniques and principles of design characteristic of the art, and many reveal a creative ability which gives them a special place among artists of the common people in America (Fig. 42, left). The Norwegian-American Mu-

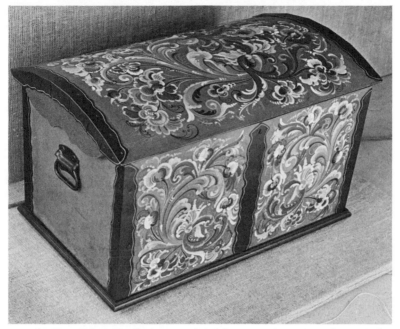

Figure 43. Ethel Kvalheim, trunk with rosemaling. Stoughton, Wisconsin, 1973. (Norwegian-American Museum.)

seum has cheated on this folk movement by bringing painters from Norway to Decorah, Iowa, to teach the art. This has not stultified or academicized the movement; it has rather given it new impetus and breadth.

Other Norwegian-American folk arts—such as wood-carving, metal work, weaving, and embroidery—have not enjoyed the same degree of recent development of public interest as has rosemaling. Still, a ferment is also beginning in these crafts. Symbolic of the growing interest in wood-carving is the history of the Landsverks. Tarkjil's son, Halvor, who had originally worked with his father as a wood-carver and folk sculptor of figures in cement, had been forced to give up this activity and take employment as a factory worker in a nearby city. The farm is not of sufficient size to support the family. In the 1960s demand again arose for the deco-

rated log chairs, and he was able to return to this craft as his sole source of income. In 1977, at age sixty-eight, he had a backlog of orders which he felt would carry him through his lifetime.

The Norwegian tradition in folk arts has revealed remarkable tenacity in America. Beginning with a broad base in the first decade of settlement, it continued in the work of unique individuals until the 1930s when, again, it began to gain a broader popular base. The specific reasons for its retention have changed, but they have always been based in the peculiar economic, social, and psychological needs of an immigrant people.

It is easy to think of the folk materials of the Norwegians in America as falling into several levels of significance, with the earliest, and therefore supposedly the most "genuine," being of greatest importance and the latest, and therefore supposedly the most superficial or commercial, being of least importance. Ultimately, all the material documentation of a people's history must be considered with equal seriousness in order to understand that people. The rosemaling being done today could ultimately be considered the most important contribution of the immigrants from Norway to folk art in America. The early arts and crafts, which carried the immigrants through the preindustrial phase of their American experience, did not strike roots here. The achievements of exceptional individuals, amazing as they may be, were for the most part dead-end manifestations of a folk tradition which no longer had a base in the people. The work of the folk craftsmen who adapted their skills to the special needs of middle- and upper-class Americans eventually lost both its ethnic and its folk character. The hobbyists have come the nearest to representing an ongoing folk tradition among the Norwegian-Americans, but their work exists largely for the creators themselves and does not fill a broader need in the group. The rosemaling movement of the past forty years, primarily as it can be followed in Stoughton, Wisconsin, represents the first instance among the Norwegian-Americans of an art of the people having had adequate longevity and an adequate base to experience the kind of cross fertilization between artists essential to a living art tradition.

To many of the people involved in it, rosemaling is a hobby, but the work itself has acquired the unusual status of having a

fair market value. To many of the painters, rosemaling has become what it was 150 years ago in the rural areas of Norway, a supplementary source of income.[55] The basis for the demand then was prestige. Painted decoration was associated with the upper-class interior. The basis for the demand today might still be called prestige, but it is no longer of a social or economic kind. The appeal of rosemaling today—and I have been in a good position to make long and close observations—lies to a great extent in the ethnic associations with the art. It has become the symbol of an ethnicity to which the Norwegian-American people again feel a desire to be linked. This "new ethnicity" has actually had the power to rejuvenate an immigrant art form and make it something more than Kouwenhoven's "alienated remnants . . . in charming survivals."

[55] Per Lysne had some commissions from upper-class Americans without Scandinavian backgrounds—such as Alfred Lunt and Lynn Fontaine (Whyte, *Craftsmen of Wisconsin*, p. 36), but most of his production appears to have gone to Norwegian-Americans of modest means. Laura Hoeg, a painter totally without formal training, has supplemented family income in Decorah, Iowa, for over thirty years by painting commemorative plates in the rosemaling style for the citizens of this Norwegian immigrant community.

Baptismal Certificate and Gravemarker: Pennsylvania German Folk Art at the Beginning and the End of Life
Frederick S. Weiser

Who are the Pennsylvania Germans? We could start by including those Germans who settled in southeastern Pennsylvania between the coming of Francis Daniel Pastorius in 1683 and the onset of the war with Great Britain in 1812, and we would be partly correct. We might also include their descendants, and we would still be partly correct. Refining their geographical distribution, we should add central Pennsylvania, western Maryland, Virginia valley country, certain counties of North Carolina, South Carolina, Ohio, and portions of Ontario, and still we would be only partly correct. At least certain useful pieces of information are before us. But until we define the Pennsylvania Germans as a cultural group—largely of southwestern German origin, speaking an American (but not anglified) version of the eastern Palatinate Frankish dialects, sharing a common corpus of world view, religion, folk belief, custom, and, at least initially, material patterns, and living chiefly in a rural agricultural or a small-town crafts economy—we do not have a useful definition. A full definition would encompass a Dutch-speaking soul named Buffington (from an English family) living

in Hagerstown, Maryland, who ate *Schnitz un Gnepp*, never hunted *Elbedritsche* (snipe) unless he had to, checked out the groundhog's shadow every February 2, looked for eggs the rabbit had *laid* on Easter Day, and owned a blanket chest with English bracket feet and German floral decorations! The hardest problem of defining the Pennsylvania Germans as a group is knowing where to erect the barriers and where to close the doors. The concept of *folk*, deriving as it did largely from close study of the European regional costume or *Tract*, submits to easy definition when you can say the group (the *Volk*) is all those who dress *this* way. But there never has been a Pennsylvania German *Tract* except in the minds of people who write tourist brochures. They forget that the Amish, Mennonites, Schwenkfelders, and Brethren never constituted more than 10 percent of the Pennsylvania Germans, and while each of these groups wear, or once-upon-a-time wore, a more or less standardized attire, each Amish church district of about thirty to forty families can have local variations of garb. The majority of the Pennsylvania Dutch were Lutherans or Reformed (a denomination now part of the United Church of Christ) or of their Methodistic stepchildren, the Evangelicals or the United Brethren.

And so if one cares to hunt and peck his way through oral and material culture, one can isolate a host of folk-cultural elements that are Pennsylvania German, but these elements should be seen as in flux due to the symbiosis with other groups who "lived neighbors" in America. I recognize that the development of Pennsylvania German life since 1683 has meant a *giving-up* of certain features. Purely Germanic architecture and furniture styles seem to have disappeared with the first generation while the dialect has nearly disappeared with the latest generation—except, ironically, for the dirty joke and the dialect church service, both alive and well. Symbiosis has meant a *receiving* of far more than many chauvinistic Pennsylvania German historians would admit. (They ignored their own proverb: *Eege-lob schtinkt!* [self-praise stinks].) It has also meant a *giving* of some of the beloved, if domestic, chords to America's symphony—that groundhog, that rabbit, the fruit pie, to name a few.

Everyone knows that the Pennsylvania Germans painted their

furniture—or some of it—loud, garish colors with flowers in seen-one-you've-seen-'em-all repetition (frequently using wood, tin, or cardboard patterns or a compass to expedite production). They decorated towels, trivets, trammels, and other objects with hearts and birds, and angels, and the same flowers on an endless rerun, put round circles with geometric designs on their barns, and adorned their home furnishings with carved birds, and did the same job on their *Taufscheine* (birth records) and their tombstones. All of that and more has generously fed many exhibitions, larded the trousers of a few collectors who sold out and the pocketbooks of a few lucky old ladies who went from a long line of hoarders to the old folks' home, and it has been called folk art.

I frankly admit I do not know how to build barriers or close doors here either, but again I recognize an affinity to comparable objects among the regional and social groups in Europe from whom the Pennsylvania Germans came—objects Europeans place in a time bracket between the end of the Thirty Years' War in 1648 and the rise of industrialism about two centuries later, objects frequently developed in aping the moneyed, landed classes as an aspect of burgeoning individualism in peasant and bourgeois classes. At the same time, I see the constant development of these objects and their decoration on American soil because their makers and owners were in conversation with non-German, non-Continental persons.

To study this phenomenon correctly, two areas of its setting or context must be duly observed. The occasional yarn winder painted with flowers or geometric designs on its stem or base, for instance, belongs in a continuum of such objects which includes unpainted softwood or hardwood, plain painted examples, and, finally, those rare decorated ones, the ones which probably end up in folk art exhibitions. We have not really seen the object, except as a *Delikatessen*, until we have seen it in the context of all other objects of similar purpose and design, if not decoration. Does it need to be added that a knowledge of construction details is essential to avoid certain pitfalls, now that commercialism plays a role in many objects which only recently were being foisted unwillingly on the *Bensemann*, the pennyman, at the auction?

Moreover, and this is definitely true of Pennsylvania German

folk art, we must also see these objects in their original context as functional artifacts. Let me illustrate with a common object—the basket. These come in such variety of shapes and designs that we need take only one, the comparatively shallow round rye straw basket which is anywhere from ten to twenty-four inches in diameter and some six to ten inches deep. The figures are approximate; they do not reflect regional variations but intended usage. The wider, deeper basket was floured every Friday morning, filled with a mass of bread dough, set in a warm, draft-free place, and then dumped unceremoniously from basket to *Brotshiever* (peel) to oven floor for baking. No doubt these baskets could have been used for gathering nuts or eggs, but the many baskets usually listed on the inventories of Pennsylvania German households suggests that bread baskets were for bread alone.

They did have one other use. Every year on Christmas Eve, the children each took one of the baskets, laid a square of clean, white linen in it, and placed it in the chimney corner. There it was found during the Holy Night, when all was still, when the animals could speak, when the Christmas Rose bloomed, when the bees came out of the hive, when the water in the wells turned to wine. There it was found by the *Grischdkindel* (Christ child), who rode the Palm Sunday mule across the fields, entered through the keyhole, and placed nuts, snitz (pieces of dried apple), and raisins in the baskets for the children's Christmas.

Such baskets are always plain in appearance. The smaller, shallower ones, however, sometimes come with open-work or cutwork designs in the basket's wall. (Some of these are also oblong in shape). Obviously bread dough was no commodity for something with holes; these were sewing baskets. Often as not a piece of printed cloth, jetsam from a dress or quilting project, was tacking by a few threads into the basket, making a colorful ensemble. Add hanks of thread, a scissors, needles, pins, thimble, a darning egg, put the entirety into a drawer in the *Kiche Schonk* (kitchen cupboard), and you have the object in context.

Similar histories account for the production and use of most of the objects in Pennsylvania German folklife. Some owners may have kept objects they never used, like my great-grandmother who aired her coverlet once a year without ever putting it on a bed,

but such owners were clearly in the minority. The laments of dealers and collectors who find blanket chests with holes gnawed into their backsides (from the attack of hungry rodents seeking grain stored in them) or tops of blanket chests with the paint worn away (because ultimately the butchering had been done on the surface and penultimately little feet had clambered over them into bed, and before that who knows what) will simply have to stand. These objects were made to be used, not to be admired as folk art. The tendency to isolate decorated objects from their own world leads to an intellectual cul-de-sac and often to bizarre and unnecessary theories to explain their decoration.

After the first gasp for breath, the second important event in the life of most infants born into the Pennsylvania German folk culture of North America was when the child was taken to a Lutheran or Reformed clergyman for baptism. These two record-able events at the beginning of life—birth and baptism—were often underscored by the preparation of a fancily decorated document which became the property of the person and accompanied him through life. This document came to be called the *Taufschein* (baptismal certificate), although there exist examples designated *Geburts-und Taufschein* (birth and baptismal certificate), as well as a few with other names and some with no title at all. As I have shown elsewhere, the Pennsylvania German *Taufschein* developed from a German, Alsatian, and Swiss model, the *Göttelbrief*.[1] In America it became progressively less a phase of the institution of baptismal sponsorship, as it was in Europe, and more a personal document recording the facts of a person's birth: his full name, his parents' names (including the mother's maiden name), the date and place of birth, and sometimes the hour and zodiacal sign. Only then does it record the particulars of the baptism: its date, the baptizing pastor, the confession, the sponsors. Almost never is the place of baptism given.

[1] Frederick S. Weiser, "Piety and Protocol in Folk Art: Pennsylvania German Fraktur Birth and Baptismal Certificates," *Winterthur Portfolio 8*, Ian M. G. Quimby, ed. (Charlottesville: University Press of Virginia, 1973), pp. 19–43. My observations there have been reinforced by a book of which I was then unaware, Christian Rubi, *Taufe und Taufzettel im Bernerland* (Wabern, Switzerland, 1968).

The text, as it became standardized on these documents by the early nineteenth century, generally reads as follows:

Diesen beyden Ehegatten, als *Johannes Meyer* und seiner ehelichen Hausfrau, *Catharina*, eine geborne *Schmidtin* ist ein Sohn zur Welt geboren, als *Michael* ist zur Welt geboren im Jahr unsers HErrn JEsu *1814*, den *24* Tag *November* um 6 Uhr *Morgens* im Zeichen des *Krebs*. Deiser *Michael* ist getauft worden den *29 November 1814* von Herrn *Schulze*, ein *Reformirter* Prediger. Taufzeugen waren *Michael Schmidt* und seine Frau *Elisabetha, Grosseltern*. Obgemeldter *Michael Schmidt* ist geboren in America, im staat Pennsylvanien, im *Heidelberg* Taunschip, *Lecha* Caunti.

(This is a hypothetical reconstruction. Italics indicate those portions hand lettered on a printed *Taufschein*, or entered by the scrivener at the time of sale of a completely hand-drawn example.)

The *Taufschein* was invariably adorned with two additional features: verses of hymnody purporting to elicit the meaning of the baptismal event and the life expected to follow upon it and a border of flowers, angels, stars, hearts, and crowns in a plethora of variety and combination.

Because of what appears to be a fairly high rate of destruction, obviously more so among the earlier examples, it is extremely difficult to write the precise history of the *Taufschein*.[2] Examples survive from communities of Germans in Pennsylvania, Maryland, Virginia, North Carolina, South Carolina, New Jersey, and Ohio. They date from the 1740s to the 1860s, if we do not count documents from the printing press which kept the practice alive well into the twentieth century. Already in the 1780s, several persons commissioned the printing of blank *Taufschein* forms, obviously to expedite the production and sale of the documents. The trend toward printed forms increased as time went on which, ironically, spurred the increase of hand-drawn and lettered *Taufscheine* at the same time that it spelled their ultimate demise. Printing also encouraged the standardization of the format, text,

[2] Daniel Schumacher, for instance, between 1754 and 1773 records 233 baptisms he performed for which he issued a *Taufschein*, of which fewer than twenty have come to the author's attention.

and design of the documents. A good fifty "artists" have been isolated by signature or style attribution who drew *Taufscheine* by hand. More names will be added as more of them are studied. The commonness and wide distribution of this form of *Fraktur* in Pennsylvania German folk culture is evident from the thousands that survive.[3]

The highly personal nature of these vital records rendered the *Taufschein* an intimate part of the life accumulation of most Pennsylvania Germans. The document was often pasted on the lid of the *Kischt* (blanket chest), which each Pennsylvania German seems to have owned and taken with him as he established a new home in marriage. These chests often contained the name of the owner and a date worked into the design on the lid or the front. They were one of the few strictly personal pieces of furniture in a Pennsylvania German household. The *Taufschein* was sometimes rolled up and placed in a drawer or till of the chest. It was folded and tucked in the family Bible, which also frequently contained information about all members of the primary family. It was rarely framed for display. On occasion it was submitted as proof of age with an application for war service pension benefits. Finally, many, but obviously not all, were placed in the coffin before it was nailed shut and consigned to mother earth.

The personal nature of the document should not obscure the fact that it also commemorated the person's entrance into the cultural group of which he was becoming a part by birth and bap-

[3] The best public collections are at the Free Library of Philadelphia; the Henry Francis du Pont Winterthur Museum, Winterthur, Delaware; and the Schwenkfelder Museum, Pennsburg, Pennsylvania. There are many other public collections with outstanding examples, as well as private collections and pieces still in familial control. Together with related materials, the field is known as *Fraktur*, a name given all such decorated paper documents by Henry Chapman Mercer shortly before 1900. The best general study is Donald A. Shelley, *The Fraktur-Writings or Illuminated Manuscripts of the Pennsylvania Germans* (Allentown, Pa.: Pennsylvania German Folklore Society, 1958). For well-reproduced examples in color, see Henry S. Borneman, *Pennsylvania German Illuminated Manuscripts* (1937; reprint ed., New York: Dover Publications, 1973); Frederick S. Weiser, *Fraktur: Pennsylvania German Folk Art* (Ephrata, Pa.: Science Press, 1973); Frederick S. Weiser and Howell J. Heaney, *The Pennsylvania German Fraktur Collection of the Free Library of Philadelphia* (Breinigsville and Philadelphia: Pennsylvania German Society, 1976).

tism: the largely Protestant Pennsylvania German folk culture. The texts which surrounded the *personalia* functioned didactically and hortatorically to see that the child grew into a society-pleasing and God-pleasing adult. Even if, as in every social group, the ideals set forth in the *Taufschein* poetry were never fully lived out, their presence on such a document suggests the existence of a common standard of behavior recognized by the social group. It was, to be sure, a norm imposed "from the top down," rather than one arising popularly. A popular morality existed, too, enshrined in folkbelief, superstitution, and proverb. The texts of the *Taufschein* constituted one of the norms for living to which a child was exposed in the maturation process.[4]

In this role, the *Taufschein* will remind one reader: "Wachs auff zu Gottes ehr, und deiner elltern Freud, zu deinem nechsten nutz, und deiner seeligkeit."[5] ("Grown to the honor of God, to the joy of your parents, to the service of your neighbor, and to your own blessedness.") Or, it will pray

> Herr schaff uns wie dies kleine Kind
> In unschuld neu geborren
> Als wier getaufft in wasser sind
> Zu deinem Volck Erkohren
> Dass dennoch sich
> Herr Christ an dich
> Der Sündlich Mensch ergebe
> Dass Er wohl starb
> Und nicht verderb
> Mit dir Ersteh und Lebe.[6]

> Lord, create us like this little child,
> Reborn in innocence,

[4] For a discussion of the doggerel and hymnody on the baptismal certificate, see Frederick S. Weiser, "The Concept of Baptism among Colonial Pennsylvania German Church People," *Lutheran Historical Conference Essays and Reports* 4 (1970):1–45.

[5] Often found, as in *Taufschein* of Samuel Staud, born 1788, Braunschweig Township, Berks County (today Brunswick Township, Schuylkill County) in Reading Museum (accession no. 39.164.1).

[6] *Taufschein* dated 1809, *Pennsylvania German Fraktur and Color Drawings*, exhibit catalogue (Lancaster: Pennsylvania Farm Museum of Landis Valley, 1969), pl. 70.

As we are baptized in water,
Chosen to thy folk,
That in spite of himself,
Lord Christ to Thee,
The sinful man surrenders
That he die well
And not be lost,
With Thee arise and live.

Or,

O liebster Gott, ich danke Dir
Dass du so liebe Eltern mir
Aus gnad und huld gegeben,
und noch zur zeit
sie mir zur Freud
Erhalten bey dem Leben.
Verzeihe mir die missethat
Die dich und sie beleidigt hat,
Lass mich es night entgelten,
Dass ich mein Gott!
Auf dein gebott
Geachtet so gar selten.[7]

O, dearest God, I thank Thee,
That thou hast given me
such dear parents
Out of grace and favor
And still at this time
Keep them alive
to my joy.
Forgive me the misdeeds
Which have hurt thee and them,
Do not let me suffer because
I pay so seldom heed,

[7] *Taufschein* for Sarah, daughter of Johannes Reber and Salome, nee Steriner, born 1801, Bern Township, Berks Co. Owned by a descendant, Pastor John Philip Kline of Kingston, Pa.

Oh God,
to Thy command.

Or, even more pointedly

Wir werden da mit freuden
den heuland schauen an
der durch sein blut und leiden
denn Himmel aufgethan
die liebe Patriarchen Propheten allzumal
die marter und apostel beÿ ihm ein grosse zahl
die werden uns annehmen als ihre Brüderlein
sich unser gar nicht schämen
und menegen mitten ein
Wier werden alte dreten
zur Rechten inschrift
als Gott anbeten
der unsers fleisches ist.[8]

There shall with joy
Gaze upon the Savior
Who through His blood and suffering
Opened heaven up.
All the dear patriarchs and prophets
The martyrs and apostles, a great number by Him,
Will receive us as their little brothers,
And be ashamed in no way of us
And accept many into their midst
We shall all step forward to the right inscription
And adore God
Who is our flesh.

And again,

Gedenck ich dann an Jesu Wunden,
eÿ wie wird diese lust versüst,
beÿ ihm wird sich mein Name funden,

[8] *Taufschein* for Johan Peter, son of Johannes Henrich Line and his wife, nee Jungmeister, 1788. Private collection.

O dinte die wie Purpur fliest,
hier steht die schrift an seiner brust
Roth, wie sein blut o namens lust.[9]

If I think of Jesus' wounds,
Oh how sweetened is this desire,
By him my name will be found.
O ink which glows like purple—
Here stands the inscription on His breast,
red, like his blood, oh desire of life!

Thus, dear child, shall you be a part of the world around you! And, as a reminder on your course through life, and as a record of your birth and baptism, here is your *Taufschein*.

Each *Taufschein* invariably bore a colored border of designs which encased the text for whose sake the document was prepared. Because this artistic border can justly be called folk art, American antiquarians are attracted to it, often without any realization of the function of the piece in its culture. There has been much speculation about the meaning of the designs, but unfortunately there are few examples in which the text is patently explained and many on which some highly unusual, startlingly secular images can be found. Those few on which the design is explained, or hinted at, make clear that the crown, often repeated, refers to the crown of righteousness: *Sei getreu bis an den Tod, so will ich dir die Krone des Lebens geben* ("Be faithful unto death and I will give you the crown of life." [Revelation 2:10]). The heart is the symbol for the essence of man as in *Das Hertze mein soll dir allein, O Liebster Herre Jesu, sein* ("This heart of mine shall be but thine, oh dearest Jesus Lord divine"). Angels as emissaries of the Almighty, sometimes even bearing the crown, have obvious religious meaning.[10]

[9] *Taufschein* for Catharina Spitler, daughter of Jacob and Margareth Lehme Spitler, born 1802, in Bethel Township, Dauphin (now Lebanon) Co., Pa. Owned by the author.

[10] A possible addition may be the human being. See Walter E. Boyer, "The Meaning of Human Figures in Pennsylvania Dutch Folk Art," *Pennsylvania Folklife* 4, no. 2 (Fall 1960):5–23. Boyer, in this unfinished article, which was edited and published after his death, claimed that the human form represents the baptismal sponsor. Although much of what he says demands further testing, I have recently become aware of a *Taufschein* with human figures who hold out a paper bearing what appears to be an admoni-

Stars, flowers, birds (Fig. 1), and vines submit to no clear iconography, nor do alligators, market houses, long rifles, hunting scenes, garden tools, bare-breasted brides, and the like. To see in these motifs prehistoric, pre-Christian mythology, or pietistic imagery is to provide a more complicated explanation than the documents require. Many of the motifs were copied, without meaning, from a variety of contemporary sources, and from each other. The very fact that strikingly similar arrangements of flowers and birds and stars and hearts occur on so many objects coming from the Pennsylvania German cultural group argues against a freighted meaning and for their circulation as "popular" or "folk" designs.

At the other end of his life, after his last gasp for breath, another document was prepared for the Pennsylvania German. Like the *Taufschein*, it was personal, and yet it, too, served, in a way, to relate the individual to society. That was the tombstone, the message not written on paper but carved in sandstone, slate, or marble.

The inscription on the tombstone had two functions. It was initially a record of the *vita* of the deceased. We are not surprised to find that the *vita* were sometimes copied verbatim from the *Taufschein*, as this example shows:

Diese Beide Ehgatten als Jacob Dotterre und Seine ehefrau ElisaBeth Sie wahr gebohrene Eigholssen Sie Wahr gebohren Im iahr des Herren 1791 den 8ten März Und ist gestorben den 10ten November 1821 Und hat ihr Alter Gebracht auf 30 iahr 8 monat und 2 tag. Text Luca im 2t Vers 22 und 30 Herr nun lassest du deinen diener im Friede fahren. Wie du gesaget hast Den meine augen haben deinen Heiland gesehen.

To these two married persons, namely Jacob Dotterre and his wife Elisabeth. She was born an Eighals [Eichholz]. She was born in the year of the Lord 1791, the 8th of March, and died the 10th of November 1821, and brought her age to 30 years, 8 months and 2 days. [Funeral sermon] text Luke 2, verses 22 and 30. Lord now let

tion to bear good fruits. i.e., live in obedience to the Ten Commandments and the Sermon on the Mount. Since the commonly used Lutheran baptismal liturgy instructed the sponsors to teach the child the decalogue, there may be support here for Boyer's contention.

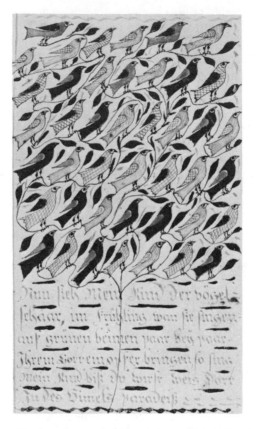

Figure 1. Bookmark, probably eastern Pennsylvania, 1790–
1820. Hand-drawn and colored on paper; H. 6¾″, W. 4″.
(Winterthur Museum.) The preoccupation of Fraktur with
death is not readily apparent on this charming drawing of
branches full of birds. The text runs: "Now see, my child, the
flock of birds / In spring, when they are singing / On branches
green, there pair by pair / To God an offering bringing / So
sing my child till you wear white / There in heav'n's glori-
ous light." This small *Fraktur*, doubtless a reward from a
parochial schoolmaster to a diligent student, even at that
preached at the child. The fact that the bird was closely asso-
ciated with death in Pennsylvania German folk belief must not
be overlooked.

your servant depart in peace. As you have said, for my eyes have seen your savior.[11]

Or this one:

Hier ruhen die Gebeine des wer Valentin Wentz ist gebohren 1717 den 10 Juli in Teutschland in der Pfalz in Partenheim. Sein Vater war Friederich die Muter Marie. Im Jahr 1749 war er getraut mit Barbera Jenawener hat erzeugt 6 Sohns und 5 Toch. und hat erlebt 79 Enckelen und ist gestorben den 1 April 1788 und ist alt worden 70 Jahr 8 Monat 23 Tag. Der Herr verleihe ihm eine freliche Auferstehung.

Here rest the bones of Valentin Wentz, who was born July 10, 1717, in Germany, in the Palatinate, at Partenheim. His father was Friederich, the mother Maria. In the year 1749 he married Barbara Jena-wener [Jennewein], and had 6 sons and 5 daughters, and experienced 79 grandchildren and died April 1, 1788, aged 70 years, 8 months, 23 days. The Lord grant him a joyous resurrection.[12]

Thus the typical grave inscription gives the name of the deceased, dates of birth and death, his age, sometimes the facts of marriage, and the number of offspring. Less frequently the names of his parents (unless he died in childhood, when they are always listed), his birthplace, the names of his sponsors, and the text of his burial sermon are cited.

It is not uncommon for the deceased to continue speaking to society through the inscription on his tombstone, or for society to comment on the meaning of life and death, as these examples indicate:

Ich liege und schlaffe ganz mit frieden
von allem jamer creutz und leyd
und ruhe bis in Ewigkeit.

I lie down and sleep completely at peace,
from all woe, cross and suffering
and rest until eternity.[13]

11 At Bender's Lutheran Churchyard, Butler Township, Adams Co., Pa.
12 At Saint David's (Sherman's) Lutheran and Reformed Churchyard, West Manheim Township, York Co., Pa.
13 At Bindnagle's Lutheran Churchyard, near Palmyra, Lebanon Co., Pa.

Durch viele grosse Plagen
Hat mich der HErr getragen
Von meiner jugend auf
Ich sah auf meinen Wegen
Des höchsten hand und segen
Er lenckte meines lebens lauf.

Through many great tribulations
The Lord has borne me
From my youth onwards
I saw upon my way
The Highest's hand and blessing
He guided my way of life.[14]

Im Himmel will ich ewig wohnen
Liebster Schatz nun gute Nacht
Eure treue wird Gott belohnen
Die ihr habt an mir vollbracht
Liebsten Kinder und verwandten
Schwäger nachbarn und bekannten
Lebet wohl zu guter nacht
Und Gott sey danck es ist vollbracht.

I will dwell eternally in heaven
Dearest treasure, now good night
Your faithfulness
Which you brought to me
Will be rewarded by God.
Dearest children and kinsfolk,
Brothers-in-law, neighbors and acquaintances
Live well to your good night
And God be thanked, it is finished.[15]

Gute Nacht ihr Meine Freund
Alle meine Lieben

[14] Tombstone for Johannes Baer, son of Jacob Baer (1791–1815), at Saint David's (Sherman's) Churchyard.

[15] A common form, this example is from the tombstone for Jacob Baer (1756–1821) at Saint David's (Sherman's) Churchyard. Other examples substitute the word *Freunde* (friends) for *Schwäger* (brothers-in-law) in line six.

alle die ihr um micht weind
thut eich nicht betriben
oh ich schon gestorben zwar
lebe ich doch wieder
mit der auserwelten Schar
sing ich lobene Lieder.

Good night to you my friends,
All my dear ones,
All of you who cry for me,
Do not grieve yourselves.
Although I am dead to be sure,
I live again however,
With the chosen circle
Sing the hymns of praise.[16]

Jetzt bin ich frei von Creuz und Leiten
Was mir mein Got hir hat bescheiden
nun wischt er mir die Thraenen
als mein Leib schlaeft sanft
Hir in dem Grab.

Now I am free from cross and suffering,
which God has assigned to me here.
Now He wipes away my tears
as my body sleeps softly
here in the grave.[17]

Mein Leib wird hier zu Staube
Wie alle um mich her
Doch saget mir mein glaube
 froh auferstehen

My body turns to dust here
Like all of those around me here

[16] Tombstone for Magdalena Dyrr, nee Mercklin (1732–1791), at Saint Mary's Churchyard, Silver Run, Carroll Co., Md.

[17] Das ist die Grabschrifft des Heinrich Kunz, welcher ist gebohren d. 14. Dec. 1729 Gestorben d. 30. May, 1800. Hat sein Leben gebracht auf 71. iar. 5 Mon. 2 Woch. und 2. Ta. Saint Mary's Churchyard.

But my faith says to me
Happy resurrection.[18]

Droben in des himmels höhen
werden wir uns wider sehen.

Over there in heaven's heights
We shall see one another again.[19]

Die Grab ist da: die besten Jahre
Sind auch des blassen todes raub
Der wüst den starcksten auf die baare
Und legt den schönsten in den staub,
Doch ich erschrecke nicht dafür,
Mein grab wird nur zur himmels thür.

The grave is there: the best years
Are also the rape of pale death
Who withers the strongest onto the bier
And lays the loveliest in the dust.
But I do not fright for that,
My grave will only be the door to heaven.[20]

Nun dieser istgestorben
[der in] der Welt gelebt
[die] Schwachheit ist verdorben
Worinnen man geschwebt
Gott eilet mit den seinen
Zur schoenen Himels Pracht
Wer mag nun den beweinen
der bey den Engeln lacht.

Now this man has died
Who had lived in the world.

[18] Tombstone for Johann Ludwig Heiner (1754–1828), Emanuel United Church of Christ Cemetery, Abbottstown, Pa.

[19] Tombstone for Isaac Schlebach (1828–1829), Muddy Creek Lutheran and United Church of Christ Cemetery near Adamstown, Lancaster Co., Pa. An angel adorns this stone.

[20] Tombstone for Jacob Schlebach (1801–1829), Muddy Creek Lutheran and United Church of Christ Cemetery. This stone is signed by "A. Bixler" (Absalom Bixler).

Weakness is spoiled
In which man must exist.
God hastens with His own
To heaven's lovely glitter
Now who might bewail
Him who laughs with the angels.[21]

Bedencke das du sterblich bist
wann du, o Mensch, die Grabschrift liest.

Consider that you are immortal,
O man, when you read the tombstone inscription.[22]

Ruhet wohl ihr toden Beine
Schlaffet in der kylen klufft
Bis der Herre wirt erscheinen
Und die Almachts Stim Euch rufft
Auf Ihr Todten zum Gericht
Kommet vor mein angesicht
Das gescheh euch nicht zum Schrecken
Gott woll euch zur Freud erwecken.

Rest well, you dead bones
Sleep in the cool cave
Until the Lord will appear
And the all-mighty voice calls you
'Up, you dead, to judgment
Come before my countenance.'
That is not to frighten you:
God will waken you to joy.[23]

Thus the tombstone, like the *Taufschein*, was both a personal and a social document. One marked the entrance of the individual into the community and told him what the community expected

[21] Tombstone for Johann Jacob Helman, 1789, at Emanuel Reformed Churchyard, Hanover, York Co., Pa. Helman was a bluedyer in Hanover. His inventory lists the blocks for "blue resist" dying and the tools to carve the blocks.
[22] Tombstone for Johann Peter Weinbrenner, 1789, at Emanuel Reformed Churchyard.
[23] At Saint Mary's Churchyard.

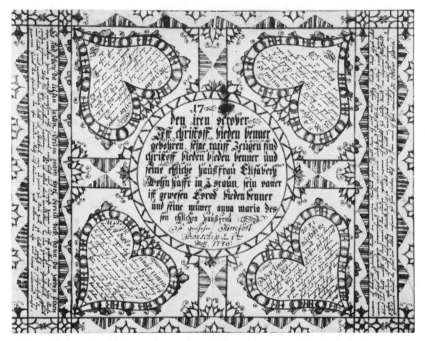

Figure 2. *Taufschein* for Christoff Biedenbenner. Berks County, Pennsylvania, March 1, 1776. Hand-drawn on paper; H. 12¹⁵⁄₁₆″, W. 16⅛″. (Winterthur Museum.) Hearts adorn many Pennsylvania German folk art objects and began to contain the printed matter on *Taufscheine* brought from the press in the 1790s. From this source they had profound influence on later hand-drawn *Fraktur* work.

of him. The other marked the exit of the individual from the community and told the community what he expected of it. The community preexisted the individual and postexisted the individual. Tombstone and *Taufschein* recorded the individual's pilgrimage through the community; at the same time, they helped the community transcend the individual and preserve its existence apart from the individuals who made it up.

The early Pennsylvania German pioneer came from social levels in Europe which probably did not erect tombstones for the deceased. As more than one European learned and commented,

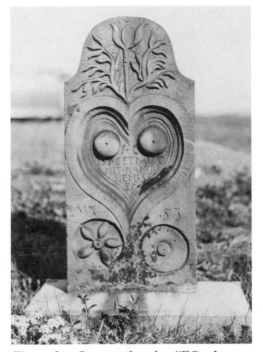

Figure 3. Gravemarker for "FC who was married to Martin Herbster 1753." Emanuel's Churchyard, Emanuelsville, Moore Township, Northampton County, Pennsylvania. (Photo, Pennsylvania German Society.)

the German peasant in the New World aspired to grandeur. The first stonecutters were obviously well trained, probably in Europe. Their work was three-dimensional and baroque in style. The work of their apprentices was quite different. While neat and carefully done, the products of second generation stonecutters are two-dimensional, relying heavily on the incised line, and provincial in style. Using the standard motifs found on other Pennsylvania German objects, they are more patently folk in every sense.

Not surprisingly, we encounter many of the same designs on

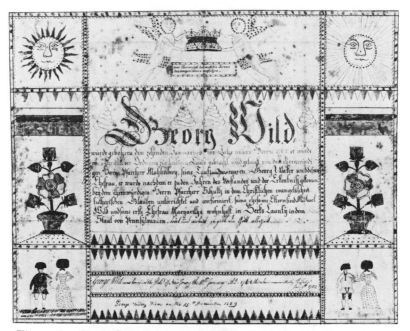

Figure 4. *Taufschein* for Georg Wild. Berks County, Pennsylvania, July 9, 1784. Hand-drawn and colored on paper; H. 12⁹⁄₁₆″, W. 15¹⁵⁄₁₆″. (Winterthur Museum.) The angels bearing a crown of blessing, or to be precise, a "crown of life" occur on *Taufschein* and on *Grabstein*. These angels on the birth and baptismal certificate of Georg Wild (born January 10, 1761, in New Jersey) carry a banner with the explanatory text, "Whoever conquers will receive the crown of eternal life," apparently a conflation of phrases from Revelation (2:10 and 3:5, perhaps). The crown is delivered by the angels.

the tombstones that are found on the baptismal record.[24] The stones lack the playfulness sometimes found on the *Taufschein*, but we encounter the same naïve portrayals of hearts (Figs. 2, 3)

[24] The only study of Pennsylvania German tombstones is Preston A. Barba and Eleanor Barba, *Pennsylvania German Tombstones: A Study in Folk Art* (Allentown, Pa.: Pennsylvania German Folklore Society, 1954). Klaus Wust published a small study of Virginia tombstones in *Folk Art in Stone: Southwest Virginia* (Edinburg, Va.: Shenandoah History, 1970). More recently, Bradford L. Rauschenberg published "A Study of Baroque- and

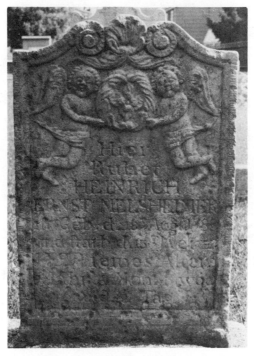

Figure 5. Gravemarker for Heinrich Ernst Mclsheimer (1788–92). Emanuel Reformed Churchyard, Hanover, York County, Pennsylvania. (Photo, Harry L. Rinker.) Cross-legged angels carry a wreath, a motif with the same meaning as the crown. (Another tombstone by the same hand in the same cemetery was purchased in Lancaster according to an estate account from that town.)

and angels (Figs. 4, 5), tulips (Figs. 6, 7) and stars (Fig. 8), and, occasionally, the human figure.

It is not difficult to comprehend the crown motif or the motif

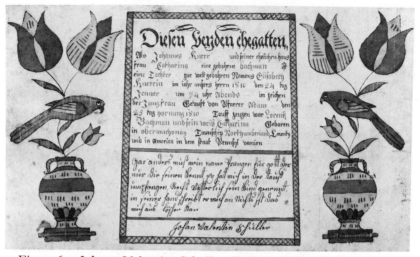

Figure 6. Johann Valentine Schuller, *Taufschein* for Elizabeth Knerr. Upper Mahonoy Township, Northumberland County, Pennsylvania, 1810–15. Hand-drawn and colored on paper; H. 7¹¹⁄₁₆″, W. 12½″. (Winterthur Museum.) Commonmost among Pennsylvania German folk art motifs is the tulip. Schuller used patterns to trace his drawings. Later he used printed forms but added the artwork by hand.

of angels bearing a crown (Figs. 9, 10), nor is the meaning obscure on at least one tombstone with a heart motif containing an inscription that refers to giving the heart to Jesus.[25] Other stones bear motifs common to all Pennsylvania German folk art or motifs borrowed from Anglo-American sources. An example of the latter is the hourglass; the Pennsylvania German equivalent is the descending moon.

The affinity of *Taufschein* and tombstone is further demonstrated when we inquire into the nature of the persons who made each of them. About *Fraktur* there can be little question. The chief practitioners were the parochial schoolteachers who supplemented their meager, indeed pitiful, incomes by cranking out *Taufscheine* (or *Vorschriften* for the Mennonites). These souls, about

[25] In Saint John's Lutheran and Reformed Churchyard, Ridgeville, Bucks Co., Pa.

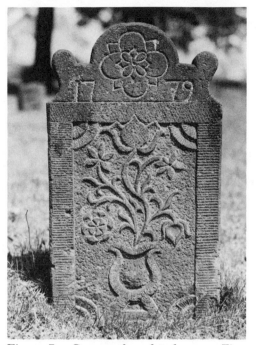

Figure 7. Gravemarker dated 1779. Zion Lutheran and Reformed Graveyard at Kreidersville, Northampton County, Pennsylvania. (Photo, Pennsylvania German Society, Guy Reincrt File.) Stones bearing a tulip in a vase by this stonecutter or a close following have been found in Franklin County, Pennsylvania, and Frederick County, Maryland.

whom a comprehensive study is badly needed, were among the few persons in the small villages who had a command of penmanship and a knowledge of German grammar sufficient to communicate meaningfully on paper; moreover, their heads were full of German poetry, since memorization was a preferred teaching method. They had leisure enough, if we may call it that, to draw and paint, and skill enough to write. When we realize that there

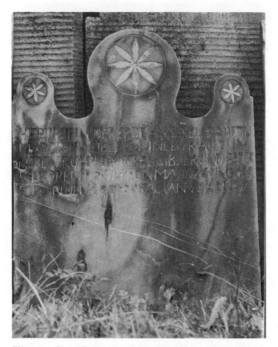

Figure 8. Gravemarker for Anna Elisabeth Margreth Gibler (1725–91). Saint Mary's Lutheran and United Church of Christ Cemetery, Silver Run, Carroll County, Maryland. (Photo, Harry L. Rinker.) Stars adorn many objects of Pennsylvania German origin. Those on this marker were cut into the stone and filled with a sulphur inlay such as is occasionally found on furniture made in southeastern Pennsylvania.

is a tradition in German life of almost four centuries standing that the village schoolmaster be the parish organist—amply attested in Pennsylvania, too—we may state that these persons were the primary practitioners of all the "art" the Pennsylvania Germans knew.

About the tombstone cutters we know less: there are few, if any, signed tombstones until sometime in the third and fourth decades of the nineteenth century, precisely the time the folk-art

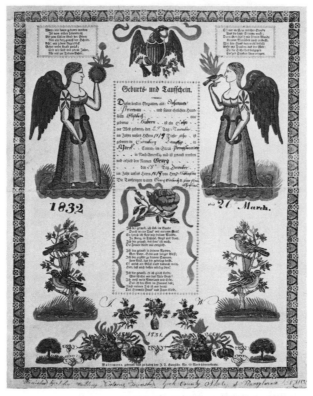

Figure 9. John Weibling, *Taufschein* for Georg Peterman. York County, Pennsylvania, 1832. Printed on paper; H. 16⅜″, W. 13⅛″. (Private collection: Photo, Winterthur Museum Library.) The printed *Taufschein* form was widely known among the Pennsylvania Germans. Its angel inspired the tombstone cutter. Although this was printed in Baltimore, the same angel occurs on certificates printed in several Pennsylvania cities as well.

decorations disappear. The tax lists are generally silent about tombstone cutters; it was a moonlighting job! But newspaper advertisements provide a clue, for several stonecutters advertised that they were also schoolteachers. A tombstone has been found

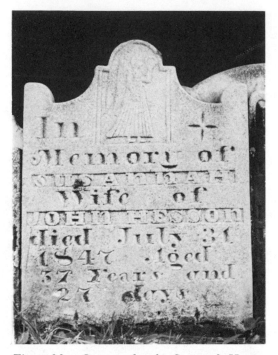

Figure 10. Gravemarker for Susannah Hesson
(1810–47). Saint Mary's Lutheran and United
Church of Christ Cemetery, Silver Run, Car-
roll County, Maryland. (Photo, Harry L.
Rinker.) This employs an angel similar to that
shown on the printed *Taufschein* in figure 9.

that was cut by Daniel Peterman (1797–1871), southwestern York
County Fraktur artist and a known schoolmaster. Other stones
were cut by David Bixler, a northeastern Lancaster County Frak-
tur artist, and by Absalom Bixler (d. 1884), his potter-gunsmith-
toymaker brother. It would be a not unexpected discovery, there-
fore, if more parochial schoolmaster-organist-*Fraktur* producers
are found to have been tombstone engravers as well.

The elements conspire to destroy the gravemarker, and hu-
man pollution hastens the process, as indeed the soil reclaims the

body and the baptismal certificates placed with it. Even the community of which these documents were once a part has largely disintegrated under the pressure of the Anglo-American culture surrounding it and of modern mass-media influence. The documents discussed here throw light upon the values of their owners and upon the sort of life they hoped to live.

> So lass mich nun in sa[n]fter ruh
> Und gehe nach eurer wohnung zu
> Ein jeder Dencke Nacht und Tag
> Wie Er auch selig sterben mag.
>
> So let me now in peace to rest
> As you go home and to your nest
> May each one ponder night and day
> How he too with blessing dying may.[26]

[26] Tombstone for Margaretha Zug (1803–1828). Emanuel Lutheran Cemetery, Brickerville, Pa.

Fachwerk *and* Brettstuhl:
The Rejection of Traditional Folk Culture
Lonn W. Taylor

As interest in American folklife has grown among art historians, folklorists, anthropologists, and amateurs, there has been an increasing tendency to search for "folk art" among the material cultures of the ethnic groups that came to America in the late eighteenth and nineteenth centuries. In a way, this would seem to be an unfruitful search, since folk art, as we usually think of it, is known to flourish in highly traditional societies characterized by a common-world view, a high degree of standardization in their artifacts, and an isolation from the stylistic trends of high art or academic art.[1]

Nineteenth-century America, with its high degree of social and geographic mobility, its emphasis on innovation, inventiveness, and fashion, and its racial and ethnic diversity, would seem to be the very opposite of this kind of society. The ethnic groups that emigrated to the United States in the nineteenth century and functioned within this social framework were subjected to all sorts of external assaults and internal strains on their cultural unity. There were pressures to reaffirm old cultural traditions. There

[1] Jean Lipman and Alice Winchester, *The Flowering of American Folk Art* (New York: Viking Press, 1974), p. 9.

were class, generational, and religious conflicts. There was a desire to express a new freedom from restraint and a desire for the security of old values. The literature of migration studies is rich with references to these conflicts, and the nature of the conflicts forces us to wonder exactly what we are looking at when we see examples of "folk art" from European, African, and Asian ethnic groups in America.

If Amos Rapoport in his perceptive book, *House Form and Culture*, is correct in saying that the form a traditional object takes—and, by implication, the decoration that is placed on it—"is the direct and unselfconscious translation into physical form of a culture, its needs and values—as well as the desires, dreams, and passions of people," then many of the objects that we study as folk art are, in fact, trying to tell us something about the stresses and strains of immigrant life in America.[2] They should reflect the maker's view of the ideal world order as it was modified by the American experience. It might be fruitful to examine some of these objects in that light, as well as for the aesthetic satisfaction that they can give us.

To see folk artifacts as cultural expressions, we must look at them in a more complex context than is usually applied to "folk art," a term that troubles me because it is so subjectively selective and so susceptible to the standards of our own taste.

Many of the objects that we categorize as "folk art" were not created as works of art at all: they were utilitarian objects with embellishments. Quilts, coverlets, pottery, furniture, weathervanes, musical instruments, votive objects, containers, bird decoys, and even houses were designed by the maker to serve a functional purpose and decorated by him with a message about himself, his client, and their world view. Objects were judged by their makers and users on both a functional and aesthetic basis: if a weathervane would not turn freely in the wind, or if a quilt did not keep you warm, they were no good. Our regard for these objects solely as works of art would truly puzzle the people who made and used them. In order to fully understand them, we need to focus our attention on the broader social context in which they were made,

[2] Amos Rapoport, *House Form and Culture* (Englewood Cliffs, N.J.: Prentice-Hall, 1969), p. 2.

used, and judged, on the methods and materials of their manufacture, and on the other kinds of objects that were used with them. If we do this, we may be able to begin decoding the messages that they are carrying and to learn something about the broader human and historical problems that they address.

This approach can be tested by examination of two kinds of objects produced by a culture that has often been described and studied as a folk culture: the houses and furniture built by the Germans who settled in central Texas in the middle years of the nineteenth century. These artifacts can tell us about the changing values of that culture as it was subjected to the American experience.[3] Texas German houses and furniture have presented a puzzle to those who have worked with them because, although the culture has many of the earmarks of an isolated folk culture (the continued vitality of the German language for more than a hundred years, the existence of many German social customs, holiday customs, games, foodways, and other folkways), it seems to be lacking in the expected German vernacular influence in its architecture and furniture, that is, in the buildings and the furniture that were made and used by the original settlers from Germany. This lack has caused some observers to strain at a gnat, and to speak of "Germanic methods of construction in log cabins," "Germanic craftsmanship" in mortise-and-tenon frame houses, and of the "Germanic pitch" of steep roofs.[4] In fact, the absence of large numbers of German vernacular buildings and a corpus of German vernacular furniture (not to mention the building and object forms that were substituted for them) may tell us more about the nature of German folk culture in Texas and the slow process of its erosion than would their presence.

Our examination of Texas German material culture will start with the nature of the whole population that made up this group in the mid-nineteenth century, then go on to look at the artisan populations that produced the objects, discuss the objects them-

[3] Julia Estill, "Customs Among the German Descendants of Gillespie County," in *Coffee in the Gourd*, J. Frank Dobie, ed. (Austin: Texas Folk-Lore Society, 1923), pp. 67–74; Institute of Texan Cultures, *The German Texans* (San Antonio: Institute of Texan Cultures, 1970), *passim*.

[4] Todd Webb and Drury B. Alexander, *Texas Homes of the Nineteenth Century* (Austin: University of Texas Press, 1966), p. 240.

selves, and close by offering some tentative conclusions about the messages encoded in the objects. This may well be a method that can be applied to the material folk cultures of other ethnic groups in America.

The Germans who immigrated to central Texas in the mid-nineteenth century were part of a much larger stream of emigration, the *Auswanderung*, in which several million people left Germany and settled in various parts of North America, Brazil, Argentina, Chile, Poland, Hungary, and the Ukraine. It had its causes in the social conditions which prevailed in Germany following the close of the Napoleonic Wars: overpopulation, economic reorganization, and political tyranny. It was not, as some seventeenth- and eighteenth-century migrations to America had been, the organized emigration of a particular religious or linguistic group; it was a migration composed of hundreds of thousands of individual decisions to leave Germany because times were bad. Those most affected by the adverse conditions were small farmers, small-town artisans, and the liberal, often middle-class, intelligentsia.[5]

The small farmer wanted to emigrate because overpopulation and the continual subdivision of agricultural land equally among heirs had placed him on the verge of starvation. As Heinrich Ochs, a Texas immigrant, wrote, "The oft-divided hearth results in privation. . . . He who does not desire to remain proletarian and become the father of beggars will take his belongings and seek an opportunity where he and his descendants . . . can become the holder of an estate and owner of his own home." [6] The scarcity of land and the intense competition for it meant that it brought a high price, and there were always ready buyers among the urban middle class or the aristocracy. The small farmer was able to turn his few acres into cash with which to finance his emigration to America, where land was plentiful and cheap.

The artisan and craftsman felt the same pressure that the farmer did. Essentially, the small-town carpenter or cabinetmaker depended on the profits from agricultural surpluses to pay for his

[5] Mack Walker, *Germany and the Emigration, 1816–1875* (Cambridge, Mass.: Harvard University Press, 1964), pp. 9–16, 37–41, 43–69.

[6] Gillespie County Historical Society, *Pioneers in God's Hills* (Austin: Von Boeckmann-Jones, 1960), p. 153.

services and when these surpluses disappeared so did the demand for his work. The end of the Napoleonic Wars had flooded England with cheap, factory-made goods; the next fifteen years saw the introduction of the factory system into Prussia itself. The old restrictive guild system which had protected artisans was crumbling under pressure from the factory owners. Development of the *Zollverein* (the German Customs Union) removed the protection once enjoyed by local economies in small principalities resulting in the displacement of many artisans. Carpenters, masons, blacksmiths, saddlers, cabinetmakers, and the like all found little to do in Germany in the thirties and forties. To cite just one case in point: between 1840 and 1847, one-sixth of all the weavers in the Kingdom of Wurttemberg went bankrupt.[7]

Finally, the restoration of "legitimate" monarchies in Germany by the Congress of Vienna created an undercurrent of liberal political unrest which expressed itself particularly among students, teachers, lawyers, editors, and other members of the intelligentsia. The failure of the revolutions of 1830 and 1848 caused a number of their participants to seek exile in America, but there was a steady trickle of dissatisfied liberals from Germany all through the middle years of the nineteenth century. They were joined by a smaller number of nonpolitical aristocrats who, due to economic misfortunes or personal preference, were unable to live (as one of them put it) "*standesgemaess*, that is, according to the demands of one's social class" in Europe.[8] Their numbers were quite small compared to the hundreds of thousands of plain people who left Germany, but they played important roles as community leaders and tastemakers for their fellow countrymen in America.

Representatives of all three of these groups came to Texas in large numbers in the 1830s, 1840s, and 1850s and in decreasing numbers throughout the rest of the nineteenth century. They settled first, in the 1830s, in the valley of Mill Creek, in the western part of Stephen Austin's colony, where they founded the towns of Industry, Cat Spring, New Ulm, Shelby, and Round Top. Later,

[7] Walker, *Germany and the Emigration*, p. 49.
[8] Annie Romberg, *History of the Romberg Family* (Belton, Tex.: Peter Hansborough Bell Press, n.d.), p. 14.

in the 1840s, they settled in the Hill Country, some two hundred miles west of the Mill Creek settlements, in the Comanche country west of the road from Austin to San Antonio. There they founded the towns of New Braunfels, Fredericksburg, and Boerne. Most of the immigrants of the thirties came to Texas because they heard about it through letters which previous immigrants had circulated throughout Germany, but in 1843 a colonization company, known to the emigrants as the *Adelsverein*, was established at Mainz. Between 1845 and 1847 this company sent some six hundred families to its Hill Country lands.[9]

A count of the manuscript census returns for the German counties of Texas (Austin, Washington, Fayette, Comal, Gillespie, and Kendall) shows that the largest number of the settlers were farmers and the next largest number were artisans. Professional men, intellectuals, and aristocrats made up a small but significant minority, some of which clustered together in "Latin Settlements" like Sisterdale, founded by a former privy councillor to the duke of Hesse-Nassau, and Bettina, where forty young men from the universities of Geissen and Heidelberg attempted a communal settlement. Others, like the Prussian officer Ludwig Siegismund Anton von Roeder and his eleven children at Cat Spring or Peter Carl von Rosenberg, a gentleman farmer from Memel who owned a plantation at Round Top, lived among their poorer neighbors, distinguished only by their libraries, their furniture, and their sense of *pli*.[10]

Frederick Law Olmstead's description of New Braunfels in 1847 bears out the evidence of the census returns.

Half the men now residing in New Braunfels and its vicinity are probably agricultural laborers, or farmers who themselves follow the plow. The majority of the latter do not, I think, own more than ten acres of land each. Within the town itself, there are, of master

[9] Rudolph Biesele, *The History of the German Settlements in Texas, 1813–1861* (Austin: Von Boeckmann-Jones, 1930), pp. 43–65, 157–60.

[10] U.S. Census, Manuscript census returns, schedules of population for Austin, Comal, Fayette, Gillespie, Kendall, and Washington counties, Texas, 1850, 1860, 1870, Archives Division, Texas State Library, Austin. For accounts of the Latin communities, see Biesele, *History of the German Settlements*, pp. 48–50, 56–57, 171–73, and August Siemering, "Die Lateinische Anseidlung in Texas," *Texana* 5, no. 2 (September 1967):126–31.

mechanics, at least the following numbers, nearly all of whom employ several workmen: carpenters and builders—20, wagonmakers—7, blacksmiths—8, gun and locksmiths—2, coppersmiths—1, tin-smiths—2, machinists—1, saddlers—3, shoemakers—6, turners—2, tailors—5, button and fringe makers—1, tanners—3, butchers—3, and bakers—4 . . . there are ten or twelve stores and small tradesmen's shops, two or three apothecaries, and as many physicians, lawyers, and clergymen.[11]

The population of German Texas also lacked homogeneity of origin. The very first immigrants, those who came in 1832, 1833, and 1834, were from the Grand Duchy of Oldenburg, the Kingdom of Hanover, and Prussian Westphalia. In the late thirties and the forties the major source of immigration moved southward to center in the duchies of Hesse and Nassau and the electorate of Hesse, and even into Baden and Wurttemberg. In the fifties and sixties it moved eastward toward Saxony, East Prussia, and even Silesia and Bohemia, and northward to Mecklenburg and Schleswig-Holstein. In fact, the only large area of Germany that did not make a significant contribution to Texas immigration was the Kingdom of Bavaria. Although most of the immigrants were Lutheran, there were sizable numbers of Catholics and a distinct minority of free thinkers.[12]

Seen in this light, the Texas Germans bear less and less resemblance to our notion of a folk culture as a conservative, traditional group of people, sharing the same world view and the same set of mental and physical forms. Rather than a single folk-culture, we begin to see them as refugees from a number of cultures—both folk and formal—that had been shattered by the Napoleonic Wars and their aftermath.

The artisans, especially those who created the houses and furniture, shared their diversity of origin. In the Hill Country, virtually all of the carpenters and cabinetmakers listed on the 1850, 1860, and 1870 census returns were born in Germany. Their places

[11] Frederick Law Olmstead, *Journey Through Texas: A Saddle-Trip on the Southwestern Frontier* (1857; reprint ed., Austin: Von Boeckmann-Jones, 1962), p. 97.
[12] Terry Jordan, *German Seed in Texas Soil* (Austin: University of Texas Press, 1966), pp. 31–33.

of birth included Prussia, Brunswick, Nassau, Hanover, Saxony Lippe-Detmold, Mecklenburg-Schwerin, and even Bavaria. In the Mill Creek settlements, there were a number of Anglo-American carpenters, but the Germans listed there show the same widespread places of nativity. Their training was as diverse as their birthplaces. The majority had been small-town artisans before migrating, but Jacob Schneider, whose shop in Fredericksburg produced fifteen hundred dollars worth of furniture in 1860, had been a Prussian army officer with a gentleman's interest in woodworking before he came to Texas. New Braunfels cabinetmaker Johann Michael Jahn had served an apprenticeship in Prague and worked in Switzerland, and his neighbor Franz Stautzenberger had worked as a cabinetmaker in the household of the duke of Nassau. Johann Umland, who worked in Washington County in the 1860s, had been employed as one of fourteen cabinetmakers in his brother's fashionable Hamburg shop.[13] It is difficult to see how such a varied group of men could be said to be working within a common folk tradition in Texas.

One thing that the Texas German cabinetmakers did have in common was the carefully circumscribed scale of their operations. Virtually all of them worked in one-man shops, usually in one room in or adjacent to their homes. At a time when Anglo-American Texas cabinetmakers were enthusiastically experimenting with horse- and steam-powered machinery, they eschewed all power sources and relied exclusively on hand tools to produce a very large amount of furniture. In 1860 there were only nine counties in Texas in which more than three thousand dollars worth of furniture was produced. Gillespie County, in the German Hill Country, was one of these. In the other eight counties, this level of production was achieved by two- and three-man shops using steam or horse power; in Gillespie County it was achieved by ten one-man shops using hand tools.[14]

This enormous rate of production reflected the intense de-

[13] Lonn Taylor and David Warren, *Texas Furniture: The Cabinetmakers and Their Work, 1840–1880* (Austin: University of Texas Press, 1975), pp. 299, 316–17, 325.
[14] Taylor and Warren, *Texas Furniture*, pp. 333–36.

mand for furniture among newly arrived and prospering immigrants: Gillespie County was only twelve years old in 1860. There was a similar demand for housing, and it is in the houses built by Germans in Texas that we first see a pattern of changes in form that we find paralleled in furniture styles.

Immediately after taking up their land or, in the implanted colonies of Fredericksburg and New Braunfels, their town lots, each German family built some sort of crude shelter. These structures generally seem to have taken the form of palisade huts, similar to the Mexican *jacales*, which had been built in southwest Texas since the middle of the eighteenth century.[15] They were replaced as soon as possible (generally speaking in the late 1840s and early 1850s) by two distinctive house types. One was the traditional southern Anglo-American log house, composed of two rooms, each about sixteen by eighteen feet, with a ten-foot wide open passage in between. The other was one of several varieties of the traditional German vernacular *fachwerk* house. The *fachwerk* ("filled-frame") building technique is a medieval technique developed in response to the shortage of timber in northern Europe. Some scholars feel that it is an urban building form that only spread to the countryside in the seventeenth century. It involves erecting a heavy, corner-braced frame of hewn timber and then filling the open spaces in the frame with stone, brick, rubble, or wattle-and-daub; the infill is then plastered over. In the Texas examples the infill was not only plastered over but frequently covered with sawn siding, a feature unknown in Europe.

A log house could be erected in several days by a man and his neighbors, perhaps with the aid of a skilled axeman. Undoubtedly, Germans in the Mill Creek area called on their Anglo-American neighbors to help them build their log houses, although there is, in the Fayette County courthouse, a contract in which three German families agreed to help each other build log houses.[16] A *fachwerk* house, however, could only be built by a skilled carpen-

[15] Ferdinand Roemer, *Texas*, trans. Oswald Mueller (San Antonio: Standard Printing Co., 1935), p. 93.

[16] "Meineke-Krause House Report," Fayette County Architectural Survey documents, Winedale Historical Center, Round Top, Texas.

ter, someone with a good deal of skill and experience in making fairly complex mortise-and-tenon joints and calculating the weight of the infill on the horizontal beams. It stands to reason that they must have been built by the German-born carpenters listed on the census returns for the six counties in question. These men—there were about one hundred of them in 1850 and about 150 by 1870 —share certain common characteristics. In 1850 they were all fairly young, in their twenties and thirties. They formed a fairly stable community of artisans; many of the men on the 1850 census appear on the 1860 census, and a few on the 1870 census. Some of them changed occupations over the years as they invested their profits in land and became farmers. They were replaced by new immigrants from Germany. In the Hill Country settlements, there were virtually no Anglo-American carpenters. Essentially the same community of German craftsmen provided housing for German Texans up through the 1870s.[17]

The Texas *fachwerk* houses built by these men exhibit the regional variations that one would expect from a group of artisans trained in various parts of Germany. But in the mid-1850s, there is a definite change of form, style, and technique. The houses built by these same Texas German craftsmen in the late fifties and early sixties for their Texas German clients are, without exception, mortise-and-tenon frame houses built on the standard southern Anglo-American floor plan. They have a closed central hall with one or two rooms on each side, and they frequently have Greek revival decorative details such as primitive dentils and diminutive square-columned porches surmounted by triangular pediments. The *fachwerk* house completely disappears from their vocabulary; in fact, every *fachwerk* house remaining in Texas (and there are not many) can be dated before 1855. One can only conclude that the German immigrant population began demanding new forms in the 1850s, forms that were consistent with the cultural values of their new nation (or perhaps simply not consistent with the restraints and limitations of the Old World) and were expressive of the independence and prosperity of the Anglo-American landowner.

[17] U.S. Census, Manuscript census returns, schedules of population for Comal, Gillespie, and Kendall counties, Texas (1870).

Figure 1. Johann Martin Loeffler, side chair (*Brettstuhl*). Fredericksburg, Gillespie County, Texas, 1855. Pine; H. 31¾″, W. 18″, D. 14½″. (On loan to Pioneer Museum, Fredericksburg.)

Turning to the furniture made and used by Texas Germans, we see the same rejection of traditional, vernacular forms and styles. Some of the earliest furniture known to have been made in the Hill Country is very much in the German vernacular tradition and would be quite at home in a *fachwerk* house on a peasant farmstead in Germany. The *Brettstuhl* made by Johann Martin Loeffler of Fredericksburg (Fig. 1) is a perfect example; this is a furniture form that occurs at an early date in all of the German

Figure 2. William Arhelger, center table. Fredericksburg, Gillespie County, Texas, 1870. Walnut and pine; H. 29¾", W. 36". (Collection of Crockett Riley.)

settlements in Texas but disappears completely by about 1855. After that date Texas German cabinetmakers were producing furniture that seems to blend the Biedermeier style (so popular among the middle and professional classes in Germany, especially small-town Germany) with the "plain Grecian" style that was popular in Anglo-American Texas homes in the 1840s and 1850s (Figs. 2, 3). Some of the cabinetmakers who came to Texas had worked in this style in Europe, and there were undoubtedly models for its continuance in the furniture brought from Germany to Texas by the wealthier immigrants. Unfortunately, no furniture brought

Figure 3. Johann Michael Jahn, side chair.
New Braunfels, Comal County, Texas. Wal-
nut; H. 33½″, W. 18″, D. 16″. (Collection
of Mrs. R. L. Biesele.)

from Germany has been found, but there are many references to
it in the memoirs of immigrants.[18]

The production of this furniture and its widespread use by
people coming from a variety of German peasant folk cultures tells
us something quite significant about the social dynamics of Texas

[18] See especially Ottilie Fuchs Goethe, *Memoirs of a Texas Pioneer
Grandmother (Was Grossmutter Erzaehlt) 1805–1915* (Austin, 1969); Rosa
Kleberg, "Some of My Early Experiences in Texas," *Quarterly of the Texas
State Historical Association* 1 (1898):170–73; and William Trenckmann, "Die
Lateiner am Possum Creek," *Das Wochenblatt* (Bellville, Texas), December
25, 1907.

German society. It appears that the former peasant, finding himself in a nonhomogenous society, freed from the social restraints of the Old World and confronted with models of new furniture forms (and artisans capable of producing them), promptly rejected the Old World vernacular forms and adopted, with enthusiasm, the forms from European high culture that had suddenly become available to him.

The rejection process went further than that. As early as 1852 furniture made in New York factories was being shipped via New Orleans to Galveston and Indianola and then hauled overland, at considerable expense, some two hundred miles to San Antonio, which was only forty miles from New Braunfels. In 1858 the New York firm of G. Ebbinghausen advertised in the San Antonio *Ledger* that they manufactured articles especially for the southern market and sold them through A. Sartor, a German merchant on Commerce Street in San Antonio. Eight years later, in 1866, cabinetmaker Johann Jahn of New Braunfels saw the trend and ordered a load of New York furniture. It was shipped to Indianola and then hauled two hundred miles by ox-wagon to his shop in New Braunfels.[19] Until the arrival of railroads in the area, in the middle 1870s, imported furniture was not cheaper than locally made furniture, but there was a definite demand for it among Texas Germans. Its purchase and placement in a frame house represented a significant step—an outward, visible step—in the rejection of the cultural baggage of the Old World and the acceptance of the values of the dominant Anglo-American society.

The superficial "Germanness" of the Texas Germans is undeniable. The rise of German nationalism in the 1870s and 1880s had important repercussions in Texas. Germans became aware of German *kultur* and partook of it through singing societies, shooting clubs, *Turnvereins*, theatrical societies, and an intense devotion to maintaining and improving the German language, through both public school instruction and a widely read Texas German press. Many examples of *kultur* survive in Texas today and are, in fact, undergoing a transformation into pop-*kultur*, complete with lederhosen, Little Rhine restaurants, and fake *fachwerk* shopping

[19] *Ledger* (San Antonio), July 13, 1854; *Zeitung* (New Braunfels, Texas), November 5, 1908.

centers. Even the genuine variety of *kultur* is not folk culture, while vernacular building and furniture forms are. The rejection of these two very basic manifestations of folk culture by the Texas Germans shows how fragile material folk culture is when removed from the context that created it and transported it across the Atlantic. We should consider the implications of this fragility and look with skepticism on examples of ethnic "folk survivals" in America. Perhaps we are looking at something entirely new that carries a message for us and our descendants.

Arrival and Survival: The Maintenance of an Afro-American Tradition in Folk Art and Craft
John Michael Vlach

It is generally assumed that every ethnic group in our nation of migrants—what has recently been called "A Nation of Nations" —made some contribution to America's material culture.[1] Be it house type, foodway, technological expertise, or mode of costume or decoration, it is thought that somewhere in the artifactual domain the presence of the Old World is recorded in the New. Yet there has been one group that has been excused from the honor roll of material contributors. People of African descent are usually credited with expertise in music, dance, and rhetoric, but their achievements in the arts and crafts, until the late nineteenth and early twentieth centuries, have been ignored. This circumstance is in large part due to the fact that Africans were given a status different from the rest of the groups who populated this land. Europeans, native Americans, and Asians are acknowledged as bearers of

[1] A *Nation of Nations*, exhibition catalogue, ed. Peter C. Marzio (New York: Harper & Row, 1976). The title appears to be derived from Walt Whitman's epithet "a teeming nation of nations."

distinct cultures, while Africans, since they were brought unwillingly as slaves, are considered to be culturally bereft. This is, of course, a racist myth and one which was thoroughly debunked by Melville Herskovits.[2]

Contemporary studies in anthropology, sociology, history, and folklore have shown the tenacity of African cultural concepts in the New World and their stability despite conditions of duress. The imagined cultural amnesia which was supposed to have afflicted Africans, once they arrived in America, is a convenient scheme for placing them at the bottom of the social heap, but it is far from being an accurate appraisal of their abilities. If they were stripped of their culture, then from whence came their narrative style, their musical ear, their kinetic sense—all of which are demonstrably African?[3] Even where such accomplishments in the performing arts are admitted, other aspects of cultural survival are excluded. Verbal and gestural forms, the argument runs, are held in the mind and therefore can be retained. Artifacts, however, because they require an overt physical manifestation, are thought to be controllable. Even Herskovits argued that "utensils, clothing, and food were supplied the slaves by their masters and it is but natural that these should have been what was most convenient to procure, least expensive to provide, and . . . most like the types to which the slave owners were accustomed."[4] This statement first ignores the fact that artifacts, like songs, tales, and religious beliefs, are based on mental concepts. Recognizing the conceptual dimension of objects allows us to understand that it is possible for an African idea to be lodged in a seemingly European object. Second, historical studies are just bringing to light a new understanding of early plantation life which indicates that slaves often had much to

[2] Herskovits, *The Myth of the Negro Past* (1941; reprint ed., Boston: Beacon Press, 1956).

[3] See Alan Lomax, *Folksong Style and Culture* (Washington, D.C.: American Association for the Advancement of Science, 1968), p. 92; Joanne Wheeler Kealiinohomoku, "A Comparative Study of Dance as a Constellation of Motor Behaviors Among African and United States Negroes" (M.A. thesis, Northwestern University, 1965); Daniel J. Crowley, *I Could Talk Old-Story Good: Creativity in Bahamian Folklore* (Berkeley: University of California Press, 1966), pp. 40–44.

[4] Herskovits, *Myth of the Negro Past*, pp. 136–37.

teach their masters about the New World.[5] If we dispense with the negative assumptions that have usually preceded study of the history and culture of American blacks and declare the African to be a culturally competent immigrant, then there is much to be learned about his contribution to the material culture of the United States.

What follows is an analysis of eight areas of material expression selected from the domains of art and craft. The approach in each case will be to consider the earliest known forms and then to follow subsequent developments chronologically. Since much of the material culture of blacks in America is shared by whites, it has been difficult to isolate Afro-American artifacts from similar artifacts made and used by whites.[6] But this circumstance should not cause us to abandon the search for earlier distinct forms. What seems to happen, again and again, is that African-derived artifacts and skills are cloaked with layers of Euro-American influence. As a consequence, African and Afro-American objects in the end appear Euro-American.

BASKETRY

The first major agricultural export in colonial South Carolina was rice. In the cultivation of rice African skills proved to be exceedingly valuable to plantation owners. Indeed, the strain of rice grown in the Low Country was allegedly brought from Madagascar in the 1680s.[7] Peter H. Wood provides the following summary of black agricultural talent:

Those Africans who are accustomed to growing rice on one side of the Atlantic, and who found themselves raising the same crop on the other side did not markedly alter their annual routine. When New

[5] Peter H. Wood, " 'It Was a Negro Taught Them': A New Look at Labor in Early South Carolina," *Journal of Asian and African Studies* 9 (1974):159–79.
[6] Henry Glassie, *Pattern in the Material Folk Culture of the Eastern United States* (Philadelphia: University of Pennsylvania Press, 1968), p. 115.
[7] Duncan Clinch Heywood, *Seed From Madagascar* (Chapel Hill: University of North Carolina Press, 1937).

Figure 1. Rice fanner, South Carolina, ca. 1850. Rush, oak; H. 2″, Diam. 20¾″. (Charleston Museum: Photo, Martin Linsey.)

World slaves planted in the Spring by pressing a hole with the heel and covering the seeds with the foot, the motion used was demonstratably similar to that employed in West Africa. In Summer, when Carolina blacks moved through the rice fields in a row, hoeing in unison to work songs, the pattern of cultivation was not one imposed by European owners but rather one learned from West African forebears. And in October when the threshed grain was 'fanned' in the wind, the wide winnowing baskets were made by black hands after an African design.[8]

[8] Wood, "It Was a Negro Taught Them," p. 172.

The last statement is particularly significant. Comparing rice fanners from western and central Africa to those used in South Carolina reveals strong similarities in form, materials, techniques of sewing, and use. In both cases, we find grass and reeds tied into bundles which are then coiled into wide trays (Fig. 1). The making of the coiled baskets by blacks was apparently known in South Carolina as early as 1690.[9] The baskets proved useful and are still made today.

In the eighteenth century, it appears that two general categories of coiled basket were known, work baskets made by men from tough reeds and split palmetto butt and "show" baskets made by women and children from light grasses and strips of palmetto leaf. In the nineteenth century, new forms were added to the basket repertoire. Large round baskets with shallow sides were still made, but tall storage baskets, oblong baskets, and baskets with strap handles became more common. By the end of the nineteenth century, black basket sewers attempted to secure a tourist market for their work, and by the 1930s roadside stands along Highway 17 in Mount Pleasant became common. The distinction remains, but the work basket has all but disappeared.

The forms made to sell at these stands seem generally to have been whatever would appeal to interested passers-by (Fig. 2). Yet one can sense that latent in some of these baskets is the shape of the older baskets. Contemporary basket sewers still remember the oldest traditional forms. Mrs. Queen Ellis, for example, can still make rice fanners on request. New combinations of material are now used, notably, pine needles, colored threads, plastic cord, and even beer can tops, but with the lack of available sweetgrass many basket sewers are now returning to rushes, the material used by their ancestors. The majority of the baskets offered to tourists in the Charleston area today seem Victorian in style. Sewing baskets and pocketbooks are made in large measure to appeal to white

[9] Much of this account of Sea Islands coil basketry is derived from personal communication with Gregory Day who spent five years researching the careers of black basket sewers in Mount Pleasant. See also Gerald L. Davis, "Afro-American Coil Basketry in Charleston County, South Carolina: Affective Characteristics of an Artistic Craft in Social Context," in *American Folklife*, Don Yoder, ed. (Austin: University of Texas Press, 1976), pp. 151–84.

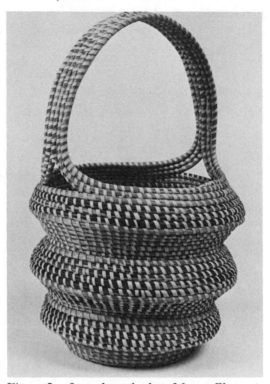

Figure 2. In-and-out basket, Mount Pleasant, S.C., 1971. Grass, palmetto, pine needles; H. 18½″, Diam. 6½″. (National Museum of History and Technology, Smithsonian Institution.)

tastes, but if we look closely at the bottom fourth of such baskets, we notice that this section is identical to an "old-timey" church collection basket. Literally we confront the layering of traditions.

Afro-American basketry was initially practiced exclusively in the coastal regions of South Carolina and Georgia. Today it largely survives in Mount Pleasant, at the northern end of the Sea Islands chain. There is adequate proof, nevertheless, that coiled grass and rush baskets were also made in St. Helena, Hilton Head, and Defuskie, near the Georgia border, and just south of Savannah

at Brownville.[10] Later, when blacks moved inland, they carried their basket-making tradition with them. Nineteenth-century examples of coiled baskets made by blacks have been recovered from Alabama, Tennessee, and Louisiana.[11] In western Mississippi, Afro-American basket makers are still making coiled baskets from "pine straw" and palm strips. African basket making has thus been spread throughout the Deep South, but it remains most visible at the point of its first arrival, the Low Country of the Carolina coast.

MUSICAL INSTRUMENTS

Another implement associated with rice cultivation is the wooden mortar. Mortars hollowed out of sections of tree trunk are well known both in Africa and Europe. Yet when we learn that whites in South Carolina tried to develop "engines" to husk rice, we can then focus on Africa as a source for the mortars made and used in South Carolina.[12] Some of these mortars may have served musical functions. Rice husking songs have been amply documented. Women kept a rhythm for their lyrics with the thump of the pestle. Gregory Day has postulated that some exquisitely curved mortars may have doubled as drums (Fig. 3).[13] Grooves on their sides could have held a thong to which a drum head was attached. Such an arrangement would have allowed the head to be quickly removed. Such precautions were found by Herskovits in Surinam where drum ceremonies were carried on with water pans substituted for actual drums.[14] The theme of sub-

[10] Rossa Belle Cooley, *Homes of the Freed* (1926; reprint ed., New York: Negro Universities Press, 1970), p. 144; Elsie Clews Parsons, *Folklore of the Sea Islands, South Carolina*, Memoirs of the American Folk-lore Society 10 (1923): p. 208; *Drums and Shadows: Survival Studies Among the Georgia Coastal Negroes*, Georgia Writers Project (Athens: University of Georgia Press, 1940), p. 52.

[11] On display at the Smithsonian Institution, Museum of History and Technology in an exhibit entitled "A Nation of Nations," 1976–83.

[12] Peter H. Wood, *Black Majority: Negroes in Colonial South Carolina from 1670 through the Stone Rebellion* (New York: W. W. Norton, 1974), pp. 61–62.

[13] Harold Courlander, *Negro Folk Music U.S.A.* (New York: Columbia University Press, 1963), pp. 116–17; Day to author, February 1976.

[14] Herskovits, *Myth of the Negro Past*, p. 142.

Figure 3. Rice mortar, South Carolina, ca. 1860.
Oak; H. 32″, Diam. 14½″. (Collection of Greg-
ory Day: Photo, Martin Linsey.)

terfuge is expected from people whose freedom has been stolen.[15]
Thus the rice mortar which served the master by cleaning his rice
also served the slave to make his music and maybe to send his
messages.

There are constant references to rhythmic concepts in the lit-
erature of Afro-American music. Drums would have been the com-
mon means of establishing the beat for African songs, but in
America alternate strategies were used. Nevertheless, in the 1930s

15 William D. Pierson, "Puttin' Down Old Massa: African Satire in the
New World," in *African Folklore in the New World*, Daniel J. Crowley, ed.
(Austin: University of Texas Press, 1977), pp. 20–34.

Figure 4. Drum, Virginia, 1675–1725. Cedar, deerskin; H. 18″. (British Museum: Photo, Smithsonian Institution.)

the Georgia Writers Project collected eleven reports of drum making from seven different communities.[16] These were generally plain sections of hollowed logs with pegged heads. While simple instruments such as these cannot be given clear antecedents, pegged log drums can be traced back to Place Congo in New Orleans in 1819.[17]

The earliest known drum, like the earliest known coil baskets, is very clearly African (Fig. 4). Placed in the British Museum in

[16] *Drums and Shadows*, p. 52.
[17] Benjamin H. B. Latrobe, *Impressions Respecting New Orleans*, Samuel Wilson, Jr., ed. (New York: Columbia University Press, 1951), p. 51.

1753, it was, possibly, collected as early as 1690 in Virginia.[18] In shape, decoration, and system of head attachment, it is perfectly Akan. But for the fact that it is made of American cedar and deerskin, this drum would probably be considered African. It is instead a document of the clear persistence of alternative cultural concepts not only for material objects but for musical performance as well. The first generation of Africans had a very definite notion of who they were. Over time their ethnic self-concept became weaker, but it still provided a basis for an alternative culture in America.

The process of change in musical instruments is perhaps most clearly represented by the history of the banjo.[19] Now primarily associated with the so-called old-time bluegrass of white country music, the banjo was first a black instrument. It is difficult to imagine a Gibson "mastertone" as derived from an African instrument, but the connection becomes clear if we first look to a transitional form—the Appalachian folk banjo. This type of banjo has a wooden frame, a fretless neck, an animal skin head, and gut strings. If we were to change the wooden frame to a calabash or a gourd, we would then have the instrument that is described repeatedly as made and played by slaves. Litt Young, an ex-slave from Mississippi, remembered from his youth in 1860 that "Us have small dances Saturday night and ring plays and banjo and fiddle playin' and knockin' bones. There was fiddles made from gourds and banjos from sheep hides." [20] Even Thomas Jefferson admitted in 1781 that the "banjar" was the instrument "which they [blacks] brought hither from Africa." [21] While the banjo as we know it is no longer physically similar to its Afro-American antecedent, it should be clear that its origins are not to be found

[18] C. Malcolm Watkins, "A Plantation of Differences—People from Everywhere," in *A Nation of Nations*, p. 74.

[19] For a history of the banjo, see Dena J. Epstein, "The Folk Banjo: A Documentary History," *Ethnomusicology* 20 (1976):347–71.

[20] Norman Yetman, *Life Under the "Peculiar Institution": Selections from the Slave Narrative Collection* (New York: Holt, Rinehart, & Winston, 1970), p. 167.

[21] Adrienne Koch and William Peden, eds., *The Life and Selected Writings of Thomas Jefferson* (New York: Modern Library, 1944), p. 258.

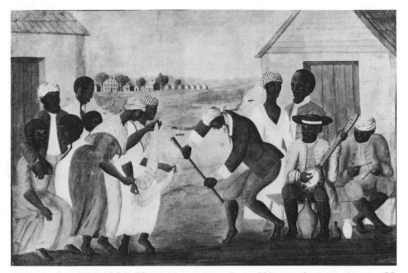

Figure 5. *The Old Plantation*, ca. 1800. Watercolor on paper; H. 11¾″, W. 17⅞″. (Abby Aldrich Rockefeller Folk Art Center.)

among the southern mountain folk but rather amidst black plantation communities in the Tidewater areas (Fig. 5).

There are many chordophones in West Africa which could have provided the earliest source for the New World instrument: *halam, garaya, kora, kasso, pomsa,* and *bania.* All have a calabash body, fretless neck, and gut strings. The *bania* has the most similar name to banjo, but we should not discount formative input from similar instruments. It is best to recognize the early banjo in America as part of a class of African instruments. The banjo was an Old World instrument that was later made to play New World songs and transformed in the process.

Despite the fact that the banjo changed radically in shape and racial association, there are some African stringed instruments that are still played in the United States which have changed very little. The mouth bow is a good example. Eli Owens of Bogalusa, Louisiana, makes and plays the mouth bow in much the same way today as he learned from his grandfather. Were it not

for the substitution of a beer can for a gourd resonator, his instrument could be substituted for one from the rain forests of central Africa.

IRONWORK

There have been many Afro-American blacksmiths. Wherever there are records of black craftsmen, many turn out to be ironworkers of some kind: wheelwrights, farriers, gunsmiths, axe makers, ornamental ironmakers. The work of a forge combined many tasks which often required a group of blacksmiths. Hence, there are a number of cases in which blacks worked as a team. Bernard Moore of Todd's Warehouse, Virginia, employed seventeen slaves in his ironworks in 1769. In 1770 at Providence Forge, Virginia, ten slaves banged out hoes and axes for local farmers. Conditions such as these provide a context in which alternative traditions in ironwork could be fostered.[22]

An unusual example of wrought iron sculpture was discovered during the excavation of the site of a blacksmith shop and slave quarters in Alexandria, Virginia (Fig. 6). It is a figure of a man, symmetrically posed, with legs spread apart and arms bent and reaching forward. The trunk retains the square shape of the original iron bar from which the statue was forged. Although the figure presents only a minimal image, it is a powerful work. Its direct frontal presentation together with the rough hammer marks clearly visible on all surfaces combine to suggest the primal essence of human form. The date of origin for this statue has been set at sometime in the late eighteenth century.

The circumstances of discovery suggest that the figure was created by a black artisan. Stylistic evidence further confirms its black origins. Malcolm Watkins has called it a "remarkable example of African artistic expression in ironwork." [23] Another commentator refers to this piece as "one of the rare objects which link

[22] Carl Bridenbaugh, *The Colonial Craftsman* (1950; reprint ed., Chicago: University of Chicago Press, 1961), p. 18.

[23] Watkins, "A Plantation of Differences," p. 77.

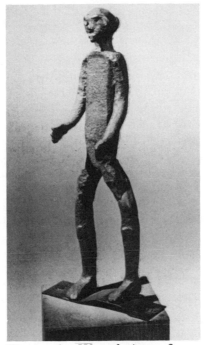

Figure 6. Wrought-iron figure, Alexandria, Va., late eighteenth century. H. 11″. (Collection of Adele Earnest: Photo, Smithsonian Institution.)

American Negro Art to Africa." [24] Indeed, comparisons with the wrought iron sculpture of the Bamana immediately set off sparks of recognition. If the forms made by Mande-speaking blacksmiths do not correspond exactly with the iron statue from Virginia, there is no question that the handling of mass and medium is very similar. It is in the gray area of attitude that the strongest resemblances emerge.[25] Since the records of the slave trade for colonial

[24] *Made of Iron* (Houston, Tex.: University of St. Thomas Art Department, 1966), p. 107.
[25] See Robert Goldwater, *Bambara Sculpture from the Western Sudan* (New York: University Publishers, 1960), p. 52, pl. 88.

Virginia reveal that one-seventh of all the Africans imported between 1710 and 1769 were from the Senegambian area and thus very likely Mande-speakers, it is not difficult to explain this iron statue's strong affinities to the wrought iron sculpture of the western Sudan.[26] Africans of Mandinka origins are mentioned several times in accounts of runaways from the 1770s.[27] Since this figure was made sometime during the late eighteenth century, its creator was probably either African-born or a first generation slave. His memory of his African heritage was still very strong. Watkins's assessment of this object as African, rather than Afro-American, is appropriate; the statue is a remarkable survival rather than an innovative adaption. The value that was invested in this sculpture is indicated by the fact that it was hidden from common view, buried in the dirt floor of the smith. Apparently, it had to be abandoned, and it only emerged again with the careful probes of the archaeologist's trowel.

Slave blacksmiths also remembered how to make weapons. In 1792 a group of nine hundred rebellious slaves from Virginia armed themselves with three hundred spears made by a blacksmith in their group.[28] Many other rebellions were also provided with weapons made by slave blacksmiths. The records do not reveal whether these weapons were African in design, but speculation in this regard is not out of place.

Most Afro-American ironwork was made under the direction of white blacksmiths. In New Orleans, from 1802 onward, records show that blacks were used in local forges.[29] Since primarily European patterns were executed, we must consider the black contribution one of manpower rather than design concept. Yet specialists in ornamental ironwork constantly comment on the distinct subtleties of New Orleans grillwork. We may suspect that these minor

[26] Philip D. Curtin, *Atlantic Slave Trade: A Census* (Madison: University of Wisconsin Press, 1969), p. 157.

[27] Gerald W. Mullin, *Flight and Rebellion: Slave Resistance in Eighteenth-Century Virginia* (New York: Oxford University Press, 1972), pp. 44–45, 173.

[28] Herbert Aptheker, *American Negro Slave Revolts* (New York: Columbia University Press, 1943), pp. 192–95.

[29] Marcus Christian, *Negro Ironworkers of Louisiana, 1718–1900* (Gretna, La.: Pelican Publishing, 1972), p. 17.

Figure 7. Toby Richardson and four unknown black artisans, Sword Gate, designed by Christopher Werner. Wrought iron. Charleston, S.C., mid-nineteenth century. (Photo, Martin Linsey.)

variations could be due to the reinterpretation of European motifs by Afro-American artisans. The same situation pertains also to the decorative wrought iron of Charleston, South Carolina, except that in the middle of the nineteenth century about one-fourth of the Afro-American blacksmiths were free men. Christopher Werner, a prominent metal worker in Charleston, owned five slaves. One of them, "Uncle Toby" Richardson, is remembered as a "top rank artist in iron." [30] Werner is credited with the design

[30] Mary Willia Shuey, "Charleston 'Signed' Ironwork," *The Reading Puddle Ball* 4, no. 1 (1935):5.

Figure 8.　Philip Simmons, Snake Gate (detail). Charleston, S.C., ca. 1960. (Photo, Martin Linsey.)

of the famous "Sword Gate" (Fig. 7), but Richardson, perhaps, should get the credit for making it.

Traditional blacksmithing is still practiced in Charleston by Philip Simmons who has been a blacksmith for fifty-two years. Having learned from an ex-slave blacksmith whose father was also a blacksmith, Simmons's work represents the culmination of more than 125 years of ironworking experience. Some of Simmons's older works fit well within the Anglo-German design canons for Charleston wrought iron, but in the last fifteen years he has taken the local traditions (for he alone carries on the tradition) into a new era. His ironwork is becoming very sculptural. His most famous gate, the "Snake Gate," is decorated with a very dangerous looking rattle snake (Fig. 8). Simmons has said of his creation:

. . . on the first sight I made the snake—the body. But the eye, I had to make several changes. Like the first, second, third, fourth time I placed the eye in the head of the snake, it look at me. That *was* the snake. . . . The eye was complicated. You put the eye in it and you just see something that look like a dead snake. He look dead. You

know that's true. You got to get that eye set that he look live. You look at it now sitting up there in the gate. Now you see it looking after you anywhere you are. Any side you looking on, it's looking dead at you. That's the important thing about the snake—to look alive.[31]

The Afro-American ironworking traditions of Charleston will not end with Philip Simmons. He has trained two men, Silas Sessions and Ronnie Pringle, who work as his helpers but who are, nevertheless, very adept craftsmen in their own right. We may safely project this tradition ahead for another thirty or forty years. Elsewhere in the country there are other black ironworkers. In Bluefield, West Virginia, W. P. Hamilton carries on the practical tasks of a farrier. There are general smiths in rural towns in Alabama and Mississippi. They tend to the many repair-and-mend jobs of their communities. In these tasks their performance is very much like that of any white blacksmith, but these similarities should not obscure the different vision of their ancestors.

BOATBUILDING

It is commonly accepted that European settlers learned to make dugout canoes from Indians. It is not so commonly known that the men who often maneuvered this shallow water craft were African. A traveler to Maryland in 1736 remarked that a log dugout was "a very small and dangerous sort of canoe, liable to be overturn'd by the least motion of the Sitters in it. The Negroes manage them dextrously, with a Paddle." [32] Africans were purchased, it seems, for their boating skills as well as their agricultural knowhow. One black boatman in Virginia was described in the following manner in 1772: "He calls himself Bonna, and says he came from a Place of that name in the Ibo Country, in Africa, where he served in the capacity of a canoe man." [33]

Blacks not only manned the boats of colonial America, they

[31] Interview with Philip Simmons, June 30, 1976.
[32] Quoted in M. V. Brewington, *Chesapeake Bay Log Canoes and Bugeyes* (Cambridge, Md.: Cornell Maritime Press, 1963), p. 4.
[33] Quoted in Wood, *Black Majority,* p. 203.

Figure 9.　Plantation barge *Bessie*, White Oak Plantation, Santee River, S.C., ca. 1855. Cypress; L. 29½'. (Charleston Museum: Photo, Martin Linsey.)

also made them, particularly log dugouts or boats made of several logs. Numerous newspaper accounts from South Carolina describe a boat called a pettiauger which was hewn by slaves from cypress logs and painted bright colors. A surviving boat from a Santee River plantation is adequate proof of the skill of black boatwrights (Fig. 9). Two massive sections of hewn cypress were pieced together to form a thirty-foot copy of a naval ship's boat. Multiple log dugouts made in the Chesapeake area seem to derive from Caribbean boats known as periaguas. The West Indian craft had a hewn log base with sides raised by hewn planks. This is the same strategy used on the Chesapeake Bay, except that in some cases as many as nine logs were pieced together (Fig. 10). Boats made this way have tentatively been credited to a slave named Aaron from York County, Virginia, sometime in the last quarter of the eighteenth century.[34] A three-log canoe was quite large and could be an effective craft with which to tong and drag for oysters. When fitted with a mast, sail, and centerboard, it would not even

[34] Brewington, *Chesapeake Bay Log Canoes and Bugeyes*, p. 31, n. 21.

Figure 10. Chesapeake Bay multiple-log dugout, Poquoson, Va., ca. 1930. L. (approx.) 30′. From M. V. Brewington, *Chesapeake Bay Log Canoes and Bugeyes* (Cambridge, Md.: Cornell Maritime Press, 1963), p. 13.

appear to be made from logs. Most log canoes were built in the nineteenth century, and few of them survive today. The survivors have been fitted with gasoline inboards and forward cuddies, and only a long look at the hull can detect the work of the log hewers.

The affiliation of blacks with the water has not been restricted to boatbuilding. In some of the earliest historical records for South Carolina, blacks are recognized as prodigious fishermen. In the West Indies, some plantation slaves were given free access

to boats and nets to provide a seafood supplement to the pro-
duce of the farm.[35] Blacks still constitute about one-half of the
crewmen on the skipjacks, the last sail-powered work vessels in the
United States. In the Sea Islands of South Carolina, distinctive
cast nets are used to catch shrimp, and their boats, called "ba-
teaux," are made in a manner possibly derived from the older log
pettiaugers. Black fishermen can be found up and down the At-
lantic seaboard. Often their rigs cannot be distinguished from
those of white fishermen, but, if we assume that they are only
copying the ways of the majority, we miss most of their story.
Africans were taken from one coast to another only to find fur-
ther opportunity to carry on their usual tasks, and their descend-
ants have often followed them to the water.

POTTERY

Throughout the South, folk pottery has been produced by
numerous family-owned shops. Almost all of these shops were op-
erated by whites. Only occasionally is a solitary black potter or
potter's helper encountered. No major tradition for Afro-American
pottery exists *except* in the Edgefield District of western South
Carolina. In an area now encompassed by Edgefield and Aiken
counties, between 1815 and 1880 a great number of blacks were
once put to work making pottery. At the present time, about forty
slave craftsmen and laborers can be identified. One researcher
thinks that eventually more than 150 will be named.[63]

The wares made in South Carolina were mostly utilitarian in
function and in form were very similar to Anglo-American pottery
types. Yet in the case of Dave the potter, the only slave to sign and
date his works, we have evidence of a deviation from normal prac-

[35] Richard Price, "Caribbean Fishing and Fisherman: A Historical
Sketch," *American Anthropologist* 68 (1966):1363–83.
[36] For a history of Edgefield pottery, see Stephen T. Ferrell and T. M.
Ferrell, *Early Decorated Stoneware of the Edgefield District, South Carolina*,
exhibition catalogue (Greenville, S.C.: Greenville County Museum of Art,
1976).

Figure 11. Dave the Potter, *Great and Noble Jar*.
Miles Mill, S.C., May 13, 1859. Stoneware, ash glaze;
H. 29″, Diam. 26″. (Charleston Museum: Photo,
Martin Linsey.)

tices.[37] First, Dave concentrated on large storage jars. This type
of jar is not unusual except that his vessels tended to be monu-
mental in scale. The largest, thought to hold more than forty-four
gallons, was made in sections (Fig. 11). Dave threw it while an-
other slave, Baddler, turned the wheel. Dave also inscribed his pots
with rhymed couplets such as: "Great and Noble Jar/Hold Sheep,
Goat, and Bear," "Dave Belongs to Mr. Miles/Where the oven
bakes and the pot biles," or "Pretty little girl on a virge, volca[n]ic
mountain how they burge." Poetry and gigantic size are modest
variations of the Anglo-American tradition, but they are clues

[37] Robert Farris Thompson, "African Influences on the Art of the United
States," *Black Studies in the University*, Armstead L. Robinson, Craig C.
Foster, and Donald H. Ogilvie, eds. (New Haven: Yale University Press,
1969), pp. 139–40.

Figure 12. Face vessel, Bath, S.C., ca. 1860. Stone-
ware, kaolin, ash glaze; H. 5". (National Museum of
History and Technology, Smithsonian Institution:
Photo, Martin Linsey.)

to the existence of alternative possibilities in design and execution
—clues which help to explain a more unusual group of ceramics
also discovered in the Edgefield District.

This series of decorative works consists of miniature vessels
approximately five inches tall, usually jugs, which are sculpted as
human heads (Fig. 12). The function of these vessels is still un-
known. We may postulate a symbolic, rather than utilitarian, pur-
pose because of the care taken in modeling the very small bodies.
The most typical examples have porcelainlike kaolin inserted into
a stoneware body. This combination of different clay bodies is a
unique achievement in world ceramic history, and the resulting
contrast in media has been noted by Robert Farris Thompson as
a key aesthetic link to Africa sources of inspiration. He traces the
stylized face jugs of South Carolina to central African, particu-

Figure 13. Face vessel, Bath, S.C., ca. 1850.
Stoneware, ash glaze; H. 8⅜", Diam. 7⅛". (Au-
gusta-Richmond County Museum, Augusta, Ga.:
Photo, Martin Linsey.)

larly Bakongo, origins. He finds "the same pinpoint pupils within
white eyes, the same long hooked nose, the same siting of the
nose at a point relatively high above the lips, the same open
mouth with bared teeth, the same widening of the mouth so that
it extends across the width of the jaw." [38]

In the same part of Africa, there is a distinctive type of earth-
enware vessel called a *m'vungo*. Its distinguishing formal features
are a stirrup handle combined with a single canted spout. Some
of the larger Edgefield face vessels, particularly those thought to
have been made in the early phases of Edgefield pottery produc-
tion, share these features (Fig. 13). These pots may be considered
African in form if not decoration. Vessels with stirrup handles and

[38] Thompson, "African Influences," pp. 145–46.

canted spouts are still made in the West Indies by black potters.[39] They are called "monkies" or "monkey jugs," terms which also occur in South Carolina. Apparently, this type of ceramic vessel entered South Carolina via the Caribbean, but its origins extend across the Atlantic to Africa. Describing the sculpted jugs of Edgefield, E. A. Barber wrote that they were "generally known as monkey jugs not on account of their resemblance to the head of an ape but because porous vessels which were made for holding water and cooling it by evaporation were called by that name." [40] The earliest face vessels made by blacks in Edgefield derived their form from the African water carrier, a form familiar to the potters. Later they switched to stoneware clay and produced smaller versions.

While face vessels made in America have usually been traced to European sources, namely British toby jugs and German bellarmines, we should not discount possible African ceramic inspiration. Vessels sculpted into heads have been found in Ghana, Ivory Coast, and Mali. In style they have several features which compare well with Edgefield wares. With respect to the question of genre, the face vessel is as much African as it is European. The synthesis of western ceramic technology and materials (i.e., stoneware clay, glazes, wood-fired kilns, throwing wheels) and African pottery forms and design concepts is a hybrid object; it is neither African nor European. Even if these hybrid vessels are markedly influenced by western technique, we should not cut short our search for African-inspired motivation in their making.

TEXTILES

Luiza Combs was born somewhere on the Guinea Coast in 1853 and brought to the United States at the beginning of the Civil War. She must have known little of slavery but nevertheless endured the hardships of the black experience in the era of Reconstruction. The legacy of her handiwork, which she passed on to

[39] Jerome Handler, "Pottery Making in Rural Barbados," *Southwestern Journal of Anthropology* 19 (1963):321–22.
[40] E. A. Barber. *The Pottery and Porcelain of the United States* (1893; reprint ed., New York: Feingold & Lewis, 1976), p. 466.

Figure 14. Harriet Powers, Bible Quilt. Athens, Ga., ca. 1895–98. Cotton, pieced and appliquéd with details, embroidered with cotton and metallic yarns; H. 69″, W. 105″. (Museum of Fine Arts, Boston.)

her children, is a wool blanket with a stripe pattern. Mrs. Combs raised the sheep to produce the wool. She sheared them and carded the fleece. After spinning the yarn, she dyed it and wove it. Every step of production was under her control; every aesthetic choice was her decision. The mixture of bright red-orange, lavender, blue, and light orange may be recognized as an African color scheme, although much more comparative study of the color preferences of African ethnic groups is needed.[41] The stripe design is common enough in Anglo-American weaving, but it is also an African pattern. Luiza Combs's blanket gives us a hint of the kinds of textiles that might have been made by slaves under the supervision of white owners. Those coverlets, blankets, and fabrics may have been African and American simultaneously.

In other textiles, particularly appliquéd quilts, there are clearer African influences. The most extensively studied Afro-American quilts are those of Harriet Powers of Athens, Georgia (Fig. 14).

[41] Roy Sieber to author, April 1977.

At least two of her quilts survive.[42] Made in the late nineteenth century, their content is largely derived from the Bible, although one of them also depicts five scenes of local historical events. A number of features of Mrs. Powers's appliquéd figures are directly comparable to West African appliquéd textiles. Her renderings of animals—notably fish, pigs, birds, and horned beasts are comparable to those made by the Fon people of Dahomey. The same background motifs—the short-armed cross, rosettes, crescents, and hearts—also occur on Dahomean cloths.[43] The most impressive correlation is a perceived continuity in style. Human figures, in both Mrs. Powers's quilts and Dahomean appliquéd cloths, are rendered as bold, iconic statements. Her figures are stiffly posed and have minimal detail as opposed to the highly representational expressions found in Anglo-American appliquéd quilting. Mrs. Powers's primal symbolism has immediate impact. Like most traditional African art, her quilts have a communicative quality that is direct and powerful. No other appliquéd quilts made by black Americans have been found which are as African in feeling as those of Mrs. Powers. We cannot, therefore, speak of an Afro-American tradition of appliquéd quilting. It is clear, however, that the farther back in time we can probe, the closer are the ties to African inspiration.

In the genre of pieced quilts, we find that black quilters often took over Anglo-American designs, such as the log cabin pattern. There is a distinct preference among blacks for designs featuring long strips (Fig. 15). Known as either "strong quilts" or "strip quilts," this type of quilt is known in black communities from Maryland to Georgia to east Texas. The tradition for this form apparently stems from the widespread West African practice of making larger textiles from thin strips woven on horizontal looms. The strips, ranging from four to ten inches in width, were

[42] For a more complete history of the works of Harriet Powers, see Gladys-Marie Fry, "Harriet Powers: Portrait of a Black Quilter," in *Missing Pieces: Georgia Folk Art 1770–1776*, exhibition catalogue, Anna Wadsworth, ed. (Atlanta: Georgia Council for the Arts and Humanities, 1976), pp. 16–23.

[43] Melville J. Herskovits, *Dahomey: An Ancient West African Kingdom*, 2 vols. (New York: J. J. Augustin, 1938), 1: frontispiece, pls. 7, 15, 33, 34, 39; 2: 328–43, pls. 51, 52, 67, 69, 84, 86–89.

Figure 15. Mrs. Floyd McIntosh, quilt. Pinola, Miss., ca. 1930. Cotton; H. 72″, W. 79″. (Mississippi State Historical Museum.)

cut into ten foot lengths and edge-sewn together to create random patterns.[44] Afro-American strip quilts often manifest an improvised notion of design, although not with total disregard for an overall plan. Generally there is a feeling of spirited playfulness with shape and color which, in the Anglo-American canon of quilting principles, would have to be labeled crazy if not a mistake. A quilt from the vicinity of Triune, Tennessee, clearly demonstrates the hybrid nature of some aspects of Afro-American quilting design (Fig. 16). It is composed of assorted quilting blocks, all of which are fairly standard examples of Anglo-American stitchery. The blocks, however, are sewn together in strips without regard to individual pattern. The resulting strips, of different widths, are then edge-sewn together to form the quilt. What we have in the

[44] Roy Sieber, *African Textile and Decorative Arts* (New York: Museum of Modern Art, 1972), pp. 181, 191–92.

Figure 16. Quilt, Triune, Tenn., ca. 1910. Cotton;
H. 81″, W. 80″. (Collection of Richard H. and
Kathleen L. Hulan: Photo, Martin Linsey.)

end is Euro-American content structured into what may be an
African-derived order.

Another way that an alternative sense of design shows itself
in black quilting is by a simple reinterpretation of standard quilt-
ing concepts. Geometric block patterns are the main structural de-
sign element in Anglo-American pieced quilts. Usually they are
small in size and repeated several times in the composition of
the whole quilt. Black quilters break with this notion by render-
ing the single quilt block as the whole pattern. A single twelve-
patch block may constitute the entire design, or one log cabin
unit may fill up the quilt where one normally expects to find
eighty tiny groups of concentric squares. A new definition of the
Euro-American pattern is thus achieved. The final product is defi-
nitely related to white design sources, but it is only rendered after
those designs have been filtered through a decidedly black aes-

thetic. If we understand the difference between design product and design process, we can pinpoint the influences of the American heritage on twentieth-century black textiles. Without this insight, we risk mistaking imagination for error, variation for imprecision, improvisation for chaos.

WOOD CARVING

In 1939 an African ritual in Georgia involving sculpted figures was recalled in the following words:

I remember the African men used to all the time make little clay images. Sometimes they like men, sometimes they like animals. Once they put a spear in his hand and walk around him and he was the chief. . . . Sometimes they try to make the image out of wood.[45]

This oral fragment records the continuity of African talents for sculpture that are generally presumed to have been lost in the New World. It is evident from this remembrance that sculpture did not disappear from the cultural repertoire of African slaves. Moreover, some sensitivity for wood carving was passed on to subsequent generations of Afro-Americans.

The most common black sculptural form is the carved walking stick. From the middle of the nineteenth century up to the present, there have been Afro-American carvers of decorated canes.[46] A common characteristic of those works is a preference for reptile motifs: snakes, lizards, turtles, and alligators. Other African traits codified by Thompson are monochromy; smooth, luminous surfaces; and mixed media.[47] Within such general stylistic constraints, there is a wide variety of personal expression. Some canes are slender with incised carving, while others, such as those made by Howard Miller of Dixie, Georgia, have figures rendered in full relief. One of the better-known Afro-American carvers is William Rogers of Darien, Georgia. Among the several different

[45] *Drums and Shadows*, p. 106.
[46] Thompson, "African Influences," pp. 150–55.
[47] Thompson, "African Influences," pp. 163–66.

types of carving created by him are walking sticks, animal figures, and utilitarian items. In each case the style of carving is bold. Rogers characteristically employed beads to mark the eyes of human and animal figures. His canes would never be mistaken for those of Howard Miller, even though both carvers are from Georgia, they worked in the same period, and they used the alligator motif. The Afro-Georgian carving tradition allowed freedom of expression within a general set of formal critieria.

Black wood carving was not limited to Georgia alone. Recently, black carvers have been found in Mississippi whose work strongly echoes the Georgia canes both in style and content. Leon Rucker, for example, decorates his canes with snakes and lizards (among other motifs) and marks their eyes with brass studs.[48] Another Mississippi carver is Lester Willis whose repertoire appears to be quite varied. Some of his canes have only the owners' name incised on them, others have quotations from Scripture, and others are topped with carved figures of men with top hats and the like. Willis said of carving: "In 1933 when the panic was on, most everybody in the community was on welfare, you know, and the bucket brigade; but I kept the wolf away from my door with walking sticks and that's the truth." [49] Sculpture for him was a mode of artistic expression and a means of earning a livelihood.

The most spectacular of all the known Afro-American canes is one which was carved in Livingston County in north central Missouri. It was here that Henry Gudgell, born a slave in Kentucky in 1826, made an extensively decorated cane for one John Bryan in 1867.[50] Gudgell was known as a blacksmith, wheelwright, coppersmith, and silversmith, and so it comes as no surprise that he was adept at sculpture as well (Fig. 17). His walking stick can be separated into two sections by differences in the selection of motifs. The handle section has, first, a five-inch sec-

[48] Worth Long, "Leon Rucker: Woodcarver," in *Black People and Their Culture*, Linn Shapiro, ed. (Washington, D.C.: Smithsonian Institution, 1976), pp. 33–34.

[49] Quoted from William R. Ferris, Jr., *Made in Mississippi*, 22 min., 16 mm., color film, Center for Southern Folklore, Memphis, Tennessee.

[50] Thompson, "African Influences," p. 133.

Figure 17. Henry Gudgell, walking stick. Livingston County, Mo., ca. 1863. Wood; L. 36¼". (Yale University Art Gallery.)

tion of serpentine fluting above a smaller section of the same curvilinear decoration bracketed by plain bands. This portion of the cane is followed by two raised rings, a band of raised diamond forms, and two final encircling rings. These geometric motifs, which cover about a fourth of the cane, are followed by a series of naturalistic figures. These are expertly described by Thompson:

At the top appear a lizard and a tortoise, both carved as if seen from above. The figure of a man appears below. He is dressed in shirt, trousers and shoes. His knees are bent and the arms are extended as if the figure were embracing the shaft of the cane. On the opposite side of the cane below the hands of the figure is a bent branch from which sprouts a single veined leaf. The fork of the branch mirrors the bending of the knees of the human figure. The lower register of the cane is embellished with an entwined serpent, an echo of the serpentine coil of the handle.[51]

A cane so African in character seems out of place in Missouri. It would have made more sense for this cane to have been carved in Georgia. Yet when we consider the movement of the tradition for carved walking sticks from Georgia to Mississippi, the source of inspiration for this north Missouri walking stick becomes clear. The Mississippi and Missouri rivers served as a route over which black culture traits were carried northward and westward from the

[51] Thompson, "African Influences," p. 135.

Figure 18. Church throne (rear view), Victoria, Texas, ca. 1920. Wood, metal band; H. 36½". Collection of Jim Aldridge: Photo, Martin Linsey.)

Deep South. Henry Gudgell's walking stick represents the furthest penetration of the black cane-carving tradition in the United States.

A very ornate wooden throne (Fig. 18) has recently been discovered and linked to a black Presbyterian church in Victoria, Texas. What function this massive chair served is still uncertain, but it is clear that it is a very special item. Carved from one piece of wood, the chair has four legs, a high back with a solid splat, and it stands on a ponderous turtle. Also riding on the back of this amphibian pedestal are a pair of full-maned lions rendered in profile and two bears carved as if seen from above. The legs of the chair have male and female figures incised in them, and the crest

rail of the chair back is decorated with two large rose blossoms. On the rear of the splat, carved in high relief, is a small tableau that appears to represent a judge perched on his bench flanked by facing figures. This wonderous assemblage of human, animal, and floral motifs stands three feet tall and is very reminiscent of a mysterious Afro-American throne and altar made by James Hampton of Washington, D.C.[52] Hampton's work was apparently motivated by a particularly idiosyncratic theology; the Victoria throne seems to share the same sense of purpose. If nothing else, we can at least acknowledge a vivid imagination inspired by religious fervor. It would be farfetched to attempt comparisons between this piece and the massive thrones of the Tikar of Cameroon or the highly figured chairs of the Chokwe of Zaire, without knowing more about the asethetic influences which affected the carver. Until more is known we can only identify this throne as Afro-American by virtue of its use and some of its stylistic elements. Whoever made this chair was saying more about himself than about his community. Such carvings may indicate a departure from tradition, a departure, which after two hundred years is to be expected. Nevertheless, it should be abundantly clear that remarks about the absence of black wood carving are premature.

GRAVE DECORATION

A white plantation mistress in 1850 noted that:

Negro graves were always decorated with the last article used by the departed, and broken pitchers and broken bits of colored glass were considered more appropriate than the white shells from the beach nearby. Sometimes they carved rude wooden figures like images of idols, and sometimes a patchwork quilt was laid upon the grave.[53]

[52] Elinor Lander Horowitz, *Contemporary American Folk Artists* (New York: J. B. Lippincott, 1975), pp. 127–32; Lynda Roscoe, "James Hampton's Throne," in *Naives and Visionaries*, exhibition catalogue (Minneapolis: Walker Art Center, 1974), pp. 13–20.

[53] Quoted in John W. Blassingame, *The Slave Community: Plantation Life in the Antebellum South* (New York: Oxford University Press, 1972), p. 37.

Figure 19. Black graveyard, Sea Islands, Ga., 1933. (Library of Congress.)

This decorative practice (perhaps it would be better to say religious practice) survives with great tenacity throughout Afro-America today. Graves of blacks in Georgia, for example, are covered with glassware, enameled metal containers, and seashells (Fig. 19). Pitchers with the bottoms broken out are commonly set atop graves. The range of materials used to ornament gravesites is enormous. The following list is not exhaustive: cups, saucers, bowls, clocks, salt and pepper shakers, oyster shells, toys, bric-a-brac statues, light bulbs, flashlights, gunlocks, bits of plaster, mirrors.[54] Some unwary archaeologists who have surveyed black

[54] H. Carrington Bolton, "Decoration of Graves of Negroes in South Carolina," *Journal of American Folklore* 4 (1891):214; Ernest Ingersoll, "Decoration of Negro Graves," *Journal of American Folklore* 5 (1892):68–69; Henry C. Davis, "Negro Folklore in South Carolina," *Journal of American Folklore* 27 (1914):248; Lydia Parrish, *Slave Songs of the Georgia Sea Islands* (1942; reprint ed., Hatboro, Pa.: Folklore Associates, 1965), p. 31; Margaret Davis Cate, *Early Days of Coastal Georgia* (St. Simons Island, Ga.: Fort Frederica Assn., 1955), pp. 207–15.

Figure 20. Congo chieftain's grave. From E. J. Glave, "Fetishism in Congo Land," *Century Magazine* 41 (1891):827.

graveyards report that they appear to contain nothing more than "late period garbage of no interest." [55] Far from being garbage, these heaps of objects are offerings or sanctified testimonies; they are the material messages of the living intended to placate the potential fury of the deceased.

The precedents for this type of burial decoration are to be found in African practices. Two cases will illustrate this fact. In 1891, E. J. Glave, speaking of his travels through Zaire, wrote, "Natives mark the final resting-places of their friends by ornamenting their graves with crockery, empty bottles, old cooking pots, etc., etc., all of which are rendered useless by being cracked or penetrated with holes." [56] His illustration of a Congo chief's grave

[55] John D. Combes, "Ethnography, Archaeology, and Burial Practices Among Coastal South Carolina Blacks," *Conference on Historic Site Archaeology Papers*, vol. 7 (Columbia, S.C.: Institute of Archaeology and Anthropology, 1972), p. 52.
[56] Glave, "Fetishism in Congo Land," *Century Magazine* 41 (1891):825.

would not be out of place in central Alabama (Fig. 20). The same funeral custom occurs in Gabon. In 1904, missionary Robert Hamill Nassau reported that

> Over or near the graves of the rich are built little huts, where are laid the common articles used by them in their life—pieces of crockery, knives, sometimes a table, mirrors, and other goods obtained in foreign trade. Once, in ascending the Ogwe [River], I observed tied to the branches of a large tree extending over the stream from the top of the bank, a wooden trade-chest, five pitchers and mugs, several fathoms of calico prints. I was informed that the grave of a lately deceased chief was near.[57]

Practices such as these are still being stringently observed today.[58] We must try to understand the Afro-American extension of this tradition within the context of folk belief regarding death and the world of the spirits. Sarah Washington of Eulonia, Georgia, commented, "I don't guess you be bother much by the spirits if you give 'em a good funeral and put the things what belong to 'em on top of the grave." Her husband Ben seconded her opinion: "You puts all the things what they use last like the dishes and the medicine bottle. The spirits need these same as the man. Then the spirit rest and don't wander about." [59] Similar statements have also been collected in Mississippi where it was reported that the cup and saucer used in the last illness, if placed on the grave, would keep the deceased from coming back.[60] An Alabama resident is recorded as saying, "Unless you bury a person's things with him, he will come back after them." [61] The existence of returning spirits is thus widely acknowledged in Afro-American folk belief. Their ability to return was clear to Jane Lewis of Darien, Georgia: ". . . we take what victuals left and put it in a dish by the chimley and that's for the spirit to have a last good meal. We cover up the

[57] Nassau, *Fetishism in West Africa* (London: Duckworth, 1904), p. 232.

[58] Andre Raponde-Walker and Roger Sillens, *Rites et Croyances des Peuples du Gabon* (Paris: Presence Africane, 1962), p. 107.

[59] *Drums and Shadows*, p. 136.

[60] Newbell Niles Puckett, *The Magic and Folk Beliefs of the Southern Negro* (1926; reprint ed., New York: Dover Publications, 1969), p. 104.

[61] Puckett, *Magic and Folk Beliefs*, p. 103.

dish and there's many a time I hear the spirit lift 'em." [62] More recently, in South Carolina, a black woman said that, after several sleepless nights following her daughter's funeral, the girl appeared in a dream and told her that she needed her hand lotion. The woman hurriedly placed the item on the grave, thereby putting an end to her insomnia.[63] The demands of the dead lead the living to follow a distinctive mode of grave decoration.

Many contemporary burials are marked with homemade headstones made of concrete. Apparently they are attempts to imitate the tablet forms made by professional stonecutters. Even in the imitation of a popular item, a folk element still emerges. Most concrete markers have a piece of broken glass inset in them with a piece of white paper set behind them. Grave goods are normally white—be they seashell, plaster, light bulb, or ceramic container. The preference for white might be traced to Bakongo belief that their deceased ancestors were white in color; therefore, white was the color of death.[64] Second, most grave decorations are broken to show that a life has ended.[65] Thus, the broken glass and the white color are symbolic elements which could have central significance in the Afro-American folk belief system. These elements are combined with a form well known in American culture as a marker of death. The result is an expression which is ostensibly American but which also allows for the maintenance of African concepts of death.

Wooden markers are also used in black graveyards. One slab of wood will mark the head, while a notched stake will indicate the foot of the grave. Often the head marker will be cut out in the vague form of a human body, representing the outline of the head, neck, shoulders, and torso. These markers are appropriate icons of lost human life. They give the vague shape of the body but no details. When bleached by the sun, these markers appear almost cadaverous. The most unusual wooden gravemarkers were

[62] *Drums and Shadows*, p. 147.

[63] Combes, "Burial Practices Among Coastal South Carolina Blacks," p. 58.

[64] Georges Balandier, *Daily Life in the Kingdom of Kongo from the Sixteenth to the Eighteenth Century* (New York: Pantheon Books, 1975), pp. 251–52.

[65] *Drums and Shadows*, pp. 130–31.

Figure 21. Cyrus Bowens, graveyard sculptures. Sunbury, Ga., ca. 1920. Wood; H. (approx.) 13'. (Photo, Malcolm and Muriel Bell, 1939.)

made by Cyrus Bowens of Sunbury, Georgia, around 1920 (Fig. 21). Of his masterwork only the center piece remains. Now badly deteriorated, it once was a simple spherical head resting on a pole that had the name Bowens carved in capital letters. It could be considered a three-dimensional version of the more common

wooden slab marker. The two flanking pieces were much more elaborate. One apparently represented a snake, while the other assemblage was an impressive vertical construction reaching almost thirteen feet into the air. Another part of this cluster of sculptures was a curving bracket from which was hung a sign bearing the names of the deceased members of the Bowens family. From all of Bowens's pieces, we sense that he considered sweeping curves to be creative forms. It is tempting to recall the dominance of reptile forms in Afro-American wood carving and to view Bowens's work as another instance of the snake motif. Bowens died in 1966 before anyone thought to ask him about his work. It is clear, however, that for Bowens the world of the dead was a world of wonderous forms, perhaps a world of awe.

CONCLUSION

Having surveyed eight forms of traditional Afro-American art and craft, we can assert that previous assessments have underrated the survival of African material culture in the United States. Even Herskovits saw the technology and art of North American blacks as lacking any trace of African custom.[66] His negative evaluation was probably due to a lack of historical depth in the materials which he analyzed. The older examples of black art and craft, those produced by people who were either born in Africa or who must have known African-born slaves, are in every instance much influenced by African practices. In some cases, such as basketry, musical instruments, and grave decoration, the customs survive with great purity despite the addition of new ideas to the traditional repertoire. What seems to happen most often is that an African concept is combined with an Anglo-American one, as in the case of quilting, pottery, boat-building, blacksmithing, or cane carving. In these creative forms of expression, the African influences are concentrated in the area of design and decoration, while the materials, the technology, and the concept of

[66] Melville J. Herskovits, "Problem, Method and Theory in Afro-American Studies," in *The New World Negro*, Frances S. Herskovits, ed. (Bloomington: Indiana University, 1966), p. 53.

genre are seemingly Western. Through a process identified by an-
thropologists as "syncretism," those elements of two diverse cul-
tures which are most similar are interwoven to create a new en-
tity, a cultural hybrid. The artifact resulting from this process of
synthesis will simultaneously be interpreted by both groups in
their own terms.

Afro-American walking sticks resemble canes made by white
carvers, but they also repeat motifs found in African authority
staffs. Black quilts seem "crazy" or sloppy to white observers,
while to their makers they are the commonplace "string" or
"patchy" designs. Nineteenth-century stoneware face vessels from
South Carolina are often labeled grotesque jugs, although, for their
black makers, they may have served as ritualistic objects. Afro-
American cemeteries look like junkyards to whites, while blacks
consider their practices crucial for their spiritual well-being. Hence,
we must be on our guard against ethnocentrism in our analysis of
black art and craft. Much of it appears to be tied to Euro-Ameri-
can patterns, and, certainly, Western influences cannot be dis-
counted. Nevertheless, if we fail to understand that there is a
black history behind black artifacts, we risk missing the essence of
Afro-American creativity. The things that look white are largely
the result of reinterpretation, not imitation.

Afro-American artifacts fall into two major categories: the
retained African artifact (comparatively rare) and the hybrid arti-
fact (very common). The retentions carry us back to a time when
Africans first arrived on the shores of America. The hybrid objects
tell the tale of survival in a creolized culture. A minority people in
the midst of a hostile alien population, they used indirect strate-
gies to maintain their sense of social integrity. They bent or ad-
justed the concepts of the majority culture to serve their own
ends. The role playing, punning, satire, and subterfuge, historically
noted among American blacks, are indications of a dual mind-set
which solved the problem of maintaining a strong sense of self
when, socially, their existence was held in low regard.[67] Ralph
Ellison has referred to this condition of mind as a "complex dou-

[67] Pierson, "Puttin' Down Old Massa," pp. 20–34; Eugene Genovese,
Roll Jordan Roll: The World the Slaves Made (New York: Pantheon Books,
1974), pp. 599–612; Blassingame, *The Slave Community*, pp. 132–53.

ble vision, a fluid ambivalent response to men and events, which represents at its finest, a profoundly civilized adjustment to the cost of being human in this modern world." [68] The examples of Afro-American folk art and craft surveyed here are concrete expressions of the black response to the New World. That response was to build upon their own sense of history and forge a new order in which they might take pride in their accomplishments—although white society often ignores or claims these achievements for itself.

[68] Ellison, *Shadow and Act* (New York: Vintage, 1972), pp. 131–32.

Beating a Live Horse: Yet Another Note on Definitions and Defining
Roger L. Welsch

They had the passion of modern men for the pre-
cision of machines and disliked vagueness of any sort.

> Loren Eiseley,
> *The Night Country*

One of my favorite stories was told to me six or seven years ago by
Oscar Henry. Like most humor, and art, the story can be viewed
as a funny instance or a widely applicable metaphor. It seems that
there were two little boys who spent an inordinate amount of time
in the local poolhall, and they had become prematurely aware of
the fact that there were a lot of things going on at Mabel's place.
The boys decided to find out what it was precisely that the older
boys were always talking and smirking about, so they saved their
nickels and dimes with an eye toward eventually amassing the
requisite five dollars. After a few weeks it became all too evident
that it was going to take years to accumulate such a fortune, and
yet their curiosity was immediate. So they went over to Mabel's

I would like to extend my special thanks to Lynne Ireland for her
patience, help, and humor during the preparation of this paper.

place with what money they had and knocked on the door. They explained to her, "We want whatever it is the big boys get for five dollars but we only have two dollars between us."

"That's all right, boys," said Mabel. She took the two dollars, reached out and took each boy by one ear, and firmly banged their heads together three times, just as hard as she could. She then tossed them, glassy-eyed and slack-jawed, out into the dust of the street. One of the boys sat up, looked at the other, and opined, "I don't believe I'm ready for five dollars' worth of that."

I have only about two dollars to contribute to this head-knocking on American folk art, but then I am not sure I am ready for five dollars' worth anyway. Once before I wrote a brief note on defining for the *Journal of American Folklore*,[1] and Richard Baumann of the University of Texas replied with an article that is, I understand, still held in awe by the people who write income tax forms and instruction booklets for assembling bicycles. Here is a sample:

> [Folklore communication is] the application of a set of parametric dichotomies as a means of defining the realm of folklore communication in such a way that it can be related to other kinds of behavior at the level of each cut.[2]

There followed three years of precisely the kind of definitional nonsense I had originally argued against, and when the dust cleared, there we all sat in the street. The pain has been largely forgotten, I am a bigger and wiser boy now, and I stay out of poolhalls. I am afraid of neither Mabel nor mixed metaphors, and, therefore, I am ready to beat this live but previously well-thrashed horse once again. There is every indication that the horse needs the beating, so I will not spare the rod.

In my previous work, I have suggested to my colleagues in folklore that definitions are arbitrary and conventional, as any first-year linguistic student knows. Definitions are products, not producers. They are descriptive, not prescriptive. They are deduced,

[1] Roger L. Welsch, "A Note on Definitions," *Journal of American Folklore* 81, no. 321 (July-September 1968):262–64.
[2] Richard Baumann, "Towards a Behavioral Theory of Folklore," *Journal of American Folklore* 82, no. 324 (April-June 1969):167–70.

not declared. More over, there are many ways to define, each system valid within its own purposes and capabilities to serve. And there can be a substantial difference—a very important difference for us—between a definition and a meaning.

It is my contention that the geographic and historic realities of a region, in their unique combinations, elicit powerful and determinant influences on folk expressions—from folk art to folk speech—and it is from these expressions we draw our definitions. That is certainly true of the Plains, my own region of study. There were no fibers—no wool, no flax, no cotton, no hemp—and thus no spinning or weaving. There is little stone, very little wood; therefore, carved artifacts from whittling to sculpture are rare in highstyle art as well as folk art. The major population on the frontier was made up of migrants from Poland, Germany, Czechoslovakia, and Scandinavia, but they arrived shortly before World War I when there was a savage repression of foreign forms—Danish language, Czech food, German music. The history and geography of the Plains have thus wrenched and torn folk art potentials in obvious ways, and if the artists have been profoundly affected, so too have been those of us who study them.

About ten years ago I heard a visiting lecturer in geography at the University of Nebraska repeat the tired nonsense that Plains pioneers had no time for art because they were too busy struggling for survival. What about the Eskimos, I argued, and the pygmies of the Kalahari? Life for them isn't exactly a game of skittles, but *they* have art. I used that argument to write a proposal to the Nebraska Arts Council for money to survey the folk art holdings in small county and private collections in the state, intending to show that there was plenty of art around if you just looked for it.

After a year of work I found myself in the very ungrantsmanlike position of having to state a negative conclusion: I found nothing. Almost all of the paintings, carvings, weaving had been brought to the Plains from somewhere else. Little had been produced here in the way of art. Very little. And yet the insistence of informants that there was "art" was clearly more than regional chauvinism. Homesteaders insisted there had been art and an

understanding of beauty. Indeed, precisely as with the Eskimos and pygmies, the art had been either pragmatic or associated with pragmatic artifacts. Art was not considered a separate, and essentially useless, form. "*Beyond* necessity," to be sure, but not *apart* from necessity. To that degree, the expressions and perceptions of beauty on the Plains were perhaps the ultimate articulation of *folk* art.

Because of the region, because of the demands of the Plains, there was another convention of understanding. Since I am an observer, not an advocate, I found myself viewing folklore and folk art from quite a different direction than that which I had been using before and of which my colleagues are largely still victim. This paper is meant to demonstrate how the region of the Plains has affected an understanding of folk art.

In 1950 *Antiques* published a symposium on folk art which presented a confrontation of concepts about folk art ranging from the oxymoronic "folk art is . . . essentially the expression of the individual" to the impressively foresighted essay by Louis Jones and Janet MacFarlane, but the symposium was more a clash of defining techniques than of definitions.[3] Contributors tried to define folk art in terms of who the folk are, what the folk artist is, who the folk audience is, what degree of "sophistication" the artist has or does not have, the modes and materials of the art. Some labored through the long agony of establishing delimitative definitions, always falling short (as, by definition, they must) by a couple of adjectives, always (as they must) setting up a whole new series of abstractions that demand defining.

To believe that we can detect folk art by the degree of *sophistication* applied in perspective, proportion, or color is a curious idea from scholars presumably familiar with the work of Dali, Van Gogh, or Delacroix. It is even stranger to judge what is folk art by its *audience*, since we scholars are a good part of the audience. One can scarcely discuss the *materials* of art in a meaningful way after a stroll through any exhibit of contemporary art.

The problem of defining folk art, I argue, lies within the

[3] "What is American Folk Art?: A Symposium," *Antiques* 57, no. 5 (May 1950):355–62.

process of defining products of the human spirit and within the dimensions of the need for such a definition. In another paper, published as part of a critical symposium in *Ethnologia Europaea,* I outlined the problems of defining, thus refining my previous discussion in the *Journal of American Folklore.* In our definitions we demand crisp lines, clear and discrete boundaries, symmetrical paradigms, and unconfused rubrics. An ideal definition would look something like this:

ART

Or perhaps where the definer fancies himself progressive:

ART

Relationships are thus displayed:

Or:

ART

But such images of definitions and categorization are dead wrong. Not perhaps in the labeling but the conceptualization. They suggest all of those things we want: that the categories are discrete, equal, parallel, symmetrical, precise, joined with straight, rectilinear articulations. Even a chart so composed—

ART

leaves to the ever-receptive mind the full potential for the lines, boxes, and angles.

But these things do not exist at all in the reality. If we are indeed dealing with expressions of the human mind, the boxes cannot be of equal size, of equal shape and texture, at equal distances, separated by spaces—equal spaces, with straight lines. That suggests a stability, and any such suggestion is a disservice to the

study. None of these characteristics exist in folk art's reality (or for that matter in the reality of folklore, or history, or language). The image produced is painfully and manifoldly incorrect, and yet it imposes its tyranny of order on the ideas being examined.

Other disciplines are in far worse condition. In a headlong plunge to seize the "method" of science (and therefore its money, power, and prestige), fields like history, anthropology, and sociology have abandoned the productive potential of the humanistic method of investigation and have taken on a cloak of dour mien, arcane language, and formulaic presentation in keeping with their understanding of what science is and what scientists do. In 1977 I was in a discussion with a group of analytical chemists who were baffled by the custom of sociologists to devote the first three weeks of any class to an impassioned polemic developing a case for sociology as a science. Such a procedure would be considered mad in a chemistry class, not simply because chemistry is understood by most people to be a science, but because there is so little profit in the debate.

Loren Eiseley, also a Nebraskan, was one of the preeminent scholars in the history of science. Perhaps for that very reason he understood the clear advantages of the humanistic methodology. In *The Night Country* he wrote:

We have lived to see the technological progress that was hailed in one age as the savior of man become the horror of the next. We have observed that the same able and energetic minds which built lights, steamships, and telephones turn with equal facility to the creation of what is euphemistically termed the "ultimate weapon." It is in this reversal that the modern age comes off so badly. It does so because the forces which have been released have tended to produce an exaggerated conformity and, at the same time, an equally exaggerated assumption that science, a tool for manipulating the outside, the material universe, can be used to create happiness and ethical living. Science can be—and is—used by good men, but in its present sense it can scarcely be said to create them. Science, of course, in discovery represents the individual, but in the moment of triumph, science creates uniformity through which the mind of the individual once more flees away.

It is the part of the artist—the humanist—to defend that eternal flight, just as it is the part of science to seek to impose laws, regulari-

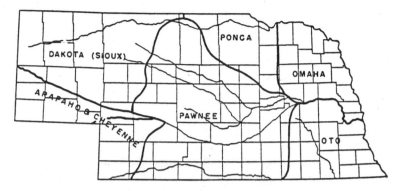

Figure 1. Distribution of Indian tribes of Nebraska, ca. 1800. From James Olson, *History of Nebraska* (Lincoln: University of Nebraska Press, 1966), p. 21.

ties and certainties. Man desires the certainties but he also transcends them. Thus, as in so many other aspects of life, man inhabits a realm half in and half out of nature, his mind reaching forever beyond the tool, the uniformity, the law, into some realm which is that of mind alone. The pen and the brush represent that eternal search, that conscious recognition of the individual as the unique creature beyond the statistic.[4]

A modest example of the kind of trouble that comes of insisting on clarity and precision where there is in reality no clarity or precision is a map, frequently reproduced, that purportedly shows the distribution of Indian tribes on the Nebraska Plains in 1800 (Fig. 1). The map is a fabrication with no substance. No such boundaries existed. There were no such lines in any sense whatever. The boundaries shown spring not from a reality but from our own culture's need for such lines, even where there are none. One must say the same thing for the border lines of Nebraska. There are of course no lines, no distinguishing physical feature save for the Missouri River on the eastern side of the state, a reality that is lacking for most other Plains states' boundaries. Indians ranged from *centers* of power for which there were no

[4] Loren Eiseley, *The Night Country* (New York: Charles Scribner's Sons, 1971), pp. 140–41.

edges. From centers of strength they moved outward toward other centers, with increasing vulnerability and intimidation. Every step constituted a fraction of a degree of less "home-ness"; there were no edges to the definition of Pawnee territory. The concept of centers of power reflects the realities of life for the Plains Indians.

We could, perhaps, symbolize folk art or folklore as the rolling hills of my central Nebraska farm. Does this clump of Indian lovegrass belong to that hill or this one? Where does one hill begin and the other end? Where do the bottomlands end and the uplands begin? Such questions are absurd. An arbitrary and absolutely pragmatic line separates my land from my neighbor's, but it exists only within that conceptual context. No such arbitrary divisions exist where they are not needed, and if they were needed they would be just as arbitrary. What is important about the hills of my farm is not boundaries between hills but the slope of the sides, the peaks of the hills, the dynamics of the relationship of the hill with the valleys and with other hills, the texture of the soil within the hill. Without ever defining the precise beginning point of one hill and the ending of another, a party of observers could agree precisely on how many hills there are along any range. *Hills are defined not by their edges but by the middles.*

The same can be said of folk art. All contributors to this volume, whether from the field of high art or folk art, will agree on the labeling of a substantial proportion of individual artifacts. Within our respective disciplines we will agree, almost unanimously, on what folk art is. Contrary to Michael Owen Jones ("There is no consensus in definitions as to what folk art is . . ."),[5] there is almost total agreement. If one hundred widely diverse art objects representing the widest range of forms were shown to 100 folk art scholars, I suspect that almost 95 of them would agree on which of the objects were folk art and which were not. Moreover, where there was disagreement, it would center on the same five or ten samples from the corpus. Here again, we agree on the center, but we will inevitably disagree about the precise location of the edges. This is the way it must be in the defining of humanistic artifacts. Once that premise is recognized,

[5] See elsewhere in this volume, p. 329.

there is scarcely any reason to go on arguing about those edges; there is no chance of agreement, no profit in polemics. It is the very nature of the subject that discrete boundaries are constructs of the intellect with no corresponding reality. Like all words and definitions of words they are arbitrary and conventional.

Questions like "The Nebraska Round Barn: Folk Architecture?" become useful only where there is a need for an answer. Otherwise there will eventually appear on the scene the mystic response that has destroyed any number of schools of intellectual investigation: "So what?"

There are times, of course, when definitions are desirable and even crucial to the solution of a problem. "For the purposes of this exhibit [survey, investigation, book, museum] 'folk art' will be understood to be [fill in the blank]." It may or may not be a useful and meaningful definition, but it reflects a realistic understanding of a definition.

Whether a consensus is needed for the organization of a section of papers, a whole symposium, or a collection of artifacts, it is easy to arrive at an understanding of what folk art is. The understanding is not expressed in words but in shared recognitions. As I have insisted above, we agree on the vast majority of artifacts. If we chose to extrapolate from that corpus a definition, we could take all of the agreed-upon items—the center of that hill identified as "folk art"—and find the common element that brings such a contentious crowd to temporary agreement. In reality we have all tried to do precisely that in our struggles with the definition and the defining process, and yet we fall short again and again. Perhaps we are looking for the wrong kind of common denominator. We have been looking for a definition of material that is the product of the spirit, not the mind, and yet we have been using techniques designed for analysis of products of the mind.

Some time ago I began to feel uneasy about using the "scientific" approach to the study of literature and art, and that uneasiness was strengthened considerably by the constant warnings of Loren Eiseley, a teacher I hold in immense esteem. My confidence in my discomfort with what has been touted as the only serious methodology of investigation was further enhanced when Henry Glassie and I appeared on the same panel at an experi-

mental archeology meeting in Philadelphia.[6] I had come prepared to present an idea I was certain would be unpopular and politically damaging only to find that the most respected authority in American folk architecture was saying the same thing: It is time to stop measuring buildings and time to start thinking about them.

Next, I encountered Gaston Bachelard's *The Poetics of Space,* in which a brilliant mind deals with architecture in precisely those terms, producing answers of impressive force if not crushing finality. Bachelard opens his text,

> A philosopher who has evolved his entire thinking from the fundamental themes of the philosophy of science, and followed the main line of the active, growing rationalism of contemporary science as closely as he could, must forget his learning and break with all his habits of philosophical research, if he wants to study the problems posed by the poetic imagination.[7]

This is no nihilistic surrender to inevitable defeat; rather, it is a suggestion that there are other more productive courses of investigation than those of scientific logic. Popular culture in America has already seized upon this course—perhaps in reaction to technology rather than science—and has chosen as its new heroes (in an age of antiheroes) Luke Skywalker and Avatar (as in *Wizards,* not as in the Hindu incarnation). If science can accept the idea of aspirin but not the form of the willow twig, from which salicylic acid comes, perhaps we can also accept the idea, if not the form, of subjective analysis for art investigation. Bachelard writes,

> To specify exactly what a phenomenology of the image can be, to specify that the image comes *before* thought, we should have to say that poetry, rather than being a phenomenology of the mind, is a phenomenology of the soul. . . . In many circumstances we are obliged to acknowledge that poetry is more relaxed, less intentionalized than a consciousness associated with the phenomenon of the mind. Forces are manifested in poems that do not pass through the circuits of

[6] Joint meeting of the Society for Historical Archaeology and the International Conference on Underwater Archaeology, January 10, 1976, University of Pennsylvania, Philadelphia.

[7] Gaston Bachelard, *The Poetics of Space* (Paris: Press Universitaries de France, 1958), p. xi.

knowledge. The dialectics of inspiration and talent become clear if we consider their two poles: the soul and the mind. . . . The poet does not confer the past of his image upon me, and yet his image immediately takes root in me.[8]

Then what is the nature of the common element of the soul that we can find and thus "define" as folk art? No, we cannot be lured again into that morass! These boundaries, too, are like those of my rural Nebraska hills. All we can know with any certainty is that a common understanding of the boundaries is shared by many, perhaps most, rarely by all. Bachelard attacks scientific efforts to detect the elements of the soul that produce poetry and art:

The poetic image, which stems from the *logos*, is personally innovating. We cease to consider it as an 'object' but feel that the 'objective' critical attitude stifles the 'reverberation' and rejects on principle the depth at which the original poetic phenomenon starts. As for the psychologist, being deafened by the resonances, he keeps trying to *describe* his feelings. And the psychoanalyst, victim of his method, inevitably intellectualizes the image, losing the reverberations in his effort to untangle the skein of his interpretations. He understands the image more deeply than the psychologist. But that's the point, he 'understands' it. For the psychoanalyst, the poetic image always has a context. When he interprets it however he translates it into a language that is different from the poetic logos.[9]

Right away, the psychoanalyst will abandon ontological investigation of the image to dig into the past of the poet. He sees and points out the poet's secret sufferings. He explains the flower by the fertilizer.[10]

Eiseley, the historian of science, has much the same lament: "Today problem solving with mechanical models, even of living societies, continues to be popular. The emphasis, however, has shifted to power. From a theoretical desire to *understand* the universe, we have come to a point where it is felt we must understand it to survive." [11]

[8] Ibid., pp. xvi, xvii, and xviii.
[9] Ibid., p. xx.
[10] Ibid., p. xxvi.
[11] Eiseley, *The Night Country*, p. 140.

How then are we to examine and define the essence of art if the scientific method is inappropriate, if conventional objective analysis is out of synchronization with the materials we are to examine? Bachelard suggests, "Contemporary painters no longer consider the image as a simple substitute for a perceptible reality. Proust said already of roses painted by Elstir that they were 'a new variety with which this painter like some clever horticulturist, had enriched the rose family.' " [12]

If we grant that same kind of nonobjective creativity in a communal or cultural sense to folk art, how does the scholar, if he can at all, achieve a relationship with the art object?

Faithful to my habits as a philosopher of science, I tried to consider images without attempting personal interpretation. Little by little, this method, which has in its favor scientific prudence, seemed to me to be an insufficient basis on which to found a metaphysics of the imagination. The image in its simplicity has no need of scholarship. It is the property of a naïve consciousness.[13]

Since a phenomenological inquiry on poetry aspires to go so far and so deep, because of methodological obligations, it must go beyond the sentimental resonances with which we receive (more or less richly—whether this richness be within ourselves or within the poem) a work of art. This is where the phenomenological doublet of resonances and repercussions must be sensitized. The resonances are dispersed on the different planes of our life in the world, while the repercussions invite us to give greater depth to our own existence. In the resonance we hear the poem, in the reverberations we speak it, it is our own. The reverberations bring about a change of being. It is as though the poet's being were our being. The multiplicity of resonances then issues from the reverberations' unity of being. Or, to put it more simply, this is an impression that all impassioned poetry-lovers know well: the poem possesses us entirely.[14]

The real phenomenologist must make it a point to be systematically modest. This being the case, it seems to me that merely to refer to phenomenological reading powers, which make of the reader a poet on the level with the image he has read, shows already a taint of pride. Indeed, it would be a lack of modesty on my part to assume personally a reading power that could match and re-live the power of organized,

[12] Bachelard, *The Poetics of Space*, p. xiv.
[13] Ibid., p. xv.
[14] Ibid., p. xviii.

complete creation implied by a poem in its entirety. But there is even less hope of attaining to a synthetic phenomenology which would dominate an entire oeuvre, as certain psychoanalysts believe they can do. It is therefore on the level of detached images that I shall succeed in "reverberating" phenomenologically.[15]

If the museum exhibitor or researcher can sense the reverberations of the artifact as folk, if it evokes the sympathetic vibrations that Bachelard feels are at the core of art, then it is the stuff called folk art. Other arbitrary limitations can be imposed, of course, to suit the problems of budget, room, motif, appropriateness for research, or institutional whim, but it must always be remembered that such decisions have nothing to do with what folk art is or is not. Debate about what is and is not folk, is or is not art, has nothing to do with reality, and, when such debate swirls around an exhibit or collection, it can only enhance the potential of the materials for intellectual excitement.

While the tops of hills on my farm are their most prominent feature, it is in the low swales where the high grasses grow, where the deer hide, and the flowers bloom the brightest. In the seams— between the categories—is where the problems lie and where the most fertile ground for controversy and debate lies. My concept of the centrist definition and Bachelard's thesis for a phenomenological approach to the study of art are, I must emphasize again, not surrenders to a futility but invitations to the productivity that is available in realization of the indeterminate nature of the differentiations between the categories. The only ground rules are that the debaters must themselves realize and admit publicly before the battle begins that they are playing Monopoly and the money is only play.

Perhaps the greatest danger of the approach that combines experiential, phenomenological, and humanistic systems of investigation is the confusion of the phenomenology of one's own mind with the phenomenology of the object of study, objet d'art or artist, the confusion of impetus with reverberation. The most splendid example of this confusion I have yet encountered was in the form of a charming confession delivered before a section of the

15 Ibid., p. xxi.

American Folklore Society a few years ago in Los Angeles. Angie Berry was reporting on her important work with Basques and expressed a special excitement with magnificent decorative plaster work in the town's public privies. She was struck by the magnificent geometric design and one day took a camera to the toilets to record the art work ethnologically. She was stopped by her horrified relatives who explained that the wall work was not art at all, but only shit smeared there in the absence of toilet paper.

There is also a dimension of art, extant in a canon of beauty, beyond or separate from human products. A community may well understand a system for the appreciation of beauty in nonhuman products that can be applied both to human and natural products or, in the momentary absence of one, only to the other. Thus, there is a traditional understanding of the idea of beauty in the absence or presence of an actual artifact or in the presence of an artifact not conventionally included under the rubric "art."

In Dannebrog, Nebraska, a town close to my farm, there is a maple tree just down the street east of the bank and the hardware store. Each fall that tree explodes into the most exquisitely formed, flamboyantly iridescent blast of color that has ever been seen around Nebraska. Admittedly, there may be ten thousand trees on Lake Otsego or in Brown County, Indiana, each of which is more beautiful than the Dannebrog tree, but in Nebraska where there are so few trees and where there are so few varieties of trees, this tree is awesome in its splendor. I cannot adequately describe the beauty of that tree.

Is the tree folk art? I wouldn't say so, and neither would most other people interested in folk art or folklore.

But the tree exists in a context and has a cultural significance that confounds that certainty. The four hundred citizens of Dannebrog watch that tree and anticipate and hope. They worry about the early frosts and high winds; they resonate with the easy chill of a fall night. They watch the slow, uneven change and almost use body English to push the color into its most splendid intensity. Scarcely a conversation passes in Dannebrog without some mention of The Tree. The Dannebrognagians roll the vision around in their heads like a cabernet should be rolled about in the mouth. They compare its color and brilliance with those of

previous years. They speculate on the reasons for such variation. They pity other towns while simultaneously rejecting any suggestion that other pretender trees can even be regarded as being in the same class with The Tree. Photographs of other trees and The Tree during other falls are compared with the contemporary display. New photos are taken. Then the whole town permits a reluctant submission to the inevitability of The Tree losing its color and its leaves as fall becomes winter.

Is The Tree still not folk art? It has struck a common chord in an otherwise stolid, unsophisticated community. For a while the discussion in the streets has not been of cents per bushel or hundredths of an inch of rainfall but of aesthetics. At this moment in the community's life there is the vibrance of a gallery opening, for everywhere there is talk of color, texture, technique, form, and style. Thus, within this homogeneous, relatively unsophisticated, relatively isolated community, part of the larger culture and society and yet distinct from it, there is a common concern and understanding of beauty. Whether there is any "folk art" within this community, there is clearly the reflective, explicit canon for a folk art, including Bachelard's resonances and reverberations.

Does it matter that the item itself is not a human product? How does The Tree differ from Jasper Johns's paintings of random blobs or beer cans, currently hailed as the products of "The New Master." What possible profit for us in accepting or rejecting the canon? What possible consequence can such debate have? Certainly none for Dannebrog! The concentration of the community on beauty is, I believe, an actual quality of the human spirit, apart from the palpable products of wood, canvas, stone, or fiber that we call folk art. Any determination of that quality's boundaries necessarily rests upon a previous, arbitrary, conventional establishment of the criteria for the articulation. The vagueness at the edges or conceptualizations or definitions, like folk art itself, can be cause for hand wringing or rejoicing—rejoicing because it is here that the questions lie, and the questions are more exciting than the answers.

The Arts: Fine and Plain
George A. Kubler

In our century, art has undergone such an inflation in every sense that we may rightly consider our theme of the fine arts and popular art to be nearly identical with an older conception that has today practically vanished, namely, the difference between *sacred* art and *profane*. Art museums fulfill many of the functions of churches, and the cult of art in museums has its clergy in the academies, universities, and schools, as well as its *cofradiás*, processions, exhibitions of relics, and adoration of sainted practitioners of the three holy crafts of architecture, sculpture, and painting.

But what of the profane aspect? In the Middle Ages, representations of everyday life and labor were confined to marginal places in manuscript illumination and on the lesser bands of portal sculpture, but these secondary portrayals of the labors of the months and of other secular subjects were all bound into an armature of theological beliefs and received from it a major increment of sacred meaning. Thus, the profane art of other, more religious centuries seems functionally different from the popular art we are discussing here.

That difference is explained mainly by the historical position of popular art. Wherever the authority of institutional religion was dominant, popular expressions were subordinated to the armature of religious belief to such an extent that secular or profane representations normally have no existence apart from religious ones. No secular statement had authority outside the framework

of religion, and all secular meaning was overlaid by the network of religious iconography.

To discuss the theme of fine art and popular art, it is helpful to approach the dilemma inherent in the subject when it is considered as an historical problem. This dilemma was first noted by George Boas when he observed that theories about history are based upon how the beginnings of history are valued.[1] He distinguished, accordingly, two modes of valuation. The first is an attitude of discontent with present civilization manifested as a "soft" or nostalgic primitivism. The second, or the "hard" variety, appeared after 1800 in prehistoric archaeology and ethnological science; it may be restated as a choice between Arcadian and Neanderthal modes of primitivism. Of course, both were once realities. When Boas examined various theories concerning the distribution of value in the history of the world, he noted the Renaissance view of history as a gradual degeneration from an early perfection; as well as the contrary Darwinian and Marxist view of history as progress toward future perfection; and the view proposed by Vico of history as a wave action, moving back and forth rather than in one dominant direction.

Fine and popular art evoke a similar dilemma as to social structure, in obliging us, if we are honest, to consider whether we value a "soft" or nostalgic society governed by the *people* more highly than a "hard" society governed by an *elite*, which takes the form of a choice between "folk" and "elitist" modes of social organization. Here are aristocratic and popular, as well as intermediate bourgeois theories of value. In both cases, whether of primitivism in history or of the sociology of art, our theories of value will depend on our attitude towards the present.

When thus considering the arts as an historical dilemma between conflicting theories of value, an advantage is gained in allowing us to see clearly the key part played here by the phenomenon of "good taste." It appears to function for all participants as an aesthetic backing to moral judgment. Right and wrong are reinforced as good taste and bad taste in a web of distinctions

[1] George Boas, *Essays on Primitivism* (Baltimore: Johns Hopkins, 1948). A. O. Lovejoy and G. Boas, *Primitivism and Related Ideas in Antiquity* (Baltimore: Johns Hopkins, 1935), ch. 1.

constantly distinguishing upper-class behavior from lower, and spreading across all forms of behavior, from speech and dress to table manners and gait. This coherently coded system of comportment corresponds to and reinforces social class. The "rule of taste" thereby becomes a consistent behavioral code assimilating "good taste" to "right conduct," and reaching from the "top" to the "bottom" of society, defining norms of conduct at each stratum. These norms also acquire statutory character through literature and art, whenever social class is the subject of representation.

This alliance between taste and morality is obviously related to official academies of right artistic practice. The academies, in effect, close the chain between class and morality through the link of the "rules" governing taste.

Turning to the present, popular art is a complex term that conveys at least three ideas to most persons: (1) as an art portraying in an everyday way everyday things and events, rather than recondite symbols; (2) as an art liked by nearly everybody; and (3) as an art associated with the people rather than with an elite. The first relates to iconography, the second pertains to the history of taste, and the third belongs to the history of social classes.

Fine art, in turn, is surely the equivalent of an older and now unfashionable designation as the noble arts, comprising architecture, sculpture, and painting. Fine art, again, conveys ideas about meaning, taste, and class, but it loses the idea of higher rank and of the individual identity of each of the personified arts that mourned the death of Michelangelo on his tomb erected in 1574, at the beginning of the official history of the Academy in Florence.

The fact that we are today discussing fine art and popular art as a binomial expression is peculiar to the present age, and it suggests that both kinds belong simultaneously to the history of meaning, of taste, and of social classes, rather than being separated, in the naïve sense that fine art is historical, but popular art is not.

Some years ago, when discussing the relation of Latin American painting to that of Europe, I suggested that two modes of transmission, horizontal and vertical, were effective between the

continents.[2] *Horizontal transmission* was from metropolitan centers in Europe to similar centers of Latin America, as when Americans received their artistic training in Europe rather than from each other in America. Thus Juan Cordero, returning from Rome to Mexico in 1853, was more representative of Italian schooling than of Mexican teaching. Diego Rivera also owed more in 1922 to Europe than to his Mexican teacher, the landscapist José Maria de Velasco.

Vertical transmissions, on the other hand, were more social than geographic, as when European imports were diffused into popular expression at different levels of Latin American society. A vertical transmission is also the reverse phenomenon of an upwelling from popular sources into official expression, as in Posada's relation to Rivera. We still know very little about these processes. They appear to have attained their peak in the nineteenth century, with folk-production of textiles and pottery, utensils and furniture all in an astonishing variety of regional and local types. These products, made in farms and villages, took the place of the courtly splendor of colonial art in church and palace. Each village came to have its specialties of pottery or clothing or furniture, which it traded with its neighbors in a marketing pattern that favored diversification more than standard products.

It was like a release of the rural population from the burdens of colonial taxation, and it ended with the appearance of modern industry and the imposition of new stresses disrupting agricultural communities and drawing their citizens to cities. But the "interlude of release" had allowed villagers and peasants to enjoy leisure enough to invent many new kinds of ornaments and decorations, before their reduction to a barren and proletarian existence in the slums of huge cities.

This at least is an hypothesis to explain the extraordinary florescence of the nineteenth-century Latin American crafts. There if anywhere are the archives of an expression shared unconsciously by Spanish-speaking villages from New Mexico to Chile and the Antilles. It differs from the horizontal transmission. It

[2] George Kubler, "Remarks on the Yale-Texas Exhibition of 'Latin American Art Since Independence,'" *Ventures, Magazine of the Yale Graduate School* 7, no. 2 (Fall 1967):61–67.

consists of progressive transformations, by simplification and enrichment, undergone by European forms in their outward and downward passage into the remotest and smallest structures of rural and urban life.

The nineteenth-century case of Latin America is possibly the paradigm of similar instances elsewhere and in other centuries, for which the revealing clues are less plainly evident.

In principle the necessary conditions may be as follows. Between regimes of intensive exploitation a period of respite for the rural proletariat occurs during the dismantaling of the *ancien régime* and the institutional reorganization of a new mode of social enslavement. The respite may be so brief that its effects are invisible, as during the Middle Ages in Europe, or during the dynastic disorders of the ancient world. But if the periods of interregnum are prolonged, the beneficiaries of the "interlude of release" will be the populations who are isolated from the seats of power by distance and poverty. These populations are the peasants and the villagers whose time during interregnum is their own after they have raised their own food.

It is an axiom here that people whose leisure time is both abundant and uncommitted will use that time in pleasurable activities, such as making various forms of art for delight rather than gain. Although gain may be a common and welcome by-product, it is not the prime mover, as in those distinct recent species which are tourist art and commercial kitsch.

Clearly, it is time to consider fine art and popular art as an indivisible binomial expression, in order to achieve the greatest clarification of both terms in relation to each other. But when this binomial expression is placed in historical perspective, its identity and autonomy as a binomial appear to vanish. When we search Byzantine art or Maya art at Dumbarton Oaks for convincing evidence of substantial traditions of popular expression, all art seems rooted in and governed by religious iconography. Scenes of everyday life are rare, and they seem to be relegated to marginal positions in what are often called the "minor arts" of manuscript illustration and/or pottery painting. On the other hand, the public expressions of architecture, monumental sculpture, and mural painting, which we know also as the "fine arts," all seem conse-

crated solely to statements of religious symbolism in relation to priestly and dynastic rulership. Whether or not this is an optical illusion and a flaw in historical vision will be discussed later.

The binomial term may be like a theorem in that each of its members must be related to the other, or else the exercise is an empty one. For example, the popular art of Mexico has an evident relationship to the academic art of the nineteenth century. Both Velasco and Posada become more and more understandable in relation to each other, but it is probably useless to invent a connection between Posada and Greek temple sculpture at the Parthenon.

On the other hand, unrelated or distantly connected kinds of popular art can be compared profitably. An example is the case of Andean seventeenth-century architectural ornament, compared with Mexican *tequitqui* carving. Additional comparisons with Coptic and Romanesque sculpture help to establish resemblances among different varieties of the planiform ornamentation they all share, and to weaken racist theories of their origin in pre-Columbian Indian traditions, or in the emergence of a *mestizo* sensibility.[3]

The historical examination of the binomial expression next leads us to the question of its antiquity and distribution: When did it first appear and how widely has it spread? A textural review is not in place here nor would it be an easy task to assemble the relevant sources, but a provisional answer seems possible without precise proofs at this time. If popular art is assumed to have been marginal under theocratic social organization, then its emergence as a separate kind of art may be related to the disruption of the rule of theocracy, and its replacement by more secular forms of authority.

In recent European history, the great divide between sacred and secular rule is marked by the French revolution and the Napoleonic reorganization of government, which had among its consequences the disruption of the control of aristocratic landowners over the labor of the peasants who raised the food. With

[3] Graziano Gasparini, "Las influencias indígenas en la arquitectura barroca colonial de Hispanoamerica," *Boletín, Centro de Investigaciones Históricas y Esteticas*, no. 3 (June 1965):51–61.

these releases by revolution of time and energy among the rural populations, we note throughout Europe the emergence of new forms of popular expression in all those crafts concerned with dress and furnishings.

Coinciding with the romantic revolution in sensibility and manners among urban people, the peasant liberation produced a recognizable European configuration of provincial and rural arts to which the generic name of *folk* art has come to be applied. Craft practices emancipated from academic rule are a characteristic trait of folk art; they are as well, the expression of individuality and an interest in nature. Folk art is usually presented in the forms of geometric stylization, with vivid colors and strong contrasts, spreading over the entire spectrum of the "minor arts" of decoration from the shores of the Mediterranean and from Scandinavia to the Iberian Peninsula and the plains of central Europe, wherever romantic sensibility and the liberation of the crafts from aristocratic and academic rule coincided.

The aristocratic form of oppression, however, had been relaxed only to be replaced before long by another tyranny following the Industrial Revolution, when banks and factories began in their turn to incorporate peasant craftsmen into the new labor pools, where international finance could invest in industrial labor, at the expense of the short-lived autonomy of the rural population.

We have witnessed, even in our lifetimes, the terminal stages of the transformation of folk art into tourist art, which is a redirection of popular energies into another mode of the exploitation of marginal labor for the amusement of vacationing industrial peoples.

Is any popular art of pre-Columbian origin? It has here been suggested that the necessary conditions for its appearance are the emancipation of people from an overlordship, whether theocratic, aristocratic, or militaristic. The Maya "hiatus" of the sixth and seventh centuries might be one such possibility.[4]

[4] T. Patrick Culbert, ed., *The Classic Maya Collapse* (Albuquerque: University of New Mexico Press, 1973). Gordon R. Willey, "The Classic Maya Hiatus: A 'Rehearsal' for the Collapse," in *Mesoamerican Archaeology: New Approaches*, N. Hammond, ed. (Austin: University of Texas Press, 1974), pp. 417–30.

At this time the making of public commemorative art, glorifying the godlike rulers of Maya society, ceased abruptly for a century in every form of expression. But we still lack a secure archaeological record for this dim period of apparent inactivity in the crafts, and we do not know of any figural art so distinct from elite traditions that we could assume its production by peasant craftsmen.

The resumption of public sculpture at the end of the hiatus continued for another three centuries. It appears superficially similar to the art of the period before the hiatus, but the structure of power looks different: priestly rule has yielded to dynastic lineage, perhaps as aristocracy yielded to finance in the nineteenth century, while the outward forms of respect to authority continued with subtle alterations.

Lacking a complete record of such changes, we can assume for the time being that the hiatus was only an interregnum. The "period of release" for the rural proletariat may have failed to happen. The hypothetical case is possibly useful in explaining the absence of a recognizable popular expression during the European Middle Ages, as owing to more persistent exploitation of the people by the elite.

A Mesoamerican phenomenon that needs discussion can be raised here. It concerns the permanence of the village, both pre- and post-Conquest. I shall use the examples of Mayapan (in Yucatan) and Cholula. Charles Gibson has magisterially reconstructed the colonial history of native settlements in the Valley of Mexico, showing from documents how Indian government was swiftly decapitated, being replaced at the top ranks by Spanish priests and officials, but leaving the lower structures of native authority intact.[5] This process, repeated throughout Hispanic America with minor regional and local variations, is perhaps the chief reason for the striking resemblances among villages and towns from New Mexico to southern South America, resemblances so close to local government, "town" planning, and architectural types, that colonial Spanish America rightly has been compared to the Roman Empire in the uniformity and permanence of its urban creations.

[5] Charles Gibson, *The Aztecs Under Spanish Rule* (Stanford: Stanford University Press, 1964), ch. 14.

But the colonial process was prefigured repeatedly in Meso-america and in the central Andes by native states using similar methods for the imposition of alien authority over old local institutions.

Mayapan is an example in Yucatan. Its monumental precinct is a reduced copy of the Toltec Maya buildings of Chichen Itza, hastily built with inferior materials to serve the ritual needs of a large agglomeration of dwellings closely crowded inside the city wall. The excavators during the 1950s were impressed by the decline in the quality of construction. The archaeological reports often refer to the degenerate character of buildings in Mayapan.[6] Comparing the evidence with Chichen, we must agree, but how shall we interpret the degeneration?

One possibility is that Maya peoples were here subjects of colonial government, expressed by the imitations of "official" buildings at Chichen. Yet in their own dwelling arrangements they reverted to ancient house-types and layouts. In the same way today, many towns in Latin America contain large areas of "spon-taneous" settlement where immigrants from the rural country-side settle and build informally, recreating the village in the city. But at Mayapan the ruins and the artifacts also suggest that alien authority had crumbled and vanished, leaving the people free to resume village ways without foreign interference. Yet their worship still was affected by the Toltec intrusion, as we know from large numbers of clay images representing Mexican deities for use in household ritual. These objects can perhaps be regarded as the equivalents in the fourteenth and fifteenth centuries of simi-lar religious articles of Catholic worship made by the inhabitants of Cholula for the feasts of the Roman calendar. Both Mayapan and Cholula may thus have in common the responses of villagers who reassert ancient folkways within the borrowed forms of for-eign religions. This rough model may be the framework common to other parts of the world where popular art has been abundant at different times in history, as in India, or in West Africa after the early European colonizations.

To detect the existence of popular expressions within the

[6] H. E. D. Pollock et al., *Mayapan, Yucatan, Mexico* (Washington, D.C.: Carnegie Institution of Washington, 1962).

dense ritual patterning of ancient Mesoamerican life is not an easy task. In the first place we are still unsure of the historical texture of pre-Columbian society as a whole: was it, as some believe, a homogeneous fabric showing little or no change during two thousand years, or was it, as I believe, a group of diverse historical traditions, each with its own capital places and dependent provinces? Second, the ranking of the principal centers of cultural activity is uncertain. We cannot yet be sure, for instance, whether Teotihuacan influenced Tikal directly, or indirectly, via relay points like Kaminaljuyu, or whether Chichen Itza received more from Tula than it gave during the Toltec-Maya domination. Finally, the analysis of stylistic influences and traditions in Mesoamerica has only recently begun, and the effort is still hampered by insecure chronologies and uncertain guesswork about commerce and trade.

Let us examine the first difficulty of the presumed unity of Mesoamerican civilization. As stated, it reflects our west European habits of resolving civilizations into a pattern of dominant regional centers, surrounded by dependent edges. Another difficulty with the presumed unity of Mesoamerican civilization arises over the definition of Mesoamerica. Recent thought prefers to exclude the West from the Mesoamerican cultural tradition. This is mainly because of the great differences between the relatively dense urban area lying east and south of the Valley of Mexico, and another western and northern area of thinly scattered, tribal villages. These surround the urban area like a Cimmerian outer world of impermanent settlements existing in what Carl Sauer called the "protective isolation of aboriginal living." [7] Their relation to other peoples is still uncertain.

These west Mexican peoples had a "tradition in figural art that is on the whole amazingly uniform," [8] lasting from 200 B.C. to about A.D. 500, being coeval with the late pre-Classic and early Classic of Central Mexico. Only two themes relate the tradition to central Mexican rituals: the ball court and an aged man bearing

[7] Carl O. Sauer, *Aboriginal Population of Northwestern Mexico* (1935; reprint ed., New York: AMS Press, 1977).
[8] Hasso von Winning, *The Shaft-Tomb Figures of West Mexico* (Los Angeles: Southwest Museum, 1974), pp. 80, 82.

a basin on his head who has been compared to the "Old Fire God" of the Valley of Mexico.

Several different views on west Mexican iconography have been advanced. The oldest and most widely shared is the argument that west Mexican art is secular in meaning, being illustrative of daily life, and free of supernatural symbols. Others oppose this view with the argument that west Mexican art was predominantly sacred and shamanic in its symbolism. Hasso von Winning more cautiously concedes that the figures belong to a widespread mortuary cult "emphatically representative of the living." [9]

To these views a fourth may be added, suggesting that west Mexican secular realism proceeds by oblique reference to represent sacred themes as existing in the acts and things of everyday life. Such was the practice of those medieval European painters of everyday life who preferred to express religious matters indirectly by portraying objects and scenes of daily familiarity, in an ancient tradition of simultaneous explanation on different levels that continues to the present in the occidental world.

West Mexican stylistic connections with the rest of ancient America today seem tenuous. The shaft-tombs from Colima to Nayarit are unlike the masonry chamber tombs of Oaxaca. The human figures of pottery from them do not resemble those of Jaina or Veracruz, nor are they related to the urns of Oaxaca. To the north, these traits are not apparent among the tribes of northwestern Mexico or the southwestern United States. Far to the south the resemblances between Mochica pottery in Peru and west Mexican sculptures are merely visual similarities, too general to document any historical connection.

Just this lack of compelling connection is what suggests the existence of a separate and autonomous style in western Mexico that resists efforts to reduce it to influences from elsewhere. It is a regional style of long duration and ample extent. Being an art of durable tombs seems to identify it as an art of the ruling class. Yet its transitional date, between the pre-Classic and Classic eras, suggests that it may have occurred during a period of relaxation between Olmec and Teotihuacano exploitations of west Mexican

9 Ibid., p. 82.

peoples. Finally, its stylistic genesis may relate to Guerrero and the early formative sources suggested by Xochipala.

For nearly four centuries, western peoples accepted the division separating the "fine" arts of architecture, sculpture, and painting from the "lesser" arts. This boundary was fixed by the academies of art, and it was faithfully observed in education and in professional life, until its general abandonment about the time of the Second World War. It also marked off a class division between "upper-class taste" and "lack of taste" among the lower classes. The tacit abandonment of the rule of taste in this century thus corresponds to a wiping out of class distinctions, as well as of the separateness of the "fine arts" from "the others." But the study and the teaching of the history of art have not accepted this levelling of the subject. Historians of art stubbornly retain the criterion of "quality," and their attention is still drawn to "great" artists and to the "greatest" works in museums and collections. The objects of "low quality" made outside the rule of taste for proletarian consumers still are not accepted as proper subjects for searching art-historical study by university faculties and museum curators in either western or eastern Europe.

The reason may well be that the humanistic study of western culture requires the retention of some part of the value system concerning the culture itself. Thus the history of art is like a play in which students and scholars must still act out the values of the vanished classes of society in order to reach some understanding of the meaning of class-bound works of art.

Be that as it may, the situation in the study of "arts that are not fine" remains precarious. Serious study is restricted to the decorative arts in the art museums, but it is still conducted under the criteria of quality. Only anthropologists today are concerned with "material culture," where the criterion of quality is disregarded in the search for such objectivity as the social sciences can achieve.

It is likely that the study of popular art can best be conducted in countries of complex racial and social history like Mexico, where many traditions coexist in the production of the richest stores of popular expression in existence, as we can see in the Museo Nacional de Antropologia e Historia.

But the study of these collections by anthropologists as "material culture" cannot satisfy the conditions of humanistsic study, where the relationship to the rest of history is necessary. For example, anthropologists have conducted many community studies, but the arts and crafts are treated as economic subjects, never as bearers of attitude and meaning, as in the history of art.

In conclusion, the two terms of our binomial theorem here again come together. As in a regenerative circuit, the study of popular art cannot now be conducted in the absence of full knowledge of "fine" art. Nor should it be entrusted solely to social scientists. Its study is perhaps the last of the major tasks of discovery for humanistic study in the visual arts. From it we can gain altogether new insights about fine art, much as historians like Marc Bloch have studied rural society to clarify the complexities of the oldest history of modern institutions.

All the arts are brothers,
Each one is a light to the others.

Voltaire

Folk Art from an Anthropological Perspective
Johannes Fabian and Ilona Szombati-Fabian

The reflections that follow are offered as a somewhat indirect contribution to the study of folk art in Euro-American contexts. Our own empirical material is chronologically and culturally removed from eighteenth- and nineteenth-century America that produced the objects which the twentieth century reevaluated as folk art. Our observations derive from research, conducted since 1972, on a vast corpus of paintings which we discovered in the urban-industrial region of Shaba in southeastern Zaire (formerly known as Katanga).[1]

Created by artists of the people and for the people, these paintings are displayed in private homes and in places of commerce and entertainment. Land- and city-scapes and, above all, historical-political scenes and portraits are striking to the outside observer (Figs. 1–4). Buyers of this art are the urban masses, people who left the rural and traditional worlds and now form an

[1] Research was initially part of a project on conceptualizations of work and creativity among Swahili-speaking workers, supported by a grant from the National Endowment for the Humanities. Further aid was received from the Rockefeller Foundation program at the National University of Zaire and from Wesleyan University. Their help and the kindness and cooperation of many artists is gratefully acknowledged.

Figure 1. C. Mutombo, *The Smelter (mumbunda na mampala)*. Lubumbashi, 1974. H. 39 cm., W. 68 cm. The smelter, a landmark of the city of Lubumbashi, represents the genre "city-scape" in the category of Things Present. (Photo, Ilona Szombati-Fabian.)

aspiring *petite bourgeoisie*, affluent enough to be concerned with furnishing and embellishing their habitations. Realistic presentation, narrative intent, and a surprising richness of generic differentiation characterize popular paintings in Shaba. Equally impressive is its sheer quantity. By now, the number of paintings in one of the major cities alone may be in the range of twenty to thirty thousand.[2]

These remarks may suffice to show the importance and interest of the art form we are investigating. But what is the relevance

[2] Unless otherwise specified, all paintings of the popular variety are in commercial oil paints or acrylics on unprepared canvas generally called *amerikani* (an old Swahili term for calico). In Shaba most painters use flour sacks from local and foreign mills. Because much of the imported flour comes from the United States, the local popular etymology of *amerikani* also points to the origin of these imports. The titles of paintings are, with some exceptions (Figs. 6, 11, 14, 15, 20–23), generic-descriptive as used by the painters and their clients. Whenever possible we note the Shaba Swahili or French version in parentheses. For further explanation, see Ilona Szombati-Fabian and Johannes Fabian, "Art, History, and Society," *Studies in the Anthropology of Visual Communication* 3, no. 1 (Spring 1976):1–21; see esp. pp. 4–6. All paintings are part of the authors' research collection.

Figure 2. E. Nkulu wa Nkulu, *Arab Slave Trader (waarabu, arabises)*. Likasi, 1974. H. 36.5 cm., W. 49 cm. An example for historical genres in the category Things Past. (Photo, Ilona Szombati-Fabian.)

of popular painting in an African country, as a corpus and an activity, for the study of folk art in general? Its most immediate significance, as is often the case with contemporary ethnography in relation to historical research, is that this particular corpus offers the spectacle of a folk art in bloom. People relate to these paintings without the slightest antiquarian interest. No one collects these objects (except us, the emissaries of an antiquarian culture). Most paintings can easily be traced to their creators. Information about socioeconomic conditions, materials and techniques, topics and meanings is available in a quantity and quality usually unknown to students of folk art.

But is it "folk art"? The question is important because the answer would seem to determine what we have to offer: Is it only interesting as an ethnographic parallel, or are we dealing with a phenomenon that is comparable to, and perhaps actually connected with, Euro-American folk art on aesthetic as well as on his-

Figure 3. K. Matchika, *War (vita, matroubles)*. Kolwezi, 1974. H. 42 cm., W. 72 cm. A remembrance of Things Past, depicting a skirmish between Tshombe's Katangese army and Luba rebels of northern Shaba fighting in traditional garb and with traditional weapons. (Photo, Ilona Szombati-Fabian.)

torical grounds? Since it is an avowed aim of this book to provide the basis for a better understanding of the term *folk art*, these questions need not be resolved unequivocally. Nevertheless, we can offer some tentative observations.

The suspicion that we might simply be dealing with a degenerate form of "primitive art" is easily disposed of. Traditional art in central Africa has been overwhelmingly tactile, mobile, and audial: sculpture (including pottery), dance, music, and oral lore. Representational painting on detached surfaces (i.e., other than walls, vessels, and the human body) is a recent import whose origins are quite well known.

Is popular painting in Shaba (and in many other parts of Africa) therefore only an import, an ill-digested imitation, or a contact-phenomenon of the tourist or airport-art type? We believe we can demonstrate that this is not the case. This art form is an integral part of cultural expression in an emerging postcolonial

Figure 4. Unsigned (Kayembe Ndala-Kulu), *Lumumba and King Baudouin of Belgium*. Kipushi, 1974. H. 48 cm., W. 60 cm. This painting belongs to the category of Things Present and to the genre of political portraits (*nsula, foto*). (Photo, Ilona Szombati-Fabian.)

society. For this reason, it might be one of the most interesting parallels with American folk art.

Is it "folk," if the meaning of that term is restricted to rural, peasant-based production of images? Should it, perhaps, better be characterized as "popular art" (as our own use of the attribute might suggest)? Clear distinctions between folk and popular are notoriously difficult to draw and even more difficult to apply outside the situation for which they were devised. This is the case with Henry Glassie's tripartite definition of culture as folk (conservative-individualist), popular (normative-mass oriented), and elitist (progressive).[3] These psychological cum political criteria

[3] See Henry Glassie, *Pattern in the Material Folk Culture of the Eastern United States* (Philadelphia: University of Pennsylvania Press, 1968), pp. 1–33, and Glassie, "Folk Art," in *Folklore and Folklife*, Richard M. Dorson, ed. (Chicago: University of Chicago Press, 1972), p. 258.

may describe a de facto situation in American history (although to think of elitist culture as inherently progressive seems even less plausible than to qualify all folk culture as conservative). His distinctions would not work at all in countries of the Third World, such as Zaire where an art form that is manifestly mass oriented and "popular," namely, recorded music, shows conservative tendencies; where the social and intellectual elite appreciates academic "shlock" in painting and sculpture; and where the people's painters give expression to a changing historical consciousness.

Nor do we think that technological conditions are sufficient to separate popular from folk productions. One might point out that hardly any of the objects considered to be folk art, and certainly very little that counts as American folk art, can ever be defined against, or outside of, the aesthetic and material conditions of industrial production and commercialization. If some pioneers of American folk art seem removed from the conditions and mechanics of industrial reproduction, such distance was only temporary. Since the late eighteenth century, and certainly since the development of chromolithography and photography, all folk painting occurred in the context of industrial reproduction.[4]

Of course, what remains to be done is to specify these relations. Cases where mass-produced images have served as models for folk artists are well known. More important is the overall life experience of an industrializing and urbanizing society and the ways that it affects folk art. Popular painting in Shaba offers vivid illustrations for such a situation. It is, as yet, radically different from Euro-American folk art in one respect. The paintings, apart from serving in transactions between producers and consumers (without intermediaries), are not part of a market.[5] It seems to

[4] The industrial context of American folk art was noted by some of the more critical contributors to "What is American Folk Art?: A Symposium," *Antiques* 57, no. 5 (May 1950): Holger Cahill, p. 356; Carl W. Drepperd, p. 357; John A. Kouwenhoven, p. 359.

[5] The transaction is not far removed from primitive exchange. Like other craftsmen in these towns, the painter sells his product at a price just high enough to give him a daily income comparable to that of other workers and artisans. If, in 1972–74, he sold a painting at about one to five dollars then he would have to paint about one every day. The price of the painting reflects the value of materials (and therefore varies with size) and the artist's labor.

us that the character of art in the West as merchandise, folk art not being an exception, is the most basic, if not most salient, quality to which a critical reflection must address itself.

FOLK ART, THE LOGIC OF THE MARKET, AND ANTHROPOLOGY

Let us begin by observing that there are always two "movements" operating when folk art (and probably any art) is evaluated. One is directed to individual objects, sometimes individual producers, whose value is gauged according to a set of criteria beauty, originality, formal perfection, elegance, etc.). As a general attitude toward art, this may be called "aesthetisizing." This is not to say that such an attitude is merely aesthetisizing, in other words, that it is contemplative and rather inconsequential. On the contrary, when it is directed to, and pronounced over, concrete objects, it has the practical effect of assigning to them a distinctive value, something that might be called a denomination.

The other "movement" of evaluation goes in the opposite direction. Denomination of objects implies a scale; in fact, it presupposes a corpus (a currency or reserve) which guarantees comparability and actual connection between valued objects. The search for contexts and connections gives rise to an attitude we might call "sociologizing." One often is led to believe that the corpus is then given (and hence the natural starting point for inquiry), whereas the objects are the problematic aspect. In reality, as in the case of folk art evaluation, the object is found (collected) and the corpus is problematic. Because it is problematic, the corpus needs legitimation (like a currency) and such legitimation is necessarily abstract. By this we mean a tendency which not only does not seek to fill its corpus-concepts (such as folk art) with concrete historical, social, and political significance but which, in a way, must avoid concretization. The reason is that concretization jeopardizes the currency value of a corpus, hence makes clear denomination difficult or impossible, hence annuls the value of individual objects. Let us call this process the logic

A separation between use/exchange value and market value (one that would permit the "circulation" of paintings) has not yet occurred.

of the market. Notice that we use the term *value* equivocally. Do we mean artistic or commercial value? The answer is that we mean a system of exchange of which this distinction is as much an integral part as those between form and content, structure and function. Under conditions that govern our relationship to art in the Western world, art appreciation is always also, and sometimes nothing but, art appraisal.

If there is any validity to this view—that sociologizing of art if carried out in complicity with the logic of the market espoused by our own society must lead to abstraction from historical-political concreteness—then it follows that an anthropology of folk art cannot have the simple task of providing ethnographic data for a "better" sociology of the corpus. At best, this would amount to projecting the logic of the market onto societies other than our own or on classes other than the leading elites. Being purely projective—in this sense hallucinatory—anthropology would have no power whatsoever to generate new knowledge. At worst, it would be actual, practical complicity with the many attempts our society has made to absorb the creations of other societies into its logic of the market. This happened some time ago with "primitive art" (Eastern and pre-Columbian art included). More recently, the market has turned its attention to various contemporary art forms such as Eskimo carving, Haitian, Balinese, and Australian painting—in short, the many "contact" arts.

Of course, one might ask, what is wrong with the logic of the market? Some answers come immediately to mind: it leads to grave-robbery and cultural thievery on a grand scale; it creates a kind of market where profits realized by intermediaries are in no relation to the benefits that go to producers, i.e., it creates a kind of exploitation that can be explained but not excused by the mechanics of a free market. In the long run, this sort of art market creates a kind of dependency which is not only political or economic but also intellectual and aesthetic.

Another question is even more vexing theoretically: Can any "art of the others," be it primitive, folk, naïve, or contact, be confronted (experienced, researched, understood, interpreted) outside the logic of the market? Notice that this question does not

regard motives or moral intention but rather epistemological conditions. Does the fact that we belong to societies in which objects of art are inextricably part of a market and its laws condemn us to a specific kind of relationship to, and view of, folk art? A negative answer seems obvious if we consider that the same bourgeoisie that created the market brought forth many different, often violently opposed attitudes toward, and theories of, art. On the other hand, one may look at things the other way round and wonder why such a variety of aesthetic and historical approaches to art is espoused, given the rather unvarying nature of the market. One is then tempted to conclude that all that theoretical pluralism is only superficial and that it really functions as a verbal screen concealing the hard reality of a worldwide market in a commodity called art.

In any case, for the anthropologist who is aware of the logic of the market but must try to carry on a dialogue with other cultures, the choice of a theoretical position and its methodological consequences become a matter of very careful and critical reasoning. On his choice depends not only whether he will be close to one or the other school in the vast field of art studies. Something more fundamental is involved. Theory, in this case, will determine and in a way constitute his object of study. This must be so because the anthropologist as a mediator between cultures and societies (and increasingly between classes and ethnic groups) cannot naïvely rely on a tradition of art production, nor can he naïvely join a school of interpretation. He is essentially without support from the two pillars of science: empiricism, which rests on an ultimately metaphysical assumption that there is a reality out there to be observed, conceptualized, and classified, and conventionalism (to avoid "positivism") which dictates that these operations be carried out according to established canons of logic and procedure. This is the meaning, perhaps not fully realized by its author, of Jacques Maquet's remark that there "cannot be an anthropology of art." [6] "Art", we need to be reminded, is an estab-

[6] Jacques Maquet, *Introduction to Aesthetic Anthropology* (Reading, Mass.: Addison-Wesley, 1971), p. 17. This essay should be of much interest to students of folk art, although it does not, in our opinion, overcome the two alternatives of aestheticizing and sociologizing.

lished object of inquiry only within the limits—epistemological, but also political and economic—of our own Western societies. Maquet's radical formula signals the limitations on the possible use of anthropology for established art studies in the more narrow sense. But it also points to its potential for any attempt to transcend the intellectual boundaries circumscribed by the logic of the market. Anthropology can, specifically, address itself to the more subtle paradoxes created by bourgeois aesthetics, such as formalism vs. substantivism or contentism, contemplation vs. explanation, l'art pour l'art vs. sociological reductionism, art theory vs. art history, and so on and so forth.

Most recently, the anthropologist Clifford Geertz located his own conception of "art as a cultural system" in one of these paradoxes: Somehow we feel, he observes, that all talk about art is vacuous, but we cannot resist talking about it. He points out that as a solution to this dilemma some societies have developed discourses about art that are defined in craft terms, as technical languages (so that some may talk about art and others shouldn't). But, he maintains, our society is the only one in which "some men . . . have managed to convince themselves that technical talk about art, however developed, is sufficient to a complete understanding of it; that the whole secret of aesthetic power is located in the formal relations among sounds, images, volumes, themes, or gestures." As he shows later on, through examples as varied as Javanese ritual choreography, Yoruba sculpture, and Arab verse making, most talk about art in most societies is not of that kind. This leads him to conclude, from an anthropological perspective:

The definition of art in any society is never wholly intra-aesthetic, and indeed but rarely more than marginally so. The chief problem presented by the sheer phenomenon of aesthetic force, in whatever form and in result of whatever skill it may come, is how to place it within the other modes of social activity, how to incorporate it into the texture of a particular pattern of life. And such placing, the giving to art objects a cultural significance, is always a local matter.

This may sound as if Geertz had opted for the sociologizing shortcut in approaching art. But the thrust of his essay is directed

against this tempting way out. In looking for connections between art and society, one must reject aesthetisizing as well as
functionalizing. The connection worth looking for, Geertz insists,
is a semiotic one: "Art is ideationally connected to the society . . .
not mechanically," or, put in a slightly different way, works of art
"are directly about [society] not illustratively." Paintings, statues,
etc., "connect to a sensibility they join in creating." [7]

These few quotations suffice to evoke, if not adequately justify, a theoretical position similar to our own. Stated in a summary
and axiomatic fashion it maintains: (1) That artistic expressions
("objects") in our own society and, *a fortiori*, in societies other
than ours cannot be presumed to constitute ensembles, corpora, systems; nor can such ensembles simply be established on
the basis of immediately observable formal or substantive properties. Hence, the inevitable necessity to talk about art which in
turn rests on the connectedness of art with all expression of human life. (2) That this connectedness and talk about it (i.e., discourse about art) is irreducible to mechanical or functional (economic, psychological, sociological) links. The connection of art to
culture is not given but made; it is not structure but process.
Hence, it is uninteresting (and probably misleading) to look for
ways in which arts match other aspects of culture. Anthropology
seeks to understand how art realizes and produces culture.

If the connection of art and society lies in processes, it becomes crucial to have a conception of the nature of such processes. Geertz, as we have seen, maintains that the connection is
semiotic. We can accept this as a general frame, but we do think,
based on our own research experience, that this concept needs
further precision. To hold a semiotic concept of culture is to assert that cultural expressions have a sign function ("symbols" in
American anthropology, signifiers-signifieds in French structuralism). Cultural process, then, is semiosis: the transformation of
human experience into shared significations. Such a view is preferable to many other approaches in anthropology, past and
present, which tend to do away with culture, either by declaring

[7] Clifford Geertz, "Art as a Cultural System," *Modern Language Notes*
91 (1976):1474–75, 1478, 1480.

it a secondary product of socio-economic adaptation, or by insist-
ing so much on its autonomous character that culture is in effect
removed altogether from human praxis. But the notion of semio-
sis alone is too general and too abstract and therefore susceptible
to as much ideological misuse as, for instance, the logic of the
market.[8]

Methods and techniques derived from semiotic theory make
possible intricate analyses of objects, or classes of objects (if one
follows the French bent); they may result in superb contextual ac-
counts (masterfully exemplified in the work of Geertz). However,
both procedures, although they start with a process-oriented con-
ception of culture, tend to result in synchronic, static accounts.
This is because a conception of culture as semiosis alone, i.e.,
either as signification or as symbolization, may describe the nature
of relationships between things cultural but it does not really
address the problem of their genesis or, more precisely, of their
production. In other words, we feel that we can only go along
with Geertz's postulate that connections between art and society
are "ideational" if ideation is seen as a practical activity, a mode
of production. A theory of art- or image-production is needed pre-
cisely because it is the only way in which we can ask questions of

[8] It should be remembered that Ferdinand de Saussure was quite con-
scious of homologies between this theory of semiosis and political economy
(especially with regard to the notion of value); see Saussure, *Cours de lin-
guistique générale*, Tullio de Mauro, ed. (Paris: Payot, 1975), pp. 114f., 157.
Many observers have noted this but it is probably Jean Baudrillard who drew
some of the most astute and disturbing conclusions; see Baudrillard, *L'échange
symbolique et la mort* (Paris: Gallimard, 1976). See also Ferrucio Rossi-
Landi, *Sprache als Arbeit und als Markt* (Munich: Carl Hanser, 1972),
especially the chapter on Wittgenstein. In our own work we have found that
semiological analysis may be descriptively useful; see Szombati-Fabian and
Fabian, "Art, History, and Society." But we do not think that a formalized
theory of semiotics will be of much use to the anthropologist; for example,
see Umberto Eco, *A Theory of Semiotics* (Bloomington: Indiana University
Press, 1976). The reason is that anthropology must be concerned more with
the production of signs than with the mechanics of signification if its aim is
to interpret culture as process. Furthermore, we do not think that philosophi-
cal problems such as that of the "subject of sign interpretation" have been
resolved; see Karl-Otto Apel, "Szientismus oder transzendentale Hermeutik?"
in *Hermeneutik and Dialektik*, Rüdiger Bubner, Konrad Cramer, and Reiner
Wiehl, eds., 2 vols. (Tübingen: J. C. B. Mohr [Paul Siebeck], 1970), see
esp. vol. 1.

art that go beyond the logic of the market in our own society, questions that reach beyond mere projections of that logic onto the arts of other societies.

In this sense, we advocate a genetic constitutive view. But we do not propose that our understanding of an art form will be guaranteed if we know its origins and subsequent evolution. For us "genesis," "constitution," and "production" are epistemological concepts. The only way, we feel, to avoid projecting extraneous schemes on art forms, in fact, the only way to be sure that a set of objects is actually a kind of cultural expression which may be designated as art is to gain access to the concrete, material conditions of their production. Only if knowledge is mediated in such a way can we hope to understand the process of semiosis in societies and classes other than our own. Paradoxically, or perhaps not at all, to emphasize material production leads one to give all the more importance to talk about art, more precisely, to communication with producers and consumers about their products. Such talk is an important part of ethnography, and this is the main reason why anthropological investigations of art production can contribute to our understanding of art in general. Our work, carried out *in situ*, can complement approaches which, by necessity or by choice, have been guided by contemplative or classificatory, i.e., noncommunicative, discourse.[9]

The question is now what difference such an approach—

[9] That position is summarized in the following statement from our earlier essay: "For us, anthropological knowledge of this art form is neither mere classification of objects according to the schemes of a logic of inquiry, nor simply transformation of a presumed ethnographic domain into a structured system. Rather, the kind of knowledge we are seeking *constitutes* its object through confrontation with its material, visual, and observable manifestations, *and* through V*erständigung*, a process of understanding of, and agreement about, these manifestations based on communicative interaction with their producers and consumers. In other words, we neither assume a 'given' reality in the form of discrete objects ('painting'), nor do we presume a domain of thought and action (such as 'art');" see Szombati-Fabian and Fabian, "Art, History, and Society," p. 1. We might here acknowledge a general debt to the writings of Benjamin, Lukács, Raphael, and others, although we cannot in this context discuss specific elements of their theories of art production. We should like to point, however, to a very interesting study by Hans Heinz Holz, V*om Kunstwerk zur Ware* (Darmstadt and Neuwied: Luchterhand, 1973).

semiotic, genetic, and communicative—would make with regard
to problems encountered in the study of folk art. Because folk art
is not our field of competence, we are not prepared to offer a sys-
tematic statement. Instead, we will select a small number of issues
that we, from our limited readings in the field of folk art studies,
perceive to be recurrent, indeed perennial, challenges faced by
students of folk art. We will assume that, in the present world,
barriers to understanding that exist between different cultures (the
traditional domain of anthropology) and those between different
classes (the traditional domain of sociology) are essentially ho-
mologous. In other words, anthropology can, in theory at least,
bring insights to the study of folk art seen as a differentiation of
artistic production in our own society.

ANTHROPOLOGY AND SOME RECURRENT PROBLEMS IN THE STUDY OF FOLK ART

Having noted our reflections on a number of typical prob-
lems arising in the study of folk art, we found that they could be
grouped around three issues: identity, quality, and meaning. Iden-
tity asks what should be counted as folk art (in the sense of be-
longing to a recognized domain, corpus, or period). Quality goes
beyond classificatory or genetic problems and regards the nature of
folk art as it is visible in a given object. Meaning signals the
difficulties we seem to have in understanding and appreciating
folk art. The question of meaning is especially urgent because we,
the interpreters, do not usually belong to the class or society that
produces (or produced) this art.

In art historical praxis, the question of *identity* of works of
art and their components arises first. Anthropologists cannot pre-
sume to contribute much to a craft established in several cen-
turies of historical and iconographic research. The standards of
attribution, historical derivation, authentication, etc., that were
developed in this tradition constitute a craft which probably can
be challenged only on its own grounds. Yet, as we tried to show
by bringing up such notions as the logic of the market, any search
for the identity of an art object raises questions of a higher order

than those that regard attribution to an artist, a school, or a period.

In fact, it may be precisely the high standards and achievements of identification in high art that tend to create or reinforce the first recurrent problem in folk art to which we want to address ourselves: its fragmentariness. The fragmentary character, not only of our knowledge but of almost any given cultural record, has been an anthropological problem since the beginnings of the discipline. We can pass some of its more obvious aspects in rapid review: There is, first, the problem of what one might call *de facto* fragmentation due to two main reasons and often to a combination of both.

The first reason is fragmentation caused by accidents of preservation. A given corpus of objects may appear fragmentary and disjointed because, and as long as, we try to establish its identity and coherence *only* on the basis of properties displayed by the objects. This is a situation that will lead to great emphasis on formal attributes—shape, decoration, and a host of other criteria often subsumed under the cover-all term *style* (as in pottery style) or even *culture* (as in megalith culture). The early study of material culture and the emerging field of preclassical archaeology (i.e., archaeology without support from written sources) were dominated by these concerns until a praxis of anthropological fieldwork in living contexts was firmly established. Together with the latter there appeared a theoretical trend often called functionalism and characterized by an emphasis on the systemic nature of culture and its socioeconomic determination. It was at the convergence of these practical and theoretical developments that the so-called "new archaeology" emerged in the late 1950s (later to be bolstered by computer techniques and cybernetic views of cultural systems). What interests us here is the theoretical optimism generated by the new archaeology which at times almost made a virtue out of the vice of fragmentariness in the archaeological record. Archaeologists and prehistorians no longer felt limited to a few objects and some stratigraphy; they now reveled in relationships *between* objects, in micro- and macro-contexts and in the relationships between assemblages and ecological data. Vertical stratigraphy (the analog to art historical chronology) be-

came less important with the advent of C_{14} dating; complex and far-reaching systemic relationships, synchronically and diachronically, now generated the research problems and often led to impressive results. Students of folk art who are often plagued by the fragmentary character of their collections and who are searching for models to overcome this state of affairs might profit from consulting recent archaeological literature.

In passing we might also note the developments in post-classical archaeology (often called historical archaeology and industrial archaeology in which these new techniques are applied to periods that were not traditionally the domain of archaeology (e.g., eighteenth- and nineteenth-century New England factories and workers' settlements). Finally, although this may at first seem a bit far-fetched, we perceive intellectual affinities between these new achievements and the approaches advocated by George Kubler and the "archaeology of knowledge" proposed by Michel Foucault. What they all have in common is that considerable intellectual energy is directed to the problem of fragmentariness (or "dispersal"); all seem to agree in their refusal to accept fragmentation as a mere fact.[10]

Fragmentariness due to inadequate preservation is not unrelated to another kind of fragmentation which, ironically, is often caused by the very concern for preservation: collecting. Much as archaeologists have been plagued by the havoc created by grave robbers and amateurs, the study of folk art must constantly confront the damage caused by collectors (although the study itself would probably not exist without them). Collecting almost inevitably results in fragmentation, sometimes because it is done at random, sometimes because it is carried out with a narrow purpose. But, unlike grave robbery and amateurism, which are now universally disdained, the art collector's privileges are rarely questioned and frequently exalted. We find this reaffirmed with disarming frankness in a recent catalogue to an important exposition of American folk art written by two eminent authorities: "The process of selection [of objects to be exhibited] was similar to

[10] See George Kubler, *The Shape of Time* (New Haven: Yale University Press, 1962), and Michel Foucault, *The Archaeology of Knowledge* (New York: Harper, Colophon Books, 1976).

that of the *Guide Michelin*, where, from thousands of restaurants and hotels in France, a small number is listed for special quality." [11] This sort of intellectual tourism and connoisseurism is adopted, magnified, and consecrated by the dictates of a publishing industry which has made the coffee-table art book the principal vehicle for the popularization of scholarship.

Students of folk art may profit from discussions and developments in anthropology, especially from recent studies of primitive art and a renewed interest in material culture. In our own area of competence, African art, we can point to a growing number of excellent critical appraisals.[12] Their most striking common trait is, perhaps, an increasing subtlety and complexity in tracing the contextual determinants of art production. Even more important are the signs of an epistemological breakthrough: the realization that new and significant knowledge in this field can be generated when the ethnographer/collector interacts through the objects with their producers and consumers. Ethnography then becomes a communicative activity, and we find a growing awareness that communication is the only basis on which to build a discourse about an art form that does not amount to mere projection of extraneous and often ethnocentric criteria.[13] One may object to this view on the grounds that the student of eighteenth- and nineteenth-century American folk art can no longer interact with its producers. Yet this condition does not altogether invalidate the theoretical significance of the "new ethnography." To show this we must first consider the other major aspect of the fragmentation problem.

[11] Jean Lipman and Alice Winchester, *The Flowering of American Folk Art (1776–1876)* (New York: Viking Press, 1974), p. 6.

[12] For instance, see Warren L. D'Azevedo, ed., *The Traditionalist Artist in African Societies* (Bloomington: Indiana University Press, 1973); Anthony Forge, ed., *Primitive Art and Society* (London: Oxford University Press, 1973); Douglas Frazer and Herbert M. Cole, eds., *African Art and Leadership* (Madison: University of Wisconsin Press, 1972); and the debate on authenticity in "Fakes, Fakers, and Fakery: Authenticity in African Art," *African Arts* 9, no. 3 (April 1976):21–31.

[13] Regarding the theoretical foundations of such an ethnography, see Johannes Fabian, "Language, History and Anthropology," *Philosophy of the Social Sciences* 1, no. 1 (January 1971):19–47; and Kevin Dwyer, "On the Dialogic of Field Work," *Dialectical Anthropology* 2, no. 2 (May 1977): 143–51.

The vagaries of history and the whims of collectors are often reinforced by what we would like to call "ideological fragmentation." What is to be considered fragmentary and what complete cannot simply be determined with reference to a given record for the simple reason that the kinds of totalities, of which particular objects are supposed to be parts, are themselves theoretical constructs. Let us illustrate this point with the one totality concept which supposedly is the distinctive domain of anthropology and has been freely borrowed by other disciplines: the concept of culture.

To see the result of an uncritical use of this concept, one only needs to recall the astounding temerity with which diffusionists and earlier archaeologists constructed "cultures" from a few potsherds and implements (enjoying of course the respectable company of art historians and many of their "schools" and "styles"). Then there are other, seemingly less harmful, totality concepts such as the tribe (or tribal culture) and its contemporary reincarnation, the ethnic group, which, predictably, is gaining currency in talk about folk art. Such concepts, we must insist, are never mere generalizations (i.e., convenient classificatory labels derived from the study of particular objects); they always are imposed concepts of order and consistency. Nor are they harmless in the sense that they would make little practical difference, provided they are used as mere tools. Anthropologists have come to realize that their musings about culture—whether, for instance, there should be one standard of culture as opposed to the uncultured, or whether there are only cultures, pure difference without an overriding oneness—are eminently practical and indeed often political in nature.

A short and excellent critical analysis of the culture concept in anthropology, recommended to anyone who uses the term *culture* in vain, is Zygmunt Bauman's *Culture as Praxis*.[14] Bauman demonstrates that culture is at best a field of discourse, i.e., a field of questions and problems in which to move, not a label on whose proper usage one could agree. Historically, culture has been used in a hierarchical sense (high versus low, Western versus

[14] Zygmunt Bauman, *Culture as Praxis* (London: Routledge & Kegan Paul, 1973).

primitive) and, somewhat later, in a differential or relativist sense (one people-one culture). Confusion between the two ways of using the term has been helpful in camouflaging elitist interests (such as when we talk about acculturation and modernization). Calling a given cultural record (folk art) fragmentary may not be a neutral statement of fact at all. It may imply a characteristic of a stage, level, or kind of culture. Much of the talk about unsystematic, sporadic, individualistic creativity in folk art must be examined in light of these critical insights.

Although we would not follow Bauman in his solution to the problem, we agree with him when he stipulates that conceptualizations of culture should aim at understanding "the human praxis." [15] We will now report on our own attempt to see popular painting in Shaba as a cultural praxis.

To begin with, the odds were against such attempts, and we think that our situation was a fairly typical one. At the outset, there were only two models available to deal with identity in contemporary African painting. The first model is totally derivative from traditional art history and leads one to concentrate on the identification and monographic description of schools, styles, and periods. It presupposes highly visible (institutionalized) production around major artists or workshops and often, also, a sort of bridgehead in Western society in the form of collections or galleries that promote particular art forms.[16] Such situations exist and were typical of the colonial period during which African painters gained recognition and patronizing support because their work was European-initiated, -evaluated, and -marketed. Until and unless these art schools are restudied in their historical context, they are of little theoretical significance for our problem. Popular painting in Shaba is not organized around masters or schools; it was neither directly initiated by expatriates, nor has it reached their markets.

Another model could have been that of tourist or airport

[15] Bauman, *Culture as Praxis*, p. 117.
[16] Exemplified by Ulli Beier. *Contemporary Art in Africa* (New York: Praeger Publishers, 1968); Marshall W. Mount, *African Art: The Years since 1920* (Bloomington: Indiana University Press, 1973); and Judith von D. Miller, *Art in East Africa* (London: Frederick Muller, 1975).

Figure 5. Y. Ngoie, *Mermaid (mamba muntu)*. Kolwezi, 1974. H. 49 cm., W. 75 cm. Mermaid paintings are quantitatively the most important product of popular painting in Shaba. Their generic status is that of a "totalizing symbol" for the entire corpus. (Photo, Ilona Szombati-Fabian.)

art. Here is a field of inquiry that was often conceived in revolt against elitist, Western-imported aesthetics, but it is addressed to products that are the result of contacts with an outside world and that depend on commercialization in an outside world.[17] In regard to popular painting in Shaba, the first model applies, although it would need much specification, whereas the second model—commercialization outside—exists in rudiments only as inner-African trade.

We chanced upon popular painting in Shaba in the course of other pursuits—without a scholar's project or a collector's purpose. We found our first two paintings in two cities, two hundred miles apart, one in the house of a mine worker (Figure 5 is an example of the genre; we did not acquire this particular painting); the other (Fig. 6) was on a street where a man carried it to-

[17] For the first attempt to gather results of research and to construct a theoretical frame, see Nelson H. H. Graburn, ed., *Ethnic and Tourist Arts* (Berkeley: University of California Press, 1976).

Figure 6. Tshibumba Kanda Matulu, *One People, One Leader, One Party*. Lubumbashi, 1974. H. 39 cm., W. 69 cm. The title is a slogan of President Mobutu's Movement of the Popular Revolution. (Photo, Ilona Szombati-Fabian.)

gether with others (it was the first painting we actually bought). We had never seen paintings of this kind in the curio markets of Zaire, nor had they been offered to us by the many traders in "genuine" African art who called on us with exasperating regularity. In other words, our first encounter with popular painting had all the marks of accidental, in this sense fragmentary, curiosity. In retrospect, we know that the concrete situation in which we came upon these two paintings contained many of the ethnographic elements which later allowed us to overcome initial impressions of disjointed curiosity and to describe popular painting in Shaba as a distinctive cultural process. These ethnographic elements were: (1) One painting was part of the furnishing of a living room. The room was itself the result of a differentiation of living space directly related to socioeconomic conditions of incipient embourgeoisement. As a concept, the living room (*salon* in local parlance) gave rise to a distinctive set of objects such as furniture, certain textiles, but also "decorative" objects crafted from wood or metal. (2)The two paintings were (topically) quite different from each other, suggesting thematic and,

probably, stylistic variations whose magnitude and significance was, of course, impossible to assess at that time. (3) When it turned out that the first painting was bought locally, and when we found out that the person selling the other one was the painter himself, we had our first glimpse at the "relations of production" that characterize this art form.

The theoretical and methodological significance of these few observations is this: In every one of our encounters with problematic objects, the particular painting mediated, i.e., signaled, gave access to, total contexts (urban life style, economics, a certain aesthetic sensibility, and, indeed, a kind of consciousness or world view). The full implications of these initially perceived totalities had to be worked out in a long ethnographic process. We had to enter not one but many houses, follow producers and networks connecting them, join, through the local language, in talk about these pictures, research regional political history, and so on and so forth. But the point is that these totalities were not simply generalizations established by classifying a large number of objects. They were arrived at in a constant back and forth movement from particular object to often surprising connections and between different objects defying quick and easy classification. In this sense, the fragmentariness with which a folk art presents itself, if understood as differentiation and dispersal in a cultural context, is an essential prerequisite toward establishing an identity that is not merely imposed from the outside.

Finally, another problem which is related to the question of identity is the often observed and sometimes lamented *anonymity* of folk painting. This issue is frequently clouded by comparisons to the self-effacing anonymity of medieval masters; it also carries romantic, nineteenth-century overtones of nostalgia for the anonymous, collective soul of a people as a creative source of art. Concretely, the problem may be approached with regard to the role of signature, and here again we can offer some observations based on our research. Most of the popular paintings in Shaba are signed; in our sample less than 1 percent were unsigned. Yet the presence of a signature is very often an equivocal datum. Discarding cases of false or faked identity, we encountered the following complications.

Figure 7. E. Nkulu wa Nkulu, *The Belgian Colony (fimbo, colonie belge)*. Lubumbashi, 1973. H. 40 cm., W. 55 cm. This represents the most important genre in the category Things Past. (Photo, Ilona Szombati-Fabian.)

Paintings signed by one painter were in fact produced cooperatively (sometimes approaching assembly line conditions similar to those known from the production of schlock art "originals" in our own society (shop and procedure are illustrated in Figures 7, 8, 9). Paintings were signed, not by the artist who executed them, but by the owner of the means of production (paint and canvas, brush, stretcher). Painters signed with a *nom de pinceau*, e.g., "Laskas". One outstanding painter, very intent on establishing his authorship, often signed with *"d'apres . . ."* (Fig. 10). According to Western conventions this suggests a copy after an original. The same painter hid his name elsewhere in the picture. See figure 11 where the shop sign "galerie Laurent Marcel" contains his Christian names. In a variant practice the painter's home town or territory was used as an inscription on a colonial building (Fig. 7).

There are probably other examples, but these are sufficient

Figure 8. The painter Nkulu wa Nkulu at work at his "studio" in Likasi, 1974. (Photo, Ilona Szombati-Fabian.)

to suggest that identification through signature is not merely a matter of labeling and attribution. The signature is but a special case of the interpretation of linguistic messages and their relation to iconic messages.[18] Such interpretation must be addressed to the process of image production, which in turn calls for attention to the total context as it was described earlier. Concretely, the examples of problematic signatures are challenges to our own cultural canons which predispose us to attach the identity of a work simply to its author (a Rembrandt or a Pollock). From an anthropological point of view, conceptions of authorship (and also of ownership) cannot be treated as transcultural constants. Like all things cultural they are semiotic; they call for interpretation.

We now turn to a second group of often discussed issues in the study of folk art. These issues treat the question of whether

18 This is dealt with in Szombati-Fabian and Fabian, "Art, History, and Society," p. 13f., for further references to literature.

Figure 9. The painter Matuka showing his work at his "studio" in Likasi, 1974. (Photo, Ilona Szombati-Fabian.)

the "folk" in such art is reflected in the quality of its products. *Quality* here has two different but not unrelated meanings. One refers to a descriptive question: Are there formal or stylistic characteristics typical of folk art? The other aims at evaluative statements: Is folk art inherently of "minor" quality (a rule only confirmed by occasional bursts of genius) or, if this is not the case, what makes of certain instances of folk art "masterpieces" comparable to the products of academic art? To us, the interest of these two questions of quality lies in the fact that they are not easily separated. We will illustrate this point by discussing some stereotypes commonly used in evaluative talk about folk art: repetitiveness (or repetitiousness?), decorativeness, and triviality.

As is often the case with stereotypes, "repetitiveness" may hide any number of understandings. We will try to disentangle some of these. First, when attributed to folk painting, repetition or repetitiveness may carry a positive connotation. In that case, it may point to the craft-character of image production. Like the

Figure 10. Tshibumba Kanda Matulu. The
detail shows the painter's signature on a
"Belgian Colony." (Photo, Ilona Szombati-
Fabian.)

master cabinetmaker who builds his furniture in recognizable
forms and always with the same excellence, the folk artist may be
depicted as a reliable but predictable creator. Careful execution
and solid appearance are the results of such craftsmanship. Of
course, such an image is not without its ideological underpin-
nings. True artistic creativity, it seems to imply, comes in rare
bursts and results in rare, nonrepeatable achievements. In this
way, repetitiveness, even if at first it may appear to have a positive
value, serves to distinguish folk art from high art.

But repetitiveness is not only predicated on an artist's
oeuvre (i.e., on a sequence of products); it is often pointed out in
individual paintings, as if the routines and rhythms of craft pro-
duction had crept inside the image and affected its form and com-
position. This type of evaluation underlies one of the common
denominators of folk art stipulated by Lipman, namely, that
"lack of formal training . . . made way for interest in design rather

Figure 11. Tshibumba Kanda Matulu, *Long Live the Thirtieth of June—Zaire Independent.* Lubumbashi, 1973. H. 44 cm., W. 70 cm. A remembrance of Zairean Independence Day, in 1960, this painting belongs to the category of Things Past. (Photo, Ilona Szombati-Fabian.)

than optical realism." [19] Formulas of this kind are packed with unarticulated critical standards. One need only follow lines of association inspired by the terms *formal training* and *optical realism.* They suggest nothing less than nineteenth-century academic art as *the* standard of formal training and artistic excellence. "Design," on the other hand, evokes a reduction of expressive means and a certain standardization; from there to "decorativeness" is but a small step, and who doesn't know that decorativeness is a typical quality of the minor arts? Somewhere in these associations there lurks a persistent commonplace of evolutionary (more specifically nineteenth-century evolutionist) thinking: decorative design (especially geometric design) is thought to be characteristic of a stage preceding the capacity for naturalistic rendition. Little does it matter that this sort of logic has long been shattered

[19] Lipman and Winchester, *Flowering of American Folk Art,* p. 6.

Figure 12. Kabuika Mukendi, *Mermaid*. Kipushi, 1974. H. 44 cm.,
W. 61 cm. (Photo, Ilona Szombati-Fabian.)

from two ends, so to speak, by prehistoric cave painting and post-
impressionist art. It continues to inform discourse about primitive
and folk art both as an evaluative standard and as a rule for his-
torical reconstruction.

 There is only one way to counteract the invidious implica-
tions inherent in this view, and that is to unpack the loaded no-
tion of repetitiveness. Repetition, or replication, in regard to a
sequence of products must first of all be seen in the context of
cultural postulates. Exact copies from a recognized ideal model
may be called for by metaphysical or magical notions in terms of
which the efficacy of an image is thought to depend on the fidelity
with which it reproduces the original (or a culturally shared men-
tal image). We think that such a magical logic is involved in at
least one of the genres of popular painting in Shaba, namely in
the endlessly repeated pictures of the mermaid (Figs. 12, 13).
Certain cultural premises concerning the act of visual expression

Figure 13. Muteb Kabash, *Mermaid*. Kolwezi, 1974. Acrylics on rubberized textile used in industrial filtration; H. 46 cm., W. 83 cm. (Photo, Ilona Szombati-Fabian.)

itself may have to be considered. If, as is the case in Shaba, the source of a painting is consistently defined as "intellect," "memory," or "thought" (not "nature," or "event," or "vision"), it is, perhaps, not surprising—in fact it is logical—that artists render successive paintings of the same genre as more or less exact copies. (In figures 14 and 15 the artist no longer used any model, although he probably did so initially.)[20]

Furthermore, repetitiveness must be seen in the context of certain historical and economic conditions whose impact on folk art is often noted but not sufficiently clear. Since the late

[20] Notice that Henry Glassie proposes a similar explanation for repetition and variation in Pennsylvania German benches; Glassie, "Folk Art," p. 259f. His is a psychological model which generalizes relationships between concepts and material objects. Our material allows us to concretize that relationship. Notions such as "thought" (Shaba Swahili *mawazo*), intellect (*mayele*), and memory (*ukumbusho*) are gleaned from conversations with painters and are part of an explicit aesthetic vocabulary. Many thoughtful observations on repetitiveness and its opposite in the context of contemporary art may be found in a study by Dieter Hoffmann-Axthelm, *Theorie der künstlerischen Arbeit* (Frankfurt: Suhrkamp, 1974).

Figure 14. Tshibumba Kanda Matulu, *Calvary of Africa*. Lubumbashi, 1973. H. 41 cm., W. 69 cm. This painting is part of a series, the "Passion of Patrice Lumumba." (Photo, Ilona Szombati-Fabian.)

eighteenth-century (a period which saw the flowering of American folk art), all production of objects has been drawn into the system of industrial production which is, inherently, reproduction of identical objects in a series. It has been argued that this relationship (together with the rise of photography) has profoundly changed the attitude of our society toward all objects.[21] Therefore it is only to be expected that it had effects on folk artistic production.

Again, this point can be illustrated from popular painting in Shaba. Consider the chromolithograph (oleograph?) depicting the disastrous results of selling goods on credit (Fig. 16). This imagery was reproduced in countless examples. It was displayed not only in Europe and the United States (we assume that it was

[21] This is the topic of Benjamin's classical essay, "The Work of Art in the Age of Mechanical Reproduction"; it also figures prominently in Abraham Moles's theory of kitsch; see Moles, *Psychologie des Kitsches* (Munich: Carl Hanser, 1972). William Morris's work should be seen in this context since it relates directly to modern concerns with folk art; see Glassie, "Folk Art," p. 254f.

Figure 15. Tshibumba Kanda Matulu, *Calvary of Africa*. Kipushi, 1974. H. 45 cm., W. 70 cm. This version was painted exactly one year after the one depicted in figure 14. In both cases the artist worked without a model. (Photo, Ilona Szombati-Fabian.)

manufactured by Currier and Ives) but also in innumerable trader's shops throughout the colonial world, where the legend was translated into local languages. In Shaba, where it is called *credit est mort*, it was taken up by popular painters and again reproduced, but non-industrially, in numerous paintings. Interestingly enough, it is the only genre of which we have seen local graphic reproductions (Fig. 17). Notice that we have here a case where industrial reproduction of an image preceded its artistic reproduction which allows us to compare the two kinds of repetitiveness. First, the popular paintings of *credit est mort* never exactly reproduce the original (Figs. 18, 19). This is by no means due to a lack of ability on the part of the painters. The reason for inexact copies lies in a premise that is characteristic of this culture (but perhaps operative in most folk art): The unity behind a series of images is not simply, and not primarily, a visual template. What links successive renditions of *credit est mort* is

Figure 16. Anonymous, *Credit is Dead (credit est mort, hakuna deni).* Chromolithograph; H. 32 cm., W. 42 cm. This print was found in a bakery in Lubumbashi formerly owned by a Greek merchant. The new Zairean owner would not sell it but agreed to have it replaced by a painted version. (Photo, Ilona Szombati-Fabian.)

that each can be recognized as realization of a narrative unit, the story of the rich and the poor merchant. That is not to say that these images are mere illustrations of a cultural complex that "really" exists in another medium, verbal lore. Usually the story is not told except through images. In other words, the iconic realization is an integral part of a larger context of sign production. That larger context can be discerned on the level of generic differentiation. Without generic differentiation, i.e., without unfolding of the global message into distinct narrative units, popular painting in Shaba could not be described as a semiotic, hence cultural, complex. But genres could not be established if it was not for the repetitiveness of images through which they are

Figure 17. Signed "Kasarthur Typographer," *Credit is Dead.* Linoleum cut; H. 35 cm., W. 43 cm. Found in a gasoline station in Lubumbashi. (Photo, Ilona Szombati-Fabian.)

realized. Understood in this way, repetitiveness is an index for the degree to which the production of images has come to express a communal or societal consciousness.[22]

[22] Any cultural expression that is recognizable as such has this aspect of repetitiveness (although the linguistic notion of recursiveness is perhaps better suited to the idea). Repetitiveness in this sense is a central element in the theory of genre we are presupposing in these remarks. Such a theory was formulated for a different medium, oral expression, in Johannes Fabian, "Genres in an Emerging Tradition: An Anthropological Approach to Religious Communication," in *Changing Perspectives in the Scientific Study of Religion,* Allan W. Eister, ed. (New York: Wiley-Interscience, 1974), pp. 249–72. But theorizing about repetitiveness becomes questionable when this formal condition of semiosis and communication is projected onto the nature and

Figure 18. Y. Ngoie, *Credit is Dead*. Kolwezi, 1973. H. 49 cm., W. 70 cm. (Photo, Ilona Szombati-Fabian.)

Let us now consider repetition inasmuch as it evokes emphasis on design and decorativeness. The short history of painting in Shaba offers some interesting perspectives. Soon after World War II, a French nobleman, colonial officer, and marine painter, Pierre Romain-Desfossés, established an atelier for African painters in what was then Elisabethville, the capital of Katanga. His ideas and approaches to painting and African culture were rather complex; perhaps the best short formula to describe his role is to say that he aspired to be the midwife of a genuinely indigenous popular art, Western in its techniques and materials, but African in its expression and content. By the 1950s, several of his painters had received international recognition with their "typically Afri-

history of society. It is in the latter sense that anthropologists have talked of primitive societies as "repetitive," i.e., ahistorical. Repetition has also been recognized as a philosophical issue which will continue to have an impact on aesthetic theory; see Gilles Deleuze, *Différence et répétition* (Paris: Presses Universitaires de France, 1968).

Figure 19. N. K. M. Kamba, *Credit is Dead*. Kolwezi, 1973. H. 39 cm., W. 56 cm. (Photo, Ilona Szombati-Fabian.)

can" products (Figs. 20, 21). Desfossés had pointed out connections between his project and contemporary revival of the folk arts in France and elsewhere.[23] It is, therefore, not surprising that he and other European mentors of new African art propagated decorativeness. The painters as well as the exclusively expatriate clientele were educated in its uses and meanings. We know from surviving members of the Desfossés school that they were taught to define their identity by means of a characteristic decorative style. Usually repetitive patterns filled the backgrounds for scenes which, in turn, were rendered in stylized, i.e., recognizably "African," forms. Colors were either natural earth tones or they were gaudy. To the tortuous colonial mind, these canons of *art populaire* were more plausible than realistic pigments, representational images, and the illusion of depth and perspective—in short, the achievements of Western academic realism.[24]

Some of the painters from the Desfossés school and an art academy that succeeded his workshop achieved remarkable re-

[23] See also Pierre Desfossés, Preface to *Hommage à Pierre Romain-Desfossés* (Elisabethville [Lubumbashi]: Imbelco, n.d.).

[24] It should be noted that the Desfossés school was typical of the intellectual climate in the former Elisabethville. In Kinshasa (formerly Léopoldville), always considered the most advanced and open of the big cities in Zaire, the academy taught "modern" European techniques and styles, from academic realism to "abstract" art.

Figure 20.　Pilipili Mulongoye, *Fish and Flowers*. Lubumbashi, ca. 1965. Oil on canvas; H. 24 cm., W. 30 cm. (Photo, Ilona Szombati-Fabian.)

sults within the constraints imposed by an extraneous aesthetic. Under the guise of decorative serenity, they managed to express a good deal of the strife and anguish that was characteristic of their life in colonial urban Africa (Figs. 22, 23). As soon as Zaire achieved political independence, however, this colonial *art populaire* became a thing of the past. To be sure, it continues to serve expatriates and the emerging upper class of the country; collectors in Europe and in the United States look forward to its rediscovery. But the new urban masses ignore or reject it precisely because of its stylized decorativeness. The popular painters of Shaba have, without exception, opted for representational painting.[25] As a result, popular painting in Shaba, although it signals

[25] Thus our findings would be difficult to align with Henry Glassie's notion of the "symbolizing nature of the folk filter" (Glassie, "Folk Art," p. 264) and the following generalization: "The beginning of Renaissance art

Figure 21. Mwenze Kibwanga, *Antelope Couple.* Lubumbashi, ca. 1965. Oil on canvas; H. 27 cm., W. 37 cm. (Photo, Ilona Szombati-Fabian.)

a process of liberation from colonially imposed canons, looks more derivative from Western models and less "typically African" than colonial *art populaire.*

Derivative and imitative are two more connotations of repetitiveness. Both are but a small step away from the verdict of triviality which is the third stereotype. Trivial, as applied to musical, literary, and visual art connotes two kinds of critical judgment.

was marked by a move from convention to realism. Folk art is characterized constantly by moves from realism to convention" (Glassie, "Folk Art," p. 266). For one thing, realism and convention make a doubtful logical contrast, certainly as far as the Renaissance is concerned; on the many conventions (economic, perceptual, linguistic) in Italian Renaissance painting, see Michael Baxandall, *Painting and Experience in Fifiteenth-Century Italy* (London: Oxford University Press, 1974). If, on the other hand, the reference to Renaissance realism is to stress the "liberating" effect of this development, popular painting in Shaba would not be folk art in terms of Glassie's categories.

Figure 22. Pilipili Mulongoye, *Bird's Nest Attacked by Snake*. Lubumbashi, 1974. Oil on canvas; H. 46 cm., W. 60 cm. (Photo, Ilona Szombati-Fabian.)

One says that the product so characterized makes an uninteresting, uninspiring, perhaps vulgar statement; the other implies that trivial products, as a corpus, are without inner consistency or systematic connection (as in "sports trivia"). The anthropologist is reminded of stereotypes that used to be pronounced over "primitive thought" and, slightly earlier, "primitive language": shallow, pragmatic, undifferentiated. One of the few lasting achievements of our discipline has been to show that semiosis, the transformation of experience into coherent systems of signification, is a universal feature of culture. It is true that since Marx and Freud we must also consider the possibility of breakdown and antagonistic development; from such a point of view, the study of triviality in art might be a fruitful subject. Alleged or true triviality, then, assumes a symptomatic significance. It can serve as a

Figure 23. Mwenze Kibwanga, *Fight between Hunter and Buffalo*. Lubumbashi, 1969. Oil on canvas; H. 50 cm., W. 36 cm. (Photo, Ilona Szombati-Fabian.)

cultural diagnostic instead of being dismissed summarily. Elitist art criticism has come to grips with pop art and Andy Warhol; it has confronted kitsch and rediscovered the delights of nineteenth-century academicism. Naïve and primitive painting has been exhibited in the temples of high art. All this should help us to see triviality in folk painting in a new light. Practicing artists have appreciated triviality at least since the 1920s; without their rediscovery of the plain and ordinary, we might not be talking about folk art now.

Inasmuch as triviality is predicated on the message of a paint-

ing (not just on artistic means), it leads us to a third set of re-
current questions concerning the *meaning* of folk art. What kind
of meaning does the folk artist give to his products and how do
these products convey meaning?

The first commonplace that comes to mind is that of the so-
called functional or utilitarian significance of folk art (perhaps a
spillover from talk about primitive art). Murals in commercial
places, shop signs, images on otherwise "useful" objects, are often
cited as examples of such functional art. Of course, no one cares
to debate that some objects of folk art are functional, or that all
folk art may also be functional. What concerns us is an underly-
ing, far-reaching ideological implication which expresses itself in
formulas such as this opening passage in an essay on traditional
and contemporary art in Africa: "Art historians and anthropolo-
gists, the first [are] concerned primarily with objects and the sec-
ond with functions." [26] Such division of labor condones the vices
of aesthetisizing and sociologizing we denounced at the outset. We
need not repeat our reasons; instead we might pause briefly at
this point and examine the logic that underlies talk of functional-
ity in folk art.

Let us say functionality evokes only a rather harmless and
foggy contrast between *art pour l'art* and art for a use or purpose.
Applied to folk and primitive art, attributes such as functional and
utilitarian may then have a positive connotation. They would
qualify art that is less alienated, less divorced from reality, than
certain kinds of high art. It is our impression that this is the
meaning most often found in discourse about folk art. The an-
thropologist is reminded here of the Noble Savage, a figure of
speech conceived to express Enlightenment disdain for purpose-
less cultural refinement. Just as talk of "savages" really expressed
concern with "civilized man," we must assume that whenever folk
art is called functional and utilitarian, the real subject is high art.
In fact, the contrast that appears to be established between aesthet-
isizing high art on the one hand, and sociologizing low art on the
other, is internal to ideological positions held by the Western

[26] Daniel J. Crowley, "Traditional and Contemporary Art in Africa," in
Expanding Horizons in African Studies, Gwendolen M. Carter and Ann
Paden, eds. (Evanston, Ill.: Northwestern University Press, 1969), p. 111.

bourgeoisie.[27] The mundane world of utilitarian pursuits is transcended simply by conceiving of a notion of "pure" art (with all its implications, e.g., that art history may have to be explained in terms of its own inner laws, not by the events of mundane history). This position is ideological because it dissimulates, camouflages, what must be the first thing the proverbial man from Mars would notice about high art, namely its merchandise character and its total immersion into the logic of the market. What a splendid paradox; the most useless art fetches the highest prices! As such, high art is *the* symbol of our economies; it could not exist without the separation of value from function preached by the guardians of high art.

The situation is so wicked that even those who criticize functional views of folk and primitive art cannot help completing the circle of the logic of the market. By exalting some of the timeless qualities of folk art and by declaring them comparable to the greatest achievements of high art, one does, in fact, affirm the logic that led to denigration in the first place. In short, many well-meaning attempts to aesthetisize folk art may be only symptoms of its being absorbed by the market.

We should also remember that both functionalism and utilitarianism have served in many combinations as paradigms for the social sciences. Anthropology, which has had some particularly disconcerting experiences with functionalism,[28] is now in a position to offer interesting theoretical alternatives for the interpretation of art forms other than high art. Whether or not one cares to subscribe to the Wittgensteinian "meaning is use" (and hence treat as a false problem all oppositions between pure significance and utilitarian value), we can now safely maintain that the study of folk art cannot leave "the object" to the art historian any

[27] Nicos Hadjinicolaou, *Histoire de l'art et lutte des classes* (Paris: Maspéro, 1974), p. 38f.

[28] Functionalism was a powerful paradigm in anthropology. Its critique has produced a literature too voluminous to be quoted here. Examples of such criticism from three totally different directions are: Ian C. Jarvie, *The Revolution in Anthropology* (New York: Humanities Press, 1964); Marvin Harris, *The Rise of Anthropological Theory* (New York: Thomas Y. Crowell, 1968), esp. chap. 19; and Clifford Geertz, *The Interpretation of Cultures* (New York: Basic Books, 1973).

more than it can leave "function" to the anthropologist or sociologist. Without the object, without, in our case, attention to its specific constitution as a painting, we would have no access to the process of semiosis, and we would be talking past, or around, the purposes of anthropology. To investigate social functions only, if that is possible, would make of art a mere occasion for sociological theorizing; in the end it would produce neither understanding of art nor new knowledge about society.[29] This is why students of folk art who look for ways of making their analysis culturally and socially more meaningful should be especially wary of aid from the social sciences.

Thus we can see how stressing its utilitarian functions does injustice to folk art by skipping, so to speak, its visual-material aspects. Yet similar injustice may be done by yet another stereotypical attitude that appears to be the exact contrary. This is the claim that folk art is best understood if one lets objects speak for themselves. Some of the paintings from Shaba are likely to trigger such reactions (Figs. 24, 25). Outsiders will find them quaint, charming, touching, naïvely powerful, or perhaps just cute. One may note in passing that these are attributes our society reserves for children, and that they evoke classical colonial associations between the primitive and the infantile.[30] But there is a more interesting theoretical element underlying these attributes. We will call it the stereotype of *positivity* in folk art.

Later on, we will argue that positivity is a problem of much wider significance; let us first see how it manifests itself in the discourse on folk art. Positive labels, such as quaint, charming,

[29] Such a position is gaining acceptance. For instance, Pierre Francastel insists that a "true sociology of art," "ne se présentait pas comme une certaine méthode de classement des connaissances sans remise en cause de la nature même de l'objet considéré"; see Francastel, *Etudes de Sociologie de l'art* (Paris: Denoël, 1970), pp. 10, 14. One may argue, therefore, (as does Hadjiniolaou, *Histoire de l'art et lutte des classes*, pp. 57–63), that a sociology of art whose object would be different from the history of art does not exist.

[30] We found examples for this in a recent exhibition of naïve art where contemporary popular paintings from Africa were placed together with prehistoric art and paintings by children and inmates of mental institutions; see *Die Kunst der Naiven*, catalogue of an exposition of naïve art, 1974–75 (Munich: Ausstellungsleitung Haus der Kunst, n.d.). (Note that the numbering in the catalogue does not reflect the fact that these categories were exhibited in the same space.)

Figure 24. Unsigned (Kabinda), *Lion Stalking Antelope*. Kolwezi, 1973. H. 53 cm., W. 79 cm. (Photo, Ilona Szombati-Fabian.)

etc., we submit, are not attributes of objects; they are attitudes in the beholder. This can be demonstrated, for instance, with regard to the animal paintings in figures 24 and 25. Endearing adjectives, such as charming and quaint, are totally absent from the critical language used by producers and consumers of popular painting in Shaba. Furthermore, the images of leopards, lions, and buffaloes, which are likely to trigger such reactions in us, have their symbolic significance in terms of a genre we call "powerful animals." For the African beholder they are images of power and danger; they inspire awe. They recall a village past (where they were, above all, symbols for political and magical authority) and thus have a definable position in history.[31] Like all paintings of this corpus they are reminders, things that make you think; they are intellectual as well as emotional, never just vehicles of diffuse sentimentality.

Conversely, when the outside viewer uses attributes such as

[31] For detail, see Szombati-Fabian and Fabian, "Art, History, and Society," p. 4f.

Figure 25. Muleba, *Leopard (chui)*. Likasi, 1974. H. 36 cm., W. 52 cm. This is an example of the genre "powerful animals" in the category Things Ancestral. (Photo, Ilona Szombati-Fabian.)

quaint and charming, he never simply expresses an appreciation of wholesome, unspoiled simplicity. When applied systematically, these terms signal a far-reaching rejection of the problematic, critical, and often disturbing intents of folk art. Such language implies that folk art is "to be seen, not heard," one more way in which the folk is assimilated to childhood. We all know that, at one time or another, folk and primitive art has been presented as *speechless* (devoid of any complex, discursive messages in need of interpretation); as *nonproblematic* (not fraught with the kind of tensions and drama we associate with creativity in the high arts); as *timeless* (expressive either of totally unique individual visions or of archetypal, mythical images); and, alas, as *artless* (untouched by the formal aesthetic problems which must be confronted by the producers and critics of high art). Cumulatively, all these negative labels add up to the stereotype of positivity.

Positivity, then, amounts to yet another ideological verdict.

To praise it as a virtue in folk and primitive art serves to assign a subordinate status to its producers and to the class or people for whom they produce. Aesthetic initiatives and decisions (which are also economic and political decisions) are the prerogative of the ruling class or of the Western world. The two terms are practically synonymous in the present situation. One need not be a rabid Marxist to see through this kind of discourse and maintain that what masks as aesthetic theory is often dictated by interests to control and dominate.

This is not to say that aesthetic theory, because it serves class interests, is nothing but a mere reflex of class structure. Critical shortcuts of this kind are themselves ideological, for they prevent recognition of intellectual issues which, logically, must precede class analysis. Let us mention one of these before we conclude our survey. In the last instance, positivity signals an epistemological position which constantly needs to be examined by the anthropologist.[32] Applied to the objects and images of folk art, it asserts their "givenness," their status as objective data, or perhaps social facts. The corollary of such a view, as in all variants of positivism, is that the prime task of a science of folk art should be a thorough description and classification of objects and behavior, to be followed by generalizations regarding relationships or causal attribution. That is what scientistic social science means by "explaining" culture. Yet anthropology has come to realize, in a painful process, that its materials are never simply given; and that is true even of such manifestly objectlike things as paintings. Everything cultural is *made*, hence part of activities, processes from which it cannot simply be lifted for inspection. No science of culture can be built on mere contemplation of pristine givenness. Every cultural expression, indeed every object produced by humans, is immersed in processes of semiosis. To treat it as if it

[32] And by art historians, one might add. A most interesting argument for the "negativity of the image" has recently been developed by Oskar Bätschmann, *Bild-Diskurs* (Bern: Benteli Verlag, 1977). Perhaps one should also recall the fact that in the Western tradition the history of visual art always seems to have been paralleled by a history of anti-art movements; see the interesting study by Horst Bredekamp, *Kunst als Medium sozialer Konflikte* (Frankfurt: Suhrkamp, 1975).

were a fact in and of itself, a mere datum to be fed into the interpretive machinery of science, is not to save objectivity but to destroy it in its roots. All cultural knowledge is mediated and art is such a mediation. A science of folk art that seeks its meaning beneath the surface of its images and behind the backs of its producers is forever condemned to manufacture purely projective knowledge.

Folk Art:
The Challenge and the Promise
Kenneth L. Ames

At the 1976 annual meeting of the Society of Architectural Historians, folklorist Henry Glassie chaired a session on vernacular architecture, a subject generally ignored by architectural historians. In his published summary, Glassie emphasized the innovative aspect of the session and drew an analogy to the Trojan horse. He spoke approvingly of scholars with a new orientation who were invading the discipline of architectural history. Once inside, they would "upset the comfortable life within the walls" by challenging not only the dominant methodology and theory of architectural history, but that field's basic assumptions as well. As Glassie saw it, these invading scholars would pose questions that would go beyond buildings and their architects to the people who lived in them and eventually lead to a reexamination of cherished and fundamental concepts about humanity.[1]

Although Glassie was writing about architectural history, his analysis can be extended to other aspects of material culture study. If the troops within the Trojan horse alter the direction of architectural history, we may expect similar invasions of related disciplines. In fact, in recent years there have been notable changes in studies of material culture, both in the kinds of artifacts examined and the questions asked about them. Yet there has also been,

[1] Henry Glassie, "Vernacular Architecture," *Journal of the Society of Architectural Historians* 35, no. 4 (December 1976):293–95.

and probably there will continue to be, disagreement about the desirability of these changes. People with another point of view may see the transformation Glassie envisions in a somewhat different light—just as the Greeks and Trojans differed in their appraisal of the Trojan horse. If the Trojan horse suggests imagination, cunning, and the triumph of right to some, it means fraud, deception, and an assault on a way of life to others. Those "within the walls" may see the conspiring scholars of vernacular architecture and their confederates in other fields as vandals and traitors, desecrating treasured values and initiating destructive lines of argument that reduce disciplines to intellectual chaos. How people feel about a change in the nature of architectural history depends on their point of view. In a very real sense point of view is related to position; the Greeks and Trojans might have felt differently about the Trojan horse if their positions had been reversed.

This paper is about point of view and the study of American folk art. As the reference to the Trojan horse indicates, one's view of folk art is dependent upon position. People who are inside the folk art movement have a different perspective than those on the outside. What I offer is an outsider's view of the folk art movement. My purpose is twofold: to determine what points of view underlie conventional folk art study, and to suggest what these points of view reveal about the positions of those who hold them. This means, to paraphrase Glassie, that the discussion will move from objects to people, and from people to some rather basic notions about humanity. It also means that it will deal with conflict, for from my point of view the manifest and latent functions of the study of folk art point to explicit as well as implicit conflicts within our society and, at another level, perhaps within our own minds as well.

It might be helpful at the outset to clarify what I mean by folk art study. For my purposes here it consists of activity in the form of exhibition and publication of objects explicitly described as folk art. Whatever other functions or purposes these objects serve now or might have served in the past, it is their identification as folk art that is emphasized. To put it another way, folk art study is carried on by people who identify the subject of their

articles, books, collections, catalogs, and exhibitions as folk art.[2] I am, then, discussing the field as it is defined by its own practitioners. Not included is the work of those who study the same or similar artifacts but for one reason or another prefer to describe their study in different terms.

It is possible to learn a good deal about a field of study by examining the questions its practitioners ask. One way to envision inquiry is in terms of centripetal and centrifugal patterns. The centripetal, roughly identifiable with the work of antiquarians, curators, and technicians, starts with an object or an artisan and spirals inward, comprising smaller, tighter, and more specific questions. The centrifugal pattern, marking the work of conceptualizers, theoreticians, or as James Deetz describes them, those interested in "the study of man in the broadest sense," [3] is characterized by questions which move outward from small issues to larger, more encompassing, and more fundamental concerns. With centripetal questions, point of view is taken for granted; underlying assumptions are usually ignored and untested. Centrifugal patterns may bring point of view into the scope of inquiry and lead to an examination of the nature of questions asked and the motives behind them.

In any field there is room for people to follow both patterns. Such division of labor has obvious advantages. In folk art studies, however, the centripetal pattern seems to predominate at the expense of the centrifugal. Centripetal patterns generally yield safe and relatively predictable results which offend or surprise few people because they avoid substantive issues. Centripetal patterns are generally predicated on the acceptance of a status quo; major

[2] A commentary on some of the major writings on folk art may be found in Kenneth L. Ames, *Beyond Necessity: Art in the Folk Tradition* (Winterthur, Del.: Winterthur Museum, 1977). Often strongly romanticized, much of this writing is recognizable as what has been called "folklore"; see Richard M. Dorson and Inta Gale Carpenter, "Can Folklorists and Educators Work Together?" *North Carolina Folklore Journal* 26, no. 1 (May 1978):3–4. A recent publication strongly steeped in the folklore tradition is Ruth Andrews, ed., *How to Know American Folk Art* (New York: E. P. Dutton, 1977). My observations in this paper are limited to the latter type of publication and are not intended as a critique of folklore studies in general.

[3] James Deetz, *Invitation to Archaeology* (Garden City, N.Y.: Natural History Press, 1967), p. 3.

questions are either considered to have been settled or assumed to be the responsibility of someone else or of some other field.

Another way of looking at patterns of questioning is in terms of levels. Low level questions are concerned primarily with identification. Mid level questions involve a search for relationships and correlations, while high level questions are part of a search for broad, explanatory concepts.[4] The most common questions in folk art study—what? when? and who?—belong to the lower levels. Questions of how one group of objects relates to other groups of objects or to society are asked less frequently, and comprehensive conceptual frameworks are rarer still.

In all fairness, we have to admit that folk art study is hardly alone in these inclinations. It shares with other studies within the broad category of the humanities serious difficulties in formulating questions of pressing human significance which have any chance of being answered or resolved. It takes considerable sophistication and great learning to pose questions about folk art or any other realm of the humanities which are both meaningful and at least tentatively solvable. Any judgment on the modest and inconclusive accomplishments of humanistic learning should be tempered with sympathy and understanding. Studying or collecting folk art is one answer to the question of what to do in life, a problem that confronts all human beings to a varying degree.[5] Studying folk art fills time and provides meaning as well as studying Shakespeare's sonnets, Attic red-figured vases, or Norse mythology, or, for that matter, collecting stamps or building model railroads.

If we look at folk art study and other scholarly work within the humanities as a way of giving meaning to one's life by providing answerable questions, we can see why grand inquiries, which may yield unsettling answers, are uncommon. And, when we understand that people model their behavior on others, we can un-

[4] For a discussion of levels of explanatory concepts in psychology, see Benton J. Underwood, *Psychological Research* (Englewood Cliffs, N.J.: Prentice-Hall, 1957), pp. 195–233.

[5] Part of the problem within the humanities is that scholars are still much involved with the accumulation and manipulation, for its status value, of what Veblen called useless knowledge. See Thorstein Veblen, *The Theory of the Leisure Class* (New York: Macmillan, 1912).

derstand how many people who have written about folk art have similarly patterned their work on that of their predecessors. Many folk art writers rarely pose questions per se; instead they emulate certain study models or perpetuate certain study orientations.[6] Folk art study, as it is currently practiced, is largely a twentieth-century phenomenon. Its study orientations have been derived from other, older fields which are tangential to it: art history, the study of antiques, and folklore. Folk art study partakes of certain aspects of each of these, and different writers or activists will be more strongly oriented to one of these areas than all the others, which means that diversity and, occasionally, even conflict exist within the field.

Within the field of folk art study, four recurring orientations can be identified: toward the object, the creator, primacy, and evaluation. The emphasis on the object, sometimes called object fetishism, has been so widely noted and critiqued that it needs little comment.[7] Also termed by its advocates "object primacy" or "letting the object speak for itself," this orientation, radical when it appeared in its present guise in the late nineteenth century, is now both safe and conservative. It is safe because the objects are usually presented in a neutral or mystifying setting which defuses any potentially explosive elements, and conservative because it perpetuates an archaic tendency to ascribe special power and importance to certain objects.[8]

[6] Another explanation for this emulation of certain models may lie in the limitations of the human intellect; very few people are bright enough to look at the world in radically new ways or to blaze new trails for others to follow. Those who have, Copernicus, Newton, Marx, Freud, and Piaget, we identify as geniuses. For further discussion of patterns in study and innovation, see H. G. Barnett, *Innovation: The Basis of Cultural Change* (New York: McGraw-Hill, 1953), and Thomas S. Kuhn, *The Structure of Scientific Revolutions* (Chicago: University of Chicago Press, 1970).

[7] For appraisals of art history practices and paradigms, see James S. Ackerman and Rhys Carpenter, *Art and Archaeology* (Englewood Cliffs, N.J.: Prentice-Hall, 1963); W. Eugene Kleinbauer, *Modern Perspectives in Western Art History* (New York: Holt, Rinehart & Winston, 1971), pp. 1–105; Michael Owen Jones, *The Handmade Object and Its Maker* (Berkeley: University of California Press, 1975); and Theodore K. Rabb, "The Historian and the Art Historian," *Journal of Interdisciplinary History* 4 (1973):107–17.

[8] On the mystification of objects, see Svetlana Alpers, "Is Art History?" *Daedalus* 106, no. 3 (Summer 1977):1–13; and Stephen A. Kurtz, *Wasteland: Building the American Dream* (New York: Praeger, 1973), pp. 9–18.

Object fetishism can be seen as a present-day continuation of a long-standing inclination to treat art as a supernatural or divine phenomenon. To identify an object as art is to elevate it, sanctify it, and declare it worthy of worship. What are sometimes called "key monuments" in the history of art are often given the reverence accorded to sacred things. Many were, in fact, considered sacred in their original context; now they have taken on a form of secular sanctity. When object reverence informs centripetal patterns of inquiry or low levels of questioning, researchers become ascertainers and keepers of arcane knowledge, of sacred lore about the object. This lore becomes increasingly sacred in inverse proportion to its earthly utility.[9] From the object fetishist's point of view, the purpose of studying folk art—or any art—is to understand and appreciate each individual object more fully.[10] While such study may be accompanied by certain incantations, a sort of reassuring patter, ritualistically repeated in the uncritical manner of the faithful, inquiry usually starts with the object and burrows deeper and deeper into it.

Because object fetishists find the artifact implicitly significant, their attention need not move far from it. Yet it is only a short logical step to the second orientation, creator worship. A given artifact may pass through several environments and contexts in the course of its material existence, from its original fabrication to its first customer or consumer, and then, possibly, through many hands or over many miles before eventual enshrinement or destruction. As objects change hands and contexts, they pass through, accumulate, or shed many and diverse layers of meaning. Yet for those who write about the people associated with folk art, it is usually the creator of an object who is of interest rather than the many other people, including ourselves, who may also have

[9] The contents of a journal like the *Art Bulletin* indicate how academic status may be achieved and maintained by asking increasingly miniscule questions about certain highly valued episodes in world art, the Italian Renaissance in particular. It provides a noteworthy case of the way prestige accrues from knowing the most subtle details of data nearly totally free of utility for twentieth-century life.

[10] John Kirk, *American Chairs: Queen Anne and Chippendale* (New York: Alfred A. Knopf, 1972), p. 11.

been associated with it in some way. Customers and consumers fare poorly, unless they happen to be affluent individuals who have amassed great collections, in which case they too are treated as creators: creators of collections or creators of taste. If objects can be sacred, creators can be divine. Although George Kubler several years ago pointed out the limitations of biography as an investigative tool, writers about folk art and many other arts still chronicle the lives and accomplishments of selected artists and a few collectors as earlier scribes did those of the saints.[11]

Closely related is the third orientation: toward primacy. As Mircea Eliade notes, "implicit in this belief is that *it is the first manifestation of a thing that is significant and valid*, not its successive epiphanies."[12] Histories and mythologies are both dominated by primacy. The first settlers, the first president, the story of Apollo and Daphne, Narcissus, or other gods or ancestors explain, legitimize, and confirm the cosmos. If "folk" can be defined as an underlying continuity in human behavior and thought traceable to what Freud called the childhood of man, then this emphasis on primacy is a folk element in contemporary historical scholarship; ironically, some folk art scholarship itself may be seen as a folk phenomenon.[13]

Hierarchies within art and antique study reflect a persistent fascination with and high evaluation of primacy.[14] This emphasis on primacy explains the zealous search and preference for the first over the second, third, or fourth, or, to use Kubler's terms, the prime object over its successive replications.[15] It explains why the search for sources is a major preoccupation of conventional art historical scholarship and why the early manifestation of a style or idiom is usually valued over the late. It helps to explain why

[11] George Kubler, *The Shape of Time* (New Haven: Yale University Press, 1962), pp. 5–12.
[12] Mircea Eliade, *Myth and Reality* (New York: Harper & Row, 1963), pp. 34, 21–38.
[13] A good deal of history-writing may be described as a parareligious folk activity; there are important parallels between the foundation of religion and the writing of history. See comments in Thomas J. Schlereth, "It Wasn't that Simple," *Museum News* 56, no. 3 (January-February 1978):36–44.
[14] Alpers, "Is Art History?"
[15] Kubler, *The Shape of Time*, pp. 39–53.

many people are willing to spend vast amounts of money on conservation and restoration and why collectors avoid the marred, the married, and the mongrel in artifacts. It also helps to explain the prominent but complex and muddled role of the unique in folk art study.

Within the field of folk art study people who come from an antiques background may differ in their approach to this point from those who come from an art background. An art orientation may stress the creative individual and be willing to accept or even seize upon idiosyncratic fabrications, combinations, or arrangements of material, including those atypical and personal solutions to problems that Jencks and Silver call *ad hoc* solutions.[16] Those with an antiques orientation, which tends to define categories more restrictively, may reject isolated artifacts that do not fit into a broader class. In reconciling folk and its connotations of tradition with the ideology of the unique, antiques-oriented folk art enthusiasts tolerate invention within narrow limits because it can be touted as a first, conceptually if not temporally, yet it does not disturb the vision of the cosmos and matters as they now exist. To the ideological functions of the unique in folk art, then, can be added its role as a ritually recurring first which reaffirms both the principle of creativity and the established order.

The fourth orientation of folk art studies is to evaluation. It is not merely early from late or prime objects from replications, that are differentiated, but good from bad. Many writers treat this issue as though it could be easily settled. Implicit in much folk art rhetoric are the notions that only "good" folk art has any value, economically or aesthetically, and that it is possible to arrive at a satisfactory shared definition of what good folk art is.[17] The words good and bad carry with them extensive connotations so that good, right, and truth, and bad, evil, and false become locked together in a moralizing reading of the artifactual world. Normative and factual questions are indiscriminately thrown together. Just as the question "What is art?" has been repeatedly confused over time with the question "What is good art?," the

[16] Charles Jencks and Nathan Silver, *Adhocism: The Case for Improvisation* (Garden City, N.Y.: Doubleday, 1973).

[17] For a summary of folk art rhetoric, see Ames, *Beyond Necessity*.

apparently factual question "What is folk art?" is confounded with the normative question "What is good folk art?" [18]

Why does this compulsion to evaluate persist? Why is this need to differentiate so prominent and forceful that it inveigles its way into so many inquiries? How can it be explained? What purpose does it serve? Some answers to these questions can be found if we consider some of the ways people respond to or interact with objects they consider art. Four levels of interaction can be identified: sensory-motor, syntactic, private symbolic, and communal symbolic. The order of these levels roughly approximates the development of the human mind, moving from what the Swiss genetic epistemologist, Jean Piaget, calls the sensory-motor stage through cognitive and socialized levels. Each of these levels needs a few words of description.[19]

SENSORY-MOTOR

This stage and type of interaction with objects might be described as precognitive, or prelogical. It has been explored extensively by psychologists, including Howard Gardner who has synthesized contributions of Freud, Erikson, Piaget, and others into a discussion of what he called modes and vectors.[20] Gardner discusses the manner or *mode* of functioning characteristic to each physiological zone of the body. He follows Erikson in demonstrating that physiological modes "initially related to drive states and bodily patterns, become social and cultural modalities, the child's way of experiencing the world beyond his own skin." As children in their development gradually differentiate themselves from their environment, sensations and percepts that were previously characteristic of their undifferentiated selves are brought

[18] D. E. Berlyne, *Aesthetics and Psychobiology* (New York: Appleton-Century-Crofts, 1971), pp. 21–23.

[19] I should stress that this hierarchy of levels only parallels Piaget's work; it is not a rigorous application or test of his theory. For a systematic attempt to relate Piaget's work to art, see Suzi Gablik, *Progress in Art* (New York: Rizzoli, 1977).

[20] Howard Gardner, *The Arts and Human Development* (New York: John Wiley & Sons, 1973), pp. 98–107.

to bear on external objects and forces which gradually acquire a separate existence. When Gardner talks about modes, he refers to behaviors like holding on to, letting go or releasing, and pushing out. The vectors for these modes would include such aspects as facility, that is, ease versus strain, direction, force, comfort, texture, speed, temporal regularity, and spatial configuration. While the psychological argument is subtle and complex, the salient point here is that evidence of response to openness, closedness, denseness, smoothness, roughness, roundness, and other properties is evident at a very early stage of infant development. It is presumed that these responses are not confined to infants but are maintained by adults in later life, although they assume a less prominent role as other manners of interaction become more prominent. The difficulty adults encounter in expressing in verbal terms their responses to what Gardner calls modes and vectors suggests that they are outside the cognitive aspects of our being; they may be muscular or glandular in nature.[21]

What we are calling sensory-motor responses to objects comprise a notable part of what is sometimes defined as an aesthetic experience: a direct, prelogical or precognitive interaction with, or action upon, the external world. Responses to the flow of line, the grain of a piece of wood, the gloss and dribble of ceramic glazes, the rich, saturated colors of oil or acrylic paints, the softness of watercolor, the contrast of brightness to shadow, or the different feelings generated by open or dense patterns can all be subsumed under this heading. Sometimes writers seem to feel that this is the only legitimate way to respond to an object defined as art. Nelson Goodman calls this the Tingle-Immersion theory, which he attributes, with tongue in cheek, to Immanuel Tingle and Joseph Immersion, circa 1800. According to this theory:

the proper behavior on encountering a work of art is to strip ourselves of all the vestments of knowledge and experience (since they might blunt the immediacy of our enjoyment), then submerge ourselves completely and gauge the aesthetic potency of the work by the intensity and duration of the resulting tingle.[22]

[21] Gardner, *Arts and Human Development*, pp. 100, 106, 153–54.
[22] Nelson Goodman, *Languages of Art* (Indianapolis: Bobbs-Merrill, 1968), p. 112.

While a sensory-motor interaction may be common with objects considered art, it is important to realize that individuals may respond to any object in this way. Indeed, infants apparently do.

SYNTACTIC

Syntactic or structural, roughly interchangeable terms, refer to interactions with or operations on objects that pass beyond gross properties to focus on the relationship of the parts to the whole. While we idiomatically refer to a sensory-motor interaction as a "gut" response to an object, a syntactic response may be defined as a logical, cognitive, if not necessarily voiced, comprehension of the way the components interact, the way the entire object is designed; it is an understanding of the parts and how the parts are deployed within the entire composition. It means noting pattern, proportion, balance, rhythm, order, and similar elements. A syntactic understanding of an object is necessary, for example, if that object is to be replicated and not just symbolized.[23]

A syntactic approach is often promoted and studied as a key to certain persisting problems in aesthetic theory, such as, "What is beauty?" Some scholars assume or hope that answers to such a question can be found through this kind of interaction with given objects. Along with the sensory-motor response, syntactic responses are also analyzed as primary factors in what is called the aesthetic response. Because syntactic operations involve cognitive interactions with objects, they can be readily expressed in verbal terms.[24]

All human creations can be read syntactically, for they are all composed of ordered form. This point, however, is misleading and has induced some scholars studying art or trying to define it to toss novels, poems, paintings, carvings, buildings, songs, chants,

[23] Howard Gardner, "Senses, Symbols, Operations: An Organization of Artistry," in *The Arts and Cognition*, David Perkins and Barbara Leondar, eds. (Baltimore: Johns Hopkins University Press, 1977), pp. 88–117.

[24] Conventional formal or compositional analysis in art history might be identified as a type of syntactic response.

and other objects and activities from different societies into the same hopper and discuss them together. Because all of these cultural expressions can be called art, they presumably share more qualities than they do not. Yet visual, spoken, and musical languages are not the same; they are not transpositions of each other into different media but vary significantly on many counts. The salient distinction between visual and verbal languages, for example, is that visual language, except for certain highly specialized forms, is internationally, interculturally, and interracially comprehensible, if only at a limited or restricted level, while verbal languages may be totally incomprehensible to those not trained in them.[25] It might make more sense to consider objects as elements in nonverbal communication and experience, for current evidence suggests that they are processed by a different hemisphere of the brain than verbal language.[26]

When children begin to speak, they learn the language in use around them. At this moment, millions of children are learning hundreds of different languages and dialects. When they learn to produce the visual language, they have much in common. Most children begin to draw, for example, in much the same way.[27] Their ways of drawing diverge and become culturally specific as they move to higher levels of development and socialization, but the beginnings show considerable similarity. This distinction between visual and verbal languages has prompted Gardner to suggest that the visual language antidates the verbal in human history, but is also more primitive and less capable of conveying the refinements, subtleties, and specificities of meaning possible through the verbal language.[28]

There is, then, a trade-off of sorts. The visual language grants more immediately but less in the long run. Yet it is readily accessible at a syntactic level. There is no humanly produced object

[25] Lawrence B. Rosenfeld and Jean M. Civikly, *With Words Unspoken: The Nonverbal Experience* (New York: Holt, Rinehart & Winston, 1976), p. 9.

[26] Rosenfeld and Civikly, *With Words Unspoken*, p. 9.

[27] Miriam Lindstrom, *Children's Art* (Berkeley: University of California Press, 1962).

[28] Gardner, *Arts and Human Development*, pp. 125–77.

on which one cannot perform a syntactic operation. This does not mean that we necessarily understand the functions or purposes of an object in its original context; often we do not or do not wish to. There is a long and still active Western tradition of removing objects from their native context to place them in the awe-inspiring and worship-inducing environment of the museum where they are considered art, as examples of comprehensible human design, as the externalization of internal syntactic principles shared by all humanity. We have done this with anthropological artifacts and we still do it today with what we call folk art. We can "read," using that word loosely, all things that people make.

I would argue that it is possible for any humanly produced object to be defined as art and placed in a museum where visitors may respond to it in a sensory-motor and syntactic way. Indeed, over the last century sizable segments of the material world have been rotated, like players on a volleyball team, into the position of art. The determination of those objects is not solely based on their ability to reward sensory-motor and syntactic interactions. There are other factors which can be explained by examining two other types of responses to objects.

PRIVATE SYMBOLIC

The private symbolic and the communal symbolic can be seen as poles of a continuum in which division is somewhat arbitrary. Yet because the developing person passed from egocentrism to greater responsiveness to social expectations, this distinction has some basis in empirical data.

Although the theory of association expounded by David Hume in the eighteenth century has been heavily critiqued, the basic premise of association is still valid: that people's responses to objects will be strongly conditioned by previous experience.[29] Gross and syntactic properties, as well as aspects of the culturally shaped symbol and expression systems, of which each object is a part, are

[29] Walter Jackson Bate, *From Classic to Romantic* (New York: Harper & Row, 1946), pp. 93–128.

acted upon by the individual in ways based, to varying degrees, on personal affective and cognitive associations. In other words, every object may be a Rorschach test of sorts, which people read in their own ways and either assimilate or reject from their own mental structures. Red may be the color of an automobile demolished in an accident. High heel shoes may be a personal fetish. Images of water may remind one of a near drowning. Autumn leaves may bring to mind a youthful dalliance. These are personal, sometimes private, individualized responses to an object, and as such they vary from person to person. Private symbolic, then, means the personal, individual meanings that an object may have, meanings not necessarily shared or even known by others. Yet private and specific responses to objects are not normally dominant, for if they were, there would be little order or agreement in society. Hierarchies of evaluation could not exist. Our judgment usually coincides with that of others, and sometimes many others. An explanation for these shared responses and judgments can be found in the social nature of people. This consideration brings us to the last category.

COMMUNAL SYMBOLIC

If any object can be responded to at the sensory-motor level, syntactically, and privately, what, then, makes some objects art and others not art? Or to put the question in Goodman's words, "when" is art? [30] One answer is that art is when a society or a segment of society determines that certain social purposes will be fulfilled by elevating specific behaviors or products to this higher realm. Or when the position of certain activities or objects is reaffirmed within this realm. This is not necessarily as conspiratorial or self-conscious as it sounds. It means that art is a normative category, a statement about what ought to be important, and therefore a social tool, but a social tool for many different purposes. Although the social concept of art has come under criticism

[30] Nelson Goodman, "When is Art?" in *The Arts and Cognition*, David Perkins and Barbara Leondar, eds. (Baltimore: Johns Hopkins University Press, 1977), pp. 11–19.

lately, there are valuable insights to be gained from looking at it in this way.[31]

Learning to live with and interact with other people is known as socialization. We are socialized not only in behavior, but in attitudes and values as well.[32] Our socialization cuts across and controls, in varying degrees, most aspects of our being. Our socialization determines what objects we will regard as art, as well as what constitutes good art. It determines how we feel about museums, historic preservation, and the art scene in New York. Social factors affect how we feel about object purism or its opposite, *ad hocism*, and how we feel about airport art or folk art watering can kits or tissue boxes. In other words, there is a social explanation for the point of view we bring to an issue.[33] What communal symbolic means, then, is the socialized or taught meaning of an object. Whereas private symbolic meaning stems from incidents of individual biography, the communal symbolic is acquired from others, it is superimposed or indoctrinated.

Communal symbolic response dominates the other three categories of response. Our notions about what objects we should leisurely engage in sensory-motor and syntactic operations are socially shaped. People do not wander through life acting as described in the Tingle-Immersion theory; indeed, they probably would not live very long if they did. Instead, they go to a socially sanctioned place like an art museum or a folk art gallery where such behavior is appropriate. Furthermore, social factors determine which private symbolic meanings we will admit in public and which we will keep to ourselves. The power of social conditioning is immense. It provides us with structured reality and order to live by, but it also shapes and limits the way we look at the world, ourselves, and others.

The relationship between human thought and the social context in which it arises is the central concern of the sociology of knowledge.[34] It has long been accepted that values and world

[31] Berlyne, *Aesthetics and Psychobiology*, pp. 19–30.

[32] Peter L. Berger and Thomas Luckmann, *The Social Construction of Reality* (Garden City, N.Y.: Doubleday, 1966).

[33] Berger and Luckmann, *Social Construction*.

[34] The following argument follows Berger and Luckmann, *Social Construction*, pp. 1–18.

views have social foundations. How else can one explain Pascal's observation that what is truth on one side of the Pyrenees is error on the other. Marx set forth two central theses of the sociology of knowledge: people's consciousness is determined by their social being, and ideologies are weapons used for social interests. Mannheim tried to take Marx's propositions beyond a narrowly political context by arguing that nearly all human thought is affected by the ideologizing influences of its social context. He claimed that knowledge was always from a certain point of view and that ideologizing influences could not be eradicated in the search for knowledge or the understanding of a phenomenon. They might, however, at least be mitigated by a systematic analysis of as many as possible of the various socially grounded positions. In other words, the quest for an understanding of a human phenomenon like folk art could be aided by accumulating and analyzing the different perspectives on it. In a sense, that notion underlay the 1977 Winterthur conference on folk art and this collection of papers.

An explanation for the diversity of viewpoints expressed here, or in any poll of opinion, can be found in the different socialization of individuals. Our society is not a unified mass; it is composed of many groups of varying sizes, drawn up along sexual, ethnic, religious, economic, educational, occupational, and other lines. All individuals have one group or, more likely, several groups that they identify with and look to for approval; these can be called reference groups.[35] They are both the products of and producers of socialization. People whose lives involve many roles or who become socially mobile may find that they have conflicts caused by taking cues from different reference groups. On the other hand, as part of the process of socialization, individuals often acquire "filters" or "blocks" which make it possible to ignore or disparage ideas and values not consonant with their own. Thus, they protect and sustain their own views. Similarly, they may develop concepts or ideologies to further their own interests over those of other social groups.

We can come to some understanding of the definitions of

[35] Robert K. Merton, *Social Theory and Social Structure* (Glencoe, Ill.: Free Press, 1964), pp. 225–436.

art in our society by considering the social roles of these defini-
tions and the nature of the groups that support them; in other
words, we might profitably consider the contemporary enthusiasm
for folk art as a social fact. Viewing the folk art movement—that
twentieth-century enthusiasm for buying, selling, collecting, and
studying objects identified as folk art—in this way makes it pos-
sible for us to shift our emphasis from the objects, which are only
part of the phenomenon, to the objects and their living human
context. We can then see the folk art movement as a social fact
in much the same way that the rock music phenomenon is a social
fact. Like the rock music phenomenon, it is in favor of many
things; but it is also, simultaneously, against many other things.[36]
Movements are defined as much by what they exclude as by what
they include. Distinguishing between objects, values, and people
is the real function of evaluation. Evaluation is the application
of socialized standards, an inevitable testing of ourselves against
others as part of a continuing endeavor to judge our place, and
theirs, in the social order. We judge not only people, but objects
as well, for objects are extensions of people.

Earlier we asked about the role of evaluation in folk art study.
I would maintain that evaluation is both central to folk art study,
as it is currently being practiced, and at the same time inde-
fensible. The very act of defining folk art is a process of evalua-
tion. The category of folk art is a construct with little or no
objective basis. When one asks what is eighteenth-century French
rococo art, the only element open to discussion is the question
of art. That which is French, eighteenth-century, or rococo can
all be more or less objectively determined. With folk art, on the
other hand, the situation is different. Both collectors and museum
curators have testified that the act of defining folk art is an eval-
uative process, which they, as members of one segment of society
with their own reference group, perform on objects created by
people from other segments of society who belong to other ref-
erence groups. Cross-cultural evaluation of this sort is untenable
as a scholarly activity as Roger Rollin points out.[37] Rollin argues

[36] Michael Lydon, *Rock Folk* (New York: Dial Press, 1971).
[37] Much of the following argument is indebted to Roger B. Rollin, "Against
Evaluation: The Role of the Critic of Popular Culture," *Journal of Popular*

that the scholar's role is to explicate, not evaluate. Scholars can serve many ends, but the chore they need not perform in a culturally pluralistic society like ours is "the placing of a given work (or object) in a scale of values." In the end that action is no more than a reflection of the scholar's point of view. Rollin is particularly unhappy about critics from one reference group or taste culture who evaluate according to their own standards the products of another group, which they usually perceive as beneath them. Since evaluation is inevitable in any case, it is unnecessary for the critic to make this judgment. The only evaluation that really matters is how large a portion of a creation's potential audience responded to it positively. There are plenty of reliable yardsticks for measuring the success of contemporary products. Television shows can be measured by Nielson ratings, plays or movies by the box office receipts. Books can be rated according to the number of weeks they stay on the bestseller list. If a creation fares well in any of these contests it is a success.

Rollin goes on to argue that the best authority for determining the beauty or excellence of a work from any reference group or taste culture is the people within that group. This obviously means that works which do not satisfy the requirements of a large number of people may still, nevertheless, be viewed as successful by the small coteries that support them. An object is validated by its success within its intended group, not by criticism from outside of that group. Rollin sees this as a democratic stance for a democratic aesthetic.

Scholars are coming increasingly to realize, in Rollin's words, "that the house of criticism is built on sand." Attempts to validate it often degenerate into circular arguments searching for a rational, objective basis for a hierarchy of values which is, in the end, social in origin. Social sciences in particular have encouraged a new relativism. Matthew Lipman notes that "It is not surprising that skeptics, relativists, positivists, and others have joined

Culture 9, no. 2 (Fall 1975):355–65. For a response to Rollin's article, see John Shelton Lawrence, "A Critical Analysis of Roger B. Rollin's 'Against Evaluation,'" *Journal of Popular Culture* 12, no. 1 (Summer 1978):99–112. Rollin's response to Lawrence, "Son of 'Against Evaluation': A Reply to John Shelton Lawrence," appears in the same publication, pp. 113–17.

forces to cast doubt upon both the possibility and the necessity for the evaluation of works of art." [38]

This doubt is advanced in the work of A. J. Ayer, who took a long look at the evaluative terms "good" and "bad," and concluded that they did not refer to anything knowable at all. "Good" was simply a term referring to emotional attitudes of approval, and "bad" was reciprocally a term for expressing disapproval.[39] B. F. Skinner maintains that "to make a value judgment by calling something good or bad is to classify it in terms of its reinforcing effect." Good things are positive reinforcers; bad things are negative reinforcers.[40] When writers or scholars evaluate, then, they speak about themselves, their reference groups, and how an object supports or threatens, confirms or contradicts values held by themselves and their groups. A negative response to an object which others have responded to positively tells us how the respondent feels about those other people but comparatively little about any qualities intrinsic to that object. Rollin finally reminds us that the social functions of evaluation become particularly clear when we recall "the ways in which standards of aesthetic value can be transformed into moral imperatives which are then employed to celebrate some human beings and oppress others." [41]

The increasing disenchantment with evaluation is directly related to the growing appreciation and tolerance of cultural pluralism in American society. If evaluation of all human creativity by a single group of critics makes sense in a unified, homogeneous society with an unchanging system of values, it is at the very least presumptuous in a dynamic society composed of several subcultures, each with its own point of view. Sociologist Herbert Gans argues that while the notion of an American culture may make sense in gross terms or when it is compared, let us say, to English or Indonesian culture, American culture might better be seen as

[38] Rollin, "Against Evaluation," pp. 357–58. The concept of taste in cultures, from Herbert J. Gans, *Popular Culture and High Culture* (New York: Basic Books, 1974), p. 10.

[39] Quoted in Rollin, "Against Evaluation," pp. 358–59.

[40] B. F. Skinner, *Beyond Freedom and Dignity* (New York: Vintage Books, 1971), p. 99.

[41] Rollin, "Against Evaluation," p. 362; David Watkin, *Morality and Architecture* (Oxford: Clarendon Press, 1977).

a number of subcultures coexisting around a common core.[42] These subcultures do not necessarily coexist peaceably, however. While there has been no open warfare, there was and is an intensive cultural struggle by some of the educated and affluent practitioners of high and upper middle culture against most of the rest of society, which prefers the popular culture produced by the mass media and consumer industries.[43] Indeed, the entire history of American art can be seen in terms of one group, powerful but insecure, criticizing and ridiculing another group for not living up to the former's standards of taste.[44] The folk art movement plays a role within this critique of popular culture.

Central to the critique of popular culture is the assumption that popular culture is an aberration born of commercial greed and public ignorance.[45] For each of its failings or faults, folk art has been prescribed by its partisans as a corrective, a therapeutic alternative. If popular culture is mass-produced by profit-minded entrepreneurs solely for the gratification of a paying audience, folk art, allegedly, is or was made by unpaid folk for themselves, or for someone within their circle of acquaintances. If popular culture borrows from high culture, and thus debases it, folk art either ignores high culture or, instead of borrowing from it, contributes to it by providing themes, structures, plots, and melodies. If popular culture produces spurious gratifications or, even worse, is emotionally harmful, folk art elicits pure, authentic, undiluted, and beneficent emotions. And, if popular culture reduces the level of cultural quality in a civilization and creates passive people who can be manipulated, folk art represents a timeless achievement

[42] Gans, *Popular Culture and High Culture.*

[43] Gans, *Popular Culture and High Culture*, p. 3; Dennis Alan Mann, "Architecture, Aesthetics and Pluralism: Taste and Architectural Standards," lecture (Popular Culture Association, April 1978).

[44] As such the study of the history of art criticism is also the study of social control; see Neil Harris, *The Artist in American Society* (New York: Braziller, 1966); H. Wayne Morgan, *New Muses: Art in American Culture, 1865–1920* (Norman: University of Oklahoma Press, 1978); and Paul Boyer, *Urban Masses and Moral Order in America* (Cambridge: Harvard University Press, 1978).

[45] The following line of reasoning is after Gans, *Popular Culture and High Culture*, pp. 19, and passim.

of pure art whose creators and collectors are noble individualists who think for themselves and triumph against the overwhelming odds of popular culture and the corrupt industrial age. That, at any rate, is the gist of the rhetoric which serves both those who, nostalgic for old ways and values and hostile to or afraid of change, support the folk art movement from the right, and those, fired by the romantic socialism of William Morris, or, by more recent varieties, who support it from the left.[46]

There is one notable way in which the American folk art movement differs from the conventional critique of popular culture: it is anti-intellectual. Unlike the field of folklore which both in Europe and America has become an intensely and impressively challenging study, folk art study is remarkable for its lack of depth and analysis. To be fair, we have to admit that it is not much of a scholar's domain. It is still largely a field dominated by the collector-amateur. Were Hofstadter alive today, he might be tempted to add a chapter on folk art to his *Anti-Intellectualism in American Life*.[47] Much of the writing on folk art is either an attempt to generate similar affective states, a political manifesto of folk art's lofty place in the hierarchy of human creation, or a recitation of some data considered implicitly significant. More importantly, however, the folk art movement is anti-intellectual in its dedication to the romantic and scientifically undemonstrable contention that the processes of civilization, socialization, and education defile the unblemished state in which people are born. In the folk art view, the simple is superior to the complex, and the plain, unelaborated statement of the common man is superior to the learned analysis of the scholar. And, despite considerable rhetorical speculation about unique vision and childlike innocence in folk art, the activists in that field have made little inquiry into the domain of psychology, from which they might learn more about the making and enjoying of folk art. They also have not pursued the relationship between the level of artistic capability and intellectual development. Piaget argues that a child's drawing

[46] A summation of folk art rhetoric appears in Ames, *Beyond Necessity*.

[47] Richard Hofstadter, *Anti-Intellectualism in American Life* (New York: Vintage Books, 1963).

serves as a test of intellectual development.[48] Much of what the folk enthusiasts tout as major masterpieces of human creativity may also be statements of modest intellectual capability. If that is the case, they are singing the praises of the undeveloped mind.

I should stress that the problem lies not in enjoying folk art, but in what is said about it, in the way folk art is used as a social tool, to repeat Rollin's words, "to celebrate some human beings and oppress others." The mind, in the end, is all we have. Only by encouraging intellectual growth, by encouraging the stretching of the mind in every way possible are we likely to learn how to deal with the destructive side of man which reappears periodically and threatens life on this planet. There is something wondrous about every new birth and breath and in the first word and scribble of every child, but we will learn nothing if we simply contemplate these mysteries in delight or awe. People continue to live in fear and hatred; their minds remain captives of dogma and indoctrination. With its inclination to devalue thought, reflection, analysis, and ultimately education, the folk art movement offers no escape and takes its place beside other anti-intellectual movements in the history of America.

Anyone who has read this far might fairly observe that I have contradicted myself. After arguing against evaluation, I have evaluated. After claiming that a phenomenon's popularity is its only meaningful criticism, I have superimposed my own views on what can be quantitatively demonstrated to be a successful phenomenon. I have attacked the folk art movement as though it were an academic discipline, which it is not, for the most part, and I have presumed to describe the social purpose of those who advance the cause of folk art, even though the views I attribute to folk art enthusiasts are certainly not unanimously shared by them. Furthermore, I have condemned folk art writers for not keeping abreast of developments in psychology, a field which is difficult going by any standards.[49] I have criticized a group of people for asking only centripetal, or low level, questions that

[48] Howard E. Grober and J. Jacque Vonèche, eds., *The Essential Piaget* (New York: Basic Books, 1977), pp. 576–642.

[49] For an implicit treatment of folk art as the expression of a low level of cognitive development, see Gablik, *Progress in Art*.

would stretch their minds when all they wanted was enjoyment and an escape from the boredom of life. What I hope I have also done in the process is to illustrate, rather than merely describe, one last form of conflict that the folk art movement provokes: conflict within ourselves between the drive to participate and the responsibility to analyze.

The conflict between analysis and participation is intense for those engaged in academic pursuits. Scholars, it seems to me, have to be more than agitators or activists with a larger vocabulary. Their role is initially to assess, to analyze, to comprehend a phenomenon or manifestation as fully as they are humanly able. But their very humanness gets in the way. Scholars are first of all human, and being human, they are social, have been socialized, and have a point of view. Their initial response to any situation may be to read it from their conditioned point of view. Their responsibility, however, is to suppress their own initial private response, or at least to prevent it from coloring their public pronouncements. The peculiar charge of scholars, then, is to reverse the normal order of participation and analysis. They may participate in social conflicts—indeed they should—but their participation should be based on their analysis, from a position of greater knowledge and broader understanding, not simply from better articulated emotions, or unevaluated assumptions. An evaluation will ultimately take place, but that evaluation should be based on a judgment of what a movement or phenomenon means for society as a whole, and whether it serves the ends of some people at the expense of others.[50]

Contemporary folk art studies are shaped and limited by the folk art data base, which people from outside of that field are likely to find arbitrary both in what is included and what is excluded. As pointed out earlier, folk art identification is a process of evaluation based on unspecified guidelines. The ability to select a data base with little worry of scientific accuracy makes studies neater and conclusions more assured, but it also condemns folk

[50] For discussions of participation and analysis, see Jack D. Douglas, ed., *The Relevance of Sociology* (New York: Appleton-Century-Crofts, 1970); and Jean Chesneaux, *Pasts and Futures: Or, What is History For?* (London: Thames & Hudson, 1978).

art study to recommit the familiar sins of conventional art history by producing narrow, unreflective, casual studies of limited value to scholars in other fields.[51] It is possible, even using the biased data base of folk art, to pose questions that will unfold the broader ramifications of the material. This is what Michael Owen Jones did in *The Handmade Object and Its Maker*. Because he wanted his arguments to be read by folklorists and students of folk art, Jones took a data base familiar to people in those fields. But he went on to analyze and develop his material in such a way as to illuminate a wide range of critical aspects of human creativity. In the hands of another author, Jones's subject might have yielded only more object fetishism or creator worship; instead, Jones's book yields valuable insights with broad applications to other realms of intellectual inquiry.

While this paper cannot begin to rival Jones's magisterial study, it is possible to offer some suggestions concerning lines of inquiry which could emanate from the current data base of folk art. We can start with an object which, if framed and hung in a gallery, might be accepted as folk art: a drawing of "Old Paul" (Fig. 1). Old Paul might be classifiable as folk art for several reasons. First, he is depicted in profile, a manner of representation common in folk art but hardly confined to it. Second, the creator's competence is clearly of that relatively modest level apparent in much of what is agreed to be folk art. Third, the "Old Paul" referred to in the inscription is Paul Bunyan, the legendary figure of the North Woods, fulfilling a requirement that folk art be concerned with traditional, conservative, or nonpopular subjects. Last, the drawing was not originally produced for mass consumption; it was a single artifact, unique (if one wants to use a word with great appeal for folk art enthusiasts), given and not sold to its current owners.

The drawing was made by James F. McClaire, who possesses many of the traits that appeal to "moldy fig" students of folk art, to use a term revived by Charles Keil.[52] McClaire is seventy-seven years old. He usually wears a railroad cap and suspenders and re-

[51] See Rabb, "The Historian and the Art Historian."
[52] Charles Keil, *Urban Blues* (Chicago: University of Chicago Press, 1970), pp. 34–38.

Figure 1. James F. McClaire, *Old Paul*. Fort Lauderdale, Florida, 1977. Ballpoint pen on paper; H. 4⅝″, W. 3¾″. (Photo, Winterthur.)

tains speech patterns and a vocabulary not now common, especially in suburban Fort Lauderdale where he lives. He was wearing a similar outfit when I first met him about fifteen years ago. When we shook hands after our first meeting, he said, "Well, so long, young fellow. Don't take any wooden nickels."

Sometimes his speech is more colorful, liberally salted with expressions unfamiliar to middle- or upper-middle-class Americans. Once when he and I were working a bit of carpentry, he tried to help me use one of the tools more effectively. "An old fellow once told me," he said, "there are two things in life you've got to use the whole length of. One is a saw. The other is your pecker." On another occasion he commented about a female member of the family he held in especially low regard, "I wouldn't piss down her throat if her heart were on fire." Recently, one of his daughters telephoned to see how he was. To her inquiry about whether he was busy he responded: "Busy? Oh, sure. Busier than a cat covering shit on a marble floor." [53]

McClaire spent much of his youth in upstate Wisconsin near Eau Claire. He worked in logging camps as a teenager and later moved to Duluth, Minnesota, where he was employed by the Northern Pacific Railroad. With his retirement in 1965, he moved to Florida. Fighting recurrent bouts of poor health, he sometimes worked in construction in Florida, and for a time ran a lawn care service with his son. He also built a number of small log cabins which he gave to children. Until recently, much of his time was spent at a farm, where he and his son-in-law kept horses, cows, pigs, and chickens. McClaire took full responsibility for the animals and became increasingly involved with mending pens and fences, chasing cows, and, especially, locating inexpensive food. He came to spend much of his day driving a route between area markets, picking up discarded produce for the animals. A heart attack put an end to that project and for the last year or so he has been rebuilding a Conestoga wagon which his son-in-law had brought back from Kansas to give him something to do. Recently, McClaire became prominent in the Miami and Fort Lauderdale newspapers, for he had finished the wagon, except for the canvas top, and it was ceremoniously drawn by four horses through the busy traffic on state road 7 down to the farm where it is kept.

[53] Folklorists have tended to suppress those aspects of folklore that offend their genteel sensibilities; they tend to believe that folklore should be "sweet, cute, and charming." See Dorson and Carpenter, "Can Folklorists and Educators Work Together?" pp. 4–5.

McClaire's son-in-law, Roger Johnson, will probably use the wagon in local parades. He and his friends are talking about using six horses rather than four, for greater effect, no doubt.

One could study this man, the drawing, or the wagon, along conventional folk art lines. We could, as others have done, "discover" McClaire and get him to do more drawings, or to rebuild more wagons. We could sit down with a tape recorder and try to get him to recite as many picturesque sayings as he can remember. In short, we might dwell on those aspects of his life and behavior which are most unlike our own. Yet this approach, which focuses only on certain eccentric features of an individual and ignores the rest, like psychology in its early days when it emphasized only the abnormal, is likely to produce rather unbalanced results. The objects and the person associated with them have to be put into a larger social context. We noted earlier Kubler's comment that biography, if too closely adhered to, restricts our ability to deal with issues that extend beyond a certain individual.

To many of the romantics who study folk art, people like McClaire represent a fragile grip on the past, a grip they can see loosening before their eyes. They can try to hold on to the past by taping and filming such people, or they can, simultaneously, step farther back and move closer to these people. By stepping back, they can bring into their field of vision not only a single person, but they can see that person within the larger context of his society which is also their own. By drawing closer to that person, they can eliminate the condescension, the distinction between "we" and "they" that appears in a great deal of folk art writing. McClaire lives in the same world we do and not in the isolation of a case study. Many of his experiences and activities have been shaped through interaction with other people; many of his experiences are like our own. His son-in-law gave him the wagon so that he would have something to do. Now the latter intends to use it in parades. McClaire's knowledge of wagons has as much to do with watching years of "Bonanza" on television as it does with growing up in northern Wisconsin. The whole wagon episode was a project of retirement, itself an escape from

the frozen north to the sun-warmed mecca of aging Americans. Discussing his wagon building as folk art or folk craft cuts it off artificially from the larger social context which prompted it and gives it meaning.

The same part of McClaire's behavior that interests folk art enthusiasts might also interest gerontologists. What, for example, does retirement mean in America? What does it mean to grow old? How do people cope with their own declining strength and vitality? How do people deal with social change or the changes involved in moving across the country? [54] What does their own past mean to them? And, finally, what can we learn from McClaire's behavior? In my earlier discussion, I do not claim to have completely accounted for the appeal of old time things and ways. Nor do I assume that commonplace clichés about the reasons the past fascinates people completely explain the phenomenon. We need further study into the private symbolic and communal symbolic meanings of the past, for folk art study is but one facet of those larger issues.

This detour to comment on a single person was only to suggest what Jones laid out more extensively: that posing new questions of the conventional data base of folk art studies can lead to centrifugal patterns of inquiry which can build bridges to other disciplines and help create a broader and more thorough understanding of human beings. Once we realize that there is more than one way of dealing with this material, it becomes clear that the objects and people recorded by students of folk art offer a great and exciting basis for studies of considerable potential significance. While we have talked about folk art as a social tool employed against the consumers of popular culture, it is possible that folk art has greater potential to become a tool for entirely different purposes: to promote a truly democratic tolerance of pluralism and diversity; to help answer some of the pressing questions in the field of gerontology; to help us learn more about nonverbal communication, intellectual development, and the nature of our affective being. Let me comment briefly on each of these.

[54] Andrea Fontana, *The Last Frontier: The Social Meaning of Growing Old* (Beverly Hills: Sage Publications, 1977).

TOLERANCE OF PLURALISM

Regardless of the, occasionally, contrary intentions motivating it, folk art study has had the very positive effect of expanding the range of humanly created objects considered worthy of serious consideration. In this way, it has had a democratizing impact on the concept of art. Through insistence that objects emanating from outside of the domain of elite society are worthy of attention, folk art has helped to contribute to a greater tolerance of aesthetic pluralism in American society. It is difficult to determine whether the folk art movement will continue to grow in a more democratic direction, or whether it will retain the notion of folk art as a tool against popular culture. If the field comes under the influence of some of the more capable and imaginative of the folklorists or the liberal art commentators and historians, we may expect to see a broader definition of folk art. The work of Michael Owen Jones is particularly tantalizing in this respect. Jones has developed a promising interpretation of the term *folk* by which he means recurrent or persistent elements in human behavior which cut across social class, ethnic groups, taste cultures, and financial scales.[55] The study of fundamental aspects of human behavior can provide a way to go beyond the artificial boundaries which have been thrown up around the category of folk art.

Those who accept this orientation will be obliged to look for the relationship between things people do or make instead of unreflectively accepting social or artifactual divisions as barriers to inquiry. It means that, having noted strong relationships between objects defined as folk art and those seen as products of elite or popular culture, they cannot be content to serve social needs by claiming one artifact automatically prior or superior. It means that, although style or fashion change less readily in folk artifacts, by definition they cannot, when confronted with two syntactically similar artifacts—one augmented with identifiable period style and the other without it—ignore one and embrace the other. Indeed, the great accomplishment of folk art has been to convince us that something important can be found in those ma-

[55] See Jones's essay elsewhere in this volume.

terials. The field is ready for those who pose centrifugal questions and can formulate compelling and convincing theories.

GERONTOLOGY

The association of gerontology with folk art may seem bizarre, but it is a logical extension of folk art studies. Because folklore is concerned with tradition and continuity, there is a tendency for folklorists to concentrate a good deal of their attention on old people. Extreme forms of this tendency have been critiqued by Charles Keil, who revived the term *moldy fig.* The term was originally used by jazzmen to refer to those whose interest in jazz stopped at the first World War. In the context of folklore, moldy fig refers to those whose definition of prototypal folk focuses on people who are "more than sixty years old, blind, arthritic, and toothless," obscure, and from a rural environment.[56] Those who study folk art have some of the same tendencies. At the present there is a fascination with "discovering" in some relatively isolated part of America aged artists who preserve an earlier, purer vision. Folk art study has accumulated a significant bank of data about old people who make things. From this data it may be possible to draw some broader conclusions about growing old in America. The information and insights about the old gathered by people studying folk art may enhance our understanding of the personal satisfaction old people derive from making things. We should know more about the role this activity plays in producing feelings of worth and personal satisfaction in the aging.

NONVERBAL COMMUNICATION, INTELLECTUAL
DEVELOPMENT, AND THE NATURE OF OUR AFFECTIVE BEING

This last cluster of potential lines of inquiry can only be commented on briefly. All three areas are being actively and energetically investigated at the present time and represent lively,

[56] Keil, *Urban Blues*, pp. 34–35.

expanding fields of intellectual inquiry. Nonverbal language and nonverbal experience, relatively obscure notions only a decade ago, are now the subject of undergraduate courses and have an immense and rapidly expanding bibliography. Yet the role of objects in nonverbal communication is among its less studied facets. For many lines of inquiry into the role of objects in nonverbal communication, folk art is not necessarily superior to other kinds of objects, but it may be that those objects which stress tradition and continuity will prove to be particularly fertile places to search for the most fundamental aspects of nonverbal communication.

What about the relationship between folk art and intellectual development? Some might argue that any attempt to define a relationship is only an elitist attempt to deny the value and importance of folk art. This view, however, ignores the broader implications of the study of intellectual development carried out by Piaget and others. The frequently noticed correspondence between folk art and children's art should not be denied but rather explored, with full realization that most people develop their various abilities to greater or lesser degrees. Despite notable strides in recent years, we know relatively little about the mental processes involved in making things and how these processes change as one passes through different levels of intellectual development. The apparent correlation between folk art and children's art suggests that it might provide a good entry point for the testing of hypotheses about intellectual development and capabilities in drawing, rendering space, proportion, and other matters. Piaget and others have sketched out tentative lines of development which remain to be tested.[57] There may be those who will argue that the search for intellectual levels is antithetical to democratic goals. It is not, of course, the goal of a democratic society to repress the intellectual development of its members or to compel all to fit a uniform mold. In a democratic society all persons may find their own fulfillment. Yet a truly democratic society will require the greatest of intellectual development to make it possible. We need to encourage an understanding of intelligence, for ex-

[57] See Gruber and Vonèche, *The Essential Piaget*, pp. 576–642, and passim.

ample, if we hope to possess the mental capability to bring about the democratic society we envision.

Finally there is the matter of our affective being. Above all else we are left with the fact that people like folk art. I tried to suggest earlier, in discussing ways of interacting with art objects, some of the reactions people have when they encounter an object and some of the reasons that they like it. Although I have argued that liking something can be explained both in terms of our socialization and in the psychological terms discussed by B. F. Skinner, I have a nagging feeling that these explanations only partially account for the positive feelings we have toward objects. Because so many people find so much enjoyment in folk art, this material again seems a viable place to reexamine the questions of what produces enjoyment. There are probably far more factors involved than I have touched upon.

I have tried to suggest a few avenues of inquiry that might be explored starting from folk art. There are, of course, many others. Clearly, folk art is a field of study rich in potential. It will be interesting to watch the direction of future development and to see how long the old point of view will remain prominent.

L. A. Add-ons and Re-dos: Renovation in Folk Art and Architectural Design
Michael Owen Jones

This article reviews aspects of home remodeling that have important ramifications for folk art study, architectural design, and public policy. The choice of subject matter grows out of a mixture of personal motives and academic purposes. Having "fixed up" several properties myself I can include purposely my own behavior in the data base. The subject of additions and alterations to houses is a frequent topic of conversation among my friends and family, for my wife is a licensed real estate salesperson, many of the people we know have remodeled or added to their homes, we are in the process of remodeling our own home, and the current housing boom in southern California looms so large in the lives

I wish to single out and thank for their assistance in the preparation of this report Joe and Suzie Arpad; Reba Bass; Phil and Leslye Borden; Paul and Susan Deason; Robert A. Georges; Bruce and Gen Giuliano; Jim and Geraldine Kennedy; my sister-in-law, Martha McKinley; Susan Wilson O'Brien; Ron and Jean Shreve; Sam Stavro; Steve and Mus White; and my wife, Jane. I talked to many other people who will not be named. I will not identify all comments and activities with their authors because attribution might prove embarrassing, because more than half of this paper is given over to methodological considerations rather than ethnographic concerns, and because I often feel uncomfortable identifying sources of information given to me in confidence. Additional information comes from several publications that survey owner-built houses and home remodeling.

of so many of us that it has replaced the weather as a subject with which to initiate conversation. Furthermore, I have grown weary of the popular notion, for whose reinforcement I am partially responsible, that the folklorist studies rural, isolated, conservative groups of people who are the fortuitous inheritors and perpetuators of a cherished cultural legacy. The potential contribution of folklorists, it now seems to me, lies not in their ability to record and preserve seemingly old-fashioned ways of allegedly inarticulate people but in their capacity to solve some of the enigmas of human behavior. An investigation of additions and alterations to homes has much to offer any student of human behavior. It also has practical ramifications, for, by using this subject as a basis, one can develop a more behaviorally oriented conceptual framework, broaden the data base, and expand the applicability of insights.

The importance of studying the construction of personal space becomes apparent when a few figures are cited. According to one report, owner-built houses account for at least 40 percent of all new housing in rural areas and 20 percent of all new single-family housing in the United States, which means that minimally 160,000 families every year build their own houses. Statistics of government agencies are incomplete in respect to the number of owner-built houses, many of which go unreported, and they do not include at all building additions, alterations, and repairs.[1] A recent newspaper article reported that, because of the present housing boom, "Thwarted buyers, incidentally, have been part of the horde of families remodeling their homes, last year to the tune of a record $29 million spent throughout the nation on new bedrooms, dens, bathrooms, other additions and alterations."[2] The source for this figure of $29 million is not given, but it is probably based on recorded home-improvement loans; if so, it

[1] Ken Kern, Ted Kogon, Rob Thallon, *The Owner-Builder and the Code: Politics of Building Your Home* (Oakhurst, Calif.: Owner-Builder Publications, 1976), p. 3; their information is based on *Construction Reports, C-25 Series*, issued by the Bureau of the Census, Department of Commerce, with the Department of Housing and Urban Development (Washington, D.C.: U.S. Govt. Printing Office. 1963–69).

[2] Dick Turpin, "Another Buying Barrier Falls," *Los Angeles Times* (June 19, 1977), pt. 7:1 (Turpin has a regular column in the real estate section).

excludes the many alterations paid for in cash, or with private financing, or from refinancing of the property, and thus represents but a fraction of expenditures. (Indeed, when one considers that contractors in southern California estimate $60 a square foot to remodel or add kitchens and bathrooms and $30 a square foot for other rooms, $15,000 to $25,000 to add a swimming pool, and $40,000 or $50,000 to add a second story to a house, $29 million sounds more like what was spent in Los Angeles alone last year.[3]) For an even fuller appreciation of the prevalence of this behavior of crafting and readjusting personal space, one need only observe oneself and one's neighbors; it soon becomes obvious that there is an enormous data base of incalculable value waiting to be examined for its implications.

This data base consists of several, interrelated phenomena. A "re-do" is a "fixer-upper" that no longer needs fixing, which is to say that someone has "remodeled" the structure, changing it to conform to recent architectural or decorative trends as well as to personal taste. Or someone has "renovated" the building, bringing it up to date according to building codes and to notions of modern convenience (sometimes also known as a "re-hab"). Or, rarely, the structure has been "restored," which is to say that someone has gutted the place of accumulated renovations and remodeling attempts in order to return the building (or at least some parts of it) to the original appearance or "character." Reversing the trend of "deferred maintenance"—or making repairs —is expected. But where there is little hope of "re-doing a place," because of its alleged economic or functional obsolescence, the property is sold "for lot value" and its building is dismissed as a "tear-down" (which is occurring less often now because of the high costs of labor and materials; even older apartment buildings are being moved from one site to another, and in Santa Monica a service station was converted recently to a fresh produce business called "Nature's Power Station"). Re-dos and add-ons are similar in many respects to "conversions" (making a home of a mill,

[3] Information from Los Angeles architects Boris Marks and Herb Katz; contractors Larry Rose and Don Burgess; designer Geraldine Kennedy; and home owners Joe Arpad and Jim Van Trees who recently remodeled their homes.

barn, school, bank, warehouse, and so on),[4] and to "owner-built" or "handmade" houses.[5] Some people have called these structures folk, spontaneous, indigenous, nonformal, nonclassified, nonpedigreed, vernacular, anonymous, exotic, or communal architecture, or "architecture without architects."[6] Sometimes these structures are contrasted to "official" or "commercial" architecture produced by contractors, professional builders, designers, and architects. Such a dichotomy is not quite accurate or adequate, although it does have some sort of experiential basis. There are many instances of remodeling or building additions by or with contractors, designers, and architects; some fixer-uppers were once notable works of architecture, while many add-ons and re-dos by contemporary homeowners are of houses that were not owner-built. The common feature is that the homeowners personalize the space.

What do re-dos and add-ons have to do with folk art study? Fixer-uppers invoke "tradition" (models are used for guidance and inspiration), and many of the same questions entertained in regard to quilting or chairmaking or candle dipping can be asked.

[4] For examples of conversions of buildings to homes, see Hubbard H. Cobb, *The Dream House Encyclopedia* (New York: Peter H. Wyden, 1970), pp. 355–59 (coach house), 360–67 (pioneer way station), 399–403 (horse barn), 404–12 (iron mine), 413–17 (California winery), 418–23 (lampshade factory), 437–45 (grist mill), 464–68 (ice house), 478–87 (ice house); see also Roland Jacopetti, Ben Van Meter, and Wayne McCall, *Rescued Buildings: The Art of Living in Former Schoolhouses, Skating Rinks, Fire Stations, Churches, Barns, Summer Camps and Cabooses* (Santa Barbara, Calif.: Capra Press, 1977); most of the structures are in California and include, in addition to those in the subtitle, a culvert (p. 8), water tower (pp. 10–11), wine barrel (pp. 12–13), opera house (pp. 26–27), hotel (p. 30), light house (p. 31), silo (p. 32), chicken house (pp. 33–35), creamery (pp. 36–38), laundromat (p. 44), automobile garage (p. 46) and service station (p. 71).

[5] For examples of owner-built houses, see Kern, Kogon, and Thallon, *The Owner-Builder and the Code*; Virginia Gray, Alan Macrae, and Wayne McCall, *Mud Space and Spirit: Handmade Adobes* (Santa Barbara, Calif.: Capra Press, 1976); River, *Dwelling: On Making Your Own* (Albion, Calif.: Freestone Publishing Co., 1974); and Art Boericke and Barry Shapiro, *Handmade Houses: A Guide to the Woodbutcher's Art* (San Francisco: Scrimshaw Press, 1973).

[6] John A. Kouwenhoven, *Made in America: The Arts in Modern Civilization* (Garden City, N.Y.: Doubleday, Anchor Books, 1962), pp. 13–14; Clovis Heimsath, *Behavioral Architecture: Toward an Accountable Design Process* (New York: McGraw-Hill Book Co., 1977), pp. 44, 178, and *passim*; Bernard Rudofsky, *Architecture Without Architects: A Short Introduction to Non-Pedigreed Architecture* (Garden City, N.Y.: Doubleday, 1964).

To be consistent, however, a behavioral approach, as advocated here, requires the posing of questions in a slightly different fashion from the ways in which research problems are posed within a historio-textual framework or a sociocultural-contextual perspective. For example, one would ask how and why certain behaviors and outputs of behavior are generated, not what are the origins (suggesting the long ago and far away) of an object or text. What are the motives and rewards, rather than the social or cultural functions of some activity? New concepts need to be employed. As will be discussed, words, terms, and constructs such as folk, art, culture, and aesthetics need reassessment or even replacement in any attempt to renovate the study of what people make and do in face-to-face interaction with one another.

The question of whether alterations and additions to homes are, or are not, folk art is problematic for several reasons. There is no consensus in definitions as to what folk art is, no criteria are exclusive, and no distinguishing characteristics are consistently employed. Differentiating folk art from non-folk art is not simple nor clear-cut, as if there were two classes of people, processes, and objects: folk and non-folk, indigenous peoples and technological man, them and us. Furthermore, fundamental similarities among people suggest the complexity of the conceptual problem—all of us narrate, build and construct, personalize living space, celebrate, ritualize, and structure events; all of us employ models for our behavior; all of us learn from a multiplicity of sources including oral communication. In regard to the remodeling of houses, there are architects and designers who, part of the time, work closely with specific individuals in order to tailor the space to their personal needs, although at other times they may be more concerned with requirements of geometry, standardization of materials and functions, and systematization of labor resources. Some homeowners sometimes make highly personal statements in their construction or remodeling, and sometimes they, or other homeowners, do not. Some people who act as contractors and interior decorators for occupational purposes are without licenses, formal business trappings, and official training; other individuals who build or remodel their own homes in a highly personal way are licensed and trained designers or contractors. Any dichotomy be-

tween "folk" and "other" (non-folk, official, elite, and so on) is not hard-and-fast, nor is it based on anything tangible. And yet, a distinction is often made, and it does have an experiential basis of sorts. What that basis constitutes seems to be one of the greatest mysteries in folk art study. The differentiation appears to grow out of an intuitive feeling about concern and accent: one tends to distinguish a "re-do" from a "remodeled home" and an "add-on" from an "addition" not so much on the basis of who did the work or on the quality of the output as on the grounds of the attitude and assumptive framework of the builder or redecorator. I submit that the attempts to distinguish between folk and non-folk are based on similar processes of conceptualization. In regard to the construction and redesigning of buildings, objects and activities are ignored by many folklorists when the conceptual framework and attitude inferred by them seem to be that of an impersonal, often "systems," approach developed a priori and applied with little concern for the specific needs of particular individuals. When the outputs seem to manifest behavioral concerns primarily, and to result from highly individualistic and obviously personal considerations, then those outputs and behaviors are more likely to attract the attention of folklorists.

Preoccupation with the question of whether or not such-and-such a phenomenon is folk art assumes that there are distinguishing features and consistent criteria for making this attribution, when in fact the process of conceptualization is intuitive, the standards variable, and the bases elusive. What distinguishes folkloristics as a field of study is not so much a data base that can or should be labeled folklore or folk art but a method comprising questions, hypotheses, and models emphasizing and examining behavior. Since the early part of the nineteenth century, folklorists have in fact focused attention on the outputs of behavior and sometimes on the behavior itself, rather than on "culture," "psyche," "society," or "art." The only task remaining is to generate a specifically behavioral methodology that organizes some of the insights from the past and renders this field of study more contemporaneous in outlook and application. This task has been undertaken by a number of folklorists; I think it can be helped

along with an examination of such contemporary, and prolific, behavior as that of altering personal space.

What follows is a review of add-ons and re-dos in Los Angeles in terms of several familiar research problems, for which I have some solutions that are a bit different because, in part, the questions are posed in a different way. I shall examine also the topic of folk art study, which I feel is in need of being "re-done." Remodeling and adding to something does not necessarily mean tearing down the earlier structure; rather, it is possible to identify the character of the structure and then to enhance it, which is the goal of surveying the implications of these data for studies of human behavior and for considering the ramifications for folkloristics and the related fields of architectural design and public policy.

Among the several implications in an investigation of the ways that people construct, redesign, and readjust personal space are those considerations relating to motivation and rewards. The reasons for contemplating remodeling or adding onto a structure, and of doing some or most or all of the work oneself, can be reduced to half a dozen principles.

An obvious reason for altering space is the response to changing physical needs (for more space or different kinds of space and space utilization, or for certain amenities). This motive was rarely stated or implied by homeowners I talked to, although it is one of the most frequently cited rewards in articles that try to stimulate the homeowner to action.[7] Perhaps this reason is rarely expressed because it is so obvious and therefore assumed, or perhaps this motive is really not such an important one, even in respect to building an addition.

A second reason, frequently mentioned in how-to articles and books, and sometimes orally, is that of taking advantage of an attractive financial situation (to make or to save money). Some

[7] In the *Los Angeles Times* in the summer of 1977 there were many "Special Advertising Supplements" each of which was called a "Home Improvement Guide" and in each of which were articles about contractors, salvage yards, and the advantages of remodeling a home; adding space and saving money over the purchase of a new home were emphasized.

people "fix up" properties as a long-term investment, renting the houses at a price commensurate with the amenities, or for immediate resale. Some individuals do much of the work themselves, not only to capitalize on their own labor but because they claim not to be able to afford the labor of others. Other individuals say they are motivated by the fact that they can obtain more space for less money, and, besides, the house needs work. Others point out that often they cannot duplicate the quality of workmanship or the features found in older homes. But often remarks about the economics of remodeling one's own house shift to other matters, as when Stanforth and Stamm write, "Many couples are finding that they can buy more space than they can afford to rent, discovering they can even live rent-free in houses that were built with twelve foot ceilings, wood paneling, and half a dozen marble-manteled fireplaces instead of boxy little plasterboard rooms." [8] Fahy suggests other motives for owner-alterations: "Chances are you will do as good or even a better job than the professionals. The reason? It's your place you're working on, and you care about it." In addition, "Fixing an old place makes you a more competent person. It gives you control over your life. The more you do, the more you are willing to tackle," he continues. "And finally, when you do the work yourself, the house becomes truly yours. You'll enjoy living in it far more than you would if you had it all done by somebody else." [9] My sister-in-law admits: "It's just us; we don't like new houses. They don't have warmth, they don't have storage space: they're just boxes." A few minutes later she added, "I think the basic reason we have restored houses is that we could get a heck of a lot more house—and an older house—for the money."

It is apparent from these statements that economic incentives are not in themselves the only, or even the major, motivation for adding to and altering the nature of houses. Newspaper headlines often scream "speculation" as an explanation of the inflated prices

[8] Deirdre Stanforth and Martha Stamm, *Buying and Renovating a House in the City: A Practical Guide* (New York: Alfred A. Knopf, 1976), p. 3.
[9] Christopher Fahy, *Home Remedies: Fixing Up Houses and Apartments, Mostly Old But Also Otherwise* (New York: Charles Scribner's Sons, 1975), pp. xviii, xx.

of houses in Los Angeles, the topic of financial rewards often crops up in conversation, and many people claim to be inspired initially and partially by dreams of wealth; yet financial reward as an explanation of behavior is usually given when the commentator does not wish to reveal other motives. The first four males whose behavior was studied in preparation of this paper became involved in remodeling houses when they were having problems with their jobs which had been an important part of their lives and identities. While they considered home remodeling as an occupational alternative, none in fact has pursued that as a career. The houses they worked on for a few months now serve as a small source of income and a potentially large source of future gain, but the actual work of remodeling the houses seems to have been precipitated by grief and its attendant needs to occupy one's attention with other matters and to reestablish a sense of self-worth, both of which were accomplished by undertaking a task with perceptible outputs and a task which was very unlike their jobs. In essence, one reconstructs oneself through the act of successfully reconstructing an object external to oneself. Grief is like that; it can and often does spur building, structuring, ordering.[10] But as an impetus, it is subsumed by a broader principle, that of self-expression.

A third reason for redesigning personal space, especially when one does much of the work oneself, is that of maintaining a sense of authority and degree of control over oneself, one's life, one's possessions. Here I have in mind such remarks as those by John Yount in his article "Hooked on Hardware" which is subtitled "How the Author, in Need of a Fix, Picked Up Some Tools and Repaired His Life." [11] Analyzing his addiction to hardware he writes, "I isolate ownership as a huge contributing factor in my case. Ownership of anything." He continues: "Why not call painters, carpenters, whoever might be needed, you ask? I do, I do, I answer. But often they don't come when I need them." Further,

[10] The theme of grief as it relates to creativity is explored in Michael Owen Jones, *The Handmade Object and Its Maker* (Berkeley: University of California Press, 1975), especially pp. 163–67.

[11] John Yount, "Hooked on Hardware: How the Author, in Need of a Fix, Picked Up Some Tools and Repaired His Life," *Esquire* 86, no. 6 (December 1976):97–101, 144–50.

"Sometimes they do perfunctory work when they finally arrive. Always their bills shock me. One illusion of addicts, alcoholics, and hardware freaks is that they were driven to their fates," he concludes, "and so it is with me." But, he also notes, there are additional sides of a hardware freak neither paranoid nor defensive: "The wish to make something work, to build, devise, to construct." [12] One of the people involved in this study told me, "At one time I worked on an assembly line for GM creating aberrations. There was no consciousness attached to the product, no wholeness and integrity. But if you built an entire car, then you would have a projection of self into the whole project. The same with houses." Some other homeowners contended that only they, having lived in the house and thus sensed its many peculiarities, are capable of understanding and appreciating and maintaining the uniqueness and integrity of the home. One family went to two architects and two contractors for help in designing alterations, only to be frustrated by receiving plans that were too expensive to implement, simply unmanageable (moving a fireplace weighing several tons 60 degrees, for example), or inappropriate to the present character of the structure. Their solution was to design the space themselves. [13]

A fourth principle is that of attaining intellectual and sensory goals. One exercises control over the product; learns new skills while learning about oneself; constructs unique and highly personalized spaces; takes pleasure in the associations engendered with respect to past owners or builders and eras as well as in regard to the materials; enjoys the sensuousness of different smells, textures, colors, and even kinesics (as in working with certain tools); or derives pleasure from solving tangible problems. According to Fred Schurecht, who turned a horse barn into a house, "It's really just a question of maintaining the character of the original building." He advises: "You start with a shell. Old barns are great fun projects—they don't have the problems normally associated with remodeling an old house. On this project

[12] Yount, "Hooked on Hardware," pp. 97, 146.

[13] Susan G. Wilson, "Bootleg Building: The Interface of Folk Art and the Law in a Small Community," fieldwork report for the course, Folklore 118: Folk Art and Technology, UCLA, 1973, pp. 9–10.

there was no major problem other than cleaning out the manure." [14] And River quotes several people, including Douglas Patrick, who said, "Building is like yoga. You can't do it any other way than one nail at a time. It's the meditation of it. It's a constant surrender. 'Look at that hammer hit that nail!' As within, so without." [15] And Kent said to River, "Well, y'know, building a house isn't nearly so hard as living in it." [16]

These comments also suggest a fifth principle, that of actualizing self through symbolic statements. People build an environment and create objects expressive of what they think they are or wish they were or hope others think they are. Or, they generate a sense of self-worth by accomplishing a task with perceptible outputs, engaging in a rite of trial in which they test themselves. Or they produce a sense of identity with respect to place and to others. Wayne told River, "I seemed to be trying to prove something to myself while I was building the house. It was a lesson in perseverance. I wasn't sure I could do it or not, 'cause I'd never done it before." [17] Charlie Ramsburg, who restored an adobe house, told the authors of another book, "It can be addiction, this adobe building. A lot of people building houses are always looking for the perfect space, trying to find peace of mind through building." [18] Said Hal Migel, "When you live in a house while you're building it, each time you add a detail, paint a stripe around a doorway, you become part of its growth." [19] Adrienne told the authors about her house, "The whole thing is very symbolic. It records our changes." [20] Warns Fahy in his book on remodeling, "Fixing a house is an intimate proposition. You get to know its every inch, and when you leave it, it's like leaving a friend." [21] I was told by one person, "The house on Tennessee Street is still part of me—it's my house even though I sold it after fixing it up.

[14] Cobb, *Dream House Encyclopedia*, p. 440.
[15] River, *Dwelling*, p. 60; see also remarks by Fil Lewitt in the same book, p. 84.
[16] River, *Dwelling*, p. 127.
[17] River, *Dwelling*, p. 106.
[18] Gray, Macrae, and McCall, *Mud Space and Spirit*, p. 61.
[19] Gray, Macrae, and McCall, *Mud Space and Spirit*, p. 36.
[20] Gray, Macrae, and McCall, *Mud Space and Spirit*, p. 52.
[21] Fahy, *Home Remedies*, p. xiv.

It is probably how an artist feels: even though he no longer owns a particular work, it is still a part of him."

The sixth principle concerns the socially symbolic rather than the personally significant. Alterations and additions to homes can be, and sometimes are, a social experience and the basis for interaction and communication. Remarks by Stanforth and Stamm, in their book about buying and renovating a house in the city, illustrate this point. According to the authors, ". . . one day in the midst of construction their doorbell rang, and Merle Gross introduced herself. It was obvious that the Stanforths were renovating a house, and so was she, on Seventy-seventh Street. So she came in and talked, comparing experiences." Later the Grosses invited the Stanforths to a party, along with a dozen other couples, "all of them brownstoners, all indulging in the game of one-upmanship over who had suffered the worst experience, whose house had looked the grimmest (rather like people comparing their operations). Everybody was having a delightful time." The Stanforths met the Stamms at this party and began the friendship that led to the writing of their book on remodeling houses.[22] Remodeling a house may be a family affair, and sometimes friends have an urge to help. But often it is a strain. Susan Wilson O'Brien was told by one woman that she has "lived in sawdust" for twenty years.[23] Other people complain that they never have had a house to "show off" because it is always under (re-) construction. Divorce is not infrequent. Some people purposely generate rituals as a technique to solve, or prevent the development of, interpersonal problems during remodeling. When Joe and Susie Arpad were working on their house recently, there were seven people living in the midst of the rubble. "At dinner, we had a five-minute gripe session to air all the problems that day," said Joe. "And we also had grace. We 'thanked God' that the dirt was moved that day, or that we managed to get something else done." To some individuals, remodeling a home is interpreted as an ac-

[22] Stanforth and Stamm, *Buying and Renovating a House in the City*, p. 170; and see Cobb, *Dream House Encyclopedia*, p. 469: "The Robert Crozier Family: They Found the Perfect Barn and Made It into a Conversation Piece."

[23] Wilson, "Bootleg Building," p. 7.

tivity that unifies the family. And for some people renovating an older house is a moral imperative, redounding to the advantage of the community as a whole.[24]

Many people who want to remodel would prefer not to do it themselves; if renovating must be done, the task is turned over to others. In regard to the notion that doing it yourself is enjoyable and rewarding, Chuck Scarborough writes, "For people like me it is not. Doing it myself was thumb-smashing, muscle-straining, temper-wrecking, and miserable. Only having it finished was rewarding. Even boasting to your friends about having done it yourself isn't what it's cracked up to be." And with respect to the assumption that one will save money, "If you try to save, you'll end up owning a lot of cheap things. If you don't try to save, you'll end up owning a few expensive things. But either way," he contends, "you'll spend more than is prudent. And money you save by doing it yourself you'll only blow on dinners out or [on] radial tires." [25]

Generally, students of architecture assume that major elements in designing and using space are texture, openness, light, color, proportion and scale, geometry or morphology, flow, and acoustics, as well as the principles of harmony, rhythm, and balance. But personal opinion among home remodelers varies in regard to the type and amount of each element; all that is standard is the elements themselves, not their combinations. Some additions look "added on," while others are integrated more completely with the original structure. Visually the building may not accept an addition without major and expensive restructuring, the homeowner may be trying intentionally to alter the appearance or character of the structure, and so on. There are also different notions of formality and informality, inside and out, and of public, private, and utility space. To some people, front yards are public and formal, yet a few years ago the *Los Angeles Times* featured a

[24] See remarks by Stanforth and Stamm, *Buying and Renovating a House in the City*, p. 157, about feelings of the Stamms regarding the upgrading of a neighborhood; and see A. J. Harmon, *The Guide to Home Remodeling* (New York: Holt, Rinehart & Winston, 1966), pp. 3, 5, and introduction in which the moral imperative of remodeling is emphasized.

[25] Scarborough, "How *Not* to Do it Yourself," *American Home* 80, no. 9 (September 1977):31.

photo and an article on Eddie Albert who had converted his front yard to a vegetable garden—rather private and somewhat informal use of a public space. An otherwise public and formal room may at times be cluttered with the paraphernalia of several activities because there is no other space available, or because this space has other meanings and uses.

When the remodeling or construction of a house is under the control of the owner who intends to live there, other elements, not usually considered by architects or contractors, are also of great importance. These features include *territoriality* (that is, which space is for whom and for what), *symbolism and self-expression, association,* and *identification.* It is the possibility of achieving these features that inspires many homeowners to undertake the task of remodeling by themselves. The achievement of these features truly "personalizes" a house, custom-tailoring it and rendering it a "home." Some people do not feel comfortable in a newly-acquired house until they have conceived of some space as "their" territory, marked it off, asserted that proprietorship, and had it recognized by others, thus affirming their identification with the house, then the lot, and then the neighborhood. Not infrequently, new homeowners will clean and even repaint houses that are, for all intents and purposes, perfectly clean and painted in acceptable colors. The cleaning and repainting are largely ritualistic, symbolically ridding the house of associations with former owners and preparing it for new associations. One woman, experiencing marital stress, often had what she called "house dreams." She dreamed of rooms in her home emptied of furniture (later interpreted by her as love and affection "stolen" from her marriage by her husband) and of a new room added to her home (where she would be away from the problems). A man who is remodeling his house now conceives of the activity as an act of personal redefinition. The remodeled home will symbolize his new self in his own eyes, or it will serve as impetus to changing his behavior to make it consistent with the image generated by the remodeled house. Conversions of attics and basements to living spaces—especially to a "family" room, or to a "study," or to a "sewing room,"—may be motivated as much by the need to ex-

press symbolically one's identification and association with a certain territory as by the need for more space.

Another consideration in regard to re-dos and add-ons is that of behavioral similarities, and in particular the use of models on which to base one's behavior. What is done to the structure that is "fixed up" includes a "face lift" (inside and/or outside), an addition, enhancement of the inherent qualities of the structure as conceived by the owner, alteration of the structure to change its character completely, or varying degrees of updating the amenities. What is done depends on the owner's skills, finances, motives, and personal taste as well as their self-concepts. Often there is a difference between what owners do for themselves, if they intend to live in the house for a long time, and what they do in anticipation of the desires of others, if they intend to sell or rent the house soon. For any remodeling, however, there tends to be some reliance on models, tempered, of course, by particular circumstances. These models include conceptions of what the building ought to look like (that is, what are the characteristic features of a "true" Spanish, California Bungalow), what one thinks others desire in a home (the models are usually derived from personal observations and published illustrations of contemporary trends), and what other people do or advise.

Another set of models concerns techniques of construction, uses of tools, choices of materials—otherwise sometimes known as "tradition." These models include how-to books, magazines, friends and acquaintances with some experience relevant to a particular problem, suppliers (especially knowledgeable people in hardware stores, lumber yards, and plumbing and electrical stores), contractors and designers who are hired to assist or who are asked for estimates and then pumped for information, other houses, and tradesmen (observed at work and questioned).[26] In other words, behavior in this context is influenced by print, by oral com-

[26] Magazines such as *American Home, Sunset Magazine,* and *Better Homes and Gardens* often have articles for the remodeler; and in Los Angeles the series of books published by the editors of *Sunset Magazine* (Lane Books, Menlo Park, Calif.) and the Time-Life series on "Home Repair and Improvement" (Time-Life Books, New York) are especially popular.

munication, and by objects and activities that are observed. (For example, "I've finally figured out how to do the door and doorway; remember that house we saw on Oceano . . . ?") Typically many homeowners alter plans during construction and remodeling and make further adjustments during use as they begin to realize the kinds of space they want and the meanings that they are giving to the space, and as they also seek inspiration and knowledge from various sources as they proceed.

Other models refer to outlook, assumptive framework, or accent. Many people distinguish, in the behavior of others and sometimes in themselves, at least implicitly, between two processes, attitudes, and approaches. On the one hand, there is the "systems approach" commonly associated with a contractor or architect unfamiliar with the specific uses to be made of the space. It consists of advance planning (often based on standardized procedures and designs employed a priori), the use of the ideal sequence of "layering materials" in construction, and the relegation of specific tasks to different specialists. This approach is considered cost-efficient by those who are not trying to personalize the space, but it is objected to by others, including homeowners employing some contractors and designers, because of the expense to them and because of what seems to be a lack of concern for their specific values and personal needs. On the other hand, there is the "person-specific approach," or "customizing," commonly associated with the homeowner or owner-builder, concerned more with personal space utilization than with the most efficient way to operate a business. An extreme example of this approach is the homeowner who selects one feature of the house to remodel, usually for symbolic purposes, with little regard for the remainder of the structure which, he finds, must be altered for the sake of consistency—only to find that these changes require modification of the first element remodeled.

A curious dilemma is generated for some homeowners who find themselves caught between the extremes of wanting, on the one hand, to mythologize the space to conform to and express their fantasies and to fulfill their particular symbolic and ritualistic needs, and, on the other, to make the remodeled house appeal to others for resale purposes. One family, for example, nailed

to a wall of the dining room old, moss covered, weathered shingles but acknowledged that trying to eat a meal in such an environment might be a nauseating experience to other people. Another family, when remodeling and adding to their home, actually diminished the rather small living room area, taking space from it to enlarge the bedrooms to a grander scale, for they, unlike many people they know, tend to "live" in the bedrooms as if they were private "islands." Yet another person was overheard to remark, "I would like to have a free-standing restaurant stove in my kitchen, but since few other people are really gourmet cooks maybe we ought to just install a simple built-in; on the other hand, maybe we can put in the built-in, but also have a space for a commercial range and then take the range with us if we move; but then again, maybe I could . . . , or . . . , or maybe. . . ." The point is, there seem to be two intuitive models by which homeowners and researchers alike distinguish attitude, approach, and principal concern.

In essence, those of us who do much of the work ourselves, and for whom the guiding principles seem to be reparation, piecemeal learning, and salvaging, feel that our approach is one of "organic growth" developing from a "living experience" and leading to "wholeness" through "self discovery." As the well-known psychiatrist C. G. Jung, who was also an owner-builder, writes in his book *Memories, Dreams, Reflections*, "I built the house in sections, always following the concrete needs of the moment. It might also be said that I built it in a kind of dream. Only afterward did I see how all the parts fitted together and that a meaningful form had resulted: a symbol of psychic wholeness." [27] Such sentiments probably take shape in part because of the nature of the process of building or remodeling while living in the structure, designing while building, collecting information and learning skills as they are needed, and preferring to work with and within the existing structure instead of superimposing another geometry.

The foregoing survey of some aspects of owner-built and homeowner-redesigned structures suggests a number of ramifica-

[27] Carl Jung, *Memories, Dreams, Reflections* (New York: Viking Press, 1957), p. 225.

tions, one of which is consequential for folkloristics and related fields of study. The architect Frank Lloyd Wright contends, "The true basis for any serious study of the art of Architecture still lies in those indigenous, more human buildings everywhere that are to architecture what folklore is to literature or folk song to music and with which academic architects were seldom concerned." He continues, "These many folk structures are of the soil, natural. Although often slight, their virtue is intimately related to environment and to the heart-life of the people. Functions are usually truthfully conceived and rendered invariably with natural feeling. Results are often beautiful and always instructive." [28] What Wright calls "folk" is that which is most directly behavioral because it is person-oriented, customized or tailored, subjective rather than objective, mythologized, and ritualized (i.e., "more human buildings," "of the people," "functions truthfully conceived," "rendered with natural feeling"). "Folk" is not the output of a category or class of people or a particular output readily distinguishable from other objects; it is an *attitude, approach, and principal concern,* and such an attitude is a *function of a particular individual and of a specific circumstance.*

Architectural research in recent years has witnessed a growing sense of alarm at what is taken to be the abuses of the systems approach. Especially well known are the articulate calls to action by Clovis Heimsath and John Friedmann who are concerned primarily with the planning of institutions, office buildings, and multiple-unit dwellings, and who point out some of the dilemmas in current design approaches.[29] There is also an increasing number of publications featuring verbal descriptions and visual documentation of so-called exotic or spontaneous architecture represented by the works by Rudofsky and Christopher and Charlotte Williams. Unfortunately, they are without examples of modifications in pre-fab houses, tract homes, and mobile homes and they

[28] Frank Lloyd Wright, *The Sovereignty of the Individual,* quoted in River, *Dwelling,* p. 19.

[29] Heimsath, *Behavioral Architecture,* especially pp. 25–34; and Friedmann, *Retracking America: A Theory of Transactive Planning* (Garden City, N.Y.: Doubleday, Anchor Press, 1973), especially pp. xiii–xx.

usually lack analysis.[30] What is needed is a combination and integration of the two interests to develop a new approach to architecture, derived at least partly from a study of architecture without architects. "Users are not principal members of the design team," writes Heimsath, and after a building is constructed, "there is no feedback to check that the assumptions used in designing the building were indeed valid."[31] He lists "rules of thumb" customarily followed by architects in designing a structure, at least half of which are relied on for designing single-family residences, and he observes: "None of these twenty-three rules of thumb *directly* involve behavioral considerations, yet each will affect some aspect of the behavior of people using the buildings designed by means of these rules."[32] Although there are, he is quick to point out, behavioral assumptions implicit in the current design process, they are not usually tested, made explicit, or added to with new data and insights.

The relationship between the do-it-yourselfer and "the code" ought to be examined. Some of the health and safety regulations, while designed to protect homeowners from unscrupulous contractors and from themselves, often require expensive and otherwise unnecessary solutions to problems. They mitigate against innovation, ignore the behavioral processes inherent in owner-built and homeowner-redesigned houses, and create an atmosphere in which violating the codes is in fact encouraged (even by licensed contractors). Some years ago several people in a canyon community performed a skit in which a real estate salesman shows some "flatlanders" a house that, to everyone's surprise, even has wall-to-wall flooring. Later in the skit someone says, "Show me where it says in the code that the drain field has to be out-

[30] Rudofsky, *Architecture Without Architects*; and Christopher and Charlotte Williams, *Craftsmen of Necessity* (New York: Random House, 1974).

[31] Heimsath, *Behavioral Architecture*, p. 31.

[32] Heimsath, *Ibid.*, p. 29; see also p. 91. I find it ironic that at about the same time that Heimsath's book and Friedmann's *Retracking America*, both of which emphasize behavioral input and thus represent a challenge to the system's approach, were published, so also was Francis Ferguson's *Architecture, Cities and the Systems Approach* (New York: George Braziller, 1975), which takes the systems approach to an extreme.

side." [33] An owner-builder, testifying to a grand jury about when he was an "outlaw" builder, explained, "I never bought a permit, because there weren't any for sale for what I wanted to do!" [34] One way to make regulations more realistic and reasonable is to examine the actual behavior of people who construct shelters and readjust personal space, and, on the basis of such studies, to propose alternatives to the present code and its manner of enforcement. Other behavior needs to be treated as well, namely, that of the people in the building department. Homeowners (and sometimes architects and contractors) have complained about the problems of trying to get information, advice, and approval from people behind the counter at the building department, many of whom seem uninformed or uncaring. Rarely have I heard complaints about the building inspectors (one of whom boasted to me that he has never required anyone to tear out work done without a building permit), for they are in the field where they become aware of the problems faced by the homeowner and are aware of alternative solutions, few of which are actually acceptable to the letter of the code.

Yet another ramification of the study of homeowner-redesigned space concerns housing and its availability. Abandoned houses constitute a rich resource which, through rehabilitation rather than destruction and costly replacement, could provide housing of a type that many people find acceptable.[35] It would

[33] Wilson, "Bootleg Building," p. 13.
[34] Kern, Logon, and Thallon, *The Owner-Builder and the Code*, p. 43.
[35] Donald R. Brann, *How to Rehabilitate Abandoned Buildings* (rev. ed.; Briarcliff Manor, N.Y.: Directions Simplified, a division of Easi-Bild Pattern Co., Inc., 1975); and John Getze, "Abandoned Homes: Idle U.S. Resource: Restoration Could be Key to Solving Urban Problems, Experts Say." *Los Angeles Times* (September 22, 1976), pt. 1: 1, 26, 28. See also " 'Recycled' Home Program to Get Under Way in South-Central L.A.." *Los Angeles Times* (May 14, 1977), pt. 2: 5 (the sale of city-rehabilitated abandoned homes to qualified purchasers for repair costs at low-interest loans). Two recent articles demonstrate that with or without approval, some individuals are taking over abandoned structures: "Price is Right on Ghetto Homes: $0," *Los Angeles Times* (no date noted), pt. 1: 2; and Don A. Schanche, "Tombs Turn into Houses: Cairo's 'City of Dead' Is Full of Live Tenants," *Los Angeles Times* (July 10, 1977), pt. 1, 1, 12. The rehabilitation of houses has been spurred by considerations in addition to providing low-cost housing or saving buildings, as apparent in the article "Student-Rehabilitated Home Open to Public," *Los*

also appear that remodeling and adding to houses, or otherwise refurbishing them, plays a significant part in the current housing boom with its spiraling prices. Many pepole, unable in the current market to afford a larger house or a "better" home, add to and remodel their present one. Others derive part of their income fom fixing up houses for immediate rental or resale. This contributes to rising prices but it also saves structures from demise and improves neighborhoods. Still other people, by fixing up one house as their home and then selling it to buy another fixer-upper can repeat the process and thereby improve their housing situation over the years.[36] Explanations of spiraling real estate prices are usually broadly based (e.g., speculation, inflation, and supply and demand [37]) and thus fail to answer specifically the question often

Angeles Times (August 14, 1977), pt. 7: 11 (L.A. high school students rehabilitated a structure as part of a Youth Housing Opportunity Program); and Peter G. Beidler, "Learning Literature—and Fixing Houses," *Los Angeles Times* (April 3, 1977), pt. 7: 1 (at Lehigh University Beidler teaches English 198: Self-Reliance in a Technological Society; students are required to remodel a house as well as to read works by Emerson, Thoreau, B. F. Skinner, Aldous Huxley, Ken Kesey, and others).

[36] For example, see Turpin, "Another Buying Barrier Falls"; Margaret Daly, "Which Home Improvements Pay Off Best When You Sell?" *Better Homes and Gardens* 55, no. 5 (May 1977):46–48, 50, 52, 54; Dan MacMasters, "A Steal for Fixer-Uppers," *Los Angeles Times Home* (June 2, 1974), pp. 56–57; "Homebuyers Spur Renovation Trend Across Country," *Journal of Commerce Review* 64, no. 133 (July 6, 1977):1, 24; "Remodeling Is a Good Option As R. E. Costs Escalate," *Los Angeles Times Home Improvement Guide* (May 6, 1977), pp. 1, 10; George E. Hatt, "Remodeling Costs Less, Adds to Home Value," *Los Angeles Times Home Improvement Guide* (July 28, 1977), pp. 1, 5, 7.

[37] C. C. Douglas, "Speculation Wild in S. Calif. Real Estate," *Moneysworth* (June 6, 1977), pp. 1, 9; David M. Kinchen, "Inflation, Speculation Hit Existing Houses" *Los Angeles Times* (May 15, 1977), pt. 2: 1, 10; "Apartment Speculation Can Be Way for Unwary to Lose Shirt," *Journal of Commerce Review* 64, no. 116 (June 13, 1977):1, 24; Dave Berman, "When a House Is Not a Home," *Evening Outlook* (Santa Monica, Calif.) (June 10, 1977), pp. 13, 14; Dick Turpin, "Feasting on the Fast Buck," *Los Angeles Times* (May 1, 1977), pt. 10: 1; Leon Brauning, Letter to editor, "Builders Blamed for Speculation," *Los Angeles Times* (July 10, 1977), pt. 8: 5; Dick Turpin, "Speculator Label Resented," *Los Angeles Times* (no date or pagination recorded); "Speculator Element in Housing Boom Worrying," *Journal of Commerce Review* 64, no. 80 (April 22, 1977):1, 2; Dick Turpin, "Best Bet: Buy Home," *Los Angeles Times* (June 20, 1976), pt. 7: 1, 12; David M. Kinchen, "As Speculators Proliferate the Affordable House Is Vanishing," *Los*

asked about how some people are able to afford houses on today's market. The few attempts to profile buyers have tended to dwell on the broad socioeconomic categories of age, ethnicity, level of income, and marital status.[38] To my knowledge there have been no studies of actual sources of money used for down payments and monthly payments. These would include factors as the increase in moonlighting and the number of working spouses, people

Angeles Times (April 17, 1977), pt. 8: 1, 6; Anthony Cook, "California's Soaring House Prices: The Ceiling is in Sight," *New West* 2, no. 12 (June 6, 1977):28–30, 33.

[38] "Profile of the Single-Family Home Buyer," *Realtors Review* (June 1977), pp. 8–14 (exerpts from longer study completed by the Department of Economics and Research of the National Association of Realtors); "Today's Homebuyers Young, Well-To-Do," *Journal of Commerce Review* 64, no. 160 (June 17, 1977):1–2 (study conducted by Walker & Lee, Inc., an Anaheim-based residential real estate services company); "Meaning Unclear: Study Shows Major Increase in Unwed Couple Households," *Journal of Commerce Review* 64, no. 35 (February 18, 1977):1 (annual report of the Census Bureau).

That the question of what accounts for the radical increase in cost of property is an important one with significant socioeconomic ramifications is apparent when two types of headlines are juxtaposed. First, according to date published, are articles chronicling the rise in housing prices, such as "Banner Year Ahead for Housing, Realtor Says," *Journal of Commerce Review* 64, no. 17 (January 25, 1977):1, 2; "Security Pacific [a savings and loan association]: See Area Homebuilding Up Moderately in '77," *Journal of Commerce Review* 64, no. 22 (February 1, 1977):1, 2; "December Data Show: Existing Home Prices At New High in State," *Journal of Commerce Review* 64, no. 28 (February 9, 1977):1, 13; "Makings of Housing Boom Seen for California in '77," *Journal of Commerce Review* 64, no. 39 (February 24, 1977):1, 2; "Survey Shows Significant Increase in Home Sales," *Journal of Commerce Review* 64, no. 41 (February 28, 1977):1; "1st Quarter Average: $51,600: Price of New Home Up 38% in 3 Years," *Journal of Commerce Review* 64, no. 99 (May 19, 1977):1; Charles Ellis, "Prices to Stay High: No Turn-Around Seen in Housing Market," *Los Angeles Times Home Improvement Guide* (August 6, 1977), pp. 9, 10; "Building Activity: Southland's Pace Sets New Record," *Los Angeles Times* (August 14, 1977), pt. 7: 4; "In Orange County: Median Price for New Homes Outpaces Used," *Journal of Commerce Review* 64, no. 163 (August 18, 1977):1; and Lou Desser, "Median Figure Now $101,990: Soaring Prices Fail to Slow Home Sales in Orange County," *Los Angeles Times* (September 18, 1977), pt. 7: 1, 5. Contrast those headlines with the following three: David M. Kinchen, "Southland Home Prices Outpace Income: Housing Up 40.8% While Income Rises Only 18.9%," *Los Angeles Times*, pt. 10: 1; "Budget Analysis: 'Austere' Family Needs $10,000,'" *Los Angeles Times* (April 27, 1977), pt. 1: 22; "Low Level Budget for Urban Family Now at $16,236," *Journal of Commerce Review* 64, no. 87 (May 3, 1977):1, 2. How indeed, as many ask, can one afford to buy a house in today's market?

living together and contributing several incomes to rent or purchase, refinancing one property to buy another, receiving windfalls, upgrading one property and then selling it to buy another in need of rehabilitation, and so on. Other behavioral considerations involved in a study of spiraling property values would include the recent practice of holding lotteries for the sale of development homes which seems simply to have spurred panic buying, the practice of many homeowners known as stretching their family finances in order to meet payments, and perhaps even "redlining" by some lending institutions.[39]

To return for a moment to the fundamental matter of personal space and its meaning, I wish to refer to one example that emphasizes the importance that a dwelling may have in the lives of people. In 1936 an eleven-year-old girl in Iowa was required to prepare for class a booklet expressing her conceptions of "home planning." Inside the front cover she pasted a magazine illustration of a smiling youth held tightly in the air by the strong hand of a man. One page of the booklet contains the following verses entitled "Home Poem":

Home ain't a place that gold can buy or get up in a minute
Afore its home there's got t'be aheap a'livin' in it;
Within the walls there's got t'be some babies born, and then
Right there ye've got to'bring 'em upt' women good, an' men.
And gradjerly as time goes on ye find ye wouldn't part
With anything they ever used they've grown into yer heart

[39] For example, see, "Bad Marriages Are Good for the Housing Industry," *American Business* (April 1977), p. 12 (an estimate that the need for shelter for divorced people who are between spouses will help boost housing expenditures to $1.2 trillion over the next decade); David M. Kinchen, "No Signs of Overbuilding: Economist Sees Continuation of Booming Housing Market," *Los Angeles Times* (June 26, 1977), pt. 9: 1, 6 (contributing to heated market are liberalized lending policies, more two-income families especially among first-time buyers, and greater willingness to spend more income on housing); "3-Day Camp-Out to Buy Homes Friendly Queue," *Journal of Commerce Review* 64, no. 123 (June 22, 1977):1, 2; Bill Boyarsky, "Buyers Camp Out in Search of a Home: Line Forms Early for Houses Yet to Be Built," *Los Angeles Times* (July 17, 1977), pt. 2: 1, 6. "Redlining" refers to the ethically questionable policy (and in some places, illegal procedure) of a lending institution not to loan on properties in a certain area; conceivably, one result is to inflate prices in another section of the city while the redlined area deteriorates.

the old chairs, the playthings, too, the little shoes they wore
Ye hoard; an if ye could ye'd keep the thumbmarks on the door.

Seven pages follow the poem and contain illustrations cut out of
magazines of a house seen from the street, a floor plan, the
kitchen, living room, dining room, bath, and two bedrooms from
different houses (and hence with features not consistent with
one another). Next are views of the facades of four houses
thought to typify some "American Styles" accompanied by a list
of traits (for example, for "Modernistic" are listed "straight lines,"
"fire proof," "porchs on the roof" and for the category "French
Houses" appears the single trait "castle entrance"). Following that
section are illustrations of furniture and a listing of some furniture
features (for instance, "Jacobean Furniture—lived in 1600" is fol-
lowed by "lighter weight," "straight lines," "eight-leg table" and
"French Furniture" is characterized as "delicate—elaborate—rich
velvet—upholstering," "uses lots of yellow & white"). The next
section is "The Ideal Home" which is conceived of as being
economical, containing mechanical conveniences ("electrical ap-
pliances, car, running water"), providing religious training, stimu-
lating learning, generating a happy social life, being morally whole-
some, being artistic ("make the best of what you have, neat yard,
clean house"), being healthful, and encouraging love and re-
spect. Six of these attributes are illustrated. The final section con-
cerns "good habits to teach children" of which nine or nearly
half are illustrated with images cut out of magazines ("good table
manners," "play by themselves," "care of clothing," "cleanliness,"
"morally wholesome," "good sleeping habits," "be kind to ani-
mals," "tidy," and "dependable").

Twenty-one years later this woman and her husband bought
a house in the Los Angeles area. The only feature in common be-
tween the house dreamed of in 1936 and the one purchased in
1957 is that both of them are green. The Los Angeles house is
well constructed, built by the Meyer Brothers in 1947, and, as
a simple stucco box, it is in many ways an ideal "tract" house if
cost-efficiency is the primary consideration. The house has draw-
backs, however, in that the spaces are rigidly defined, not lending
themselves to the generation of other meanings and uses. There

are no nooks and crannies, no bay window, no attic to excite the imagination, generate associations, or encourage symbolic behavior.[40] Even radical attempts to add on to the house are likely to produce anomalous designs. I am not suggesting that this owner and other owners of the house have not tried to personalize, mythologize, and ritualize space, for indeed they have tried. The first owner, for example, added a carport in order to use the garage for activities other than storing an automobile. He also added an open front porch, and the shrubs in front of it provide some degree of privacy both to the porch and to the entrance; perhaps also the shrubs provide a transition from yard to house or outside to inside. This woman, the second owner, put a wallpaper mural of Colonial Williamsburg on the living room wall, which we, upon buying and moving into the house a few years ago, immediately covered with white carpeting to produce a variety in texture and installed a large mirror to suggest greater room size. Sometimes an approach to architectural design that stresses the systematization of labor and standardization of materials, which requires the replication of models and techniques on an a priori basis, and which is generated and perpetuated solely or primarily for the benefit of the builder of the house ignores the behavior and the needs of the people who will dwell in these structures. When we moved into the house I found in the trash the booklet concerning the ideal home prepared by this woman in her youth. Why she discarded it I do not know. Our solution to the problem of trying to personalize the house proved no solution at all. And so, having found a structure with a greater number of ambiguities and a larger number of discreet spaces, we moved.

Adding on to, remodeling, decorating, redecorating, and designing shelters is so prolific a behavioral phenomenon in contemporary American society that the necessary information and conditions exist for testing the assumptions of Heimsath and others who demand that urban planning and architectural design become more amenable to people's need for and use of space. "In mutual learning," writes Friedmann, "the processed, scientific knowledge

[40] For some remarks on the poetics of space, see Gaston Bachelard, *The Poetics of Space*, trans. Maria Jolas, with a foreword by Etienne Gilson (Boston: Beacon Press, 1969).

of the planning expert is joined with the deeply personal, experiential knowledge of the client." [41] Homeowners and owner-builders have been aware of the need for some time now. True, the exploration of the implications of these statements requires the dominance of a certain point of view, the generation of a particular attitude, the expression of a specific concern. The methods are available in both folkloristics and architectural research; all that is wanting is the action of particular individuals in specific circumstances.

Some investigations in recent years by folklorists concerning narrating, singing, dancing, and object production reveal a tendency to broaden the data base, to grapple with the generation of new methods, and to reconsider common assumptions regarding data and methods.[42] Conceptual alternatives are implied if not actually stated and refined. It is apparent from this study of the renovation of houses, which has important practical ramifications, that new approaches are required—even to the extent of questioning the usefulness of, and perhaps posing alternatives to, words such as "folk," "art," "aesthetics," "creativity," "tradition," and "style."

[41] Freedmann, *Retracking America*, p. xix.
[42] See Robert A. Georges, "Toward an Understanding of Storytelling Events," *Journal of American Folklore* 82, no. 326 (October-December 1969): 313–27; Robert A. Georges, "The General Concept of Legend: Some Assumptions to Be Reexamined and Reassessed," in *American Folk Legend: A Symposium*, Wayland D. Hand, ed. (Berkeley: University of California Press, 1971), pp. 1–19; Joann Wheeler Kealiinohomoku, "Folk Dance," in *Folklore and Folklife: An Introduction*, Richard M. Dorson, ed. (Chicago: University of Chicago Press, 1972), pp. 381–404; Richard Bauman, "Differential Identity and the Social Base of Folklore," in *Toward New Perspectives in Folklore*, Américo Paredes and Richard Bauman, eds. (Austin: University of Texas Press, 1972), pp. 31–41; Dan Ben-Amos, "Toward a Definition of Folklore in Context," in *Toward New Perspectives*, Paredes and Bauman, eds., pp. 3–15; Beth Blumenreich and Bari Lynn Polansky, "Re-Evaluating the Concept of Group: *Icen* As an Alternative," in *Conceptual Problems in Contemporary Folklore Study*, Gerald Cashion, ed. (Bloomington, Ind.: Folklore Forum Bibliographic and Special Series No. 12, 1975), pp. 12–17; Kenneth L. Ames, *Beyond Necessity: Art in the Folk Tradition* (Winterthur, Del.: Winterthur Museum, 1977); Richard Bauman, "Towards a Behavioral Theory of Folklore: A Reply to Roger Welsch," *Journal of American Folklore* 82, no. 324 (April-June 1969): 167–70; Roger D. Abrahams, "Introductory Remarks to a Rhetorical Theory of Folklore," *Journal of American Folklore* 81, no. 320 (April-June 1968): 143–58; and Alan Dundes, "Texture, Text, and Context," *Southern Folklore Quarterly* 28 no. 4 (December 1964): 251–65.

Consider the word "folk." When used as a noun, it has meant to different individuals a certain class (the folk), any group whatsoever as long as it is a group with a distinguishing and an allegedly unifying trait such as religion or residence or language (a folk), and people generally (folks).[43] As an adjective the word has been employed to qualify behavior or outputs of behavior as crude, vigorous and forthright, makeshift, spontaneous, old-fashioned, traditional, uncritical, unselfconscious, child art on the adult level, democratic, a sport, untutored, learned by oral or imitative means, nonprofessional, anonymous, a collective phenomenon, and so on.[44] For any allegedly distinguishing criterion, however, there are exceptions. For example, one object of anonymous origin is folk, but another is not. One object of known authorship is not folk, but another is. One producer is not a professional, and therefore is folk, but another producer is a specialist and is also folk. A producer is folk because of the use of traditional techniques learned orally and by imitation, but the objects produced are not folk because they seem to be more original than old-fashioned and more individualistic than collective in spirit and nature. These criteria lack exclusivity. For instance, that which is called folk is assumed to be traditional, but not everything conceived of as traditional is referred to as folk (such as trends and conventions in literature, architecture, and scholarship). Criteria are inconsistently employed. Some commentators shift from one criterion to another when, because of the lack of exclusivity of each alleged characteristic, a criterion obviously does not apply to every act or object or person conceived intuitively as folk.[45] That which is labeled folk has been assumed by many people to be an isolable phenomenon consisting of discreet entities repre-

[43] As can be inferred from an examination of the following works: Alan Dundes, ed., *The Study of Folklore* (Englewood Cliffs, N.J.: Prentice-Hall, 1965), especially pp. 4–51; Jan Harold Brunvand, *The Study of American Folklore: An Introduction* (New York: W. W. Norton & Co., 1968), especially pp. 1–27, 268–86; Arnold Hauser, *The Philosophy of Art History* (Cleveland: World Publishing Co., 1963), pp. 98, 281–82, 295, 302, 347.

[44] As, for example, in the contributions to "What Is American Folk Art?: A Symposium," *Antiques* 57, no. 5 (May 1950):355–62; as well as references in note 43.

[45] See criticisms by Kealiinohomoku, "Folk Dance"; Ben-Amos, "Toward a Definition of Folklore in Context"; and Ames, *Beyond Necessity*.

senting survivals that are inherited and perpetuated by members of a group as part of their cultural heritage. And yet no distinguishing criteria have been agreed upon to isolate this phenomenon, and it is recognized that there are activities as well as objects that are unique inventions and discoveries by specific individuals rather than cultural survivals.

Despite these conceptual problems, many individuals still feel that folk is a meaningful label that serves a useful purpose. They would insist that, even though defining criteria are not exclusive and are not consistently employed, there is a phenomenon that is different from other phenomena and can be given a distinguishing name. If they are not exclusive, then why are the criteria mentioned above cited with such frequency? Given the great diversity in the nature of the objects and activities and in the people labeled folk, why assume that they are related in some way and thus constitute a single category? What, in the final analysis, is that intuitive basis, heretofore not ascertained, for the attempts to distinguish folk from non-folk? Answers to these questions have been implied in the discussion of L. A. re-dos and add-ons.

There seems to be an admixture of two conceptual tendencies in discussions of the data base that is labeled folklore or folk art. It has been argued persuasively that in the nineteenth century "folklore," like the words it tended to replace (such as "popular antiquities"), "was neither a term for a theoretical construct nor a collective term for some group of data or phenomena that exhibited any one common characteristic or any set of common characteristics"; rather it was "merely a word that could be used to refer to anything and everything that *seemed* to anyone to be . . . a 'survival' from the historical past." [46] Such a notion of folklore is still to be found in the literature. But often another orientation is suggested, too, complicating and confusing attempts to understand the ways in which a data base has been distinguished. This other orientation involves the commentator's

[46] Robert A. Georges, "Models of Inquiry in Folkloristics: The Nineteenth Century," lecture (American Folklore Society meeting, Washington, D.C., November 12, 1971); see also Michael Owen Jones, "In Progress: 'Fieldwork—Theory and Self,'" *Folklore and Mythology Studies* 1, no. 1 (Spring 1977):1–22.

inference about the dominant identity and major preoccupation of the producer. It is derived largely from observations of the perceptible features of objects, as contrasted to an intuitively based standard of comparison assumed to constitute the norm by which things are judged and identified. Supposedly, there is an "avant garde" or an "elite" or a "vanguard" consisting of "creative" people who are conceived of by some others and by themselves as "artists," whose goal is to produce "major monuments" and "great works" of "art" which evince "stylistic trends" and generate an "aesthetic" experience in the percipient. Objects and people are contrasted, often intuitively and on the basis of limited information, to this standard of measurement, the features of which are rarely stated. When an insufficient (but not articulated) number of correspondences seem to obtain, the objects or the people are designated by the catch-all category "folk" or "popular" or "non-academic."

Thus, if a painter is seemingly unaware of, or ignores, contemporary trends and theories in art, he risks being labeled a folk painter.[47] If a chair or cabinet does not fit into "period styles," then it is called "no-style" or "country" furniture.[48] If a toy or textile or eating utensil is of unknown authorship, it is assumed, sometimes correctly, that the author did not consider it a "major monument" or a "great work," and it is assigned by default to the category folk.[49] If buildings are constructed by people who do not call themselves "artists" and "architects" and whose names cannot be found on the rosters of the American Institute of Architects, then they are called examples of "architecture without architects," "spontaneous buildings," or "handmade houses." [50] If photographs were intended principally for personal satisfaction, family use, and as aids to memory of the event, then they are

[47] Herbert W. Hemphill, Jr., and Julia Weissman, *Twentieth-Century Folk Art and Artists* (New York: E. P. Dutton, 1974), pp. 9–20.

[48] See Charles F. Montgomery's remarks in "Country Furniture: A Symposium," *Antiques* 93, no. 3 (March 1968):355–59.

[49] Michael Owen Jones, " 'They Made Them for the Lasting Part': A 'Folk' Typology of Traditional Furniture Makers," *Southern Folklore Quarterly* 35, no. 1 (March 1971):44–61.

[50] See, respectively, Rudofsky, *Architecture Without Architects*; Heimsath, *Behavioral Architecture*; and Boericke, *Handmade Houses*.

called "snapshots" and "folk art"—even when those photos were produced by well-known photographers who also made other photographs in the role of "professional photographer" intended for commercial use or gallery display.[51]

The alleged distinguishing features of folk art, then, are not primary considerations at all, but their use implies the intuitive basis for the distinctions that are made. There is no consensus regarding these criteria as defining characteristics, because, in fact, they are not the principal basis for attempts to isolate phenomena as folk. There is no one common characteristic or any set of common characteristics among phenomena labeled folk art. In the process of conceptualization dominant identity as well as intent of producer are inferred by the commentator on the basis of shifting kinds and quantities of information and in terms of a standard of reference constituting an ideal type that itself is not expressed by the commentator. Hence, what is folk art to one person may very well not be folk art to someone else who relies on other kinds of information or who makes other inferences about the producer's self-concept and purpose or who has different standards of comparison. Furthermore, one individual at a particular moment in a specific circumstance while engaged in a certain activity may or may not assume the identity of an "artist" who has "patrons" or "clients" and who is involved in the act of making or doing something considered by self or others to be "great" and to be responded to "aesthetically." In the final analysis, while distinctions often are made between folk and non-folk, or between a "re-do" and a "remodeled home," no differentiation is, or can be, hard-and-fast; as a consequence, the field of study called folkloristics must be defined principally not in terms of a data base but with respect to its questions and concepts.

Because the phenomena studied by folklorists are behavioral and therefore distinguishable in behavioral terms, there is no need to modify the activities with the adjective "folk"; instead, one can

[51] See statements in Foreword by Weston Maef, pp. 7–10, as well as comments by the author Mark Silber in *The Family Album: Photographs of the 1890s and 1900 by Gilbert Wight Tilton and Fred W. Record* (Boston: David R. Godine, 1973), pp. 11–16; see also Ken Graves and Mitchell Payne, *American Snapshots* (Oakland, Calif.: Scrimshaw Press, 1977), p. 5; and Jonathan Green, ed., *The Snapshot* (Millertown, N.Y.: Aperture, 1974).

speak generally of narrating, making things, dancing, singing, cele-
brating, and ritualizing with the well-founded expectation that
the listener understands that one is not referring to literature or
assembly-line airplanes. One can speak specifically of owner-built
houses in Marin County, California, of homeowner-inspired and
-controlled remodeling of houses in Los Angeles, or of "street
dances by neighborhood merchants who hire musicians to play for
both popular dancing and beer barrel polkas," [52] instead of folk
architecture and folk dance. In addition, one need not use "folk"
as a noun. Who would question that we are concerned with peo-
ple and specific individuals? If the word "folk" is used, however,
which is only rarely desirable for political, economic, or intellectual
reasons, the commentator should explain the ways in which pro-
ducer identity and intent have been inferred and contrasted to
some standard of measurement, the nature of which also should
be expressed. Furthermore, one should avoid confusing the rec-
ords of behavior with what they are records of or mistaking objects
for the processes they manifest. One should, rather, recognize the
behavioral basis of objects and outputs and focus attention on
that behavior,[53] thereby maintaining as primary the realization
that one is relying on inferences about producer identity and in-
tent. Finally, *human behavior*, not folk or art or group or culture,
should be the principal construct in the field of study called
folkloristics. If "behavior" is elevated to the status of a centrally
informing concept in folkloristics, the kinds of problems encoun-
tered in using the word "folk" or "folklore" no longer plague re-
search. Indeed, the folklorist focusing on "human behavior" could,
say, study the activities of welders in a factory without having to
be concerned directly with the products that tumble off an as-
sembly line, or examine a writer's familiarity with and incorpora-
tion of characterizations of behavior in fiction without having to
be committed to the other kinds of questions that intrigue a
literary scholar, or research his or her own behavior such as that
of singing and hypothesizing and ritualizing and constructing

[52] The quote is from Kealiinohomoku, "Folk Dance," p. 393.
[53] One of the points made by Robert A. Georges in "Toward an Under-
standing of Storytelling Events" is that the researcher must not mistake the
(always partial) records of a narrating event for the event itself.

things. The history of scholarship in folkloristics provides the
precedent for this solution, which is also implied in the attempts
mentioned above to generate defining criteria of folk and lore and
foreshadowed by discussion in recent years of "performance in
context," "artistic communication in small groups," "dance event-
ing," and "storytelling events as a social experience and commu-
nicative act." [54]

It follows from the preceding discussion of the word folk that
several other words ought to be reconsidered for purposes of en-
hancing the behavioral basis of folkloristics. "Art," like folk, is as-
sumed to be a distinctive phenomenon, different from "craft" and
"science" and other things. Exactly what it is, however, is not
always or entirely clear. Depending on whose statement one reads,
art is everything made by human beings, or only a certain class of
objects, or only certain objects within a class, or a part of an ob-
ject, or an object serving a particular purpose, something made by
a certain individual, or that which is intended to be art. It is also
said to be the expression of imagination, communication of emo-
tion, desire for beauty, elaboration beyond utility, or embellish-
ment on ordinary living.[55] Basically, the word art seems to be
used in two ways: to refer to a class of objects (or activities and
perhaps further qualified by the identity "artist," the intended
purpose, and the consequence) or to speak eulogistically. Prob-
lems of inconsistency, non-exclusivity, contradiction, and excep-
tions abound.[56] Studies of human behavior suggest that in any
particular circumstance what is an example of art to one person is
not necessarily so to another. Certainly, it cannot be categorically
stated or intellectually defended that only a specific class of ob-

[54] See, respectively, Dell Hymes, "The Contribution of Folklore to Socio-
linguistic Research," in *Toward New Perspectives in Folklore*, Américo Paredes
and Richard Bauman, eds. (Austin: University of Texas Press, 1972), pp. 42–
50; Ben-Amos, "Toward a Definition of Folklore in Context"; Kealiinohomoku,
"Folk Dance"; and Georges, "Toward an Understanding of Storytelling Events."

[55] For various conceptions of art, see Herta Haselberger, "Method of
Studying Ethnological Art," *Current Anthropology* 2, no. 4 (October 1961):
341–84; and Thomas Munro, *The Arts and Their Interrelations* (Cleveland:
Press of Western Reserve University, 1967), especially pp. 26–153.

[56] See discussions appended to Haselberger, "Method of Studying Ethno-
logical Art," and surveys of problems throughout Munro, *The Arts and Their
Interrelations*.

jects or activities is art (for example, painting, sculpture, architecture).

But there does seem to be a fundamental, recurrent feature to all conceptualizations of art; this feature appears to be the feeling that art is that which has been done well. This assessment is made subjectively, on the basis, from ego's point of view, that skills have been learned and mastered, materials are understood, and the output is unique in some way and pleasing to the perceiver because it embodies principles of harmony, rhythm, and balance. Once again, the process is an intuitive one, invoking standards of comparison that rarely are articulated. To avoid engendering conceptual problems, the researcher should focus attention on behavior, which means not just *outputs* but also *skills* and their mastery and the *use* of those skills. (The way in which someone builds a fence—the economy of motions, the efficiency in the use of tools and materials, and so on—may seem to someone else as pleasing and as satisfying as the fence itself.) Furthermore, instead of calling the behavior or outputs "art," or wondering whether they fit into someone else's categories of acceptable things, or trying to make them fit, the researcher would do well to speak of them in more specific and noneulogistic terms, such as songs or houses or remodeling or narrating. Finally, because determinations of what is pleasing and satisfying vary and lack uniformity, the researcher would be well-advised to ascertain the subjects' conceptions and responses. All of these solutions permit the investigator to continue to examine matters of interest to students of art with less likelihood of imposing unnecessary restraints or of misrepresenting the behavior.

There is enough behavioral research to indicate that many attempts to delineate "the aesthetic," as a term or construct in scholarship, have not been entirely successful. This is largely because the attempts have sought to isolate a particular feature of human responses to the exclusion of other aspects of those responses. Thus, the six most common factors alleged to constitute the aesthetic are very rarely actualized in any person's behavior; even when they are manifested they are not necessarily laudable. "Psychic distance" from the circumstances of manufacture and use of an object or of preparation for and execution of a performance

is a brief, transitory state, and its attainment, in fact, diminishes the fullest appreciation of many objects and activities (certainly those which are of practical use).[57] "Manipulation of form for its own sake" is an ideal motivation and an activity rarely separable from other motives and behavior. "Purposeful intent to create something aesthetic" can be claimed but not achieved; it usually goes hand-in-hand with, or is subordinated to, other concerns. "The attribution of beauty to the object or activity" is only one, and often a secondary, reaction to things. "The attribution of emotion-producing qualities to the objects or activities" is nearly impossible to determine and is often irrelevant. "A verbalized philosophy of the aesthetic" is something that a few specialists attempt to articulate, but it is of little concern with respect to most behavior most of the time. Even the professional aesthetician is not likely to analyze the bulk of activities and responses comprising everyday existence, including why one joke was funnier than another, why one meal tasted better than another, why one yard is more appealing than another, and to codify these principles into a canon. *Responses* to objects and behavior actually embrace *associations, fitness for use, mastery of skills, technical excellence in the manipulation of materials, knowledge and personal assessment of the individual making or doing something,* and even in some instances, as apparent with respect to personal readjustments of space, *symbolic relevance, territoriality,* and the *potential for identification.* Responses also involve likes and dislikes, and they are subject to influence by extraneous factors and to change through time.[58] Thus, one solution to some of the problems encountered when trying to employ "the aesthetic" in research is to refer to the behavior as *reactions* or *responses,* and to

[57] The six factors are summarized in Alan P. Merriam, "Aesthetics and the Interrelationship of the Arts," *The Anthropology of Music* (Chicago: Northwestern University Press, 1964), ch. 13, pp. 259–76.

[58] For a discussion of some of these points, see Michael Owen Jones, "The Concept of 'Aesthetic' in the Traditional Arts," *Western Folklore* 30, no. 2 (April 1971):77–104; Michael Owen Jones, "'For Myself I Like a *Decent,* Plain-Made Chair': The Concept of Taste and Traditional Arts in America," *Western Folklore* 31, no. 1 (January 1972):27–52; and Michael Owen Jones, "Violations of Standards of Excellence and Preference in Utilitarian Art," *Western Folklore* 32, no. 1 (January 1973):19–32.

include in one's conceptualization the features mentioned immediately above.

The word "creativity" is also sometimes problematic, largely because one can never be sure which of the five common connotations the user of the word has in mind, and because most uses of the word seem to be rooted in evaluative concerns. "Creativity" appears to mean, to different people at different times, the bringing into existence of something not there before (whether radically different or closely emulative); making an activity or object "special" by doing things "well"; following a particular model but making minor changes; making major changes in behavior patterned, at least initially, on a specific model; and exhibiting a qualitative difference in behavior, especially when radical inventiveness is coupled with superior technical mastery.[59] In the use of the word "creativity" often there is considerable confusion as to whether one is referring to the act of making or doing something that results in an output, or whether one is speaking eulogistically and commenting on qualitative differences in actions and outputs. Other problems develop when one disregards cognition and physical behavior per se and dwells on outputs (for example, is a singer who does not write the songs really "creative"?), or when one assumes that behavioral similarities derive from shared values and attitudes, and thus constitute "tradition" or "culture" determining the behavior of most people, or when one supposes that the production of objects or acts exhibiting differences (that is, alleged deviations from the norm) are attributable to other behavioral deviations. As a first step toward solving these conceptual problems, one must question the tendency to equate similarities with sameness and to assume that similarities can be attributed to superorganic determinacy; further, one must not lose sight of the behavior of people. One should clarify for oneself and for others just which connotation of

[59] For example, see the remarks by Ralph C. Altman in Daniel P. Biebuyck, ed., *Tradition and Creativity in Tribal Art* (Berkeley: University of California Press, 1969), pp. 183–92; and Edward D. Ives, "A Man and His Song: Joe Scott and 'The Plain Golden Band,'" in *Folksongs and Their Makers*, Henry Glassie, Edward D. Ives, and John F. Szwed, eds. (Bowling Green, Ohio: Bowling Green University Popular Press, n.d.) pp. 71–74.

the word "creativity" one wishes to communicate. Even better, perhaps, is to avoid speaking of creativity at all, and to refer specifically to the behavior under study as well as to the extent of use or absence of particular models while recognizing that all events, and hence all behaviors, are not only similar in some respects to other events and behaviors but also are different and unique.

Mention of "tradition" leads to another set of problems for examination. We have already observed that there is a tendency to suppose a priori that behavioral similarities constitute a corpus of restrictive and influential forces which, in turn, determine subsequent behavior. Some researchers assume the existence of tradition or culture, once they have abstracted and codified behavioral similarities and discounted differences. Ideal types are posited to organize, describe, and explain behavior. "It is a cultural tradition to do such-and-such." "Tradition decrees that so-and-so." "Tradition allows for this-and-that." [60] The basis for assuming that some behavioral similarities constitute a tradition, or derive from one, is rarely discussed. The process by which the tradition was determined by the researcher is undisclosed. The meaning of the word "tradition" often remains unexamined. A behavioral approach, however, which includes cognition, would focus on the construct *models*. It would explore the use of behavioral models by people without presupposing that behavioral similarities can be attributed to the direct influence of certain models. Nor would such an approach ignore individuals and differences in behavior; it would make *individual* and *event* primary concepts. Unlike the concept of tradition, the behavioral approach would not assume that models are normative, restrictive, limiting, or serving as binding forces of conformity.

Finally, the use of the word "style," employed as a tool for ordering and classifying aspects of behavior, has been attended by

[60] To appreciate some of the problems generated by attempts to employ the concept "tradition" (or "culture"), see remarks by Fred Kniffen, "American Cultural Geography and Folklife," in *American Folklife*, Don Yoder, ed. (Austin: University of Texas Press, 1976), pp. 51–70; John J. Honigman, *Personality in Culture* (New York: Harper & Row, 1967), especially pp. 1 (quoting Sapir), 63, 67–69; and Daniel P. Biebuyck's introductory comments in *Tradition and Creativity*, pp. 1–23.

problems somewhat similar to those for creativity and tradition. Usually "style" is defined explicitly as constancies in form or combinations of forms (which include form elements, form relationships, and form qualities). Analyses of style often employ the concepts of "period," "transition," and "evolution," and they are based on the assumption that the features of one period are explicable, principally or solely, in terms of the characteristics of the preceding period or that the features in the works of one individual are explicable in terms of certain traits in the works of an epoch or a group.[61] The actual characterization of a style, however, is far more subjective than the implied objectivity of the definition. It is based in large measure on conceptualizations rather than on measurable and quantifiable perceptual features, and the behavior so designated is often variable, diversified, and dynamic rather than rigid or fixed. If that which is alluded to by the shorthand designation "style" were constancy in form, there would be greater agreement as to the constituents of one or another style, for the criteria would be objectified. There would be agreement and an explication as to how many similarities are sufficient to claim that such-and-such is a distinctive style. There would be no prevarication such as that found in the use of the modifier "fairly" in reference to "constant," and there would be greater specificity than one finds in the phrase "over a certain period of time."[62] The basic conceptual and practical problems with many stylistic studies and in the use of the word "style," then, are the diversity, uniqueness, and individuality of behavior that are denied, ignored, or minimized. Also lost are the influences on behavior and the outputs of behavior developing within or from the interactions of people, the tools employed, the materials used, and the

[61] For conceptions of "style" and some problems in stylistic analyses, see Adrian A. Gerbrands, "The Concept of Style in Non-Western Art," in *Tradition and Creativity in Tribal Art*, Daniel P. Biebuyck, ed. (Berkeley: University of California Press, 1969), pp. 58–70; remarks by Ralph C. Altman appended to Haselberger, "Method of Studying Ethnological Art," p. 357; and Robert F. Thompson, "Àbátàn: A Master Potter of the Ègbádò Yorùbá," in *Tradition and Creativity in Tribal Art*, Daniel P. Biebuyck, ed. (Berkeley: University of California Press, 1969), pp. 120–82.

[62] Quotes are from Gerbrands, "The Concept of Style," in whose essay one can see many of the basic problems in speaking of style or of doing stylistic analyses.

process of making or doing something; these are disregarded or subordinated in importance to evolutionary determinism. The subjective, elusive, and relative qualities are subsumed in one's reference to the "style" of something or someone (for example, originality or individuality, extension versus intrusion in space, fineness versus roughness) and are disclaimed or not revealed. Solving these problems with a cognitive-behavioral approach means specifying those many *features, traits, or qualities* of an object or activity that one conceives or perceives to exist, whether they constitute similarities from one object or activity to another which characterize, in one's subjective but informed opinion, that object or activity. It also means recognizing *the unique traits or qualities or features*, which are as much a part of the object or activity as are recurrent elements. It means, too, not assuming that similarities collectively in people's behavior and outputs, or through time, have explanatory power (that is, are determinants of other behavior); rather, these alleged similarities (supposing that others agree to their existence and importance) are models after which the behavior of particular individuals may or may not be patterned, either closely or loosely and in whole or in part.

Recent trends in folkloristics, enhancing earlier conceptual foundations, foreshadow methodologically a cognitive-behavioral approach that requires alternatives in constructs, concepts, models, and assumptions; a different way of framing questions; and a new means of presenting solutions to familiar research problems. The basic construct would be "human behavior" rather than folklore, culture, or group. We assume that there are behavioral similarities among all people (for example, narrating, constructing, hypothesizing, celebrating, and so on), and we also assume that behavior is dynamic, that people learn through multiple means and from multiple sources, including trial and error, and that individuals are capable of making unique discoveries and inventions. People possess multiple identities, of which one or more dominates at any particular moment and in any particular situation, for which a certain behavior may be appropriate. The minimal units of analysis would be the "individual" and "interactional and communicative networks" manifested in unique "events" (rather than group or culture). Primary concepts would embrace "event" and "mod-

els" (rather than object or text and tradition). The analogues in research would consist not of organisms with superorganic control of human behavior, or systems in equilibrium, but specific events in which certain behavior is manifested (for example, narrating events). Questions would be posed not in terms of origins and functions (which are sociocultural), but in terms of "generation," "motivations" and "rewards," and "purposes served," "uses," and "reinforcement." Solutions to research problems would be directly behavioral, rather than generally and indirectly sociocultural, with attention to the "reactions" and "responses" of particular individuals to the "features," "qualities" or "traits" of activities as well as objects. Such an approach would seem to be the quintessence of folkloristics and would update the conceptual underpinnings from the concept of survivals and the theory of evolution to foundations that are more appropriate to recent discoveries and awareness. Taking such an approach, one could investigate the more contemporary and prolific behavior in American society, such as the construction and readjustment of personal space in Los Angeles, which involves researcher and subject alike and which has important practical ramifications. Without such an approach folkloristics is limited to recording and preserving old-fashioned and rapidly disappearing ways of inarticulate people. Surely neither the scholar nor the enthusiastic collector of today will remain content with nineteenth-century methods or materials.

Index

Illustrations are given in boldface

Index